G E O R G E C A L E B

BINGHAM

River Portraitist

GEORGE CALEB

BINGHAM

River Portraitist

By JOHN FRANCIS McDERMOTT

NORMAN : UNIVERSITY OF OKLAHOMA PRESS

Books by JOHN FRANCIS McDERMOTT
Published by the University of Oklahoma Press

George Caleb Bingham: River Portraitist (1959)
Prairie and Mountain Sketches (editor, with Kate L. Gregg) (1957)
A Tour on the Prairies (editor) (1956)
Indian Sketches (editor) (1956)
Up the Missouri with Audubon: The Journal of Edward Harris
 (editor) (1951)
The Western Journals of Washington Irving (editor) (1944)
Tixier's Travels on the Osage Prairies, translated by Albert J. Salvan
 (editor) (1940)

The publication of this volume has been aided by a grant from the
FORD FOUNDATION

LIBRARY OF CONGRESS CATALOG CARD NUMBER: 59-13474

For
Mary Stephanie McDermott
My Wife

Preface

MY INTEREST IN George Caleb Bingham was first aroused, I believe, in the 1930's when I spent several summers reading the St. Louis newspapers of a century before and collected many enthusiastic stories about him. In 1947–48 under the happy beneficence of a fellowship from the Newberry Library of Chicago (for which I shall not cease to be grateful), my notes on Bingham increased considerably, even though the project on which I was working was a much more extended one concerning the Midwest as artists reported it before 1860. About 1950, realizing that I had an impressive amount of new data on "the Missouri artist," I drafted an article to embody my findings. Instead of the four thousand words I had anticipated, I found I had written three times that much and yet had not told Bingham's full story but had merely set forth new or corrective data. My thought now of a book-length study was notably reinforced when my friend Clarence E. Miller, librarian of the St. Louis Mercantile Library, suggested I use the Bingham sketchbook which the library had owned for eighty years, but which had never yet been published in full. Through his aid I sought and obtained permission from the Board of Direction of the library to use the sketches as I wished.

In the course of preparation of such a study as this, a great many debts are accumulated. My first thanks must go to Mr. Miller for his constant interest and help and to the Mercantile Library for its very generous permission to publish the sketchbook. Next, to the American Philosophical Society, which in 1954 made me a substantial grant-in-aid enabling me to visit Philadelphia, Washington, New York, and other places in the East in search of Bingham material, a vitally important part of my investigations. I have already indicated my obligation to Stanley Pargellis and the Newberry Library. I must add a similar appreciation for release from teaching to the Guggen-

heim Memorial Foundation, even though the Guggenheim Fellowship in 1954–55 was for a related but separate project.

In other ways I owe much to the interest and encouragement of E. P. Richardson, director of the Detroit Institute of Arts, who supported my request to the American Philosophical Society, who published some brief studies and notes of mine about Bingham, and who has been good enough to read my manuscript. Perry T. Rathbone, for fifteen years director of the City Art Museum of St. Louis and now of the Boston Museum of Fine Arts, also stood sponsor and abetted me. Charles van Ravenswaay, director of the Missouri Historical Society, has been generous beyond all reasonable expectation, for he gave me the run of his extensive notes on Bingham and, as a Boonville man, made many useful suggestions. Floyd C. Shoemaker, secretary of the State Historical Society of Missouri, which has extensive collections of Bingham manuscripts and paintings, has been generous and co-operative. Ross E. Taggart of the William Rockhill Nelson Gallery of Art in Kansas City has been repeatedly helpful.

To the staffs of the libraries and museums at which I sought material I have many obligations. Miss Elizabeth Tindall, reference librarian of the St. Louis Mercantile Library, has checked many details for me. Miss Sarah Guitar, reference librarian at the State Historical Society of Missouri, has repeatedly undertaken research on special points. Kenneth B. Holmes, newspaper librarian of that society, and Donald H. Welsh, assistant editor of the *Missouri Historical Review,* have been of real help. Miss Marjory Douglas, curator, Miss Barbara Kell (now Mrs. David Strudell) and Mrs. Vernon Cox, former reference librarians, Mrs. Frances Biese, former archivist, and Mrs. Frances Stadler, present archivist, at the Missouri Historical Society, together with their assistants, have all lightened my load greatly. The reference staff of my own Washington University Library has often run down details for me. The St. Louis Public Library has supplied me with special material. The staff of the City Art Museum could not have been more helpful: Charles Nagel, its present director, William Eisendrath, associate director, Thomas Hoopes, curator, Miss Catherine Filsinger, assistant curator, Merritt Hitt, secretary, and Mrs. J. Bruce Stewart, librarian, have more than met every request I have put to them.

Preface

In Kansas City, James Anderson of the Native Sons of Kansas City and W. Howard Adams have been particularly helpful. James Roth, conservator at the Nelson Gallery, Richard B. Sealock, librarian of the Public Library, Mrs. Jerome Bartlett, Mrs. Thomas Mastin, Mrs. Crawford James, Mrs. Wallace Trumbull, Mrs. Thomas B. Hall, Mrs. W. E. Royster, A. J. Stephens, and James Gibson have all been kind enough to show their pictures and share their knowledge. Mrs. Arthur Palmer of Independence was also helpful. In the Boon's Lick country, F. C. Barnhill was generous with his time and with his extensive knowledge of Bingham and local history. Mrs. H. R. Turley, a member of the Bingham family, was one of the first people I saw in his own county. Mrs. W. C. Roberts (also of the family) of Marshall, Missouri, Judge Perry D. Storts of the Saline County Probate Court, Judge Roy D. Williams of Boonville, and Miss Helen Zuzak, librarian of the Boonville Public Library, have all assisted me. Miss Hazel Price of Glasgow has been a helpful intermediary for me in her town. Leslie Cowan, retired vice-president of the University of Missouri, did me the unusual kindness of bringing his *Mill Boy* from Columbia to St. Louis that I might see it. Mrs. W. D. A. Westfall, grand-daughter of James S. Rollins, has repeatedly answered my questions and helped me with the location of Bingham portraits. C. B. Rollins, Jr., Mrs. J. D. Holtzendorff, and Mrs. Frank Rollins were other friendly and helpful members of the Rollins family. R. B. Price, of Columbia, showed his portraits. Lew Larkin and Mrs. John Hobbs of Jefferson City have answered my queries. And I am not forgetting the many owners of Bingham portraits who wrote me about their pictures and told me of others—their names fill columns in the checklist of works with which I close this volume.

In St. Louis, Tom K. Smith, chairman of the Board of the Boatmen's National Bank, W. G. Rule, retired vice-president of that bank, Stratford Lee Morton of the Board of Direction of the Mercantile Library, Arthur C. Hoskins, William Pettus, Howard S. Derrickson, C. Burr McCaughen, Dr. Harold A. Bulger, Joseph Safron, William R. Gentry, William R. Gentry, Jr., Mrs. Grace Lewis Miller, Mrs. Charles Hudson, Mrs. Bernard T. Hufft, Miss Eleanor McKinley Case, Mrs. Calvin Case, Mrs. Belden Taylor Graves, Mrs. Mary Stephens Gray, Mrs. Benjamin Read, Roy King, and Miss Mary Dor-

ward, present librarian of the Mercantile Library, have been kind and helpful in various ways.

I made my first investigation of the American Art-Union papers at the New York Historical Society in 1947 through the courtesy of W. R. G. Vail, the director. Seven years later I returned for more exhaustive work. At both times Miss Dorothy Barck and Wayne Andrews, then in charge of library and manuscripts, were of great help to me, as were other members of the staff. To them I have since added James J. Heslin, librarian and assistant director of the Society. No one can work on any subject of art history without being indebted to the Frick Art Reference Library and to its librarian, Mrs. Henry W. Howells, Jr. At the Historical Society of Pennsylvania, through the courtesy of R. N. Williams II, the director, and the able assistance of his staff, I was able to examine many files of Philadelphia and Washington newspapers and other pertinent volumes and manuscripts. The newspaper room staff at the Library of Congress, too, gave me very efficient service and I enjoyed the use of a study room in that library for two months. At the Museum of Fine Arts in Boston I have special thanks for courtesies to Henry P. Rossiter and Miss Anna Hoyt. At the National Gallery of Art in Washington I had the pleasure of meeting and talking with Dr. Fern Rusk (Mrs. John Stanley). The late Virginius C. Hall, director of the Historical and Philosophical Society of Ohio at Cincinnati, was interested and helpful, and Mrs. Alice P. Hook, the librarian there, was kind enough to run down more than one needed detail for me. At every museum I visited —the Peabody at Harvard, the Wadsworth Athenaeum, the Yale University Art Gallery, the Newark Art Museum, the Brooklyn Museum, the Pennsylvania Academy of the Fine Arts, the Detroit Institute of Arts—to mention a few whose names have not already appeared in these acknowledgments—I met thoughtful help.

Many other persons have been kind enough to let me publish their pictures or have located paintings for me or dug out information or have done more than merely answer a letter of inquiry. Among them I am happy to list Henry L. Shattuck of Boston; William A. Hughes of Newark, New Jersey; Richard W. Norton, Jr., of Shreveport, Louisiana; Claiborne Pell of Washington; Harry Shaw Newman of The Old Print Shop, New York; Paul Moore, Jr., of Convent,

New Jersey; John Sweeney, associate curator of the Henry Francis DuPont Winterthur Museum; W. Charles Thompson of the Vose Gallery, Boston; Paul Grigaut of the Detroit Institute of Arts; James T. Forrest, executive director of the Thomas Gilcrease Institute of American History and Art at Tulsa; Meyric R. Rogers, now curator of the Garvan Collection, Yale University; Stephen T. Riley, director of the Massachusetts Historical Society; the Adams Trust; Miss Elizabeth H. Rice and Dr. John J. Rice of Washington, D. C.; Mrs. Frank K. Williams of Lynchburg, Virginia; Miss Elizabeth Clare, librarian at the Knoedler Gallery, New York; John David Hatch, Jr., director of the Norfolk Museum; Paul Harris, director of the J. B. Speed Museum, Louisville; Richard B. K. McLanathan; Mrs. Fulton Stephens of Esparto, California; G. B. Birch of Teaneck, New Jersey; Yeatman Anderson III of the Cincinnati Public Library; Mrs. Edna Whitley, Mrs. Christian De Waal and Mrs. W. R. Patterson of Lexington, Kentucky; Hoyle M. Lovejoy of River Forest, Illinois; Charles E. McArthur, Jr., of New York; Walter Henderson, Jr., of Glasgow, Missouri; Mrs. Roland Whitney of Louisville; Ed. S. Carroll of Independence, Missouri; Mrs. Charles H. Coppinger and Conn Withers of Liberty, Missouri; Kearney Wornall and John B. Wornall of Kansas City; George Whitney of Upland, California; Mrs. Eulalia Price Shields of Denver; Mrs. W. P. Bowdry of Fort Worth and Miss Lucy King of Stephenville, Texas (grand-daughter and great-grand-daughter of the artist); Mrs. J. L. Morris of Siloam Springs, Arkansas, John S. du Mont of Greenfield, Massachusetts; J. P. Cayce of Farmington, Missouri; James Graham and Sons Gallery, New York; Mrs. Norman Johnson, reference librarian, Louisville Free Public Library; Miss Opal R. Carlin, librarian, William Jewell College, Liberty, Missouri; Warren V. Patton of St. Louis; and Leroy K. Robbins, Imperial, Missouri.

Considering the years I have been at work on this study, the many cities and towns, museums, historical societies, and homes I have visited, the correspondence I have enjoyed with friends and strangers, the citations of indebtedness I have made in these pages are undoubtedly inadequate. In such work one turns everywhere for help and I do, indeed, remain grateful for even the slightest bit of information I received—even "negative" bits, for slight as some of

these details may seem, they are all important in an attempt to establish such a permanent record as I hope this book will prove.

My final word—as always—goes to my best critic and severest friend, Mary Stephanie McDermott, my wife, who has in truth been of the greatest help, for she has searched for me in endless files of newspapers, she has endured thousands of miles of hot-weather travel, she has typed and retyped, she has argued and pleaded (sometimes not in vain), she has grumbled and indexed. Were it not for the sense of formality that a dedicatory page has for me I would add below her name for her private ear: "A second impossible thing."

John Francis McDermott

St. Louis
November 1, 1959

Contents

Illustrations

Illustrations

Introduction

Despite the purchase by the American Art-Union of twenty of his genre and landscape paintings, despite the thousands of engravings of his *Jolly Flatboatmen* and other paintings distributed or sold over the country, the reputation of George Caleb Bingham (1811–79) during his lifetime was local rather than national. Missouri was proud of him; her newspapers carried many stories in his praise; his enduring fame in his own state was assured. But he did not move in the fashionable art circles of his day, he did not work into the "big money," his pictures were not bought for museums. He was able to live by his art, but while he lived, the only works that hung in public view were those in the St. Louis Mercantile Library.

It is hardly surprising, then, that Bingham was treated so lightly by art historians. Henry Tuckerman in 1867 briefly placed him among "*genre* painters who have won more or less credit and manifested certain kinds and degrees of talent." The representations "of border life and history" that "Bingham made popular, though boasting no special grasp or refinement of execution," Tuckerman declared, "fostered a taste for primitive scenes and subjects which accounts for the interest once excited in cities and still prevalent at the West in such pictures as 'The Jolly Flat-Boatman.'" Clara Clement and Erskine Hutton, preparing in the year of Bingham's death a biographical handbook of *Artists of the Nineteenth Century and Their Works,* listed 2,050 Europeans and Americans, but did not include the Missourian. Samuel Isham, writing in 1905, allowed one contemptuous sentence: "Bingham produced rustic scenes in the style of Mount, and his 'Jolly Flat Boat Men,' engraved for the Art Union, may still be found hanging in old tavern barrooms; but his skill was not great." Charles H. Caffin, telling *The Story of American Painting* two years later, made no mention of him at all.

But even while the historians were ignoring Bingham, interest

in his work was rising. The four genre pictures in the Mercantile Library (*County Election, Stump Speaking, The Verdict of the People*, and *The Jolly Flatboatmen in Port*) were included in the Retrospective Exhibit of American Art at the Columbian Exposition in Chicago in 1893, where about one hundred canvases by about sixty artists were shown to represent the period from mid-eighteenth century to 1876. Missouri gave its painter a local boost in 1910 with a show at Columbia in which ten genre, historical, and landscape paintings, eight engravings and lithographs of his pictures, twenty-eight portraits, and the Mercantile Library sketchbook were on view. In 1914, Fern Rusk, a candidate for an advanced degree at the University of Missouri, submitted a dissertation on Bingham which, revised and enlarged, was published three years later as the first sustained monograph on the Missouri artist.

When an unsigned article based on Miss Rusk's book was published in *Art World* in 1917, Bingham got a nod of approval from New York. But the first real recognition from the East was the purchase by the Metropolitan Museum in 1933 of *Fur Traders Descending the Missouri*, which, like so many other Binghams, had remained quietly for several generations in the family that had originally acquired it. Harry B. Wehle's appreciative account of the picture gave the seal of approval, for the greatest museum in the United States, to the work of the western artist.

It may have been the rediscovery of the superb, long-lost *Fur Traders* that stirred Meyric R. Rogers, then director of the City Art Museum of St. Louis, to gather the most notable collection of Binghams ever exhibited at one time. The St. Louis museum had earlier been given one portrait and one landscape and, as a result of this show, acquired the 1835 *Self-portrait*, previously owned by G. B. Rollins of Columbia, and *Raftmen Playing Cards*, which the Pittsfield Athenaeum had for years sheltered without knowing its authorship until Miss Rusk established it. This exhibition, opened in March, 1934, one hundred and one years after Bingham began painting, included twenty oils and eight prints.

Oils:
1. *James S. Rollins,* 1834
2. *Self-portrait,* 1835

xxii

Rogers' demonstration of the interest and the excellence of Bingham's work proved a launching on a national scale. The show was moved to the William Rockhill Nelson Gallery of Art in Kansas City, but since Missouri from border to border was Bingham country and applause was normal, the impact of the exhibition was not apparent until the Museum of Modern Art in New York gave its accolade to the westerner in the early months of 1935. New Yorkers could at last see that the "Missouri artist" spoke not for a locality but for an era in American life. The 1935 exhibition dropped Nos. 1, 15, 16, 19, and 20 from the City Art Museum selection, but added *Fishing on the Mississippi* from the Nelson Gallery; *Shooting for the Beef*, then owned by a New York dealer; and *The Storm*, which Meyric Rogers

had lately obtained in St. Louis. The eight prints from the Rollins collection were also taken east as well as ten photostatic copies of drawings from the Mercantile Library sketchbook.

After this no show of American art of the nineteenth century could fail to represent Bingham. In the Metropolitan Museum's *Life in America* loan exhibition, held during the New York World's Fair in 1939, *The Emigration of Daniel Boone* and five genre paintings were shown. In the Carnegie Institute's important *Survey of American Painting* (1940), three Binghams were included. Today public holders of Bingham canvases include the City Art Museum of St. Louis, the St. Louis Mercantile Library, the Boatmen's National Bank of St. Louis, the Missouri Historical Society, Washington University, the State Historical Society of Missouri, the William Rockhill Nelson Gallery of Kansas City, the Detroit Institute of Arts, the Metropolitan Museum, the Brooklyn Museum, the Boston Museum of Fine Arts, the Yale University Art Gallery, the National Gallery of Art, the Wadsworth Athenaeum, and the Thomas Gilcrease Institute of American History and Art at Tulsa. Since 1900 at least seventeen lost genre and landscape paintings have been brought to light. It is hoped that the great interest in Bingham today will cause others of the more than fifty still lost paintings to be rediscovered.

Equally important with the exhibitions in bringing Bingham before the public have been several important publications. Miss Rusk in 1917 reconstructed the career of the artist in an admirable manner, although she had almost no manuscript sources and very little pictorial material on which to draw. Of the sixty-eight genre, landscape, and historical pictures which she could name or account for, she had been able to examine only fifteen; four others could then be studied only in photograph or print. With these and the Bingham sketchbook she produced a monograph which laid the groundwork for all later study of Bingham. The publication by C. B. Rollins in 1937–39 of 126 letters from Bingham to James Rollins (material not available to Miss Rusk) considerably enlarged our knowledge of Bingham's life and works. A spread of Bingham's genre pictures in color in *Life*, September 11, 1939, and Albert Christ-Janer's *George Caleb Bingham of Missouri* in 1940 brought the artist before a nationwide audience.

Introduction

It is time for a further study of Bingham's work. So many of his paintings are now available and so much historical data is at hand that something approaching a definitive account can be attempted. No work can ever be truly definitive, for new details may later be discovered that may affect interpretation. Nevertheless, Bingham has so grown in prominence that the record of his life and work must be re-examined, corrected, enlarged, and thoroughly documented, for no evaluation can be satisfactory that is not based on a full and accurate knowledge of his career.

Not merely must all newly recovered facts be entered, but legendary stories must be reduced to fact. The first accounts of his life were brief stories chiefly based upon hearsay—interviews with persons who had known the artist twenty-five or seventy-five years earlier and who often recalled facts with fancy mixed. Yet these legends have been the basis for the first paragraphs or pages of every succeeding sketch or book. The patina of age has assured them of respectability. About Bingham's youth almost nothing is known; yet fanciful stories still suit the fancy of those writing about him.

As will be seen presently, Bingham categorically denied—through the Columbia *Missouri Intelligencer* of March 14, 1835, the St. Louis *Commercial Bulletin* of November 30, 1835, the August, 1849, *Bulletin* of the American Art-Union, and the Philadelphia *Register* of September 22, 1854—that he had ever seen any painter at work before he started painting. Nevertheless, three years before Bingham's death, Walter B. Davis and Daniel S. Durrie, compiling a history of Missouri, were responsible for the story of a portrait painter "casually visiting Booneville" while Bingham was yet a cabinetmaker's apprentice, the sight of whose productions "fired his ambitions to become distinguished, as an artist." In 1898, Louella Styles Vincent, writing in the St. Louis *Globe-Democrat*, repeated this story in almost the original words. In 1901, Mrs. Helen R. Parsons in the Kansas City *Public Library Quarterly* again presented the roving painter, drawing clearly from the same unacknowledged source.

May Simonds, publishing in 1902 the most extensive sketch of the painter compiled up to that time, first injected the name of Chester Harding into this growing legend—and this she did with complete disregard of readily ascertainable fact. While Bingham, she

wrote, "was still cabinet-making and in his leisure hours painting and studying law, Chester Harding came down into Boone County to find and paint the portrait of old Daniel Boone. Hanging entranced over the artist's work, the eager boy threw forever to the winds all thoughts of a legal profession, or, in fact, of anything save art, as his life-work." Actually, the boy was nine years old when Harding painted Boone; the painting took place at Femme Osage, one hundred miles from Franklin, where Bingham then lived; and neither Boone nor the Binghams lived in Boone County. Furthermore, this moment in 1820 was six or seven years before Bingham began training as a cabinetmaker, and he did not begin studying law until he had completed his apprenticeship. This story was repeated yet again, quite as uncritically, by Thomas E. Spencer, in *A Missourian Worth Remembering* (1912).

Five years later Miss Rusk wrote cautiously, "We are told" that Bingham "again met Chester Harding" before the apprenticeship was finished, that Harding gave him his first instruction in painting, and that upon Harding's advice "he gave up all else and turned to painting as his life's work." She cited in support a letter from Rollins Bingham to May Simonds, dated March 1, 1902, and reminiscences of Bingham by Matt Hastings of St. Louis gathered by Miss Simonds (both documents have since disappeared). Rollins Bingham's credibility is somewhat impugned when we discover elsewhere that he declared it was Gilbert Stuart, who, making a professional visit to frontier Missouri, had instructed and encouraged the boy painter. Hastings, as a very young man, had known Bingham in St. Louis half a century before. But there is no shred of evidence that Harding ever returned to the Boon's Lick country after his months in Franklin in 1820. A decade later, one of the most popular and widely known of American portrait painters, he had no need to travel so far to keep busily employed, and he could not and would not have slipped in and out of Boonville without notice there or in St. Louis.

Yet the story persists. It is embalmed in the *Dictionary of American Biography*. It is retold by Christ-Janer. It is in the recent histories of American painting by Virgil Barker and by Edgar P. Richardson. It is, in fact, in almost every piece ever written about Bingham. Yet there is no evidence to support it and every reason to doubt it.

Introduction

Not content with seeking an artist-father for Bingham, the first biographers indulged in colorful stories, equally unfounded, about his early struggles and his early triumphs. His apprenticeship at cabinetmaking finished, Miss Simonds pictured Horatio Bingham, Jr., starting out "on foot, his little all tied up in a bundle slung over his shoulder, in search of a place where he might study art. St. Louis was his goal; but on the road he fell victim to small-pox and lay in a barn by the wayside, an outcast, deserted but for one kind man and an old Negress. Then, shattered in health, penniless, scarred beyond recognition, he arose from that place of suffering, made himself a raft, and floated upon it by the Missouri River back [upstream] to the little home in Arrow Rock." This, of course, was the little home that wasn't there. Bingham's mother lived on a farm three miles from Arrow Rock; the young man had been living for years in Boonville. Miss Vincent in her earlier version, at least, had Bingham headed correctly for Liberty, Missouri, at the time he took sick, but she had dramatically heightened her story by telling how upon recovery, "changed past recognition and very feeble, he was obliged to go alone in a skiff down the river to his mother's house. She did not know him, and could scarcely believe him to be her son, which was to him a painful memory throughout his life." There is one other discrepancy in this story: Bingham did not return home after this illness, but went to work in Liberty taking likenesses.

Soon after this, we are told, the young artist went to St. Louis "to pursue his studies." Mrs. L. J. B. Neff, a great-niece, pictured him there sleeping "rolled up in a blanket in an unfinished attic" because he could afford nothing better; Simonds allotted him "a log of wood for a pillow." Actually, he was busily engaged painting portraits at going rates. Vincent, Parsons, Simonds, and Spencer all stated that in 1837 he entered the Pennsylvania Academy of the Fine Arts to study for three years, whereas contemporary record makes clear that he worked there for three months in 1838. Vincent, apparently, was the first to assert in print that the portrait of John Quincy Adams introduced Bingham's work in Washington, D. C., so effectively that "he reached at a bound an eminence for which other men would be content to slave a lifetime. . . . to-day in the national capitol hang his inimitable portraits of the statesmen of the time." The facts are that the

portrait of Adams was one of the last Bingham painted in Washington and that not a single Bingham portrait was then (or is now) hanging in the Capitol. All of these writers had Bingham returning to Missouri in 1845 rather than 1844. Spencer declared that Bingham painted *The Jolly Flatboatmen* during his years at the Pennsylvania Academy and that the American Art-Union paid him $1,000 for it in 1841. These bits are typical of the accretions of legends about Bingham.

It has been my intention in this book to establish as full and sound a record as possible of Bingham's life as an artist. Since the first (and perhaps the most important) concern of the historian must be to discover and give order to facts, I have searched widely for data bearing on his career. In the attempt to produce a definitive account no scrap is so small that it may be excluded. But I have held to facts and rejected surmise, tradition, and reminiscence wherever they could not otherwise be substantiated.

My examination of Bingham and his work falls into three major sections. In the hope that they may help to explain why he painted what he painted, I have in Part I worked to build up impressions of the country in which he passed his boyhood. We know nothing of what he did as a boy; the record of what he actually experienced is practically a blank. But every detail in my picture of the Boon's Lick country is drawn from contemporary sources. All one can say is that these are scenes and actions in which Bingham could have shared. Part II is devoted to the narrative of his career. Here the emphasis is on documented fact. Part III is an evaluation of his work. Out of all this, I hope, will come a fuller understanding of George Caleb Bingham's contribution to American painting in the nineteenth century.

GEORGE CALEB

BINGHAM

River Portraitist

❧ I ❧

The Background

1. THE PAINTER OF WESTERN LIFE

GEORGE CALEB BINGHAM's *Fur Traders Descending the Missouri* did not electrify the art world nor astonish the nation when it was exhibited at the American Art-Union rooms in New York in October, 1845, but for us a century later it stands as the first of a brilliant succession of paintings superbly evoking the spirit of western life. In quick succession came *The Jolly Flatboatman, Raftmen Playing Cards, Fishing on the Mississippi, Watching the Cargo, Shooting for the Beef, The Wood Boat, Canvassing for a Vote, County Election, Stump Speaking, The Verdict of the People, The Checker Players*— to name but a third of the genre pictures he produced in a decade of astounding vigor and creative achievement. Time has tested his work, and he stands today as one of the most notable of American painters of the everyday scene.

He showed more than competence in many branches of his art. *The Dull Story, The Palm Leaf Shade, Hugh Ward, Benoist Troost, Susan Hockaday and her Daughter* show the delicacy, the strength, the vitality, the mastery of form that characterize many of his portraits. *Landscape with Cattle* (1846) is not merely an attractive scene, but the embodiment of the relaxed calm and warmth of late summer. *The Emigration of Daniel Boone* gives dramatic intensity to a moment in the history of westward expansion. *Order No. 11* is bitter realism. *The Thread of Life* is a charming allegory in soft pinks and blues quite different from any of his other styles. But all of these genres fade into relative unimportance beside the "delineations of western life" that his western contemporaries so admired. It is in the portrayal of the political scene and of life on the great rivers that his timeless achievement lies.

Bingham could paint the men of the West effectively because he was one of them. The world he drew with so much understanding and sympathy was his own world. The farmers and the politicians, the lawyers, editors, town drunks, boys, gentlemen, and boatmen were part of his daily life, people he had watched in a hundred situations, with whom he had shared a hundred experiences. The casual, characteristic pose, admirably realized, the expressive countenance, the singularly appropriate detail, the marvelous haze of water background—only a man who had lived as he had and where he had could have so captured the essence of this world.

2. LIFE AND MANNERS IN THE EARLY WEST

The frontier has often been a puzzle to those who did not experience it. Roughness of living, lack of opportunity, lack of encouragement seem to forbid the development of talent. That a man living like Bingham in the wilds of Missouri, who had no artistic background, no circle of artist friends, no period of training under a well-known artist, no galleries in which to study, could become an acceptable painter appears at first glance astounding. But to think so is to confuse frontier towns on the routes of trade with backwoods settlements and farming villages. Actually, many new towns were little outposts of civilization where the amenities of life were well known, where educated and successful people lived comfortable and pleasant lives. Roughnecks, misfits, and restless wandering hunters, log huts and coarse clothes, violence and brutality were certainly details in the frontier picture; however, they by no means constituted the whole composition.

Franklin was only the rude beginning of a town when Bingham first saw it, but it was paradoxically a metropolis on the smallest scale. Noise and rowdyism were part of daily life. Men were killed in duels and men were murdered. Drunken boatmen attempted to tear down the jail. Illiteracy was common. But the place had its well-bred, well-read, substantial citizens, who had brought with them from Kentucky and other states a culture and a propriety which they were intent on establishing quickly in their new settlement. As one resident wrote to the Washington, D. C., *National Intelligencer* in 1819,

4

it had not yet many "elegant buildings," but it did claim "an agreeable & polished society."[1]

Laid out in 1816–17 on the very fringe of civilization, made the county seat of a district that for the moment embraced the whole northwestern quarter of Missouri, selected as the location for a General Land Office, enjoying for some years the commercial advantage of being the outfitting point for the Santa Fe trade, Franklin had real importance on the frontier and was quickly prosperous. It could soon boast of a volume of business second only to St. Louis in all Missouri. By 1819, one thousand people lived in Franklin, and the population of the surrounding Boon's Lick country had increased from five hundred to eighteen thousand.

When the Binghams arrived, they saw not a haphazard squatters' settlement but a town "regularly laid out, having the principal streets running parallel to the Missouri River, and crossed by others at right angles." On the two-acre public square stood a temporary log courthouse (soon to be replaced by a brick building) and a public well. On the west side of the square was a two-story log prison that had cost the town $1,199 when it was built two years earlier. A brick market house stood on the southwest corner. Around the square "in tolerable compact order" were "thirteen shops for the sale of merchandize, four taverns, two smiths' shops, two large team-mills, two billiard-rooms." Main Street, leading up from the river to the square, was also well built up. There were perhaps 120 "loghouses of one story, several framed dwellings of two stories and two of brick." The mansion of the place was the "large and handsome two story brick" house of Thomas A. Smith, lately brigadier general in the United States Army and now receiver of Public Monies for western Missouri. Here on the very edge of savage life, nearly two hundred miles west of St. Louis, an army captain, passing through Franklin in 1820, listened to his landlord's daughter amusing herself "occasionally thro' the day . . . by playing on the Pianno."[2]

[1] Augustus Storrs in a letter dated Franklin, December 14, 1819, reprinted in the *Missouri Intelligencer*, April 1, 1820.

[2] *The Journal of Captain John R. Bell* (ed. by Harlin M. Fuller and LeRoy R. Hafen), 68–70; Edwin James, *Account of an Expedition from Pittsburgh to the Rocky Mountains* (vols. XIV–XVII of Thwaites' *Early Western Travels*), XIV, 148–50. The best account of Franklin is Jonas Viles's "Old Franklin: A Frontier Town of the Twenties," *Miss. Valley Hist. Review*, Vol. IX (March, 1923), 269–82.

The stores in the town stocked the expected utility goods, for there was much rough work to be done. But even at this moment, when almost every house was still but a small log cabin, one could buy from the local merchants not merely calico, gingham, flannel, brown shirting, and ticking but also muslin, lawn, and dimity. Cotton, thread, and silk lace, tortoise shell combs, silk shawls, Irish shirtings, silk moleskin vestings, satin gauze, velvets, Persian and plaid silks, Canton and Italian crepes, and white and black satin were displayed on the shelves. Silk hose and half-hose were in stock along with cotton and worsted; black silk handkerchiefs with working men's bandannas. Silk and kid gloves were there for the hands of these frontier men and women.[3]

Far away as it was, Franklin was no more isolated intellectually than commercially. The *Missouri Intelligencer*, the third newspaper to be established in Missouri, issued its first weekly number on April 23, 1819. Its contact with news of the outer world was extensive: in its exchange list presently were more than one hundred papers from nineteen states and several more from England. Its columns were frequently filled with excerpts from the latest works of Scott and Cooper and Irving, all as popular and as well known on this threshold of the wilderness as in the seaboard states. The editor and other local citizens contributed literate pieces satirizing, in the manner of *The Spectator*, weaknesses in morals and manners of the townspeople; they wrote lively essays on the poverty shown in the invention of place names in the American West and on the horse races held at Franklin; they indulged in pleasantly urbane wit on the coming of spring and solemn amusement in an ironic "Appeal from the General Assembly, to the people of Missouri, against laws to suppress the practice of Duelling."

Schools were quickly opened. Typical among those who came to spread book learning on the verge of civilization was Mr. D. Fisher, lately principal of Brookville Academy in Maryland and of the Hudson Street School in New York, according to his advertisement. Stopping at Henry Bingham's tavern in the winter of 1820–21, he offered to teach Latin, English grammar, geography, mensuration, and land

[3] Advertisement of Wallace, Howell and Company in the *Missouri Intelligencer,* December 9, 1820; numerous other similar ads could be cited.

surveying, "or any of the ordinary branches of a classical or polite Education, on the most approved principles." He was ready also to hold an evening school in English grammar in which he pledged himself "to make persons of ordinary capacity well versed in that useful science in one month, without using a grammar or committing its endless rules to memory." Opportunities were not lacking for girls either; they could be as well "finished" as their parents could desire. Beyond the common studies all the "ornamental branches of female education" were open to them: "Painting in its various branches, on Velvet, Sattin, and Paper; Drawing and Landscape Painting; Embroidery; plain and ordinary Needle Work; Fashionable Toilet Box, and Transparent Paper Lantern Making."[4]

The people of Franklin were not without the cultural advantages of books. A library was organized in 1819 to be succeeded by another in 1822. Books were owned privately and were borrowed and sometimes were not returned. Shakespeare, *Peregrine Pickle,* Goldsmith's *Manners and Customs,* Brown's *History of the Late War,* Bowditch's *Navigation,* Junius' *Letters,* Gregory's *Economy,* a French grammar, a heathen mythology, Volney's *Ruins,* Burns's *Poems* find mention in advertisement of sales or in plaintive pleas for the return of missing volumes ("or else call for and get the balance of the work"). In 1829 a store in New Franklin advertised a "large & valuable invoice of books" which included more than seventy titles ranging from *Pilgrim's Progress* and *Josephus,* the *Arabian Nights,* *George Barnwell,* and the *Odyssey* to a volume on the Salem witchcraft, a life of General Jackson, and *Lalla Rookh.*[5]

The "agreeable & polished society" of Franklin and the surrounding county had its share of doctors, lawyers, merchants, military men, editors, schoolmasters, and country gentlemen. Dr. John Lowry founded the first library; Dr. Hardage Lane had a hand in the second. Dr. John Sappington was to acquire note for his use of

[4] *Missouri Intelligencer,* September 30, December 9, 1820; January 29, 1821; June 18, 1825. In 1823, there were two common schools and an academy in Franklin.
[5] *Missouri Intelligencer,* February 26, 1821; May 7, 1822; July 1, 1823; September 23, 1825; June 19, 1829. Stores such as Lamme, Lindsay and Company frequently advertised "school, music, and miscellaneous books" for sale without specifying titles. Another library was organized at Fayette (which succeeded Franklin as county seat), May 29, 1829. Unfortunately, no catalogues of these libraries can be found.

quinine for malaria. Nathaniel Patten, Massachusetts-born editor and publisher of the *Missouri Intelligencer,* had learned his trade in Kentucky under John Bradford. One-armed Alphonso Wetmore, captain and paymaster in the United States Army and frequently contributor to the *Intelligencer,* a decade later was to be editor of a paper of his own in St. Louis; his play, *The Pedlar* (1821), was the first dramatic piece published west of the Mississippi.

General Smith, who in one year during the land boom at Franklin took in more than half a million dollars at the Land Office, in 1826 was to establish a show-place farm called "Experiment" a few miles away in Saline County. The lawyer-novelist Nathaniel Beverley Tucker married a daughter of Smith's in 1831 and lived not many miles from Franklin until he was called back at his father's death to fill the chair of law at William and Mary College. Lawyers, of course, abounded in such a center. Four who were to serve on the state supreme court were Franklinites in those early days; one of them and three others from the neighborhood were to be governors of the state. Jonathan S. Findlay, brother of a governor of Pennsylvania, was one of the early schoolmasters. Among the merchants were substantial men like James Hickman and William Lamme, whose portraits (like those of so many others in this agreeable society) Bingham was one day to paint.

Not the least interesting or significant in this frontier world was John Hardeman, botanist and deist, "a gentleman of fine mind, liberal education, just principles, and most excellent temper, his conversation . . . peculiarly attractive and delightful, being thoroughly imbued with a chaste and delicate wit, and perpetually enlivened with good humor." A lawyer by training but averse to practice, he was "fond of books, of poetry, of polite literature, of philosophy, and the study of nature, especially of botany." For a short time a merchant, he preferred to devote his time to the development of his botanical garden near the town. Money enough he had "to live at ease among his books and flowers, to reciprocate visits with his friends, and to dispense from his own board a liberal hospitality which knew no distinction between honorable men in all stations and conditions of life."[6]

[6] Alphonso Wetmore, *Gazetteer of the State of Missouri,* 88–89; St. Louis *Beacon,* October 3, 1829.

All this is not to say that Franklin or Fayette or Boonville as Bingham knew them offered the intellectual climate or the elegance of London and of Paris, but it is an indication that those western towns did offer some cultural stimulus not found in rough backwoods settlements.

But it was not the "elegance" of life in the Boon's Lick country that would have attracted the boy from the quiet back-country farm in Virginia. The bustle of affairs in the rapidly developing town, the new and wondrous experiences of the frontier world would have stirred and possessed anyone his age. What place could be more exciting than his father's inn on the square in Franklin for growing into this new life? George must have watched there many a fascinating character, heard much tall talk, been thrilled by many a scene, for, real as his pictures of life along the river are, over them is a romantic glow of boyhood wonder and loving remembrance. Every aspect of life on a frontier that was quickly ceasing to be frontier was spread before him. Drunken boatmen and land speculators, county politicians and newspaper editors, Osage warriors, trappers, hunters, squatters, farmers, gentlemen, preachers, merchants, village loafers—in the fields, in the woods, on the river, in the villages —all this must have been the very stuff of life to the boy at the inn, on the farm at Arrow Rock, and in the growing bustle of Boonville.

Typically uproarious was the behavior of boatmen and townspeople experienced by a passing traveler in 1823. "Hardly an hour had elapsed after our arrival at Franklin," wrote Prince Paul of Würtemberg, "when the presence of the near-by saloons was clearly seen. The entire crew was drunk and made a great noise. . . . it is incomprehensible to me how we escaped an accident on account of the gun powder which constituted the main portion of our ship's load. The indiscriminate use of pipes made an explosion seem imminent at any moment. I had decided not to go on land till the following morning, since neither the town nor the inhabitants seemed very inviting. Soon, however, I received visits of all sorts of stupidly bold and curious people, who addressed me with all sorts of indiscreet questions and whose intention seemed to be to make fun of me—a stranger. . . . They committed other incivilities. They even tried to

get possession of my papers, while they described me as an adventurer and a spy." Paul's hunter and guide attempted to get the uninvited rowdies to leave the boat, but this "the Franklinites did not seem inclined to do good naturedly." Later, "under the pretext of reconciliation two persons came to me, and after having made some awkward excuses, requested me to accompany them to the boarding house to celebrate a feast of good fellowship. At first I excused myself in a polite manner, but when they became more and more insistent and laid hands on me, I chased them from the boat amid the uproarious laughter of their comrades. As this decisive procedure seemed genuinely American to the Franklinites, the affair dropped here."[7]

The boy must surely have seen trappers like Mike Shuck, who had campaigned in the West under George Rogers Clark and had followed Daniel Boone to Missouri. In the autumn dawns he could be seen bareheaded and barefooted, exploring the small creeks that fell into the Missouri above the settlements, "bending under a load of traps, to learn whether or not his bait had attracted the cautious victim." His features had been "worn by time and the storms of nearly eighty winters" into the inflexibility of a barber's block." His hair had grown through the years "into a matted grisly substance . . . like the borrowed wig of a strolling player."[8]

In George's boyhood there were still frontier squatters in the neighborhood who lived in single log cabins not more than twelve feet square, made of rough blackjack poles with wide open interstices, and an earthen floor "filthy in the extreme, the lodging places of the inmates a species of scaffolds around the walls and elevated on forks." In one such dirty shelter John Mason Peck, in 1818, had found "eight human beings, male and female, and the youngest nearly full size." The men and women alike "were dressed in skins that once the wild deer claimed, but [now were] covered and saturated with grease, blood and dirt." Near the cabin, by way of farming, were only a cornfield of half a dozen acres and a truckpatch of turnips, cucumbers, and melons.[9]

[7] *First Journey to North America in the Years 1822 to 1824*, 288–89.
[8] *Missouri Intelligencer*, October 29, 1822; reprinted in *Intelligencer*, November 13, 1829. Alphonso Wetmore's Mike Shuck is fictitious but a prototype.
[9] St. Louis *Western Watchman*, May 7, 1857.

Saturday afternoon shooting matches were a common practice in the Boon's Lick country, matches characterized by great skill and quiet pride. "At our shooting matches 'for beef,' the steer is divided into five parts," a contributor using the pen name "Moss Bucket" wrote for the local paper, "and the hide and tallow is termed the fifth quarter. This last is the most valuable, and it is for the fifth quarter that the most skillful marksmen contend: the shot are generally so thickly planted about the centre of the target as to require great scrutiny in determining the conquerors—the '*fifth quarter* winner,' 'second choice,' &c. When this is known, great exultation is not usual, but the winners sometimes betray a little vanity in bestowing encomiums upon their rifles; and there are few who are not polite enough to attribute their success to the excellence of their arms. If the gunsmith be present, he is not a little flattered by this acknowledgment of his skill. Many of the most *distinguished* guns acquire names of most fearful import, by which they are known in the sporting circles, and small bets are sometimes made on *Black Snake, Cross Burster, Hair Splitter, Blood Letter*, and *Panther Cooler*. . . . If Natty Bumppo himself were to attend one of our shooting matches, 'for beef,' he might stake his last ninepence to no purpose."[10]

The close of the War of 1812 had quite definitely removed any threat from Indians for central and western Missouri, but there were still red men for Bingham to see as a boy. The Missouris had once claimed this country, but they had long since disappeared as a tribe, and the Osage dominated the whole region. At Malta Bend not many miles above Arrow Rock, a village of Little Osage stayed on for years after the main body of the tribe had moved out across the Kansas line. Indians were in and out of Franklin, passing to and from St. Louis. One April day in 1823 forty canoes bearing three hundred Sacs and Foxes—men, women, and children—came by. As they approached the town, "they maintained a perfect silence, which was only interrupted by a single voice, which pronounced, with emphasis, the word 'whiskey.'" They camped near by. The Frank-linites swarmed over to see them, and the next day groups of warriors in their gayest attire put on war dances about the town. As late as 1829 Indian troubles and excitement swept over the western coun-

[10] *Missouri Intelligencer*, September 2, 1825.

ties. The killing of several settlers on the Grand Chariton about seventy miles northwest of Fayette by Iowa or other northern tribes hunting in Missouri brought out fifteen hundred militia led by a major general.[11]

Talk about Indians would ever have been on the tongue of loquacious Daniel Ashby, who had settled on the Chariton at a time when he boasted, perhaps not quite accurately, that no white man stood between him and the Rocky Mountains to the west and the Lake of the Woods to the north. Many a brush with the Indians and many a friendly contest, too, crept into his reminiscences, along with many a tale of bear hunting. Martin Palmer, the self-styled "ring-tailed painter," was another unrestrained character who had come to Missouri a couple of years before the Binghams and acquired a certain notoriety in Howard County during the six or eight years he lived there. A trapper, Indian-hater, and politician, he was always notorious as a rough-and-ready fighter. "I am a raal ring-tail painter," he was fond of declaring, "and I feed all my children on rattlesnake's hearts, fried in painter's grease."[12]

With the other boys of Franklin, George must have watched with longing eyes the departure in September, 1821, of the trading caravan under Captain William Becknell headed for Santa Fe. He would have hung around the sawmills, the gristmills, the blacksmith shops, the brickyard, the ropewalk. He would have been on the spot when the stage drove in from St. Louis. He would have shared in all the noise and excitement of the Fourth of July.

All the men and boys of the countryside turned out for the races in the spring of 1823, to watch the horses struggling over a course covered with mire "as deep as the 'slough of despond.'" Between races on that notable day, if a writer in the *Missouri Intelligencer* is not mocking us, a ballad singer "without the formality of an invitation" entertained the crowd with a voice as mellifluous as "a symphony, as usually ground out of a hand-organ." The generous singer refused the collection taken up, assured his hearers they were indeed welcome to it all, and promptly struck another ditty, which he

[11] *Ibid.*, April 15, 1823; July 24, 1829.
[12] "Anecdotes of Major Daniel Ashby,"*Glimpses of the Past*, Vol. VIII (October–December, 1941), 105–29; Wetmore, *Gazetteer of Missouri*, 90. *Painter* was a frontier pronunciation of *panther*.

"keyed a little above his ordinary voice, that nothing should be lost for lack of echo." But when another race began the crowd deserted him in the middle of the second stanza. At a later race meeting the owner and friends of a mare that came in "second best," after circulating among themselves "a little of the extract of corn, mixed for her a few gallons of grog." It is not clear whether she was entered in the next race. The owner of another steed bet—and lost—on her sixty gallons of whisky.[13]

As a young man drawing near voting age in Boonville, Bingham must have been increasingly aware of politics, always one of the liveliest expressions of the American spirit in the new country. Not at all uncommon, though possibly somewhat exaggerated, was a Howard County election scene pictured by the *Missouri Intelligencer* (now published at Fayette) in 1828. With unrestrained scorn the editor declared that:

On the day of the election "the tricks of the party" (i.e., the *Jackson* party) were observable "from the rising of the sun to the going down thereof."—By means of *printed* tickets, it is believed the votes for the Jackson candidate in this Township, were increased at least one hundred beyond what they would otherwise have received. In the course of the morning, some dozen or two of Jackson *men*, on horseback, flourishing hickory bushes over their heads, and with hideous yells and furious cries of *"Old Hickory,"* made a circuit around the Court House, forcing their way through the dense collection assembled to exercise their constitutional privilege, to their great danger of personal injury. To say nothing of the puerility and childishness of this proceeding, it was a gross insult to the assembled voters.

On this occasion, *"His Excellency the* DICTATOR*,"* [the editor of the rival paper] *exhibited* himself in his real and *natural* colors. His identity could not be mistaken. There was no necessity of engraving on his forehead *"This is a Man"* or, *"This is a Beast."* Having previously well fortified himself, and brought his courage to the "sticking point" by *frequent* libations at the shrine of *Bacchus* and feeling his *spirits* rise, he put on his *shirt*, (i.e. hunting shirt or *non-descript*) and providing himself with a trusty *knife*, of formidable dimensions, sallied forth amongst the crowd, and gave the wondering and gaping spectators a specimen of his *Hero*-ism, by declaring that *"he could whip any Administration man in the country,*

[13] *Missouri Intelligencer,* March 13, September 2, 1823. These facetious accounts conceal the fact that pedigreed thoroughbreds were run at these races under the rules of the Lexington (Kentucky) Jockey Club.

in any way or manner!" This beats the "half-horse, half-alligator" Kentucky boatman. He then commenced blaspheming and abusing us and two or three other persons (none of whom were present) in language which none but the lowest and meanest blackguard would have used. Those who witnessed the disgusting and degrading spectacle turned away with feelings that may be readily imagined. . . . This is the man who issues his manifesto, *ordering* all the Jackson voters throughout the state to support such persons only as *he* names.[14]

And there was always the fascination of the river. Idling at the water front in Franklin, lying on the bluffs at Arrow Rock, looking down from the streets of Boonville, using the river as highroad and playground, Bingham was ever under its spell. He must have been on the river bank many a time when a Mackinaw boat laden with furs came down from the upper Missouri or when a couple of mountain men in a pirogue paddled by on their way to a gay time at the Green Tree Tavern in St. Louis to make up for two years in the Rockies. The keelboats, the steamboats, the lighters, the scows, the ferry-flats he must have known in every detail as any little boy today knows every make of automobile. A flatboat floats by. "One of the hands scrapes a violin, and the others dance. Greetings, or rude defiances, or trials of wit, or proffers of love to the girls on the shore, or saucy messages, are scattered between them and the spectators on the banks. The boat glides on, until it disappears behind the point of wood. At this moment, perhaps, the bugle, with which all the boats are provided, strikes up its note in the distance over the water." Such scenes, observed Timothy Flint, "have a charm for the imagination . . . [they] present the image of a tempting and charming youthful existence." It is no wonder that the young men "reared in those remote regions . . . who witness scenes like this so frequently" find the "severe and unremitting labors of agriculture . . . tasteless and irksome. No wonder, that the young, along the banks of the great streams, should detest the labors of the field, and embrace every opportunity" to make their escape.[15]

All this was the world of Bingham's boyhood. Out of this came

[14] August 9, 1828.
[15] *A Condensed Geography and History of the Western States or the Mississippi Valley,* I, 233. Flint was writing of the Ohio, but his remarks applied equally to the Mississippi and the Missouri.

the intimacy that made possible his astonishing record of men and manners in the West.

3. THE BOYHOOD OF THE ARTIST

Although he was later proudly acclaimed "the Missouri artist," George Caleb Bingham was not a Missourian by birth. He was born March 20, 1811, on a farm on South River near Weyer's Cave in the Blue Ridge Mountains west of Charlottesville, Virginia. His father, Henry, son of a Methodist preacher and farmer from New England, married in 1808 Mary Amend, daughter of a German miller, who gave his only child his mill and his farm of 1,180 acres. There Henry Bingham raised tobacco with some success until, as surety on a friend's note, he lost his property. In 1818 the land boom in western Missouri led him to look at the new settlements, and the following year he took his wife and children to Franklin. In the spring of 1820 he opened, north of the square, a "house of entertainment," which, he assured travelers, would be kept "clear of disorderly company," and he was soon engaged once more in the tobacco business. But death came before prosperity. He died in December, 1823, leaving but little property to support his widow and their six children.[1]

Mary Amend Bingham took her family to a 160-acre farm three miles from the bluff where the little town of Arrow Rock was to be founded several years later. There, too, she carried "a considerable collection of books" (unfortunately not described) and from them apparently she gave her young ones the rudiments, at least, of education. On young George certainly an effect was made which was undoubtedly reinforced by later reading, for his public speeches are evidence of a mastery of rhetoric well above average.[2]

[1] Autobiographical fragment in Fern Helen Rusk's *George Caleb Bingham, the Missouri Artist*, 7–11; "The Road West in 1818, The Diary of Henry Vest Bingham" (on this occasion he went no farther west than St. Charles); *Missouri Intelligencer*, 1819–23, *passim*. Bingham served as a county judge and as a commissioner to build a bridge. A lengthy but uninformative obituary appeared in the *Intelligencer* for December 30, 1823. The first advertisement for his inn placed it on the north side of the square, others northwest of the square.

[2] On the authority of Mrs. Louisa J. B. Neff, a niece of the painter, it has been said that Mrs. Bingham "not only taught her own children, but she also opened a small school for young women" (Rusk, *Bingham*, 15). That she taught any pupils she could get is indicated by a record that in 1825, 1826, and 1827 she was paid $8.00 for

Of the course of George's boyhood little can be written. He later said that life on the farm was distasteful to him and that his mother recognized that some other occupation might better suit him. When he was about sixteen years old, she apprenticed him to a cabinetmaker in Boonville, and he was once more immersed in the life of a flourishing little river town.[3]

About 1831, when he was working for a cabinetmaker in Columbia, George fell in love with a girl who lived close by, but he was treated with disdain by her father and mother. "As her parents appeared to treat me with particular kindness and respect, I was frequently in company with her. I thought her at that time handsome, but I admired her most for the innocence and simplicity of her manners. We were both very young. But with the expectation, that at some future time, circumstances might justify our marriage, I paid her my addresses and was accepted. It seems that previous to this time, her parents had no idea of my intentions, for upon discovering our engagement, which they did immediately, they became very much enraged, ascribed to my conduct the lowest motives, and considered me, (a 'hireling' as they styled me) guilty of the greatest presumption, in aspiring to the hand of their daughter." In 1834, when he was again living for a time in Columbia, her family attempted to revive the affair. No longer a cabinetmaker but an artist, perhaps he seemed more attractive as a son-in-law. But by this time George was deeply interested in another girl.

Not long after I arrived there, I received a special invitation to attend a camp meeting, which was to be held at the same place that I had left with so much disgust near three years before. I had no wish to go, but having no good excuse, and not knowing at that time, why my presence was so much desired, I consented to attend. I there saw Miss S. and a few of her friends so managed, that I could not well avoid an interview with her.

six months' tuition of William and Margaret, minor heirs of Bradford Lawless (*Variety Book*, 1821–33, Saline County Probate Court, 78–79). Since George was almost thirteen when his father died, he obviously would have had some schooling in Franklin.

[3] According to the Boonville *Weekly Advertiser* (June 14, 1901) Bingham was apprenticed to Justinian Williams, whose shop was on High Street near Dade's Tavern. Williams was also a Methodist preacher. In 1834, he built and commanded the steamboat *Far West*, and some time after this he returned to Tennessee (Henry C. Levens and Nathaniel M. Drake, *History of Cooper County*, 146; *Minutes of the Annual Conferences of the Methodist Episcopal Church, South*, 1859, 116). During these apprentice years Bingham is said to have thought of studying theology and law.

But few words however passed between us, and but a slight allusion to former times. Upon leaving the encampment, I left a few lines directed to her. . . . She generously replied. . . . thus it terminated.

Miss S.'s family and friends were unable to move George, for he had fallen in love with Sarah Elizabeth Hutchison of Boonville, whose father had been one of the early Franklinites. Before this visit to Columbia "the cautious reserve" in her manners had been such that the young painter was not at all certain that he "had made any impression upon [her] heart," he later confessed to her. Nevertheless he persisted. The courtship moved slowly through 1834 and 1835, but a complete understanding was presently established between them, and by the spring of 1836, George had achieved professional success enough to justify marriage.[4]

[4] The story of the earlier love affair emerges from a fragment of a lengthy letter to Sarah Elizabeth Hutchison. The top third of the pages is missing, and the remaining portions are somewhat mutilated. Someone had been gossiping to Sarah Elizabeth about the manner in which George had behaved earlier. This letter George wrote to his fiancée in candid explanation. The date is missing, but in her reply of February 8, 1836, she referred to his letter of February 1. He was then in St. Louis.

All letters to or from members of the Bingham family quoted in this book, except those specifically acknowledged otherwise, are hitherto unpublished manuscripts now in the Bingham Collection at the State Historical Society of Missouri.

❧ II ❧

The Record

1. FIRST WORKS, 1833–1837

No one could enter the studio of Mr. Bingham, declared the editor of the Columbia *Missouri Intelligencer* on March 14, 1835, "without being struck with more than admiration, with the many evidences of a deep, native originality, which surround his portraits. We are unacquainted, save to a degree, with the work of Eastern Artists, but it is tho't that the portraits of Mr. Bingham might be placed along side the finest specimens of Harding, Catlin, and Duett [Jouett], and receive honor from the comparison. . . . If the young artist, who has called forth these remarks, possesses the talents which we conceive, let them be excited and drawn out by liberality of encouragement at home, and ere long, the country shall see with delight, and hear with pleasure, the productions and the praises—to borrow a title of Rubens—of a Western 'meteor of the art.'"

At the moment of this generous launching of the Boon's Lick artist, there was in the Columbia studio "a collection of well finished portraits," but how or when Bingham began remains lost in obscurity. Whatever skill he had developed, the editor of the *Intelligencer* was certain, had been achieved by his "own unassisted application and untutored study. . . . Except those of his own execution, he never saw a portrait painted in his life." The St. Louis *Commercial Bulletin* on November 30 of this year was equally positive: "His success in portrait painting is all the result of perseverance and his own genius, no master's hand directed his pencil, no wise head pointed out his faults—he alone designed and executed."

All indications are that Bingham was self-trained. That Chester Harding visited Franklin in the summer or fall of 1820 is true—that young George was one of a crowd of boys gawking at the painter at work is quite probable. But it is not at all probable that Harding

gave the nine-year-old boy any serious lessons. Nor did he in writing his *Egotistigraphy* many years later, when he and Bingham were both highly successful and well known, make any claim to having started the Missouri artist on the road to fame. There is no proof and there is little likelihood that Harding ever returned to the Boon's Lick country. It is not of record that Gilbert Stuart visited Boonville at any time, as Rollins Bingham asserted many years after his father's death. No other painter can be named who worked in western Missouri during Bingham's boyhood. We are simply confronted by the fact that Bingham, in 1834, without instruction or example, was painting quite acceptable portraits.[1]

The accustomed tales—and likely enough they were true—show him drawing at an early age. At four he attempted to copy a figure drawn by his father on a slate. He continued to practice so that by his twelfth year he was "able to copy, with considerable fidelity, such engravings as chance or friends threw in his way."[2] A friend of his youth, Washington Adams, remembered a great many years later that one of his first attempts was a painting of "old Dan¹ Boone in a buckskin dress with his gun at his side for a sign for Judge Dade's Hottel. The likeness [said this man who had never seen Boone] was very good." Bingham had never seen Boone either—his painting would almost certainly have been done after the J. O. Lewis engraving (1820) of the portrait Harding painted in June of that year at Femme Osage in St. Charles County.[3] Adams told, too, one of those *trompe l'oeil* stories often met with in the biographies of artists as testimonials of high skill. Young George asked his friend to join him in eating a watermelon he had just cut. "I entered the shop and walked over to the bench where the water mellon was and took hold of the knife sticking in it, but the knife was not there nor the mellon and George laughed heartily at the deception."[4] Perhaps it was about this time

[1] The Harding story—quite without foundation in fact—was first published in 1902 by May Simonds and has been repeated by every writer since; for a critical look at fact and fiction in Bingham biography, see the introduction above. The Stuart story has not been equally honored, for Rollins Bingham's "The Bingham Family in Missouri" has remained in typescript (State Historical Society of Missouri).

[2] *Bulletin of the American Art-Union*, Vol. II, No. 5 (August, 1849), 11.

[3] Charles van Ravenswaay, "A Rare Midwestern Print," *Antiques*, Vol. LIII (February, 1943), 77; McDermott, "How Goes the Harding Fever?" *Mo. Hist. Soc. Bulletin*, Vol. VIII (October, 1951), 56–58.

[4] Washington Adams to James S. Rollins, Boonville, March 20, 1882, in "Letters

that he used to pay young Horace Hutchison, brother of his future wife, a quarter to pose for him for practice.[5]

When Bingham was twenty-two, "four young men of his acquaintance regarding his sketches as something extraordinary, proposed to sit to him for their portraits." He took up the suggestion "and with such colors as a house-painter's shop could supply, and a half-dozen stumps of brushes left by a transient artist in a neighboring town, he commenced his career as a portrait painter."[6] In 1833 and 1834, as far as can be determined, he worked in his own immediate neighborhood, the "upper towns" on the Missouri, and Columbia, though only in the latter "was any thing like a deserving patronage extended the young Boon's Lick artist," according to the *Intelligencer*. He was still working in Columbia in February, 1835, for on the sixteenth he wrote to Elizabeth Hutchison that he expected to remain until March "as I still meet with additional employment."

His first portrait, declared a newspaper account published after his death, was one of Judge David Todd, destroyed in the University of Missouri fire in 1892. The existing photograph, however, shows a picture so restored or altered that it has almost no similarity to other early work extant, for instance, the portraits of Dr. John Sappington (Plate No. 1), and his wife, Jane Breathitt Sappington (Plate No. 2), of Arrow Rock, both dated 1834, or those of Caleb S. Stone, James S. Rollins, Warren Woodson, and Josiah Wilson, all done in Columbia in that year. Dr. Rusk assigned to 1833 a portrait of Mrs. William Johnston which certainly looks like the work of a beginner, but, to judge from the photograph supplied, it is so inferior to that of Mrs. Sappington that one must doubt that they are by the same hand. The portrait of Meredith M. Marmaduke (Plate No. 3), dated 1834 on the canvas, was possibly another of the heads admired by the *Missouri Intelligencer* in March, 1835. The first self-portrait (Plate No. 4), and the portrait (plate No. 5), of John Thornton (signed

of George Caleb Bingham" (ed. by C. B. Rollins), *Mo. Hist. Review,* Vol. XXXIII, p. 207 n. (hereafter referred to as "Letters," *Mo. Hist. Review*).

[5] H. A. Hutchison quoted in Boonville *Weekly Advertiser,* June 14, 1901.

[6] *Bulletin of the American Art-Union,* Vol. II, No. 5 (August, 1849), 11. That he began painting in 1833 is confirmed by the St. Louis *Commercial Bulletin,* November 30, 1835: "His first efforts in portrait painting were made about two years since in Columbia, Boon county." Also by Bingham's letter to Sarah Elizabeth Hutchison from St. Louis, November 30, 1835, quoted below.

and dated 1835 on the back of the canvas) (Plate No. 6), belong to this first period.[7]

The *Missouri Intelligencer* was not without some criticisms of the prospective "meteor of the art," some suggestions for improvement. "His skill is more fortunately displayed in the design, delineation, and coloring, than in the most effective use of . . . *chiaro-scuro.* We think, likewise, that the pencil of our artist, might be permitted occasionally, a stroke or two more of flattery, with advantage. In some instances too faithful a copy of features is unfavorable in effect." Some little objection might have been raised, too, to the fact that all these portraits were very much in the same style; all presented a left three-quarters view of the face and bust, all sitters looked at the same spot, all dressed alike. The painter had learned to do an effective picture, but he had not yet discovered how to manage more poses than one, a fact that rather amused his friends. He finished the Rollins, Woodson, and Wilson portraits at one time. An anecdote current many years later in Columbia, wrote Dr. Rusk, "told of the bewilderment of the three men when they came for their pictures. Bingham turned the faces of the paintings around from the wall and bade his patrons choose. Each pretended to be puzzled as to which he should take."[8]

With his success in Columbia, Bingham was launched into the world. Early in March he made his first visit to St. Louis and duly published his professional card in the *Missouri Republican*. "G. C. Bingham, Portrait Painter, respectfully tenders his professional services to the citizens of St. Louis. Room, Market st., opposite the Shepherd of the Valley printing office, up stairs." As a specimen of his skill he had carried to the city a "very accurate and striking likeness" of the "presiding officer of the 1st Judicial district."[9]

His next remove was probably to Liberty, Missouri. On the way

[7] Columbia *Missouri Statesman*, January 16, 1880; Rusk, *Bingham*, 18–20, plates II and III. The portrait of Thornton was first published by Ross Taggart in "'Canvassing for a Vote' and Some Unpublished Portraits by Bingham," *The Art Quarterly*, Vol. XVIII (Autumn, 1955), 228–40.

[8] Rusk, *Bingham*, 19.

[9] St. Louis *Missouri Republican*, March 24, 1835. Ten days earlier the Columbia *Missouri Intelligencer* had reported that Bingham was then in St. Louis. The portrait almost certainly was that of Matthias McGirk, the senior of the three judges of the Missouri Supreme Court, who sat twice a year in each of the several judicial districts.

there he had caught "the varieloid, a disease similar to the small pox, from a man on the boat" and had been "closely imprisoned for near two weeks," he wrote to Elizabeth Hutchison on May 23, 1835. At that moment he still had a few scars on his face and was compelled to remain indoors, but hoped to break his "prison bars" that day. Before the disease had confined him, he had had a week to look about at Liberty and the pleasant country around it. "The inhabitants of Liberty I find quite agreeable, they appear kind and liberal. I have become acquainted with Mr. Yantis and family, they are well, perhaps I shall have their portraits to paint." On May 30, he wrote to his mother that he was now "permitted to go at large" and intended to commence work the next week. "I cannot tell yet what encouragement I shall meet with at this place. . . . I have two or three portraits to commence with and others speak of having their portraits taken." His likenesses of Shubael and Dinah Ayres Trigg Allen were painted at this time.[10]

How long Bingham stayed at Liberty and whether he visited other towns in that area remain unknown. We next pick up trace of him on a second visit to St. Louis in the fall of 1835. He now wrote to his fiancée on the last day of November one of the very few letters in his life in which he talked about his feeling for painting:

Though I am frequently under the influence of melancholy, when my prospects appear dark and gloomy before me, yet I have never entirely despaired, and the determination to do my utmost to rise in my profession, has ever remained strong in my mind. I am fully aware of my many deficiencies and though I generally succeed in pl[ea]sing others, it is but seldom I can pl[ease] myself—in fact no work has ever yet [go]ne from my hands with which I have been perfectly satisfied. Very few are aware of [the]mortifications and anxieties which attend [the work?] of a painter; and of the toil and study which it requires to give him success and raise him to distinction. Nearly three years have elapsed and I have yet [sc]arcely learned to paint the human face, after hav[ing] accomplished which I shall have ascend [MS torn] one step towards that emminence, to which the art of painting may be carried.

When I wrote you before I had not commenced painting, since then I have taken several likenesses, which give general satisfaction. Perhaps

[10] James L. Taylor, Jr., "Shubael Allen, Native of Orange County, N. Y., and Pioneer in Western Missouri," *New York Genealogical and Biographical Record*, Vol. LXXXV (July, 1954), 138–39.

I shall not suffer much more uneasiness for want of employment. But whether I am patronized or not, I shall continue to paint, and if men refuse to have their faces transferred to canvass, I will look out subjects from among the cats and dogs, I can't endure the horrors of inaction.

On this very day when the young artist was so downhearted William Preston Clark, editor of the St. Louis *Commercial Bulletin,* gave him a handsome puff:

We were much pleased with a visit a day or two since to the Painting Room of Mr. Bingham, on Market-street, where we found some as good portraits of a few of our well known citizens as we could expect to see from the pencil of any artist, as young in the profession as Mr. B. . . . He came to St. Louis a few weeks since, warm with enthusiasm, and full of the hope, that with proper instruction and attention, he could distinguish himself in his profession. He has, we are happy to say, found a welcome reception among our citizens, his patronage has been as extensive as he could have wished, and we have but little doubt that if he devotes that time and attention to the profession he has undertaken, which it requires, he will in the event, meet the warmest anticipations of his friends. . . . His portraits are invariably good, yet there is a want of skill in coloring evinced, which does not disclose a want of genius, but of instruction.[11]

One painting on view at this time was a portrait of Fanny Kemble, which Clark considered among Bingham's best. "The delicate and beautifully blended tints of the cheek are inferior to but few of the best paintings of the day," declared the enthusiastic editor, who presently bought the picture. Bingham had painted the popular actress from J. Cheney's engraving of the Sully portrait, published in Miss Leslie's annual, *The Gift for 1836.*[12]

There were possibilities for instruction and study in St. Louis at this time, though what advantage Bingham took of them is not known. He could have met Henry G. Fette, German-born portrait and miniature painter then living and working in St. Louis, and Leon Pomarède, Parisian-trained artist, who could turn his hand to almost anything and had lately decorated the newly-finished Catholic

[11] The reprinting of this notice in the Jefferson City *Republican,* January 2, 1836, is another indication of the spreading local reputation of Bingham.

[12] The *Fanny Kemble* was valued at $5.00 in the inventory of Clark's estate in 1840 (St. Louis Probate File No. 1554). The annual was on sale in St. Louis early in the fall.

Cathedral even to the painting of transparencies for the windows, an altar-piece after Rubens, and interior and exterior views of the building. Bingham could have seen in a good many houses portraits, miniatures, landscapes, Indian genre, and hunting scenes by Harding, Catlin, and Peter Rindisbacher. There were portraits of St. Louisans, too, by Stuart, Sully, and Jarvis. There were landscapes by Weir of West Point and copies of the old masters, not to speak of engravings of historical, religious, dramatic, and many other subjects. Friendly William Preston Clark, son of old General William Clark, editor, publisher, and man about town, likely enough showed Bingham his own collection of paintings among which were two "water scenes," two "night scenes," two "wood scenes," one "hunting piece," one "buffalo," with a dozen more portraits and fancy pictures —four among the lot were "colourings by Rindisbacher" (water color or gouache).

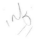

Perhaps attention from one of the Clarks did help. By mid-December Bingham's business and his spirits had picked up. He now told his fiancée (December 16):

Since I wrote to you before I have been painting without intermission. I have completed 10 portraits, and also a couple of landscapes representing the bufaloe hunts of our western praries, they are thought by those who see them to be superior to the original paintings from which I coppied them. The gentleman who employed me to paint them designs taking them to Louisville, where they will serve to make me somewhat known as a painter. I have now engagements to fill which will keep me busy for two weeks to come. Should such times continue, you will recieve no more melancholy letters from me. I feel that I have no cause to murmur but on the contrary every reason to be thankful. It [MS torn] been but a few years since I was a barefooted apprentice in Boonville, and I am indebted for the improvement in my circumstances entirely to Him, who provides for the fatherless and the widow, my mother is comfortably situated, and is content and surely I should be sat[isfied].

Although the buffalo-hunt landscapes were commissioned copies, they show Bingham as early as December, 1835, trying his hand at something other than portraiture. If these were *western* scenes, the originals were probably by Catlin, many of whose Missouri River paintings were owned in St. Louis; Major Benjamin

O'Fallon, cousin of W. P. Clark, for instance, had a considerable collection of them. If the scenes were *northern* (and they could easily have been Minnesota prairies), the originals would have been Rindisbachers and might have been some of those owned by Clark. A guess may be hazarded that the gentleman going to Louisville was Samuel B. Churchill (Plate No. 7), brother of Clark's sister-in-law and lately a partner in the *Commercial Bulletin.*

A good many portrait commissions must have come to Bingham now, for he stayed in St. Louis not two weeks longer but more than two months. On February 13, 1836, he could write to his Elizabeth: "[I am more]confident now [of suc]ceeding as a painter t[han] I was before I [came] here, I design next winter to try [what] I can do in the South and whatever I [may] be, I am determined to use every exertion to become distinguished in the profession I have adopted." With marriage in his mind, late in the month he was planning to go to Franklin "as soon as the Steamboat St. Charles which is now above shall return." He probably left St. Louis on March 9.[13]

Returning to Boonville, he married Elizabeth Hutchison some time in that spring and presumably spent the summer with her there or at Arrow Rock. Early in September he was again in St. Louis, his wife remaining at home until he could find a place in which to live. By September 19, he had been at work, he reported to Elizabeth,

just one week, and have four portraits commenced, which can be finished in four or five days. This success is flattering, as but few persons know of my return to the City, but I have not yet been enabled to obtain a room which I can hold permanently, the one I now occupy I shall be compelled to relinquish in eight or ten days, and notwithstanding the encouragement I recieve, I fear I shall be compelled to leave St. Louis. . . . [If I can get a new place] I shall willingly remain here at least until the commencement of winter, and if I can also find a place in which you would be comfortable I shall try and have you with me. I am tired of living alone. The Hotels here are all disagreeably crowded, and unless I could find a situation in a private boarding house you could not have much enjoyment in a noisy bustling place like this.

13 The mutilated letter was lent to Dr. Rusk by Mrs. Arthur J. Walter (*Bingham,* 22); Bingham's letter about returning to Boonville is in the Bingham Collection at the State Historical Society of Missouri. From the *Missouri Republican,* March 8, 1836, we learn that the *St. Charles* was scheduled to depart on the ninth.

Bingham did not have the field to himself, for Charles Soule of Ohio, who had come to St. Louis in June, found enough work to keep him busy until the next February. Others offering their services to St. Louisans that fall include William R. Herve, miniaturist, and George Markham, portraitist. Bingham, however, apparently did find a permanent painting room, for on December 13 the *Missouri Republican* gave him a line: "He gives promise of attaining to an enviable celebrity in the profession which he has chosen, and to which he devotes himself with increasing industry." Since there are no letters at this time to Elizabeth, he must also have found a satisfactory boarding house.

About December 17 or 18 the Binghams left St. Louis for Natchez. Two weeks later he "succeeded in getting a [painting] room, and commenced business," he wrote to his friend in Columbia, James S. Rollins. During the winter and spring he was "regularly employed . . . at from 40 to 60 dollars per portrait" and flattered himself that he was doing well, "notwithstanding the exorbitant price of living in this country." By May 6, 1837 (the date of the letter), the closing of two banks and the arrival of summer combined to tie up his money and to slow down his business so that he decided to return to Missouri in three weeks. "I will try and visit Columbia, and if you could procure me subscribers for a dozen portraits at $25 I should be glad to remain with you for six or eight weeks previous to making a trip eastward."[14]

Rollins apparently found Bingham the commissions he needed, for in the latter part of the year the artist painted both James and his new wife, James's parents, Dr. and Mrs. Anthony Rollins, Judge Henry Lewis and his wife, Roger North Todd and Richard Gentry, Thomas Miller, Josiah Lamme, Mrs. David Steele Lamme and her son, Mrs. Robert Aull (Plate No. 8), and probably others.[15] By this

[14] "Letters," *Mo. Hist. Review*, Vol. XXXII, pp. 5–8. At some time during this southern visit Bingham painted a portrait of S. S. Prentiss of Vicksburg (C. B. Rollins, "Some Recollections of George Caleb Bingham," *Mo. Hist. Review*, Vol. XX [July, 1926], 468). Sara Belle Chambers Penn, writing from Arrow Rock, June 9, 1837, to Mrs. Lucy Ann Smith Tucker, mentioned on Mrs. Mary Bingham's authority that George had been painting "with great success" in Natchez and added, "They have a fine son [Newton] born in March" (Tucker-Coleman Papers, Colonial Williamsburg).

[15] Rusk, *Bingham*, 23. The owner of *Mrs. David Steele Lamme and her Son* calls attention to the fact that this picture was incorrectly identified by Dr. Rusk (plate X) as *Mrs. Josiah Lamme and Son*.

time the young painter had developed a good deal of ease in the handling of his subjects. The stiff formality that characterized his earliest works had given way to a marked suavity and sophistication in such portraits as those of Judge Lewis and Richard Gentry.

During the summer, Bingham built his house in Arrow Rock. It has commonly been said that in 1836 "before the wedding he had built with his own hands a small but substantial brick house at Arrow Rock, which is still standing. To this new home, also shared with his mother until her death, Bingham brought his young bride." Since Bingham had not returned from St. Louis until the middle of March, he would have had little time to build a house before the spring wedding. That the building of the Arrow Rock house took place in 1837, after the return from Natchez, is definitely established by the fact that on July 27, 1837, George C. Bingham and wife paid to Claiborne F. Jackson and wife $50 for the purchase of lot 14 in block 3 in the town of Arrow Rock.[16]

2. FIRST VISIT TO PHILADELPHIA AND NEW YORK, 1838

Having achieved a certain success in his western country, Bingham was looking for new worlds. Having taught himself to paint, he wanted to study painting. As early as December, 1836, before he ventured south, he had been thinking of a trip east. His six months at Natchez strengthened his determination. Writing to Rollins from the Mississippi city, he said:

I cannot foresee where my destiny will lead me, it may become my interest to settle in some one of the eastern cities. The greater facilities afforded there, for improvement in my profession, would be the principle inducement. There is no honorable sacrifice which I would not make to attain emminence in the art to which I have devoted myself. I am aware of the dificulties in my way, and am cheered by the thought that they are not greater [than] those which impeded the course of Harding, and Sully, and many others, it is by combatting that we can overcome them, and by determined perseverance, I expect to be successful.[1]

[16] Laura Rollins King, grand-daughter of the artist, was cited by Dr. Rusk (*Bingham*, 23) as authority for the story about the house. For the record of the purchase of the lot, I am indebted to F. C. Barnhill and the Saline County Historical Society. Charles van Ravenswaay informs me that this house was sold in 1845 for $500.

[1] Natchez, May 6, 1837 ("Letters," *Mo. Hist. Review,* Vol. XXXII, p. 7).

The date of his departure for Philadelphia is quite uncertain. A decade later he told an interviewer that he had studied there for three months in 1838.[2] Since we know from a letter to his wife that he was still in Philadelphia on June 3, 1838, presumably he left Missouri in the late winter.

At Philadelphia, Bingham "obtained a little knowledge of color by looking at pictures which before he had had no opportunity of studying."[3] It would indeed be interesting to know just what pictures he looked at and what he thought of them, but he is of no help to us. He kept no diary, not even a travel expense book; only one letter to his wife written during this trip has survived and none to Rollins. At the annual exhibition of the Pennsylvania Academy of Fine Arts that spring he could have studied more than two hundred paintings, many of them credited to quite famous names: Correggio, Murillo, Canaletto, Angelica Kauffmann, Pannini, Zuccarelli, Rosa de Tivoli, Caracchi, Guido Reni, Salvator Rosa, Benjamin West, Washington Allston. As a portrait painter he would certainly have examined with care work by Raeburn, Gilbert Stuart, Charles W. Peale, Jacob Eicholtz, John Neagle, and Charles B. King. What did he think of Neagle's *Patrick Lyon at the Forge?* Did Thomas Doughty's landscapes impress him? Did he give thought to the possibilities of painting everyday life when he looked at Ostade's *Interior of a Kitchen* and *Village Fete*, at Coven's *Flemish Market Folk*, at Peter de Laer's *Merchants in a Tavern,* at Teniers' *A Butcher and his Beef?*

Undoubtedly he visited the April Exhibition of American Artists put on by Joshua Shaw and Manuel de França, who at this time were conducting a school of painting and design in Philadelphia. Pictures by many of Bingham's contemporaries were shown—landscapes by the prolific Shaw, fancy pictures by De França (who about five years later was to settle in St. Louis), dozens of portraits and many more landscapes by other hands. Probably a number of the twenty-one Philadelphia painters represented in the Shaw–De França exhibition were there for him to meet and talk with: Thomas Birch, J. A. Woodside, and John Neagle, possibly among others.

Bingham was not content with looking: he applied himself also

[2] *Bulletin of the American Art-Union*, Vol. II, No. 5 (August, 1849), 11.
[3] *Ibid.*

to drawing. He worked both from the antique and from models. A handful of sketches (Plate Nos. 9, 10, & 11), preserved by James Rollins in a scrapbook must belong to this period.[4] Four nudes could only have been sketched from the antique: the statue gallery of the Academy at that time included seven Venuses. Sketches of *Christ and Mary in the Garden* are also obviously student copying. Dr. Rusk is quite right in characterizing the nude figures as "rather carefully drawn, but . . . too heavy, coarse and clumsy in proportions" and in finding the drapery in the religious sketches "much worked over with hesitating strokes."[5] More interesting for their subject and much more effectively done (though they do not equal the work in the Mercantile Library sketchbook) are half a dozen heads of old men and an old woman reading a Bible—here Bingham caught the living semblance of the living figures before him. The surest touch of all—though undoubtedly she did not pose for him in the Academy room—is in a sketch of a cow grazing. This drawing practice he intended to keep up: "I have just been purchasing a lot of drawings and engravings," he wrote his wife on June 3, "and also a lot of casts from antique sculpture which will give me nearly the same advantages in my drawing studies at home, that are at present to be enjoyed here."

He now planned to leave Philadelphia in a few days for Baltimore, he told Elizabeth, where he had an engagement that would detain him for a short time. Then, "with a joyful heart" he would start home: "Look for my appearance early in July." From Baltimore, however, Bingham went to New York. Though we know nothing of the detail, this was a visit of importance, for he must now have arranged with James Herring for showing in the First Fall Exhibition of the Apollo Gallery of Art a painting entitled *Western Boatman*[6] *Ashore*. This picture was not described in the catalogue,

[4] The story runs that these sketches had been made by Bingham at the Rollins home when C. B. Rollins was a little boy in the early 1860's (Rollins, "Some Recollections of George Caleb Bingham," *Mo. Hist. Review,* Vol. XX (July, 1926), 464; Rusk, *Missouri Artist,* 95; Albert Christ-Janer, *George Bingham of Missouri; the Story of an Artist,* 111–12). It is hard to imagine Bingham sketching nudes for the amusement of the Rollins children! C. B. Rollins must have had in mind other sketches; these surely belong to an early period in the artist's career.

[5] Rusk, *Bingham,* 95.

[6] The *Catalogue of the First Fall Exhibition of the Works of Modern Artists at the Apollo Gallery* gives this noun as a singular; Mary Bartlett Cowdrey, *American*

but from its title it was clearly Bingham's first attempt at genre. Neither its size nor its disposition is known. Bingham's address in the catalogue was given as Philadelphia: the picture must have been painted that spring.

In New York, Bingham surely took advantage of the opportunity to look at more pictures. Probably Herring already had some of the paintings that were to hang with Bingham's in October: James Beard's *The Old Drunkard,* perhaps, A. D. O. Browere's *The Village Festival* (after Wilkie), John G. Chapman's full-length portrait of *Col. David Crockett in his Hunting Dress.* The annual exhibition at the National Academy of Design remained open until July 7. There Bingham could have seen much to interest him. John Cranch was showing two illustrations from Shakespeare; Asher B. Durand, a *Dance on the Battery in Presence of Peter Stuyvesant* and *Rip Van Winkle's Introduction to the Crew of the Hendrick Hudson, in the Catskill Mountains;* Quidor, *A Battle Taken from Knickerbocker's History of New-York;* J. Williams, *Ichabod Crane Teaching Katrine Van Tassel Psalmody.* Charles B. King was represented by a striking group of Indians painted on their visit to Washington in 1821. Three landscapes by Lieutenant Seth Eastman were of scenes on the upper Mississippi. James Beard was there with two subjects out of the common life: *The Mill Boy* and *North Carolina Emigrants.* Mount, whose reputation as a genre painter had been established by his *Rustic Dance* in 1830, provided for study *Dregs in the Cup, or Fortune Telling* and *The Tough Story—Scene in a Country Tavern* (known today as *The Long Story*). Charles Deas showed his *Turkey Shooting.* These, with a great variety of other pictures, must have provided effective stimulus to the developing artist.

Bingham had gone to Philadelphia by the Ohio and across the mountains.[7] Since it was his first visit to the East, quite possibly he returned home by way of the Erie Canal and the lakes. Such a trip would account for an engraving used as frontispiece in the November, 1839, issue of *The Family Magazine.* Entitled *The Last Number*

Academy of Fine Arts—American Art-Union Exhibition Records, 1816–1852, as a plural.

[7] "Since I have recovered from the effects of my trip across the mountains [I] have not been subject to the slightest illness of any kind" (G. C. Bingham to Elizabeth Bingham, Philadelphia, June 3, 1838).

of the Family Magazine, according to the accompanying text it portrayed life on an Erie Canal boat. The captain, stretched out at his ease on some barrels of superfine flour, is reading aloud from "the last number of the Family Magazine." A Negro, lying on sacks, perhaps of potatoes, to the right of the picture, is listening closely. Between these two, on the farther side of the boat, is sitting a man who has turned his head from the reader to look downward at the Negro. To the left, a seated man with a pipe in his hand has his back to us, but his profile is turned somewhat toward the captain in the attitude of one listening and amused. At the extreme left, on top the little cabin, stands the steersman, leaning forward with relaxed grace on his steering sweep. The woodcut had clearly been made from a pencil or ink sketch. The text makes no acknowledgment to the original artist or to the engraver,[8] but the picture is strongly suggestive of Bingham. That he was now interested in subjects from the common life we know from *Western Boatman Ashore.* The firmness and ease of drawing which puts us in mind of the collection of sketches in the St. Louis Mercantile Library, the air of competence and assurance of the men, and the relaxed mood of the whole picture are so typical that it is not beyond reason to suggest that Bingham did return to Missouri by way of the canal and that he spent some of his time sketching.

3. PORTRAITS, FIGURE PIECES, AND A POLITICAL BANNER, 1838–1840

Positive knowledge of Bingham's activities from June, 1838, to May, 1839, is almost nonexistent. Presumably he went home in July as he expected, and presumably he was busy with portrait work in central Missouri through the fall and winter. One picture can definitely be assigned to this winter; his portrait of Mrs. Eliza Pulliam Shackelford (Plate No. 12) is dated, on a small piece of paper she holds in her left hand, January 1, 1839.[1] It is certain, too, that in the late winter or early spring he painted Sally Buckner of Virginia, then visiting her brother in Cooper County.[2] For a group of six portraits

[8] In the lower right corner is the name "Anderson," which must have been the engraver's name.

[1] Rusk, *Bingham,* 26; Taggart, " 'Canvassing for a Vote' and Some Unpublished Portraits by Bingham," *The Art Quarterly,* Vol. XVIII (Autumn, 1955), 235–36.

[2] Elizabeth Bingham to George Caleb Bingham, May 31, 1839.

of Thomas E. Birch and others, painted at Glasgow some time during 1839, he is reported to have cut his usual price of $50 to $40.[3]

We pick up Bingham's trail again in St. Louis, when on May 16, 1839, the *Missouri Republican* announced that "MR. BINGHAM . . . who has lately acquired such distinction in his profession as may well make his state, (Missouri,) proud of him, has arrived in this city, and designs remaining here for a time, should he meet with such encouragement as will justify it." Bingham had gone alone to St. Louis, but by the close of the month he seems to have found a place for his family to live in. "I am very glad you intend furnishing our own room," Elizabeth wrote to him from Boonville on May 31, "as we will be more comfortable than if we depended on other people. I will . . . try to get ready to go on the Rhine when she goes down."

By June 6, Bingham, working in his studio at No. 62 Main Street, upstairs, had already done the portraits of several citizens, according to a paragraph in the *Missouri Republican*. "He has visited the East, studied with assiduousness and is now as all must admit, a superior artist," declared that paper handsomely. He did not lack competition; J. Philip Gerke, Jesse Atwood, Edward D. Marchant, William R. Herve, George Markham, and a brother of the now widely known Chester Harding were all painting likenesses that season. The *Daily Evening Gazette* (June 26, 1839) claimed that the Missourian, however, "has been quite happy in some of the portraits that he has taken of our citizens. His pencil is more sober than Mr. Atwood's."

It may well have been that Bingham was able at this time not merely to compare his portrait work with that of local rivals but also to study Joseph Philipson's large collection of paintings. The authorship ascribed by the owner to many of his pictures is quite impossible, for the list includes some of the most famous names in the history of painting as well as those of many less-well-known masters. It is not, however, the accuracy of these attributions that interests, but the variety of subjects and treatments to be viewed. Fowls by D'Hondecoeter stood next to the *Death of Louis the 9th, Country People Going to Market* beside an *Adoration of the Shepherds. Thetis*

[3] David Kunkle, Craigsville, Virginia, to Mrs. George B. Harrison, September 4, 1899 (courtesy of George H. Whitney, great-grandson of Birch). The others in the group were Mr. and Mrs. Lewis Bumgardner, Samuel C. Grove, and David and Sarah Ann Kunkle.

and Achilles and an *Interior of a Kitchen,* a carnival scene and a still life, the *Shipwreck of the Frigate Medusa, Ruins and Sportsmen,* and a *Dutch Cook* were side by side. *Frogs and Strawberries* stood between *St. Bernard, Abbott of Clairvaux* and *Crowning with Thorns.* A Murillo *Bandit,* a Hemmelink *Virgin and Child,* and a Teniers *Burlesque Pas de Deux,* a *Landscape and Dead Game, Turks at Coffee and Smoking,* a *Sultana,* were jumbled with a Raphael *Madonna, Child and St. John.* Classical, romantic, allegorical, scriptural, historical, figure painting, fancy pieces, portraiture, landscapes, fruit and floral pieces, fish and dead game, animals, architectural scenes, ruins, farmyards, and seaports, scenes from everyday life—Philipson had gathered in every kind of subject undertaken by painters. In one sense it would not matter whether the pictures were (as their owner thought) by Velásquez or Botticelli or Leonardo or Franz Hals or Ruysdael or Paul Veronese or Poussin or Rubens or Holbein or others among the famous, or were indifferent copies—they would show an aspiring student something of the great range of subjects possible and would give him some idea of composition and treatment of detail.[4]

Bingham by this time could turn out an effective portrait—witness the vitality of his *Portrait of Mrs. Eliza Pulliam Shackelford*—and could make a living by such work, but he was not content with this "line" alone. Perhaps under the influence of his Philadelphia and New York visits, he now began trying his hand at different subjects. The Durand and Quidor illustrations of Irving could well have inspired the first of these, brought to our attention by a report in the *Daily Evening Gazette* on June 26:

A design from "Tam O'Shanter" executed by Mr. Bingham is really felicitous. The moment chosen by the artist is when Tam approaches the kirk; and his horse stands in rooted terror, refusing to advance an inch toward the haunted sanctuary. The terror of the animal is most admirably depicted; and the maudlin, mixed expression of alarm and defiance, which covers the face of his rider, is well suited to the character and situation of Tam.

In July, Bingham moved to other rooms and about the middle of August left the city for a short time. By September 10, he had re-

[4] Art interest in St. Louis before 1865 I am making the subject of a separate monograph.

turned "to his stand on Market street" and through the autumn must have kept hard at work.[5] During another absence in early December a number of his portraits were destroyed by fire. A. B. Chambers, editor of the *Missouri Republican,* on December 12 reported the occasion with mild facetiousness:

> We have just learned the full extent of the injury done by the fire on Market st. on Friday night last [December 6]. It is horrible to relate. The editor of the Republican, in company with a number of gentlemen and ladies of this city, and last, though amongst the fairest, the inimitable Mrs. Farren, in the character of Isabella in Tortesa, in the dress and attitude she stood in the picture frame in the play a few evenings previous, perished in the flames. The sweeping destruction occurred thus. The upper story over Mr. Wm. Anderson's store had been occupied by Mr. Bingham, the portrait painter, as a studio and subsequently by another artist. Mr. Bingham having gone to the country, left a number of his life drawn likenesses, our pretty face in the group, in the room, Mrs. Farren's was subsequently added by the new artist, whose name we have not learned, and all were lost.

Bingham's professional card in the *Missouri Saturday News* on January 25, 1840, suggests that he was again at work in St. Louis, but he did not remain in continuous residence, for the same paper on February 15 reported him then in Fayette, Missouri, "transferring to canvass the countenances of some of the good citizens of that place." Sallie Ann Camden (Plate No. 13) was among his St. Louis subjects.

We now come to a turning point in Bingham's career, foreshadowed by the buffalo-hunt pictures he copied in 1835 and more particularly by *Western Boatman Ashore* in 1838. During the spring of 1840 he showed six pictures at the National Academy of Design in New York,[6] and he painted his first political subject subject for the Missouri Whig rally at Rocheport.

The six pictures sent east show the broadening of his interests. *Group, Two Young Girls* and *Sleeping Child* from their titles must have been thought of as something more than portraits. Two of the paintings, *Tam O'Shanter, from Burns* and *Tam O'Shanter* were

[5] St. Louis *Missouri Republican,* July 25, August 19, September 10, 1839.
[6] Mary Bartlett Cowdrey, *National Academy of Design Exhibition Record, 1826–1860,* I, 33. (Hereafter referred to as *NAD Exhibition Record.*)

experiments in illustration,[7] one of them in all likelihood the canvas completed by June 26 of the previous year. The title of the fifth picture, *Pennsylvania Farmer,* suggests genre interest, an aspect of everyday life rather than a portrait of a particular person; the geographical identification of the subject suggests also that it might have been painted from a sketch made while Bingham was in the East in 1838. The sixth picture, *Landscape,* is the first indication of the author's interest in another genre in which he would eventually do at least forty canvases. It is disappointing that the National Academy of Design catalogue did not describe these pictures or give their dimensions; they have not been located.

While these pictures were on display in New York, Bingham turned his attention as artist for the first time to a political subject. His friend Thomas Miller in May asked him to paint some banners for the Boone County delegation to carry at the Whig meeting set for Rocheport in mid-June. To this Bingham replied regretfully that he could not, for he was already engaged on one for Saline County: "as our designs are intended to be worthy of the occasion it will require all the time from this until the meeting of the Convention to enable me to complete them."[8] The result of these labors was a four-sided canvas frame, each side six feet square. On the front was a portrait of General Harrison, life-size, mounted on a marble pedestal which was inscribed, "Commerce, Agriculture and the Arts, in union we will cherish them." At the base of the pedestal rested the Constitution, with mechanical and artists' instruments; on its right, in the distance, was a farm with agricultural instruments in the foreground; on its left a vessel discharged freight, with other ships seen in the distance. In the circle that framed the portrait was an inscription "in conspicuous letters" which read, "one of the people," and on either side floated the Star-spangled Banner. On one side of the square banner was pictured the Battle of the Thames, with the General and his aids, on horseback, occupying the foreground. On the opposite side was seen a farmer, "a log cabin boy," with his plow and a log cabin in the background. On the rear square was painted a western

[7] In the Bingham check list of works I have entered the first of these by the descriptive title: *Tam O'Shanter Approaching the Kirk.*

[8] Quoted by C. R. Rollins, "Some Recollections of George Caleb Bingham," *Mo. Hist. Review,* Vol. XX (July, 1926), 469.

river, with a canoe on the water and the sun breaking forth from the clouds in the distance, "diffusing a warm and mellow light over the scene." It was, we are assured by the papers of the day, "by far the most splendid and imposing" banner that "graced the occasion."[9]

To this period also probably belongs *The Dull Story* (50″ x 38″), a nearly life-size portrait (Plate No. 14), which discloses the artist's wife as a "charming young woman, with jet hair and pink and white complexion, dressed in a shimmery satin gown with a rose in her bosom . . . lying back in a mahogany chair among deep green cushions, fast asleep." The title was Bingham's. Finding his wife asleep with a book in which she had professed profound interest lying open in her lap, he had been struck with the humor and beauty of the picture. There is no documentation for this painting, but Dr. Rusk thought, reasonably enough, that, though "the richness of color and firmness of finish might justify our placing it at a little later date . . . the youthfulness of the subject" suggests it was painted about this time.[10]

4. WASHINGTON CITY AND PETERSBURG, 1840–1844

In the fall of 1840, Bingham went to Washington with the intention of opening a studio and painting portraits of the political notables.[1] Business at first was slow. Chatting by letter with her mother-in-law, Elizabeth wrote early in the new year:

Mr. B. has a room in the Capital [Capitol] where he spends most of his time in painting. he has not succeeded in obtaining as much employment as he would like, but makes out to keep up with his expenses, which are not a trifle. We are boarding in an excellent house, and are very comfortably situated indeed. We have cakes, ice creams, mince pies, and a great variety of meats and fowls, oysters in abundance, but I have not yet learned to eat them. . . . we are paying fifteen dollars a week for board. . . . We live at Mrs. Brawners on Pennsylvania avenue, the first

[9] This description is a composite from the accounts in the St. Louis *Daily Commercial Bulletin*, June 22, 1840, and the Fayette, Missouri, *Boon's Lick Times*, July 4, 1840. On this occasion Bingham represented Saline County in the Young Men's Convention held on June 20 after the close of the regular meeting.

[10] Rusk, *Bingham*, 28. On the back of this canvas is painted the lower part of a woman's figure in white satin gown and white slippers.

[1] "Letters," *Mo. Hist. Review*, Vol. XXXII, p. 9.

house west of the railroad office where the cars stop when they come into the city.[2] I have met with but two persons that I ever saw before, they are Mr. Shaw and his lady formerly Miss Jane Hood. they are boarding in the same house with us. Out of twenty-one boarders in this house, Mr. Bingham and myself are the only whigs. Most of them are members of Congress but we see very little of them, as we yearly boarders prefer having a seperate table from them, and seperate parlors. We breakfast at nine o'clock, dine at four, and take tea at seven—very fashionable indeed —rather too much so to suit my appetite sometimes. . . .

I was a little disappointed in the appearance of this city, it is not as pretty a place as St. Louis. there is but one street paved, which is the one we live on. the Capital and the President's house are splendid buildings. I go to the Capital frequently it is a place of great resort with the ladies, I have walked round the president's mansion, but have never been inside. Mr. Bingham has been all through the house, and is perfectly well satisfied that there is no furniture in the house too good for the man that we would choose for our president, but perhaps little Matty has be[en packing] up the valuables to take back to Kinderhook with [him].[3]

With some time on his hands that winter Bingham undertook another kind of subject, a nude, but he painted her from an engraving, not from life. A writer in the Washington *National Intelligencer* on February 17, 1841, reported that this "portrait painter of fine promise" from the West "occasionally throws off fancy figure pictures of great merit. Among these is his Ariadne on canvas, of the kit-kat size. The copy is made from a beautiful engraving by Durand, after the celebrated original of Vanderlyn, and does great credit to Mr. Bingham's capacity. . . . I would advise all admirers of sweet painting to call at his room in the basement story of the Capitol, where this picture is at present exhibited." *Ariadne* has not been located, nor is it known that Bingham "threw off" any other fancy figure pieces at this time.[4]

Bingham's political excitement had quieted down: his candidate was elected and the country safe. All he wanted to do was paint. "Though I have a painting room in the Capitol," he wrote James S. Rollins on February 21, "I know less of the proceedings of Congress

[2] The *Washington Directory for 1843* placed Mrs. Brawner's boardinghouse on the north side of Pennsylvania Avenue between Second and Third streets.

[3] Elizabeth Bingham to Mrs. Mary Bingham, January 11, 1841.

[4] *Musidora about to Take a Bath,* among the paintings in his studio at his death in 1879, may well have been another of these fancy pictures. See p. 164, below.

than if I were in Missouri, the fact is I am no politician here, and as the great question of the ability of the people to control their rulers is settled for the present, I am . . . satisfied with the result. . . . I am a painter and desire to be nothing else, and unless another corrupt dynasty, like the last one that has just been overthrown, shall again arouse the energy of the whole people in behalf of a suffering Country I shall be content to pursue the quiet tenor of a painters life, contending only for the smiles of the graces, while the great world may jog along as it pleases."[5]

It was probably the sudden death from croup of his four-year-old boy, Newton, on March 13 that led Bingham to leave Washington in the spring for Petersburg, Virginia, with his wife and their new-born son, Horace.[6] By June 18 he was well established in the southern city, for on that day the Petersburg *Statesman* mentioned that "Mr. Bingham, Portrait Painter, from Washington City, has executed some uncommonly happy likenesses here. His room is on Sycamore Street, near Swan's Bookstore. Those who have a taste for the fine arts, will do well to call and look at Mr. Bingham's work—some of his likenesses are inimitable."

In September, "having a few days leisure," Bingham paid a visit to Port Republic and the old farm in the Blue Ridge. "I took Elizabeth . . . to her friends in Washington," he wrote his mother from Petersburg on September 25,

where she chose to remain until my return, and taking passage in the rail road cars up the valley to Winchester, and from thence to Harrisonburg in the stage, I arrived at Portrepublic on the second night. In the morning I made myself known to Doct Kemper and his lady, who were very happy to see me, they made many enquiries about you, and after satisfying them as well as I was able, as I had but little time to stay with them, I set out to see M^rs Price, but I had not the good fortune to find her at home, she being on a visit to her son Addison, who lives in Staunton. Polly however, was at home, she was equally surprised and delighted to see me. . . . As Mr. Miller did not live at the Forge, there was no one else that I cared about seeing, except Old Tom who still lives up under the Cave hill, and thither I directed my footsteps, taking the old mill in my way, after satis-

[5] "Letters," *Mo. Hist. Review,* Vol. XXXII, pp. 11–12.

[6] John Shaw, writing to Mrs. Mary Bingham from Washington on March 13, 1841, to inform her of Newton's death that day, added in pencil postscript that a new son had just been born.

fying myself by going in and around it, I went on up the river, and before
I got to the old mans house I saw a grey headed Negro whom I at once
concluded to be him, feeding some pigs in a pen, by the fence side. I
went up to him and offered him my hand, calling him by name, he looked
at me with speechless astonishment, I asked him if he had not seen me
before, he said never, that he knew of. I asked him who owned that place,
pointing to the hill, before Wiest [*sic*] lived there? Henry Bingham, he
replied, his face irradiated with pleasure as the truth flashed upon him
that I was his son. He hurried me along to his little house, which is some
distance above the one he used to live in, where I found everything within
it, the pattern of comfort neatness and cleanliness. I staid with the old
man about three hours, he appeared to talk with pleasure about the old
time, those days he said were gone now, he could no longer work like
he used to. . . . I returned and staid all night with Doct Kemper, and next
morning, refusing his proffer of a horse, and his pressing invitation to stay
longer, I set out afoot, through Brown gap over the blue ridge, on a visit
to Uncle Joseph. I found them all well, on the same old place, which had
not undergone the least alteration. Aunt and the children are all anxious
to go to Missouri, but she says that she thinks she will never get Uncle
Jo started, as long as his old mill lasts. I staid with them one day, after
which Uncle accompanied me to Charlottesville, from whence I returned
to Washington, and leaving Elizabeth there, to continue her visit a little
longer than I was able to do, came back to Petersburg and resumed my
engagements. . . . I expect Elizabeth here in a few days. . . . Horace is
the largest child of his age in the Country, he weighs 22 pounds.

After six months in Petersburg, Bingham returned to Washing-
ton.[7] Although he was living by his portraiture, the only work of
record for this winter of 1841–42 was a genre (?) painting, *Going to
Market*, exhibited at the 1842 spring show of the National Academy
of Design.[8] Nothing is known about this painting but its title.

In the fall of 1842, Mrs. Bingham and Horace returned to Mis-
souri under escort of the John Shaw who had been living at the board-
ing house with them. Jane Hood Shaw, who remained in Washing-
ton, wrote on November 22 to Elizabeth at Boonville of the loss of
her own baby during her husband's absence. George was "kind as a
brother." A friend, Liz Robertson, stayed with her most of the time,
but "when M^r Bingham found that she had gone home to stay a little
while he would always come and stay with me." Her husband's return

[7] *Bulletin of the American Art-Union,* II, No. 5 (August, 1849), 11.
[8] *NAD Exhibition Record,* II, 33.

to Washington apparently reminded her that she had promised to write Elizabeth "all the news of the house."[9] There had not been much change. "We get along pretty much the same way, M^rs N [?] gets in difficulty, every now and then as you may suppose, but we have some new boarders in addition to those we had, when you left, and your husband has concluded to remain with us, which I am very glad of. M^rs Morehead has returned, and looks very well also her children." To this letter Bingham added a P.S.: "I feel great relief in the certain[ty] that yourself and Horace are safe at home. . . . I trust, without feeling the least anxiety on my account, you will spend a happy winter."

To his wife in Boonville, Bingham this winter wrote often enough to give us some idea of his working life. On November 28, he reported that they were all "getting along as comfortably and as quietly as could be expected, with nothing occuring at present to interrupt the regular routine of this rather dull city." The members of Congress were beginning to assemble and "the stirring scenes in the Capitol will soon commence again, the Loco focos appear in high spirits after their recent victories in the State elections, but whether they will get along with his excellency [John Tyler] any better than the whigs, remains to be seen." Adding his "best respects to Mr. Tompkins," he informed Elizabeth that Tompkins' portrait was now "packed up in a box with yours."[10] He had also started a portrait of their two friends. "As this week before the session of Congress would have been otherwise unemployed by me, I requested her [Lizza Robison[11]] to sit for her portrait, intending it for you when finished—on the same canvass I will also paint a portrait of Mrs. Shaw and will keep them as memorials of two agreeable friends and companions, neither of whom we are likely soon to forget."

On December 4 he gave Elizabeth—and us—another glimpse of life in the boardinghouse:

We have received quite a valuable acquisition to our mess since you left,

9 Apparently the Binghams had not gone back to Mrs. Brawner's on their return from Petersburg in the fall of 1841.

10 For Elizabeth's portrait see p. 45, below. Tompkins was probably George Tompkins, one of the judges of the Supreme Court of Missouri and a resident for many years in the Boon's Lick country.

11 This is Bingham's version of Jane Shaw's *Robertson*.

in Mrs. Brown of the Hotel over the Avenue, and Miss Griffith, an elderly lady, they are both very agreeable and help to make our company quite a social and lively one. We have also an old quaker gentleman from Ohio Sojourning with us at present, he is rich and a widower, and professes to be very fond of the *Wimmen* as he calls them. [MS torn] would be a chance for Miss Sarah, if he was not seventy years of age thereabouts, and she did not run down the back stairs, as he went in at the front door of her room.—We have had a considerable snow storm here, and there has been sleighing for the last 3 or 4 days, but it is all now going off with a rain.

Congress assembles at the Capitol tomorrow though it is somewhat doubtful, in consequence of the recent snow, whether their [*sic*] will be a quorum for business or not.

More news about the double portrait reached Elizabeth on the last day of the year. "Mr. Bingham has been very much engaged painting mine and Liz's likeness," Jane Shaw had written on December 13. "Liz sat only once and he has made the most striking likeness of her that I ever saw." Because Miss Robertson had gone away into the country, he could not finish her portrait, but Mrs. Shaw was highly pleased with progress on her own: "as for my likeness it is something like but [MS torn] flattered that you would scarcely know that it was intended for me, Mrs N says she would take it to be a girl of sixteen, jealousy."

In January, 1843, Bingham was thinking of renting the studio near the Capitol which William Doughty had occupied the previous year. "It will be much better for me during the damp weather in the Spring, than my present room." He had no thought at this time of returning to Missouri. "It would be hard for me to tell now when we shall want our house [in Arrow Rock] to dwell in ourselves," he wrote to Elizabeth, "I fear it will be many years first, unless a great change should take place in my pursuits and feelings, I can be nothing else but a painter, and as a painter, how much soever I might desire it, I cannot live in Arrow Rock."[12]

Late in February he was still "spending each successive day" in his room in the Capitol. He had no news to pass on, for "I do not even know what the politicians are doing over my head." During the first three weeks of February the weather had been uncommonly cold; "the Potomac has been frozen over to Alexandria, the canals

[12] Bingham to his wife, January 17, 1843.

and even the Avenues have been encrusted with ice, until the boys could skate in every direction through the City."[13]

Happily for the husband but unhappily for our knowledge of his activities, Mrs. Bingham returned to Washington about the close of March.[14] In June he went to Philadelphia with Mrs. Shaw, Elizabeth wrote her mother-in-law,

Mr. B. to attend the exhibition of pictures [at the Academy of Fine Arts], and Mrs. Shaw to visit her aunt Mrs. Wright, not expecting to stay long, we thought it best for me to remain at home but after being gone a week here comes a letter for me to go on also, as Mr. B. had been solicited by Mr. Wright to stay and paint three portraits for him, so I packed one evening and went the next morning.[15]

In July, Bingham was sick for a couple of weeks, but by August 24, the date of Elizabeth's letter, he was "in perfect health" and "as industrious at his easel as ever." During the summer he painted for Mrs. Brawner, at whose house they were again living, portraits to the "full amount" of their board for three months. He was now occupying a studio on Pennsylvania Avenue near the Capitol, and there Horace, not yet two and one-half years old, used to go "three or four times every day" by himself. It may have been on the occasion of one such visit in 1843 or 1844 that he painted a picture of the boy "asleep in a big chair in which he had taken refuge when he had run away from home to his father's studio." According to the painter's granddaughter, the picture remained unfinished, for the artist was never able to get the exact pose again.[16]

Throughout the winter and spring he continued to occupy the Pennsylvania Avenue studio.[17] "Mr. Bingham is as much devoted to

[13] Bingham to his wife, February 21, 1843.

[14] She was carrying to Bingham a letter from William B. Wood, Jane Shaw's father, written in Boonville on March 18; in part it was about "another artist springing up among us Thomas Cranmer."

[15] Elizabeth Bingham to Mrs. Mary Bingham, August 24, 1843. Horace had been left with Mrs. Brawner, who had offered to take care of him.

[16] Rusk, *Bingham*, 30–31, on the authority of Laura Rollins King, a granddaughter of the painter. Horace's age is there given as six, which is impossible, since he was born on March 13, 1841, the day his brother Newton died. The photograph sent me by the present owner shows a child nearer three than six years of age.

[17] In October, Henry J. Brent exhibited three paintings "at the studio of Mr. Bingham" on Pennsylvania Avenue (Washington *National Intelligencer,* October 23, 1843).

his profession as ever but he is not making as much clear of expenses as I would wish him to," Elizabeth wrote to her mother-in-law on March 3, 1844, "he is completely weded to this city, I cannot imagine what has kept us here so long, we are very comfortable." They were soon, however, to return home and Bingham to enter his most productive decade.

He had gone to Washington in 1840 with the idea of painting the notables there, but though he had commissions enough to support his family satisfactorily, it is not known how many public figures sat for him. His portrait of John Quincy Adams has hitherto been assigned to 1840 and has been supposed his initial success in the nation's capital:

A story comes from Washington city of the days of 1840 which shows . . . how Bingham got his start [wrote Shannon Mountjoy in the St. Louis *Globe-Democrat*, November 6, 1904]. Bingham had set up a little tent not far from the capitol building, and was impatiently awaiting the work so slow in coming. Every day a withered-up, stately old man used to stop by to discuss religion with the idle young man. Bingham soon learned that his chance disputant was John Quincy Adams, but the fact did not overawe him at all. In a letter to Missouri friends Bingham said "I walloped him hard, and he got high and angry about it. One day he said to me: 'By ———, sir, if you can paint as well as you can argue religion, you may do my portrait.'"

That portrait of John Quincy Adams was Bingham's first step to some badly needed dollars. Adams' friendship resulted in a number of orders, and by 1845, when he returned to Missouri, he had painted portraits of Webster, Clay, Andrew Jackson, Calhoun; Walker the tariff reformer; Breckenridge, James Buchanan and a host of now forgotten celebrities.[18]

Now, this story was vouched for by the late C. B. Rollins (son of Bingham's closest friend, James S. Rollins), who declared that he had "often heard Bingham tell how Adams happened to give him an order for a portrait" and added that "Adams was so pleased with

[18] The 1840 date itself was an impossible one, since Adams did not reach Washington until November 23, spent at least three days early in December in Baltimore, and was very busy indeed from the convening of the new session of Congress on December 7. The tent story is without discoverable foundation: it has already been pointed out that Bingham had a studio in the Capitol. What basis there was for the anecdote of religious discussion cannot be determined. Certainly there is nothing in Adams' voluminous unpublished diary to confirm it.

this portrait that he tendered Bingham more than the price agreed upon. Bingham declined to accept it, saying that he charged what he thought his work was worth and could accept no more." A small copy of the portrait, painted on a walnut panel, the artist was said to have presented to the elder Rollins in 1840.[19]

Nevertheless, in the face of these statements, I must assert that this portrait was not the first, but was one of the last, that Bingham did in Washington. Its date is 1844, not 1840, if we can believe the diary of the famous sitter, and even then Bingham's opportunity was a chance one. On May 13, Adams noted in his diary: "Mr John Cranch had requested me to sit to him for my portrait, for his father, judge William Cranch, my cousin—At 9 this morning I sat to him in a small hut or shanty at the foot of the capitol hill and northern corner of the Pennsylvania avenue. One hour and a half exhausted his patience and mine, and I promised him another hour tomorrow morning." At half-past nine the following day Adams "sat to Mr John Cranch and Mr Bingham who occupy jointly the painting room for my portrait." The former president had no great enthusiasm for the works in progress: neither of the young painters, he thought, was "likely to make out a strong likeness or a fine picture." Bingham finished his on May 28, after six sittings in all.[20]

The mystery attached to this episode is heightened by the fact that there are extant three versions of the Adams portrait. First, a small oil on a walnut panel (10″ x 7½″), now owned by a grandson of Major Rollins, must have been that painted in Washington and given to Rollins on the painter's return to Missouri in 1844. Second, a life-size (c. 30″ x 25″), belonging to a granddaughter of Rollins, almost certainly was painted in Missouri during the winter of 1844–45 and was probably that noticed in the *Missouri Republican* on June 26, 1845. Third, another small portrait, also on walnut (10″ x 7⅞″), acquired by the Detroit Institute of Arts in 1953, bears on the back

[19] Rollins, "Some Recollections of George Caleb Bingham," Vol. XX (July, 1926), 471; and "Letters," *Mo. Hist. Review*, Vol. XXXII, p. 9.

[20] Diary of John Quincy Adams, May 13, 14, 21, 23, 24, 27, 28, 29, 1844 (courtesy of the Adams Trust and the Massachusetts Historical Society). There is no reference elsewhere in the diaries for 1840–44 to a portrait by Bingham, although Adams noted sittings to a Mrs. Toule, J. R. Lambdin, Auguste Edouart, and E. D. Marchant. Since Adams did not commission the Bingham portrait, it is unlikely he paid for it, especially since it remained in the possession of the artist.

the date 1850, which suggests that it may have been copied in that year from the 1844 study.[21] Although Adams was not pleased with Bingham's work, these two studies today impress us as sharply effective. In them he displays true insight into character, and his ability to express it is pointed up by the unrelieved concentration on the head alone. (Plate No. 15).

Bingham's portraits of most of the other celebrities listed by Mountjoy remain unknown today. That he painted Andrew Jackson at this time is most unlikely, for the old General did not leave "The Hermitage" during these years except for one brief trip to New Orleans in December, 1840. The Gilcrease Institute now owns the *Daniel Webster*. A little water color of John Howard Payne (9″x7″), Bingham's only known piece of work in this medium (Plate No. 16), remained in the artist's estate until its final dispersal in 1893. Payne, Dr. Rusk tells us on the authority of C. B. Rollins, "came not to engage in discussions, but to watch the artist at his work. And Bingham painted him in the attitude which he was wont to assume on these occasions. He sits on a small chair, his arm resting on the back of it and his head on his hand."[22] Although the location of the portrait is not known, Bingham did paint Charles A. Wickliffe, postmaster general under President Tyler, in the winter or spring of 1843; John Sartain mezzotinted it.[23] Elizabeth Bingham tells us that he also painted Robert Tyler, son of the President in the spring of 1844, as well as Henry A. Wise, representative from Virginia; "he succeeded admirably in both," she thought.[24]

Three family portraits belong to the Washington period: besides that of Horace asleep in a chair, already mentioned, which probably should be dated 1844, he painted his wife and son Newton soon after their arrival in the East. The third was a full-length portrait of Elizabeth, of which only the head remains today; perhaps this was the portrait shipped to Boonville late in 1842.

[21] McDermott, "Bingham's Portrait of John Quincy Adams Dated," *The Art Quarterly*, Vol. XIX (Winter, 1956), 413–14.

[22] Rusk, *Bingham*, 30. Payne inscribed the sketch for Bingham. It was probably painted in 1841 or 1842, since Payne embarked for Tunis on February 11, 1843.

[23] Washington *Daily Madisonian*, June 22, 1843; *Washington National Intelligencer*, June 26, 1843.

[24] Elizabeth Bingham to Mrs. Mary Bingham, Washington, March 3, 1844.

5. INTERLUDE: POLITICAL BANNERS, 1844

The date of Bingham's return to Missouri is not known,[1] but he was in Boonville and at work again for the party late in the summer—the country needed to be saved once more. Requested by his friend Rollins to paint a banner for the Boone County delegation to the coming Whig Convention, he replied, "I shall be happy to execute it, provided you allow me to paint it on linen, the only material on which I can make an effective picture." At this moment (September 23) he was just beginning two banners for Cooper and Howard counties,

each one 7 by 8 feet—on one I shall give a full length portrait of Clay as the Statesman with his American System operating in the distance, on the other I shall represent him as the plain farmer of Ashland—each of them will also have appropriate designs on the reverse side, and will be so suspended, as to be eisily borne by four men walking in the order of the procession. The cost will be from fifty to sixty dollars each.

They will be substantial oil pictures and may be preserved as relics of the present political campaign. If your delegate would be pleased with a similar banner as "old Hal" is already fully appropriated, I would suggest for the design as peculiarly applicable to your county, old Daniel Boone himself engaged in one of his death struggles with an Indian, painted as large as life, it would make a picture that would take with the multitude, and also be in accordance with historical truth. It might be emblimatical also of the early state of the west, while on the other side I might paint a landscape with 'peaceful fields and lowing herds' indicative of his present advancement in civilization.

It should be full as large as those I am preparing for Cooper and Howard and borne in the procession in like manner. If you approve of my suggestions or see proper to make others, write to me as soon as possible, as I shall have but little time to spare.

On the reverse of the Howard banner, he added in a postscript, he "intended to portray a large buffaloe just broken loose from his keepers making the poke stalks fly to the right and left in the fury of his unbridled career."[2]

[1] The letter quoted next Bingham received on September 22, 1844, after being "absent from Boonville for the last ten or twelve days."

[2] "Letters," *Mo. Hist Review*, Vol. XXXII, pp. 13–14. "Poke stalks" was a campaign tag for the Democratic candidate, James K. Polk.

Interlude: Political Banners, 1844

Completing three large banners (actually six paintings) in time for the convention set for October 10 and 11 must have kept Bingham busy, particularly as political excitement rose. As early as the eighth, the delegates began pouring into Boonville, and by the evening of the ninth, "all the hotels in the city and every private house into which admittance could be obtained, were literally crammed." The dust in the dry streets "was almost beyond enduring," but when the delegates arose on the morning of the convention they found to their gratified surprise that "a fine shower had fallen during the night." The great day began with a national salute of cannon at sunrise. The rain continued through the morning, causing some delay in getting the procession organized. First in the parade came a band from Jefferson Barracks at St. Louis. Then marched the Pilot Grove and Pisgah Rangers—"an independent cavalry company." Next appeared

the immense delegation from Howard, bearing a most splendid banner, on one side of which our noble champion is represented advocating the "American System." "All the great interests" of America are here represented. On one hand is a fortress with our National flag waving above it; on the other, and to the rearward is the ocean, crowded with shipping, and farther in the front is a farmer with his plough, a railroad, a number of [*illegible*] manufacturing establishments, the capital and other national buildings, while Mr. Clay, with his hands extended toward them, exclaims in his own impressive manner, "All these great interests are confided to the protection and care of government!"—The portrait of Mr. Clay, as well as the entire picture, is an admirable specimen of painting. . . . On the reverse side of the banner is represented a prairie, in its uncultivated state, with a herd of buffalo rushing across it.

Near the close of the procession came the Ashland Club of Boonville, bearing "decidedly the most beautiful banner we have ever seen," continued the Boonville *Observer* in its report of the convention on October 15. "On one side was represented the plain, unostentatious, but noble farmer of Ashland on his farm; on the reverse side is an Eagle high on a firm, immovable rock. The banner is without lettering—save the name of the club—the devices alone being sufficiently significant." Last of all marched the Boonville Juvenile Clay Club which also bore "a most beautiful banner; on one side of which

47

is represented a mill-boy riding merrily through the slashes of Hanover to mill; on the reverse is a little fellow carving the name of Henry Clay."

Since there is no report of a Boone County banner on this occasion, it is likely Bingham did not get around to the Daniel Boone subject proposed for it.[3] Of the three painted for the Whig meeting only one bit remains—the Juvenile Club picture of the *Mill Boy* (37¼" x 46½") is now owned by Leslie Cowan of Columbia, Missouri (Plate No. 17).[4] The masterful simplicity and appeal of this painting, in the treatment of both the boy and the landscape, leads me to think that in the destruction of the other banners we may have lost not merely documents for the history of politics, but quite possibly paintings in their own right. The others were eventually destroyed by fire,[5] but the portrait of Clay was seriously damaged at the time of the meeting. On Friday night, reported the *Observer*, "some villain went into the court-house where the whig banners were placed, and cut several gashes in the portrait of Mr. Clay, on the Howard banner. One gash, several inches in length, was cut across the throat. . . . Mr. Clay was represented as delivering one of his most eloquent and patriotic speeches in behalf of the American interests; and while so doing, he is now represented as being assassinated!"

6. THE FIRST RIVER PICTURES, 1845–1847

We have now come to the beginning of Bingham's great genre period. He spent the winter of 1844–45 at work in central Missouri, much of it probably in Jefferson City. There he had a studio in the state Capitol "opposite the office of the Clerk of the Supreme Court," and there he painted members of the General Assembly, including Bela M. Hughes of Platte County, as well as John Cummings Edwards, newly elected ninth governor of Missouri (Plate No. 18).

[3] The reader must remember that Boonville was the county seat of Cooper County and that Boone County was across the Missouri and to the east of Howard County. Rollins lived in Columbia, the county seat of Boone.

[4] Existence of *The Mill Boy* was first reported by Maurice Bloch in 1945; the canvas, he said, showed signs of having been cut down. ("Art in Politics," *Art in America*, Vol. XXXIII [April, 1945], 93–100.)

[5] C. B. Rollins was told by an old citizen of New Franklin that these banners, hanging in a store there, were lost in a fire ("Letters," *Mo. Hist. Review*, Vol. XXXII, p. 13 n.)

Early in June he was once more in St. Louis. In his painting room at this time were displayed portraits of John Quincy Adams and David Rice Atchison, lately major general of militia and now senator from Missouri. The *Missouri Republican* thought Bingham had much improved in the art of painting and coloring while in the East. According to the Jefferson City *Inquirer,* now hailing him as the "Missouri artist," he was "receiving an extensive patronage." He was firmly established as a portraitist.[1]

The editor of the *Republican,* calling attention on June 4 to Bingham's reappearance in the city "after several years absence," made quite briefly an announcement of far greater moment than he could then have realized. The artist, he said, had brought with him "some fancy sketches, and some paintings which demonstrate the possession of a high order of talent in another line, but to which, we believe, he has not devoted a large share of his time."

The last clause in this statement is particularly important as a lead in dating Bingham's earliest-known genre work. C. B. Rollins held, on the basis of letters from Bingham to his father which are no longer extant, that the artist painted his first genre piece (identified by Rollins as *The Jolly Flatboatmen*) in Washington in 1844. Dr. Christ-Janer, supporting this position, thought that "*Jolly Flatboatmen,* as well as *Fur Traders Descending the Missouri,* may well have been conceived and executed any time between 1840 and 1844,"[2] but there is no contemporary record to sustain this contention. On the contrary, current news stories indicate that Bingham took up this kind of painting after his return to Missouri. The *Republican,* obviously on his authority, asserted that as yet he had "not devoted a large share of his time" to this new "line." The interview reported several years later in the *American Art-Union Bulletin* (August, 1849) stated clearly that, "having returned to Missouri [after four years in the East], he was induced to attempt those de-

[1] Jefferson City *Inquirer,* December 26, 1844; St. Louis *Missouri Republican,* June 4, June 18, 1845; Jefferson City *Inquirer,* June 26, 1845. In St. Louis Bingham's studio was at first over Mr. Forbes' store on Main Street, but was soon moved to an upper floor in General Pratte's building on Chestnut above Main.

[2] Rollins, "Some Recollections of George Caleb Bingham," *Mo. Hist. Review,* Vol. XX (July, 1926), 472; Christ-Janer, *Bingham,* 35 and n. 9 on p. 158. Rollins also asserted that "in 1845 or '46, Bingham returned to Arrow Rock" from Washington, forgetting that he had just quoted a letter written by Bingham from Boonville, dated September 23, 1844.

lineations of Western life, as exhibited among boatmen and pioneers" which had since been purchased and distributed by the Art-Union.[3]

The pictures referred to by the *Missouri Republican* on June 4, 1845, were not named or described by any of the local papers, but they must undoubtedly have been the four paintings distributed by the Art-Union in December of this year: *Fur Traders Descending the Missouri, The Concealed Enemy, Cottage Scenery,* and *Landscape.* The date the canvases were sent to New York remains unknown, but on December 8 the Committee on Management of the Art-Union agreed to purchase *French Trader & Halfbreed Son* for $75, *Indian Figure—Concealed Enemy* for $40, and *Landscape Cottage* for $35.[4] The fourth picture listed in the *Transactions for 1845* must have been acquired separately, unless its title became telescoped with the third item purchased. Precedence among the genre paintings by Bingham must go, then, to *Fur Traders,* the first listed in the American Art-Union catalogue. The date of *The Jolly Flatboatmen* will be discussed in its proper turn.

The widely different subjects of these pictures show the painter determined on a broader expression of life and manners than he had hitherto attempted. The 1835 copies of buffalo-hunt landscapes, *Western Boatman Ashore* (1838), the two Tam O'Shanter illustrations (1839–40), *Pennsylvania Farmer* (1840), *Going to Market* (1842)—though we know these works only by title—have indicated the direction he would eventually take. Confident now of earning easily by portraiture what he needed to live on, he had at last turned much of his attention in this first winter after his return from Washington to preparing a substantial bid for attention from the American Art-Union, the successor to the Apollo Gallery where his earliest genre piece had been displayed. In the next half-dozen years he was to sell sixteen more pictures to the Art-Union in addition to painting many other landscapes and scenes of everyday life.[5]

[3] A search of Washington, D. C., newspapers for 1840–44 does not disclose any information about Bingham's work except those items I have already reported.

[4] All details of Bingham's transactions with the American Art-Union not credited to its publications are from the extensive manuscript records of the Art-Union in the New-York Historical Society.

[5] For the American Art-Union consult Charles E. Baker in Cowdrey, *The American Academy and the American Art-Union,* I, 95–240; E. Maurice Bloch, "The American Art-Union's Downfall," *New-York Hist. Soc. Quart.,* Vol. XXXVII (October, 1953), 331–59. For Bingham and the Art-Union, McDermott, "George Caleb Bing-

The First River Pictures, 1845–1847

In *Fur Traders Descending the Missouri* (29¼" x 36¼"), it is clear that the artist's apprentice period in genre is over (Plate No. 19). This canvas is not merely an admirably balanced composition brilliantly painted: it is the very essence of life on the Missouri as Bingham must have seen it and felt it many a time. Everything is right—the posture and expression of the figures, the detail in cut and color of costume, the bear cub chained in the bow of the dugout (*not* a cat, *not* a fox, but plain for all with eyes to see, a bear cub brought down from the mountains), the snags in the shallow water, the grip of the hands on the paddle, the haze thick over the river. Everywhere is the mark of a man who has throbbed to this life. No one else could draw with such authority. No one else could so convey the quality of experience on the river. This is no picturesque scene copied by a romantic visitor to the West. It is the West. By this painting Bingham established himself as the first master developed beyond the Alleghenies. The editorial enthusiasm that ten years earlier had seen in him the potentialities of a "western meteor of art" had not been far wide of the mark.

How can we pause for a moment only before this picture? Had it been his sole work to survive, we would yet know its author to be a grand painter. Here is that astounding luminosity, here are the bright, soft, smoky colors, here is the masterly control of light and air that will mark his later river scenes, at once firmly real and completely poetic. Here is the subtle merging of figures and scene, that flow of all elements in the picture into each other. This is the original, this the unique Bingham. This is the portrait of a river such as none had done before him.

It is obvious in *Fur Traders Descending the Missouri* that Bingham by 1845 had learned to draw superbly. Fortunately, we have many of his figure sketches and can study them with the genre pictures in which they appear. When he began to fill his portfolio with "boatmen and pioneers" no one can say, but by August, 1849, he had a sheaf so varied and extensive that the *American Art-Union Bulletin* was sure it would "greatly gratify those amateurs" who cared to inspect it in his New York studio.

ham and the American Art-Union," *New-York Hist. Soc. Quart.*, Vol. XLII (January, 1958), 60–69.

A fine collection of these drawings (though by no means the complete lot) was later acquired by John How of St. Louis and was presented by him to the Mercantile Library there in 1868.[6] Originally these sketches were on 111 separate sheets varying in size from six and one-quarter by five inches to fifteen by eleven and one-half inches; at some unknown date they were mounted on 110 leaves of a scrapbook. The greater part of the 117 studies so preserved are sketches of representative and highly individualized figures seen in a river town such as Boonville, ranging from the most solid citizens to drunken ne'-er-do-wells—the varied crowd of farmers, lawyers, newspaper editors, storekeepers, boatmen, and hangers-on that filled the stage of everyday life in this rapidly changing frontier area. Three sketches are of boys (one said to be his son Horace). There are no female subjects—Bingham's genre world is almost entirely masculine. There are no Indians. Occasionally he sketched a second view of a head when he did the figure. A booted foot, a pair of bare feet with trousers rolled halfway to the knee, a coat thrown over a chair, a hand raised in gesticulation, a man sharpening a quill pen show the care with which he studied detail.

Of Bingham's work habits as a painter we know little. Dr. Rusk was told that he "often made rapid sketches of attitudes and then had a model stand in the position for more careful drawing." One of his younger friends (Oscar F. Potter was fifteen when he first knew Bingham in Boonville in 1844) modeled for "a good many of his figures"; among others he "posed for the man with the pole and also the one at the right with the bare feet" in *In a Quandary*.[7] Examination of the Mercantile Library sketches bears out Dr. Rusk and her informant. It is clear that Bingham used the same model not merely for alternate views or poses, but for different purposes. No. 24 seated on a stump is the same man as No. 104 standing with his hands behind his back and under his coattails; No. 62 shows him twice more: seated on an uprooted stump and standing with his rifle by his side. In Nos. 77 and 81 the model is so differently clothed and posed that he can be taken for a different figure. Almost all the sketches are drawn with deliberate care. In contrast is one quickly penciled sketch

[6] Minutes of The St. Louis Mercantile Library Association, November 3, 1868.
[7] Rusk, *Bingham,* 35, 43.

on the lower part of No. 23, an old countryman with folded arms, glaring intently as at a speaker.

Bingham's procedure can only be guessed at. Did he conceive *Fur Traders Descending the Missouri* and then seek out and sketch the types he needed to express it? Had he already accumulated a considerable collection of studies so that when the idea for the painting struck him he had only to turn over sheets of drawings and pick out suitable figures? It is likely enough that once he had been "induced to attempt . . . delineations of Western life," he set about sketching appropriate figures as he found them about him in Boonville. One thing is certain. In the extant sketchbook we do find studies that appear as the figures in this first of the genre paintings: there the calm, competent river man, with his stocking cap, loose-fitting shirt, and clay pipe, seated in his dugout canoe, dips his paddle in the still water (Sketch No. 1), and there the shockheaded young fellow leans carelessly over an indistinguishable mound (Sketch No. 2). In transferring them to the canvas, Bingham has altered a young boatman into a weatherbeaten, aging fur trader who has seen many years on the Missouri, and he has made the companion even younger than he seems in the original drawing. The authentic strength of the studies has been but reinforced by the additional details of the pirogue and the bear cub, by the brilliant emphasis of his coloring, and by the mastery of the river haze.

The second of the 1845 pictures, *The Concealed Enemy* (29″ x 36″), is one of the two known Indian subjects by Bingham (Plate No. 20). From the title under which it was sent to the Art-Union it is clear that Bingham thought of it as a figure piece. Much care was given to the delineation of the handsome Osage warrior crouching in the shadow of a romantic rock, but when the painter placed him on a bluff overlooking the Missouri, the picture became much more than a static figure study of a noble savage staged against a conventional "wild" backdrop. The river, so real to Bingham, gives life and meaning to an otherwise commonplace representation. *The Concealed enemy* is not a first-class Bingham, for the Indian was a subject beyond his experience, but the treatment of the river marks it as genuinely his.

The other two canvases in this group must be dismissed very

briefly, for they are both among the lost Binghams. The title *Cottage Scenery* suggests that it may have been a "fancy sketch"—a venture in sentimental illustration. Of the *Landscape* absolutely nothing is known save that it did once exist. Both disappeared after this December distribution.

The acceptance of four pictures by the American Art-Union apparently encouraged Bingham to undertake more work in an area that he was marking out as his own. By the third week in March, 1846, he had completed "four really capital paintings" which were being shown in St. Louis "on their way to the exhibition in New York." Bingham, said the *Weekly Reveille,* was making "a brilliant reputation by the delineation of western scenes." The writer found in his pictures "an absolute life . . . which it is refreshing to look upon."[8]

Two of these canvases were noted on an Art-Union memorandum on May 29 as pictures to be recommended for purchase. The Committee on Management on July 6 authorized the buying of one, *Boatmen on the Missouri* (with frame), at $100. Neither subject nor size is given in the records. Nothing more is positively known of this painting, for it dropped from sight after the December drawing.

There has recently been found, however, in the collections of the Henry Francis DuPont Winterthur Museum a river scene (24⅞″ x 29¾″) which may well illustrate the composition of *Boatmen on the Missouri* (Plate No. 21). All who have examined the Winterthur canvas agree, on the evidence of brushwork, that it must have been painted around 1900; it is equally obvious that it was painted after Bingham. Treatment of the river background in detail, coloration, and tone is similar to that in *The Jolly Flatboatmen, Raftmen Playing Cards,* and other riverscapes by Bingham. Subject and figures are typically his. Three men in a small scow standing well out in a river apparently hope to sell their skimpy load of cord wood to some passing steamboat. One man, with a cracked silk topper perched jauntily on the side of his head, sits to the left showing the side view of his body, but full view of his face; a leg of his trousers is partially rolled up and one bare foot rests on the rowing seat of the boat. To the right a standing figure is posed leaning back against the pile of wood; this

[8] March 23, 1846.

young fellow stares directly at us. Behind and between them we see a third man, standing and stooping slightly forward as he uses a long-handled shovel or fork, the end of which we cannot see. The original drawing (Sketch No. 3) for this figure is in the Mercantile Library collection. The painting here reproduced must certainly be a faithful copy after a lost painting by Bingham. It will presently be shown that this composition cannot be either *Wood Yard on the Missouri* (1849) or *The Wood Boat* (1851); until evidence is advanced to the contrary, the Winterthur picture may be held to represent the lost *Boatmen on the Missouri.*[9]

Of *Interior,* the second picture named in the May 29 memorandum, I find no mention beyond the initial recommendation; it did not appear in the distribution list and probably was returned to the artist.[10] A third painting submitted was a *Landscape with Cattle.* Some difficulty must have occurred in correspondence concerning it, for Bingham's agent in St. Louis, John H. Cole, on October 23 wrote to demand information about the picture. On December 12 the Art-Union bought the landscape for $100. The scene depicted and the size of the canvas are not known. Since distribution it has been lost to the record.[11]

The fourth of the pictures shown in St. Louis on their way to the American Art-Union in the spring of 1846 was undoubtedly *The Jolly Flatboatmen* (38″ x 48½″).[12] At first known as *Dance on the Flat*

[9] The back of this canvas is impossibly inscribed "William S. Mount 1848." It was acquired by Mr. Du Pont in 1928 before interest in Bingham began to revive. Among the titles of the "lost" Binghams, none would fit this painting except *Boatmen on the Missouri.*

[10] On January 21, 1847, Robert F. Fraser, secretary of the Art-Union, wrote from New York to Charles D. Drake, honorary secretary at St. Louis, that he had "taken the liberty of consigning to your care a box of paintings for Geo. C. Bingham Esq, which you will oblige me by taking care of for him."

[11] Christ-Janer (*Bingham,* 40) suggested that this may have been a Bingham landscape destroyed when the Rollins home in Columbia burned in 1908. There were, however, so many paintings by Bingham with this title that there is no reason to assume that the destroyed picture was this one of 1846.

[12] I have already noted that C. B. Rollins declared it was painted in Washington in 1844. "This painting was purchased in 1845 by the American Art Union," he further asserted, "and an engraving of it appeared as a frontispiece of their Journal for 1846" ("Some Recollections of George Caleb Bingham," *Mo. Hist. Review* Vol. XX [July, 1926], 472). Christ-Janer (*Bingham,* 35) accepted and repeated Rollins' statement. Rusk (*Bingham,* 93) in 1917 had thought it "must have been painted early in 1845," but in her recent article on *The Jolly Flatboatmen* (after it was pointed out that the *Transactions for 1846* were actually published in 1847) she corrected the date to 1846. The detailed history of this picture was published for the first time in my "Jolly

Boat, its purchase by the Art-Union was authorized by the Executive Committee on October 9 of that year. It was selected by the Committee on Management on November 2 as one of two pictures to be mezzotinted for the subscribers of 1847. Bingham felt highly complimented by the choice.[13] Renamed *The Jolly Flatboatmen* by the Executive Committee on December 6, it was placed in the hands of the engraver the following day. Payment of $290 for the picture and its frame was authorized on February 1, 1847. Necessarily held back from the 1846 distribution, the painting was listed in the catalogues of the following year as No. 1. In the December, 1847, drawing, it fell to the lot of B. van Schaick of New York. Presumably, after the engraver finished with it in the spring of 1848, the picture was delivered to its new owner. It then disappeared from public knowledge until it was rediscovered recently in a private collection where it had been for four generations.

In *The Jolly Flatboatmen* (Plate No. 22), Bingham had hit again on a most happy subject. Glamorous as it may seem to us, in his world it was merely a scene from everyday life. The type of the flatboatman had been a familiar sight for many years on the western waters, and those who had not seen him had at least often read of him as Christian Schultz described him in 1808 and Timothy Flint in the 1820's and many another traveler before them and since. Even when the steamboats came to ply the river in their hundreds, the flatboatmen continued to talk and roar and curse and dance and sing their way down to New Orleans so that not a day could pass while the river was open

Flatboatmen: Bingham and his Imitators," *Antiques,* Vol. LXXIII (March, 1958), 266–69.

[13] "In a former letter [not found] I said something to you about Mr Bingham the Missouri artist—who is a member of the Missouri Legislature and whose seat is contested. Some way or other he has taken a fancy to me and has promised to make me what I shall consider a valuable present—and I know you will prize it. He is a member of the Art Union of New York—an association of the artists of this country and of Europe I believe. A painting of his, representing a company of flat boatmen on the Mississippi, executed sometime since, was before the society at its last annual meeting—and they chose it out of the large collection which they had, and determined to have it engraved for the ensuing year—this is the highest compliment which could have been paid to him. When it is engraved he will be entitled to a copy of it—which he says he will make me a present of when he receives it—It will be about two feet square. He receives two hundred & 25 dollars for the painting. The engraving will cost the society one thousand dollars—the copy will be worth five—though I shall prize it much more highly of course." (James O. Broadhead to Mary S. Dorsey, Jefferson City, December 13, 1846).

without at least one flatboat floating by wherever one stood, its crew quarreling or joking, talking of the women at Natchez-under-the-Hill, bragging, calling insults to other passing boatmen, tilting the whisky jug, filling the long, lazy, idle hours as mood led them.

Bingham has allowed a flatboat on the Mississippi to come up behind us (we are on one ourselves for sure) at a pleasant moment when the river is quiet and the crew relaxed and easy-hearted. The inevitable and ubiquitous fiddle is out and the fiddler tapping with his left foot while the captain or leader of the boatmen kicks up his lively heels to show off for us. On the forward edge of the flat a shirt dries, held down by a rock; provisions and freight show below; a coonskin is tacked near the ladder into the hold.

The same care was taken in gathering studies for this picture as for *Fur Traders Descending the Missouri*. In the Mercantile Library collection sketches of six of the eight figures have been preserved: the boy beating time on the tin pan or skillet, with his cap twisted to the side (No. 4), the fiddler seated on the keg (No. 5), the three men in the foreground, one seated with his back to us, one lying down, and one looking toward us over his left shoulder, all sitting on or leaning against the long, raised oars (Nos. 6, 7, 8), and the smiling man (No. 9) seen almost directly behind the dancer. The carefree central figure, that exuberant dancing boatman, however, is missing, as well as the steersman, the eighth and most distant figure.

Bingham was to be indebted to the American Art-Union not merely for the purchase of twenty paintings at a period in his career when both money and recognition were of real importance to him, but also for the much wider publicity which came from the publication of *The Jolly Flatboatmen*. It was an unexpected stroke of luck that gave him this opportunity.

The American Art-Union, operating as a nonprofit organization for the encouragement of American painters, spent the greater part of the income derived from the five-dollar annual memberships on the purchase of paintings which were exhibited at its rooms in New York and were distributed to members at a public drawing at the close of each year. Since only a few hundred could be so fortunate, however, as to draw a picture, the Art-Union sent to each subscriber an engraving made from one of the paintings of the year.

In 1843, Emanuel Leutze's *The Return of Columbus* had been chosen as the subscribers' print for 1846, but in May of the latter year, Stephen A. Schoff, the engraver, although he had contracted to devote his entire time to the work, let it be known that he would require three full years from the first of the coming year to complete the engraving. Then, when the owner of the painting, Richard Arnold of Providence, threatened to bring suit to recover the prize which had fallen to his lot so long before, the Committee on Management abandoned that project. To make up for the disappointment, a print of Leutze's *Sir Walter Raleigh Parting with his Wife* was presently issued to members for 1846, and *The Jolly Flatboatmen* and Daniel Huntington's *Sybil* were chosen as a double offering for 1847.

On December 7, 1846, Bingham's picture was delivered to the engraver, Thomas Doney, whose first job was to produce a small etching on steel for the frontispiece to the *Transactions for 1846*. This publication was off the press by March 13, 1847, in an edition of eight thousand. Doney received $30 for his little plate (4½″ x 5½″). The contract for the large mezzotint for subscribers called for its completion by December, 1847. There occurred, however, "more delay in the execution of the work than was anticipated," and it was not until February, 1848, that the plate (19″ x 24″) was finished and presswork begun. Even then progress was slow, since no more than twenty-five prints could be struck in one day. To impatient inquiries from the secretaries of the Art-Union over the United States, Robert F. Fraser, corresponding secretary in New York, could only recommend patience.

In March, Fraser was able to send single copies to the honorary secretaries to show their impatient subscribers. The records do not make clear how many prints were so distributed, but there were 308 such officials for 1847. At last, in mid-May, 1848, Fraser had a large enough supply on hand to begin his "impartial distribution." Doney was kept at work pulling prints until October or November. An edition of 9,500 had been authorized by the Committee on Management, but since the membership of the Art-Union for 1847 reached 9,665 the total issue must have been at least 10,000. Bingham had received $290 for his painting, for which he had had to supply the frame; Doney received for engraving, printing, and retouching the plate $3,374.70.

The distribution of 18,000 prints after his painting certainly put Bingham before the public eye and, as will presently be seen, put an idea into his head. The immediate popularity of *The Jolly Flatboatmen* is evident in the unauthorized borrowing of it that began with the publication of the *Transactions for 1846*. John Banvard, planning to take his huge panorama of the Mississippi to England, could think of no better advance publicity to send *Howitt's Journal* of London than "an engraving of one of these peculiar boats, with its 'jolly flat-boat men,'" together with material for an article on "Life on the Mississippi." The publication of this woodcut on September 4, 1847, without acknowledgment to the original artist, was but the first of many "borrowings." Even Bingham himself eventually painted two more variants of his popular work.[14]

One more painting is on record for 1846: a *Landscape with Cattle* raffled off at Wooll's picture store in St. Louis late in September. It is one of few landscapes by Bingham for which we have a description. According to the *Weekly Reveille* of September 22 it was "a scene on the Mississippi . . . of quiet beauty, representing the majestic old woods rising on the rich bottom; the herd reclining beneath their shade; the river winding its way in the distance, and in the background a bold bluff rearing its high summit, in wild grandeur, beside the father of waters." The outcome of the raffle was not announced, but Bingham was well enough thought of to insure the selling of twenty-four five-dollar tickets. The newspaper description justifies our saying with some assurance that this is the *Landscape with Cattle* (38″x48″) now in the City Art Museum of St. Louis (Plate No. 23), acquired in 1923 from the collections of Chester Harding Krum, grandson of Harding, the artist, and son of John H. Krum, who was a prominent citizen of St. Louis from his settling there in 1842 until his death many years later.

The summer and fall of 1846 Bingham gave over to a strenuous political campaign, but for the moment I reserve that story. During the early months of 1847 he was again painting life on the rivers.

[14] To the borrowings reported in my "Jolly Flatboatmen: Bingham and his Imitators," *Antiques*, Vol. LXXIII (March, 1958), 267–69, may be added a *Jolly Flatboatmen by Night* painted by C. Wimar at Düsseldorf in 1854 from a Bingham engraving. Banvard's story is related in my *The Lost Panoramas of the Mississippi*, 18–46.

In April, two pictures were on display at Wooll's store in St. Louis. "They are river groups, and are actually alive in the canvass," said the *Weekly Reveille* on April 20. "The first is a card party on an Upper Mississippi[15] raft; the second, a lighter crew listening to a yarn, while drifting down the Missouri from a steamer which is aground, and which they have been relieving of freight."

The latter painting (Plate No. 24), then known as *Mississippi Boatmen Listening to a Yarn*, but now commonly called *Lighter Relieving a Steamboat Aground* (29½″ x 35½″), pictured, in the words of the *Missouri Republican* of April 21, "a steamboat, in the distance, aground on a sandbar. A portion of her cargo has been put upon a lighter or flatboat, to be conveyed to a point lower down the river. The moment seized upon by the artist is, when the lighter floats upon the current, requiring neither the use of oar nor rudder, and the hands collect around the freight, to rest from their severe toil. One is apparently giving a narration of his adventures at *Natchez under the Hill*, or somewhere else, and the rest are listening—whilst a few others are seeking more congenial enjoyment in the jug, pipe, &c. The characters grouped together on the lighter, their dress, expression of countenance, positions, &c., are true to the life."

To the great satisfaction of the local press this "recently finished" painting was bought by J. C. Yeatman of St. Louis for $250. "We are gratified to hear [said the *Reveille*] that one of these masterly efforts of our talented Missouri artist has been retained in the city. . . . Admirers of the art, in the east, are snatching with eagerness at Bingham's . . . efforts, because they are not only pictures of a fresh native character in design, but admirable in their execution, and emphatically *living* pictures of the characters they are meant to portray."[16]

Lighter Relieving a Steamer Aground has been "retained" in St. Louis to this day, as have living studies for the young man sitting on a keg in the left foreground (No. 10) and the older man beyond him seated on a box with one leg drawn up and one hand to his face (No. 11). From the first Bingham removed hat and shoes; his bare feet with trousers rolled halfway to the knee were carefully sketched in No. 12. The seated man with the pipe in the right foreground is a

15 I.e., above the Ohio.
16 Also reported by the St. Louis *New Era*, April 21, 1847.

rougher looking specimen than the study (No. 13) from which he was painted. The listener wearing the tam on the right is very similar to Sketch No. 14 except for the reversed position of the arms, which suggests that Bingham probably posed his model twice, one drawing being lost. No. 15 is the original of the man at the far end of the boat, drinking from a jug.

Purchase of *Raftmen Playing Cards*[17] (28″ x 36″) for $300 (without frame) was authorized by the Executive Committee of the Art-Union on May 26. In December it fell to the lot of Edwin Croswell of Albany, New York, and eventually found its way back to St. Louis in the collections of the City Art Museum (Plate No. 25). On this canvas was portrayed, the *Missouri Republican* reported on April 21, "a group on a *raft*, floating with the current. Two men are playing a game of cards, well known in the west as *three-up*. The two players are seated astride of a bench—one has led the *ace*, and the other is extremely puzzled to know what to play upon it. As often occurs, he has two friends, on either side of him, each of whom are [*sic*] giving advice as to which card he ought to play. . . . Every one who has ever witnessed such a scene, will at once see on the canvas all the incidents and expressions of real life." A story about this picture in the New York *Express*, as reprinted in the Jefferson City *Metropolitan* on August 17, makes clear that there were two additional figures: "One individual is seated on a plank examining his injured foot, while another is in the rear, hard at work managing the raft."[18] Five of the original studies are at hand. The smiling man who has just played the ace (No. 16) has his right leg drawn back, not thrust forward as in the painting. The second player (No. 17), his thoughtful friends (Nos. 18 and 19), and the man with the sore foot (No. 20) were transferred to the canvas without alteration. Only the man poling the raft with his back to us is missing.[19]

Contemplation of these two paintings led the *Missouri Republican* critic to make some astute remarks about Bingham's purpose and his success:

[17] Letters of Bingham to Goupil & Co., January 31, 1852, and to Rollins, June 27, 1852, show he wrote the title thus.

[18] Christ-Janer, *Bingham*, 42.

[19] The confusion that once existed about this picture and *In a Quandary* I have discussed in "The Quandary about Bingham's 'In a Quandary' and 'Raftmen Playing Cards,'" *Bulletin of the City Art Museum of St. Louis*, Vol. XLII (1957), 6–9.

Mr. Bingham has struck out for himself an entire new field of historic painting, if we may so term it. He has taken our western rivers, our boats and boatmen, and the banks of the streams, for his subjects. The field is as interesting as it is novel. The western boatmen are a peculiar class in most of their habits, dress and manners. Among them, often in the same crew, may be found all the varieties of human character, from the amiable and intelligent to the stern and reckless man. In dress, habit, costume, association, mind, and every other particular, they are an anomaly. They constitute a large, interesting, and peculiar class, and in their labors they are surrounded by natural scenery, or accidental occurrences, which lend to their peculiarities a yet deeper interest. Their employment, the dangers, fatigues and privations they endure—the river and its incidents and obstacles—its wild and beautiful scenery—its banks of rocks, or its snags, sawyers and sand bars, draw out, as it were, the *points* of these hardy, daring, and often reckless men.

Mr. Bingham seems to have studied their character very closely, with the eye and genius of an artist and the mind of a philosopher. He has seized the characteristic points, and gathered up their expressive features, and transferred them to his canvas with a truthfulness which strikes every observer. To look at any of his pictures, is but to place yourself on board of one of the many crafts which float upon our streams.

There is another peculiarity about Mr. Bingham's paintings. He has not sought out those incidents or occasions which might be supposed to give the best opportunity for display, and a flashy, highly colored picture; but he has taken the simplest, most frequent and common occurrences on our rivers—such as every boatman will encounter in a season—such as would seem, even to the casual and careless observer, of very ordinary moment, but which are precisely those in which the full and undisguised character of the boatman is displayed.[20]

7. "THE STUMP ORATOR," 1847

By the end of November, 1847, Bingham was "out with another picture" which, the St. Louis *New Era* was certain, would "increase his fame as a correct and life-like painter of Western scenes."[1] Though

[20] Rusk (*Bingham*, 47–48) and Christ-Janer (*Bingham*, 45) both have better eyes than I, for I cannot find in the St. Louis *Missouri Republican* for November 27 and 28, 1847 (though I have checked at least three separate files of this newspaper), any reference to a Bingham painting entitled *Lumbermen Dining*.

[1] November 29, 1847. This picture has hitherto been attributed to 1848 because it was exhibited by the National Academy of Design and the American Art-Union in that year.

now lost, his *Stump Orator* was an important work, for, if we do not count the banners, it was his first essay in a new subject matter he was to make his own as completely as he had the scenes of everyday life on the rivers.

Though not a personal statement, the *Stump Orator* was founded in personal experience. The painter had "been on the stump," reminded the *Missouri Republican* on November 30, and had "gone through a hot and exciting canvass." In the summer of 1846, at the desire of the Saline County Whigs, Bingham had stood as candidate for the legislature. He defeated his opponent, Darwin Sappington, by three votes, only to have Sappington announce that he would contest. Bingham thereupon suggested that the two candidates "submit their respective claims once more to the test of the ballot box, leaving the people, according to the genuine republican method, to determine who shall be their representative" and declared that he would abide by the result even though his opponent had no more than a majority of one. Sappington refused. Bingham took his seat in the fall term of the legislature, but presently the heavily Democratic House declared Sappington elected.[2]

In the course of this struggle Bingham wrote on November 2 to his friend Rollins:

If when you see me again you should not find me that pattern of purity which you have hitherto taken me to be, let the fact that I have been for the last four months full waist deep in Locofocoism plead something in my behalf. An Angel could scarcely pass through what I have experienced without being contaminated. *God help poor human nature.* As soon as I get through with this affair, and its consequences, I intend to strip off my clothes and bury them, scour my body all over with sand and water, put on a clean suit, and keep out of the mire of politics *forever.*[3]

In spite of this resolution Bingham was a candidate again in 1848 and vindicated himself by defeating his rival Sappington by twenty-six incontestable votes.

In this examination of the record of Bingham as artist we are ✳

[2] Columbia *Missouri Statesman*, June 19; Boonville *Weekly Observer*, June 24; Boonville *Commercial Advertiser*, June 27; *Missouri Statesman*, October 2; Liberty *Weekly Tribune*, November 22; *Missouri Statesman*, November 27, December 25, 1846.
[3] "Letters," *Mo. Hist. Review*, Vol. XXXII, p. 15.

concerned with his political activities only so far as they bear on his painting. Although he had long had a lively interest in politics, it must have been the active work of campaigning that led him to think of depicting a gathering of the "sovereigns." That had indeed been an experience. The circumstances, Bingham declared on the floor of the House on December 17, 1846, "which have attended me during my short political career, from the time I announced myself a candidate for a seat in this House, to the present, have been in many respects peculiar. Upon the stump I had to contend with the abilities of others besides my competitor. Against me was arrayed, not only a large portion of the concentrated wealth of the county in which I reside, but I found, meeting me regularly at my own appointments, the *great* champion of our opponents from the other end of our Senatorial district. Opposed by such a combination; assailed both in front and flank, with an *Ex-Governor* whenever an occasion offered bearing down on my rear, I still found myself sustained by the consciousness of a good cause. The people rallied to my rescue, and notwithstanding the fearful odds against me, I conquered in their strength, and came off victorious."[4]

Out of this battling, out of this victory and defeat came *The Stump Orator*. Forced from the legislature, Bingham spent the winter months painting *Lighter Relieving a Steamer Aground* and *Raftmen Playing Cards*. Then, calmed down, his sense of proportion and his detachment recovered, he must have turned his hand in the summer of 1847 to the new subject; certainly there was no bitterness in it, no personal edge of satire. This painting of "a stump speaker and his audience," observed the St. Louis *New Era* on November 29, "is fine, and the representation of character, features, scenery, &c., inimitable." All "lovers of art" were urged by the *Reveille* on the same day to "look in at Wooll's, on Fourth street, if you wish to carry a smile on your face for a week. Bingham has placed there, previous to its being sent to the east, his latest painting, a stump speaker and his crowd. *Those* faces will haunt us for a long time." A week later the *Reveille* again praised *The Stump Orator* as "truly a delineation of American western character." The faces—there were more than fifty of them—were "representations true to life, we might almost say

4 *Missouri Statesman*, January 22, 1847.

64

portraits, for throughout our region such faces are seen daily." All
western, too, were "the careless abandon of the many figures, the
manly, open and fearless cast of countenance peculiar to western
men; the love of fun portrayed, as well as the style of dress, place of
meeting, &c. . . . delineated as no painter could sketch them, except
he both possessed genius and had mingled among such scenes."[5]

The *Missouri Republican* on November 30 went even farther in
its enthusiasm for Bingham's latest:

For vitality, freshness, grouping, shade and light, and costume, we have
never seen any thing to equal it. It is no carricature [*sic*], nor an attempt
at carricature, but a picture which may be seen at any of our respectable
political meetings in the West. . . . We could occupy a very considerable
space in sketching the varied countenances, the changes of expression,
and the predominant feeling, which the author has given to each indi-
vidual of the group. . . . It is a painting which may be studied by the hour
—every face may be critically examined, and yet in every one there is
evidence of a deep, thoughtful and comprehensive understanding, on the
part of the painter, of the feelings, motives and impulses which act upon
crowds and upon individuals. . . . It is . . . an effort to draw an unexag-
gerated representation of an assemblage which is familiar to every one in
the West. . . . No part of the picture is more happy, nor in any part of it
has the author displayed more skill, than in the ease and naturalness
with which he has grouped this large number of figures together, upon
a small canvass—preserving all the characteristics of dress and counten-
nance, and, what we conceive the most difficult part of the painting, the
usual posture of those who attend such meetings.

The painting was probably sent east in December. Robert
Fraser, corresponding secretary of the American Art-Union, how-
ever, was in the process of leaving that office and he received *The
Stump Orator* not as secretary of the Art-Union, but as Bingham's
private agent. He offered it to the Art-Union, but when his price was
not met, he exhibited it at the annual spring show of the National

[5] St. Louis *Weekly Reveille*, December 6, 1847. *The Stump Orator* was a true
genre painting, not a group portrait. In such pictures, however, local citizens often
want to discover local citizens. Bingham, said the *Missouri Republican* on November
30, "disclaims every thing personal—and we know that he is above any thing of the
sort." But, the writer continued with mild humor, "We think we can recognize in the
group many well known political characters. Of this, they ought not to complain, for
they have here the best—almost the only—chance of immortality." The writer made
no actual attempt to identify any of the figures.

Academy of Design. In October, 1848, the Committee on Management of the Art-Union paid $350 for it.[6] Drawn in December by William Duncan of Savannah, Georgia, the picture has never been heard of since.

Although *The Stump Orator* is lost, to reconstruct it is not impossible. The focus of the picture, it is clear from the report in the *Missouri Republican,* was upon the speaker, who is "evidently well pleased with the impression he is making" as he stands "on the *stump* of a fresh cut tree." In front of him, "whittling a stick," sits his opponent "with his brows knit, and blood veins swollen, mouth compressed, and rage and opposition depicted in his countenance." From this pair the eye of the spectator moves to the mass of listeners: "Around and along the trunk of the prostrate tree are congregated the sovereigns, comprising about sixty figures, in the attitude of listening to the orator—some pleased, some displeased, and some without any idea at all of what he is saying." Among them are seen "the little knot of busy politicians around the finely dressed Demagogue, in the background—the idiotic expression of an unfortunate inebriate behind the speaker—the joy of the zealous partizan—the cool, calculating aspect of the more reflecting citizen—the half stare and half credulity of another—the man with his coon skin cap and rifle." Most of the voters are gathered in a circle before and around the speaker; some at the end of the circle are talking at a temporary bar. In the distance (right) are a tavern and (center) a half-finished log house. The time is late in the afternoon.[7]

The St. Louis newspaper accounts thus give the spirit of the picture, the layout of the composition, and impressions of prominent figures in it. But we can go a step farther.

In the Mercantile Library sketchbook we can pick out many of the original sketches. The listening attitudes and expressions of the subjects, as well as the logs or stumps on which at least ten are sitting, strongly suggest that these were drawn at just such a political meet-

[6] This is discussed at greater length in my article, "George Caleb Bingham's 'Stump Orator,'" *The Art Quarterly,* Vol. XX (Winter, 1957), 390. The Executive Committee on April 20, 1848, resolved to offer $400, but the eventual price was $350 (October 5).

[7] "Late in the evening," said the *Republican,* but this scene was in Little Dixie and in the South evening begins after noon.

ing. For the orator we may choose between No. 21 and No. 22. Because one reporter called him "a long demagogue,"[8] I am inclined to No. 21, but Bingham used him for the speaker in *Stump Speaking* half a dozen years later and possibly did so then to avoid duplication with his earlier painting. No. 22, in his vest and shirt sleeves and with a confident smile on his face, obviously qualifies, and the tree trunk in the background adds conviction. There can be no question about his opponent—No. 23, sitting on a log, whittling and scowling, is positively identified by both the *Missouri Republican* and the *Reveille*. Nos. 24, 25, 26, and 27, representative figures, approving or critical, seated on logs or stumps, facing forward—No. 28, in profile and seated also on a log—Nos. 29, 30, and 31, with their backs toward us—No. 32, obviously a principal citizen who would be seated with other notables in the place of honor behind the speaker—No. 33, a newspaperman reporting the occasion—Nos. 34,[9] 35, 36, and 37, attentive and interested listeners—No. 38, who has been too often to the bar and has collapsed in drunken sleep on his share of the log—all of these (and others might be added to the selection) almost certainly figured in *The Stump Orator*. With the exception of No. 21, they do not appear in *Stump Speaking* or other extant paintings. I suggest that at least four more of the figure studies may have been used in the first political picture. No. 39 qualifies as the "inebriate" with the "idiotic expression" placed by the painter behind the speaker, and Nos. 40, 41, and 42 may well have been given prominent positions in the foreground; these four sketches were all used in *Stump Speaking*, but with considerable modification.

8. LIFE ON THE WESTERN RIVERS, 1848–1851

Much of Bingham's time in 1848 was taken up by politics. He spoke at the state Whig Convention at Boonville in April. Induced

[8] Letter signed "Flit," November 15, 1848, to the *Southern Literary Gazette*, as found in the American Art-Union scrapbook.

[9] Further evidence that Bingham made sketches from the same model in variant poses is seen in a drawing in the Karolik Collection in the Boston Museum of Fine Arts nearly identical with No. 34. The right knee of the Karolik sketch is drawn up higher and the right arm rests clearly upon it; the left hand is clasped around the left knee. A signature and date have been added, but erasure of the middle initial and the early date assigned (1836) throw great doubt on the inscription. So far as one can judge from a photograph, however, the sketch is assuredly by Bingham.

to run against Sappington, he spent the early summer campaigning and in the August election had the satisfaction of beating his opponent indisputably. The fall and winter months were devoted to service in the legislature. On November 24, he had the unhappiness to lose his beloved Elizabeth. He himself had a "spell of fever," but as soon as he recovered he went back to Jefferson City; politics was, do doubt, a useful distraction.[1]

Only one painting has been assigned to 1848[2] and that on the doubtful ground of a date (with signature) on the face of the canvas. This picture, now known as *Captured by Indians* (25"x30"), is a firelight scene featuring a seated white woman on whose lap a sleeping child rests his head (Plate No. 26). Two Indians to the right have fallen asleep; one in full view, another crouched down with his back to us. A third to the left is alert; he has just turned his face forward as if startled. While the subject is not usual for Bingham, comparison of the Indian figures with the Osage warrior in *The Concealed Enemy* and of the woman with the one prominently placed in *The Emigration of Daniel Boone* (1851) show obvious similarity of treatment. This was probably the Bingham painting called *The Captive* owned by Charles Derby of St. Louis in 1859 and exhibited at the Fourth Annual Fair of the St. Louis Agricultural and Mechanical Society. According to Matt Hastings, who as a young man had known Bingham as early as the 1850's, a Bingham canvas called *The Captive*, once owned by a Mr. Pearce, had been bought from him by J. J. Conroy. It represented "a white woman and her child seated near a camp fire and surrounded by several Indians, all of whom are asleep except one who looks around, as if fearing pursuit."[3] This, again, must be the picture entitled by May Simonds in 1902 *White Woman Stolen by Indians,* which she described as a "night scene," a "campfire."[4] The provenance, then, of *Captured by Indians* seems quite acceptable, although the absence of contemporary documentation makes the affixed date 1848 no more than tentative.

[1] Liberty, Missouri, *Weekly Tribune,* April 14, August 18, 1848; January 5, 1849; Mrs. Mary Bingham to H. V. Bingham, Jr., Arrow Rock, January 1, 1849. Rusk (*Bingham,* 44–46) reported in some detail Bingham's service in the legislature.

[2] The only portrait of record for 1848 was that of Oscar F. Potter.

[3] From a copy of a letter by Matt Hastings, St. Louis, December 13, 1902, that accompanied the picture when the present owner acquired it.

[4] "A Pioneer Painter," *American Illustrated Methodist Magazine,* Vol. VIII (October, 1902), 77.

The year 1849 was a productive one. By mid-April Bingham was showing in St. Louis three more of "his peculiar line of Western characters." One, reported the *Republican* (April 17, 1849) "is a scene in a bar-room in which the group is most perfect and life-like. The jolly old landlord, smoking his pipe; a politician, most earnestly discussing to a very indifferent listening farmer, the Wilmot Proviso; whilst a boy, with his coat-tail turned up to the stove, is reading a show-bill." The second was "a picture drawn from our own wharf, in which he has introduced a true and life-speaking description of some of the scenes which may be daily witnessed there." The third portrayed a woodyard. It was a scene on the Missouri: "the owner of the wood yard and his laborers, are awaiting the arrival of a boat, and their anxiety to make a sale of their wood is strikingly delineated."

On April 30, Bingham, headed for New York, arrived in Cincinnati, where he exhibited at the Western Art-Union the three pictures just described, with two others entitled *Landscape* and *Portrait*.[5] In the June catalogue of that Art-Union, *Landscape* was announced as owned by Joseph Longworth; *Portrait* was the property of the artist. *Wood Yard on the Missouri* he now sold to the Western Art-Union; in the December distribution it went to Miss E. E. Reynolds of Lafayette, Indiana, and became lost to the record.[6] The October publication of the Western Art-Union, however, fortunately gave a full description of the composition: "This elaborate picture [25″ x 30″] is one of those scenes peculiar to the West, which have stamped Mr. Bingham as an artist of the first order. . . . In this picture a broad stretch of the Missouri is seen, over which hangs that hazy atmosphere peculiar to it. In the foreground is a woodyard. Two men have discovered a boat in the distance, and are watching for the signal indicating that wood is wanted; a third lounges on the bank with his feet hanging over the water, smoking his pipe. The accessories of the wood piles, axes, whisky jug, &c., go to make up a scene that cannot be mistaken by any one who has travelled on the Western Waters." These details make certain that this cannot be the painting from which the Winterthur canvas was copied, nor can it be that now in the City Art Museum of St. Louis, similar as the com-

[5] Cincinnati *Gazette*, May 1, 1849.

[6] A Bingham painting entitled *Wood Station on the Mississippi*, owned by Alexander White and shown at the Chicago Exhibition of Fine Arts in 1859, was probably the 1849 *Wood Yard*.

position must have been to *The Wood Boat*, for, again, the details of the smoker with his feet hanging over the water and of the axes are not in the latter painting.[7]

Probably later in the year (since they were not mentioned at St. Louis in April or at Cincinnati in May) Bingham sent other pictures to Cincinnati, for in the year-end distribution three more of his works were listed. Description of two of them remind us of D'Hondecoeter's farmyard scenes: *Feeding Time* (29"x36") pictured "Horses tied in a Stable. A man mixing feed. Another asleep in the door way. Chickens &c. in the foreground." *Cock and Hen* (14" x 16") presented "admirable portraits of two game chickens." *Landscape with Cattle* (29"x36") was described as "a large and beautiful specimen of this artist's landscapes." The first notice of all three is in the *Records of the Western Art-Union* for October.[8]

Bingham may have stayed in Cincinnati but a few days. By June he was settled in New York in a studio at 114½ Grand Street, where he expected to paint for several months and where his portfolio of sketches would be open to the inspection of "those amateurs who may call upon him." On July 2, he offered to the American Art-Union, by letter, a picture not previously mentioned this year, possibly begun at Cincinnati and finished at New York.[9] In setting a price of $350 for *Raftmen on the Ohio* (36"x39") Bingham wrote "I am governed by the sum which I received for the 'raftmen at cards' $300.00—The present picture required the same amount of labour in design—and is in my judgement in advance of the former in point of colour." The minutes of the Executive Committee for the same day show that the purchase was authorized at $350 without frame. The Art-Union catalogue described the composition: "A man seated on a box is telling a story to three others, as they are 'floating down the Ohio.' In the foreground on the raft are packs of shingles, boards, &c."[10] Almost certainly in this lost painting Bingham used

[7] *Record of the Western Art-Union*, I, No. 2 (June, 1849), No. 5 (October, 1849); *Transactions of the Western Art-Union for 1849*.

[8] See also the *Record* for November and the *Transactions for 1849*.

[9] According to the Art-Union's Register of Works of Art, 1849–51, the picture had been received on June 30.

[10] In 1849 the American Art-Union began publishing brief descriptions as well as stating sizes of pictures in the monthly *Bulletin* and in the *Transactions*—these have been reprinted in Cowdrey, *American Art-Union Exhibition Records*.

for the narrator the drawing of a man seated on a box or bale gesticulating as he talked (Sketch No. 43). The amused and listening attitudes of Sketches Nos. 44, 45, and 46 suggest that they may have been the other figures in *Raftmen on the Ohio*.

Bingham's relations with the American Art-Union at this time were excellent. "We have a Missouri friend here on a visit, Mr Bingham the painter of the Jolly Flatboatmen," Andrew Warner wrote in mid-July to William P. Curtis, the honorary secretary at St. Louis. "We like him quite as well as a man as we do as a painter." The Art-Union was pleased to have his "clever picture," *Raftmen on the Ohio*, and looked forward to having more works by him soon on exhibition, works which would "attract much attention by the fidelity of their representations of Western life and manners." The Missouri artist was interviewed and praised in the August issue of the *Bulletin*. All of his works that the Art-Union had bought, it declared, had been "thoroughly American in their subjects, and could never have been painted by one who was not perfectly familiar with the scenes they represent. It was this striking nationality of character, combined with considerable power in form and expression, which first interested the Art-Union in these productions." The artist acknowledged that "the assistance of the Society was of material importance" to his development: "if it had not been bestowed, he would never perhaps have attempted that peculiar class of subjects which has given him his reputation. It is pleasant to see that this encouragement was properly bestowed"[11]

On the first day of August, Bingham sent four more paintings around to the Art-Union rooms: *Country Politician* (for which he asked $200), *St. Louis Wharf* ($350), a "group upon the Missouri watching the Cargo of a Wrecked Steamer" ($200), and a small picture, *A Boatman* ($50). The minutes make clear that he was offered and accepted $600 for the lot. The first two he had shown in St. Louis; the others were probably painted in New York.[12]

[11] Warner to Curtis, July 19 and October 26; *Bulletin*, Vol. II, No. 5 (August, 1849) 10–13. In the October *Bulletin* (p. 12) this last statement was reiterated: "Bingham acknowledges his indebtedness to us as the first patron of his higher efforts, and his main-stay in all attempts beyond the line of portraiture."

[12] Among the attractions of the year, Warner wrote to William P. Curtis, October 26, 1849, were "quite a number of Bingham's best pictures some of which he painted here, and all of them Western Scenes."

The thumbnail sketch of *Country Politician* (20″x24″) in the *Transactions for 1849* adds a point or two to the knowledge of the composition of this lost picture already derived from the April 17 story in the *Missouri Republican:* "Three men are seated around a stove, one of whom is arguing some knotty point with an old traveller. Behind the stove a man is standing warming his back with his coatskirts lifted." From the two descriptions it is easy to recognize in Sketch No. 47 the young man warming himself at the stove and lifting his eyes to the show bill on the wall. The "jolly old landlord, smoking his pipe" may well be Sketch No. 48. No. 49 will do aptly for a politician arguing or earnestly discussing a point at issue with such a traveler or "very indifferent listening farmer" as No. 50.[13]

St. Louis Wharf[14] (25″x30″) the *Missouri Republican* had found "a true and life-speaking description" of scenes daily witnessed there. The Art-Union catalogue specifically pointed out that "On the wharf are piles of merchandise, upon which are seated boatmen and travellers; behind are teamsters, and beside the levee is a steam-boat, the 'Kit Carson.'" The teamster with the whip in his hand and the bandage around his head (Sketch No. 51) must have been featured in this lost painting. So, too, the man (No. 52) with his hands upon the shafts of what must be a wheelbarrow although it has not been included in the sketch. The drunk asleep with his head on a bale of goods (No. 53), the man seated on a box reading a newspaper (No. 54), the well-dressed but unkempt traveler sitting on a barrel (No. 55), the ragged old fellow with his rough stick before him, his bottle in his pocket, and his possessions tied up in a handkerchief, awaiting deck passage (No. 56), and the unshaven man lounging on a pile of boxes with a somewhat glazed look on his face (No. 57) are all typical enough of a city water-front scene to find their places in such a painting as *St. Louis Wharf.*

A Boatman (16″x20″) pictured "a figure seated beside a pile of

[13] May Simonds' description of this painting differs so much as almost to suggest another picture: "Bingham further illustrated Missouri . . . by his painting called 'Listening to the Wilmot Proviso.' It is conceived and executed in a smiling humor; and there is a quaint and pleasing delineation of the group of village politicians gathered to listen while one of their number reads to them." ("Missouri History as Illustrated by George C. Bingham," *Mo. Hist. Review,* Vol. I [April, 1907], 190). Had she seen the painting? She did not locate it.

[14] Called *St. Louis Landing* when shown at Cincinnati.

wood, on the banks of the Missouri." I am tempted to identify here the very carefully and completely sketched No. 64, which Bingham certainly used later in *The Wood Boat* and possibly had used in *Wood Yard on the Missouri*.

Watching the Cargo (26″ x 36″), Bingham's only extant painting for 1849, featured "a group of boatmen on the Missouri river, keeping watch over the cargo of a boat which has been wrecked. A box has been opened and its contents spread out to dry." On this excellent canvas (now in the Bingham Collection of the State Historical Society of Missouri) we see the Missouri winding away in the center distance with the steamboat freight piled up to the left on a sandbar (Plate No. 27). The charming river view and the firmly characteristic figures are indeed faithful representations of western life. The original drawings of the man to the left, relaxing with his back against a barrel, and of the older man smoking his pipe (Sketches Nos. 58 and 59) again show the care with which the artist studied his subjects.[15]

Having sold his paintings, Bingham turned homeward. By the close of September he was at work in Liberty, Missouri, on a full-length portrait of Dr. William Jewell, patron of the William Jewell College. He must also have painted about this time the smaller portrait which in 1852 Jewell bequeathed to his grandson—possibly it was a study for the commissioned picture. In October, Bingham was engaged upon "several" portraits in Liberty, but the names of the sitters were not mentioned in the newspaper notice.[16] It was in this winter, Dr. Rusk suggested, that he painted the portrait of Dr. John H. Lathrop, president of the University of Missouri, which was destroyed in the university fire of 1892.[17]

On December 3, Bingham married Eliza Thomas[18] of Columbia. Her father, Robert S. Thomas, who was then a professor in the University of Missouri, was soon to become the first president of William Jewell College.

[15] This picture is signed and dated on the barrelhead: "G. C. Bingham 1849."

[16] Rusk, *Bingham*, 48–49 (citing Columbia *Missouri Statesman*, September 28, 1849); Liberty *Weekly Tribune*, October 5, 1849, and August 27, 1852.

[17] The Jefferson City *Inquirer*, December 28, 1850, reported that Bingham had presented the portrait of Lathrop to "the ladies of Columbia" who in turn were to present it to the university.

[18] Liberty *Weekly Tribune*, December 14, 1849.

During the early months of 1850, Bingham turned again to genre painting. Although he sent nothing to New York in time for the American Art-Union distribution, he did complete at least twelve pictures of western life and landscape. Early in the month of June he had nearly finished

one of those paintings which no one can sketch so well as Bingham. It is said to be of rare conception and most graphically delineated. The painting represents a western scene—*Shooting for the Beef*—and presents a group of characters with life-like fidelity. There are seen the eager marksmen in the attire of the backwoodsman; the log cabin at the cross-roads, with sign above the door lintel, "POST OFFICE GROCERY;" the prize in contest, a fat ox, chained to a stump hard by; a beautiful landscape in prospective, and—but a description is impossible. . . . Every feature on the canvass is instinct with life.[19]

Shooting for the Beef (33½" x 49¼") was on view in St. Louis in October. Originally announced as "painted for George Austen, Esq., of New York, Treasurer of the American Art-Union," it is not clear whether the picture had been done on commission from Austen or at his suggestion for the Art-Union. Bingham took it with him to New York in November. When we next hear of it in January, 1851, it was listed as "the property of the American Art-Union" in the minutes of the Executive Committee on the occasion of its being lent with four other paintings for exhibition at the Gallery of the Reading Library Company in Reading, Pennsylvania.[20] The committee, however, did not pass its resolution authorizing purchase for $350 until March 27. Since the annual distribution of 1851 was forbidden by injunction, the painting was sold in December, 1852, in the auction of works of art belonging to the Art-Union, where it brought $190. *Shooting for the Beef* now hangs in the Brooklyn Museum (Plate No. 28).

In the drawing of western scenes and characters, the *Missouri Republican* pointed out on October 11, 1850, that Bingham had "studied, and transferred to canvas, the persons, attitudes, expression, and all the surrounding circumstances of a Western scene,

[19] *Missouri Republican*, June 4, 1850, drawing on a story in the *Missouri Statesman*. The American Art-Union quoted this in its *Bulletin* for July, 1850 (pp. 64–65).

[20] This permission to exhibit was granted to J. L. Stichter, honorary secretary, on January 18, 1851.

whether on land or water, with a fidelity that embodies everything, and conveys to the mind of the spectator a perfect comprehension of the scene." In *Shooting for the Beef* he had accomplished "a most perfect representation of a very frequent amusement in the West." This praise is amply justified by the painting. No other of his works is more typical of Bingham in brilliance of color, in firmness of drawing, in naturalness and ease of composition; none is more successful in catching the commonplaceness and the uniqueness of life on the Missouri than *Shooting for the Beef*. Three of the original sketches found in the Mercantile Library collection confirm the care with which he worked. The large man thrusting the ramrod down the long barrel of his rifle while he watches the marksman about to fire (Sketch No. 60), the old man in the background leaning on his stick (No. 61), and the young man standing farthest from the group, with his rifle by his side (No. 62) are at the same time typical and absolutely individual. Such sketches are fidelity itself.

With *Shooting for the Beef* five other Binghams were exhibited at Jones's store in St. Louis in October, 1850.[21] One of these was called *The Squatter's Settlement*, later known as *The Squatters* (25″ x 30″). It featured "a family [which] has built its log cabin in the midst of a clearing, and commenced housekeeping." In offering it to the American Art-Union, the artist wrote (November 18, 1850):

The Squatters as a class, are not fond of the toil of agriculture, but erect their rude Cabins upon those remote portions of the National domain, where the abundant game supplies their phisical wants. When this source of subsistance becomes diminished, in consequence of increasing settlements around, they usually sell out their slight improvement, with their *"preemption title"* to the land, and again follow the receding footsteps of Savage.

He asked $200; after first declining the picture, the Art-Union on March 20, 1851, bought it for $125 framed. In the sale of 1852 it went for $85. Recently discovered in a private collection, it was published for the first time in the *Art Quarterly* in the spring of 1956.[22]

21 *Missouri Republican,* October 11, 1850. The description that follows is from the Art-Union catalogue.

22 McDermott, "Another Bingham Found: 'The Squatters,' " *The Art Quarterly,* Vol. XIX (Spring, 1956), 68–71.

In this long-lost painting (Plate No. 29), we see to the left a portion of a rough log cabin (the logs do not appear to be hewn); on the roof over the door are fixed the antlers of a deer. In front of the door a woman bends over a washtub; some of her wash hangs on a line that disappears to the left. A cauldron over a fire stands mid-distance in the picture with two boys sitting or lying on the ground near it. In the right distance we get a glimpse of the Missouri with its misty bluffs. The foreground is occupied by three principal figures. The squatter, an able-bodied but quite relaxed figure, is seated on a log with his right side and nearly full face turned toward us, his right foot on the log and his left on the ground behind it. Sketch No. 63 shows a similar, but not identical figure; the main body lines are the same, except that the man in the drawing is sitting on the ground. This slight difference in position and the change in the face suggest that No. 63 may have been used in another picture and altered for this new occasion. Such change is also to be observed in the standing figure of the old man leaning on the stick. This is the same old "sitter" used in *Shooting for the Beef* (Sketch No. 61): in place of the cap the artist has covered his head with a broad-brimmed dark hat, the pipe has been removed, and the stick on which he is leaning has been lengthened until it is nearly shoulder high. Pose of figure and detail of costume remain the same. Either Bingham had a now-lost second sketch of the figure in *The Squatters* or he altered No. 61; the different position of the forearms suggests another drawing. Although the pose is similar in the two paintings, the effect is different and original in each. The third principal figure in *The Squatters* is the dog in center position with the sunlight streaming down on him.

The third picture in this October showing was *The Wood Boat* (25″ x 30″), which presented, the *Missouri Republican* reported

a flat loaded with wood, its crew, master, &c., &c., laid up to the shore, preparatory for market. Here, again, the painter has combined, with the accuracy of scenery, boat, loading, &c., the distinctive peculiarity of dress, position, countenance and expression of the men engaged in this important branch of commerce. The master, leisurely smoking his pipe, is a fac simile of men of that pursuit who are frequently met with.

Of this painting Bingham himself wrote that "The 'Wood Boat' is a group such as the traveller daily sees upon the navigable waters of the west. The wood for sale is conveniently placed in a flat boat, while the hearty *choppers* await a purchaser in some approaching steamer."[23] The artist's price of $200 was declined, but the Art-Union did buy *The Wood Boat* on March 20, 1851, for $125 framed. It was duly listed in the 1851 catalogue and in the 1852 auction list, but there is no record of its sale. Lost for a century, it was acquired in 1951 by the City Art Museum of St. Louis.

The Wood Boat (Plate No. 30), was another version of the subject treated in *Wood Yard on the Missouri* and possibly a good deal like it in composition, but quite different from the wood boat scene in *Boatmen on the Missouri*. In *The Wood Boat*, to the right, sitting with his back against rocks, smoking his long pipe and looking thoughtfully forward, is the master so admirably drawn in Sketch No. 64. In the original study the right foot is missing (a booted foot is sketched separately beneath the figure), and a cane shows partially where it rests between the legs. Transferred to canvas, the figure is identical except for the kind of modifications the painter often made: the foot is in place, the cane is missing, a bit more of shirt front shows, a few more puckers are seen in the shoulder seam of his coat, the face is somewhat younger and its expression is one of faintly smiling anticipation rather than stern thoughtfulness. Near the older man stands a very tall young man resting his weight with nonchalant grace on a pole that reaches almost to the top of the canvas, a figure superbly managed in the painting and in the drawing (Sketch No. 65). The third principal figure is a boy originally sketched sitting on a bench (No. 66). Behind these three apparently sitting on the piled wood at the farther end of the boat, is a partially seen figure of a man fishing. Standing on a coat thrown down on the wood is the inevitable whiskey jug. To the left the river recedes quietly into the distance with the bluffs providing the background for the larger part of the composition. *The Wood Boat* remains one of Bingham's most vivid portrayals of river life.

23 Bingham to the American Art-Union, New York, November 19, 1850. The Art-Union catalogue description reads: "The boat is drawn up to the shore. The boatmen are resting themselves on the banks."

Three other pictures were mentioned in the *Missouri Republican* on October 11. One of these was a Landscape, "from nature," which was purchased "by one of the most distinguished of our St. Louis Artists, and will hereafter grace his private mansion." No details of composition or size were given. The guess may be hazarded that Manuel J. De França was the purchaser. Bingham could have first met the Portuguese-born portrait painter during his first visit to Philadelphia in 1838; in St. Louis, where De França moved about 1844, they had become well acquainted. It was probably this painting that in 1859 De França exhibited at the Fourth Annual Fair of the St. Louis Agricultural and Mechanical Association under the title of *Landscape with Cattle.* In 1864, he donated to the Mississippi Valley Sanitary Fair for sale an undescribed landscape by Bingham.[24]

The fifth of these paintings on show, said the *Republican,* was "a small gem, an agricultural scene, taken from nature." It was probably the "small picture Cattle and Landscape" which on November 19, 1850, in New York, Bingham offered to the Art-Union for $50 without frame. This may be one of two paintings, both[25] entitled *Cattle Piece,* entered in the Register of Works of Art of the Art-Union on February 1, 1851, with an asking price of $50 for each; both, however, were declined and were returned to the artist on February 28. It is not possible to identify this "small gem."

The Checker Players (25" x 30"), last of the group, was then an unfinished piece representing "a game of 'drafts,' or 'checkers,' in a country tavern. In this the force and power of the artist, in catching and portraying the position and expression, is finely developed."[26] Bingham must have finished the painting in New York in November or December.[27] For it he asked $200 on February 1, 1851, but it was declined. The picture remained on his hands for some time. It was on view at his studio in Columbia, Missouri, in October, 1851, and at his studio in St. Louis the following month; for some odd reason it was now being referred to as *The Chess Players.*[28] At the Fourth

[24] The Sanitary Commission was the Civil War equivalent of the Red Cross. The 1864 fair at St. Louis netted $554,591.

[25] This may have been an accidental repetition of entry.

[26] *Missouri Republican,* October 11, 1850.

[27] "The pictures I painted last year are all sold with the exception of the Checker players" (Bingham to Rollins, New York, March 30, 1851, in "Letters," *Mo. Hist. Review,* Vol. XXXII, p. 21.

Annual Fair of the St. Louis Agricultural and Mechanical Association in September, 1859, it was exhibited as *The Game of Draughts*, still the possession of the painter. Under the title *Chequer Players*, it turned up once more at the Mississippi Valley Sanitary Fair in 1864 as the property of N. J. Eaton of St. Louis. Nothing more is known of its travels until it was bought by the Detroit Institute of Arts in 1951, where it hangs today (Plate No. 31).

E. P. Richardson has pointed out that this picture is in a "class of one" in Bingham's work. Perhaps its difference from his other paintings explains why he was so long selling it, but that very difference heightens our interest in this excellently managed and unique piece. This is not his usual balancing of figures and landscape:

> In the *Checker Players* the simple compact group of three persons is seen so close to the picture plane that the figures dominate the space. . . . in attempting a new kind of figure composition he met a new problem; figures on this scale, if they are to satisfy us, must be given a greater degree of individuality and psychological relationship than is required by ordinary genre figures. . . . here he attempted a picture in which the whole point, upon which the picture must stand or fall, was in the tying of the psychological knot. It must be said that he succeeded. The interweaving of three lives in a moment of pleasurable suspense, as Old-Rough-and-Ready puts his finger on his piece and prepares to move, and David Harum across the board, and the tavern-keeper leaning on the bar, watch him, is a moment of life created in a remarkably convincing way.[29]

One more painting, not mentioned in the newspaper accounts, went to the American Art-Union. An entry in the Register of Works of Art shows that Bingham offered on December 13 a *Cattle Piece* for $100, which was purchased on February 20 following for $75. This must have been the *Cattle Piece* (26″ x 36″) listed in the 1851 catalogues, described as showing "oxen and cows feeding in a meadow," and sold in the 1852 auction to a person named Hood for the sum of $60.

There are on record five more titles for 1850. In the distribution of the Western Art-Union at Cincinnati early in January, 1851, a

[28] Columbia *Missouri Statesman*, October 31, 1851; St. Louis *Evening Intelligencer*, November 3, 1851; Jefferson City *Inquirer*, November 15, 1851.
[29] " 'The Checker Players' by George Caleb Bingham," *The Art Quarterly*, Vol. XV (Autumn, 1952), 252–56.

Cattle Piece (*not* one of those shown to the American Art-Union, for they were then still unrejected in New York) went to Dr. A. T. McClure of Cincinnati and a *Landscape* to Harvey Fowler of Indianapolis. Nothing more is known of these pictures.[30]

Three other pieces went to Philadelphia. Bingham wrote to Rollins from New York on March 30, 1851: "I sent three pictures to Philadelphia this winter, two of them sold very readily, the other not being a well selected subject I expect to keep."[31] All three were exhibited at the gallery of the Philadelphia Art-Union for sale. *Cattle at Daybreak—Stable Scene* (also called *Daybreak in a Stable*) was chosen by Joseph Weir, who had won a $40 ticket in the drawing for 1850 and added $10 to make up the artist's price. A second entitled *Landscape and Cattle* (such originality in titles painters show!), valued at $60 by the artist, was chosen by A. Coates of Philadelphia. *Mississippi Boatman* was the unwanted picture; offered at this time for $60, it still had found no takers a year later. There is no further record of any of these pictures.[32]

Throughout the winter Bingham kept at his easel in New York. Probably the first painting completed in 1851 was *In a Quandary*, a second version of the 1847 *Raftmen Playing Cards. In a Quandary* (17″ x 21″), signed and dated in the lower left corner "G. C. Bingham 1851," was certainly finished before the close of March, for on the thirtieth he wrote to Rollins from New York: "One of my recent pictures of life upon the Mississippi will be engraved this year in Paris by Goupil and Co." The identity of the painting becomes clear when, fifteen months later (June 27, 1852), he reported to his friend: "My picture of the 'Raft-men at Cards,' published by Goupil & Co. and '*dedicated to Maj. J. S. Rollins of Missouri*,' is now out, and is far superior to the 'Jolly flatboatmen.' I have reserved a fine proof

[30] *Transactions of the Western Art-Union for 1850.*

[31] "Letters," *Mo. Hist. Review*, Vol. XXXII, p. 21.

[32] *Philadelphia Art-Union Reporter*, January, February, December, 1851; January, 1852. The description of the third picture ("presented by the artist to the Art-Union of Philadelphia") as given in the *Catalogue of Prizes to be Distributed on December 31, 1852*, makes it appear to be another version of the *Boatman* sold to the American Art-Union in 1849. It reads: "an Old Man smoking his morning pipe, at the Riverside." Was it possibly this picture that James Yeatman of St. Louis exhibited in 1871 at the St. Louis Mercantile Library with the title *The Flatboatman?*

copy for you."[33] Whether the painting ever returned to Bingham's hands after being engraved, when or to whom it was sold is not of record; of its subsequent history nothing is known until it is found in the Francis P. Garvan Collection, whence it was acquired by the present owner.

In a Quandary (Plate No. 32), differs in a number of respects from the earlier painting of this subject. Two of the figures have been removed, the props shifted, and the composition group brought forward. The man with the sore foot is no longer contemplating his troubles, and the man handling the setting pole has abandoned his post to become one of the onlookers of the card play, replacing the man who had been standing behind and between the players. The box or case on the left, on which the whiskey jug stands in *Raftmen,* has been shifted to the right and the space on the left has been filled with packages of shingles dumped carelessly down. The background has changed slightly as if the raft has moved a bit farther downstream, and in the right distance a flatboat or ark, on which three men are handling sweeps and steering oar, is drifting into view. The two card players have been used again without change, but the barefooted prompter on the right stands a little closer to the puzzled player and has been given a mustache and goatee which make him appear a much older man. Standing behind the players and leaning on his setting pole, the second onlooker is crowned with the battered and broken remains of a once fine beaver dress hat (Sketch No. 67). By these changes the story effect of the picture is increased, but something of the perfect realization of the moment achieved in *Raftmen Playing Cards* is lost in the later painting. It was appropriate to emphasize this difference in the caption *In a Quandary* in contrast to the title of the earlier painting *Raftmen Playing Cards.* One is skillful anecdote, the other true genre.

Fishing on the Mississippi (29″ x 36″) was probably finished by the end of February, for on March 20 it was bought by the American Art-Union for $100 framed. In this picture (which is signed and dated

[33] "Letters," *Mo. Hist. Review*, Vol. XXXII, pp. 21, 26. That the engraving was out earlier in June is implied in a notice in the Baltimore *American* (June 18, 1852) which, calling attention to *County Election* then on display, added that "among his pictures most prominently before the public, are 'The Jolly Flatboat men,' and 'In a Quandary,' a card-playing scene also on a flatboat."

1851) the October *Bulletin* of the Art-Union informed members, "Three men are stationed on the rocks to the left, engaged in this sport. A flat-boat is coming down the stream." It was sold for $155 in the 1852 auction and does not afterward appear in the record until its acquisition a few years ago by the William Rockhill Nelson Gallery of Art in Kansas City, Missouri (Plate No. 33).

Two of the original drawings for *Fishing on the Mississippi* (sometimes called *Fishing on the Missouri*) are in the Mercantile Library collection. The tall man, whose fishing pole in the painting is nearly twice as tall as he, is sketched with Bingham's customary simplicity and force, though it is not apparent in No. 68 that the pole is a fishing rod. This is the figure subject already used as the kibitzer-with-the-pole in *In a Quandary*. Here the weight of the body is differently disposed of and for the beaver top hat an old slouch hat has been substituted. Facial expression, of course, is different. Preservation of the two sketches makes clear that Bingham did not alter the first drawing, but worked from a fresh pose. In No. 69 we see that the lazy man leaning forward on the rock is actually standing on a lower level; his rod is wedged in a crevice in the rock—why hold it until he has a nibble? In the brilliance of its sunshine this is a river scene different from most of Bingham's.

The Art-Union records for May show that a picture called *Dug Out* was purchased for $125 framed (the artist's price). This was *The Trappers' Return* (26" x 36"), announced in the October *Bulletin* —"Two figures are descending the river in a dugout, at the bows of which is a bear chained"—and sold in December, 1852, for $155 (Plate No. 34). Rediscovered in 1950, it was acquired by the Detroit Institute of Arts.[34] It is nearly identical with *Fur Traders Descending the Missouri* painted six years earlier and nearly as fine a painting. The artist has made a number of minor changes. The costumes are not quite as gay: the stripes are taken from the shirts, but they are still typically brilliant colors. A pack of furs has been removed from the bow end and consequently the canoe sits a little higher out of the water. The slant of the boy's body and the position of his right forearm have been altered and his head is no longer directly toward

[34] Richardson, "The Trappers' Return by George Caleb Bingham," *Bulletin of the Detroit Inst. of Arts*, Vol. XXX (1950–51), 81–84.

us. The bear is standing on its four legs, looking indisputably like a
anged to a more rocky shore.
lliant sunlight. The artist has
Bingham 1851." In other de-
we have the feeling that this
in its own right.

y and *The Trappers' Return*
jects suggests that Bingham
d access to the 1845 and 1847
Missouri, however, had be-
of Mobile, Alabama, and the
swell of Albany, New York,
reach. The first, we are told,
s acquisition by the Metro-
the second is unknown until
Berkshire Museum) of Pitts-
ings were not available, the
d kept elaborate sketches of
works? No such cartoons or
h in a number of instances
bust or full-length portraits.

stu

THE POLITICAL SCENE—FAREWELL TO
THE ART-UNION, 1851–1852

The Trappers' Return was the last picture Bingham was to sub-
mit to the Art-Union. Except for one or two night scenes in 1854,
The Jolly Flatboatmen in Port (1857), and *The Jolly Flatboatmen
No. 2* (1878), it was to be the last of his studies of life on the western
rivers. Between *Fishing on the Mississippi* and *The Trappers' Return,*
however, he undertook a different kind of subject. Painters in the
mid-nineteenth century still suffered under the delusion that great-
ness was to be achieved only by undertaking great subjects: the sub-
lime and the historical led many an able painter to waste his time
and talents on works that proved not grand but grandiose. Bingham
fortunately struck upon a subject in which he was in reality painting
his western folk once more and so gave life to a moment of history.

In *The Emigration of Daniel Boone* (sometimes called *Daniel Boone Coming through Cumberland Gap*) he had merely stepped back in time to a frontier world only a generation before that which he had known as a boy. His picture is genre that has been extended into history (Plate No. 35).

He was well on with this canvas by the close of March. "I am now painting the *emigration of Boone* and his family to Kentucky. ... The subject is a popular one in the West, and one which has never yet been painted," he wrote to Rollins in Missouri. At this moment his plans for disposing of the *Boone* were uncertain: he thought of selling it to "one of the Art Unions," he thought of having it engraved "with the expectations of remunerating myself from the sale of the engravings."[1] He must have finished it very soon after writing this letter, for on April 14, he offered the *Boone* to the American Art-Union. After it was declined and returned to him on April 25, he made arrangement with Goupil and Company for its engraving on steel. Details of arrangement are unknown; the *Missouri Republican*, however, on May 13, 1851, reported that Goupil had bought the copyright, the ownership of the painting remaining with the artist.

A year and a half later the print had been completed in Paris, and *The Emigration of Daniel Boone* was once more in Bingham's hands. Touring in October, 1852, with his copy of the *County Election* to get subscriptions for the engraving of that picture then in progress, he was exhibiting the *Boone* as well and was offering as a special inducement to subscribers who would pay in advance for the *Election* print a free two-dollar chance on the Boone, which he valued at $600. "A Friend of Genius," writing to the *Missouri Statesman,* suggested that the "young gentlemen of the university who are members of the Literary Societies" should "all take chances and agree if one wins to give the picture to his Society."[2] There were not, however, sufficient takers. On Christmas Day, the *Missouri Republican* announced to St. Louisans the proposed raffle of the painting, which was then on display at Nathaniel Phillips' art and music store. In view of the popularity of both subject and artist, it is a little sur-

[1] "Letters," *Mo. Hist. Review,* Vol. XXXII, p. 21.
[2] The lucky winner would have the choice of taking the $600 cash, if he preferred. Columbia *Weekly Missouri Sentinel,* October 28, 1852; *Missouri Statesman,* October 29, 1852; Glasgow *Weekly Tribune,* November 11, 1852.

prising to find the *Boone* still on display months later at the store of the "piano forte merchant" and still to be raffled. As late as May 29, 1854, we learn from a letter to Rollins, the raffle had not yet taken place.[3] Never, in fact, did it take place. The painting fades out of the news, but it remained in the hands of Phillips until he gave it to Washington University in 1890.

The *Emigration of Daniel Boone* (36½″ x 50″) as we know it today is a repainted picture. The original, judging from the Goupil reproduction, was an open, sunlit picture featuring the same main group of figures, the three men on foot and the two women mounted with many others winding along behind through a wide gap in the mountains (Plate No. 36). The man in the coonskin cap, striding on Boone's left, and the man fixing his shoe, are from originals in the Mercantile Library collection (Sketches No. 70 and 71).

The principal change has been in the tone of the landscape. In the repainting done in 1852 the gap has been narrowed and, though light is still streaming on the central figures of Boone and the horse, increasing darkness and a rising storm intensify the scene of the mysterious, the sense of something greater and stronger than the everyday matter of emigrants moving to a new part of the country. Bingham now shows for the first time the influence of Cole and others of similar tone among the Hudson River School. "The great rocky cliffs on each side with the mysterious darkness back under their projecting crags, the blasted tree trunks, the lowering clouds darkening parts of the sky emphasize the danger of the undertaking," Dr. Rusk pointed out,[4] "as the calm, serious hero leads his people into a strange and unknown land."

Bingham had been dissatisfied with the *Boone* print—perhaps for the good reason that Goupil had actually made a lithograph and not the expected engraving! In the fall of 1853, the painter wrote to Rollins that Goupil was "anxious to publish another superior and more costly engraving from the Emigration of Boone, provided he

[3] "Letters," *Mo. Hist. Review*, Vol. XXXII, p. 29; St. Louis *Daily Evening News*, June 1, 1853; Columbia *Missouri Statesman*, June 17, 1853; "Letters," *Mo. Hist. Review*, Vol. XXXII, pp. 165, 185. On May 29 he wrote: "I have Philip's note for the picture and whether it shall be raffled or not. I expect to get possession of it when I reach St. Louis."

[4] *Bingham*, 51.

can obtain, upon reasonable terms, the use of the picture for that purpose."[5] Later he declared, "The mistake in reference to the engraving of the Boone picture, resulted from the want of proper information. I had a mere verbal understanding with the agent of the firm, who sent them no specific instructions. As soon as they can obtain the picture again, they will engrave a large steel plate from it in the style first contemplated by me."[6] No record exists of the proposed second engraving—probably it was never made.

On the disposal of *The Trappers' Return* to the Art-Union and the delivery of *The Emigration of Boone* to the New York agent of Goupil and Company, Bingham and his wife returned to Missouri. After a few days in St. Louis they went to Boonville and then to Columbia, where Bingham opened a studio and settled down to portraiture.[7] Although he expected "to be thus employed for some time," he was soon engaged in other genre work. In fact, he told Colonel Warner that he might be able to send the American Art-Union "two or three small pictures this fall."[8] What subjects he had in mind no one knows. It is certain, however, that they were *not* the "several new and exquisitely executed oil paintings" that the *Missouri Statesman* saw in his studio in October. One of the latter was *County Election,* to which I shall soon return. "There was also in this studio a smaller painting, another political scene of great originality of conception and beauty of finish, to wit: *Candidate Electioneering.* We likewise examined the *Chess Players* [*The Checker Players*], and a very beautiful landscape *Scene on the Ohio.*"[9]

Scene on the Ohio near Cincinnati, the landscape to which the *Missouri Statesman* first called attention on October 31, is another lost painting; not even its disposal is of record. Fortunately, we

[5] "Letters," *Mo. Hist. Review,* Vol. XXXII, p. 165.

[6] *Ibid.,* pp. 184–85.

[7] They reached St. Louis May 12 (*Missouri Republican,* May 13, 1851). "We went immediately to Boonville to get our dear little Clara, we concluded to leave Horace there during the summer, as he was going to school and the Dr. and Mrs. Hutchison insisted so much on his remaining" (Eliza Bingham, Columbia, May 25, 1851, to Amanda Barnes). Mrs. Mary Bingham, the painter's mother, had died sometime before the date of this letter.

[8] Bingham to Warner, Columbia, June 29, 1851.

[9] *Missouri Statesman,* October 31, 1851; reprinted in Jefferson City *Inquirer,* November 15, 1851.

know the detail of the composition, for Bingham carried it with other paintings to St. Louis in November, and a woodcut was made from it by G. A. Bauer for publication in the January, 1852, number of the *Western Journal and Civilian* (Plate No. 37).[10] The scene was five miles above Cincinnati. The *Western Journal,* praising the engraver's work, pointed out that:

The leaves in the foreground are represented with an elaborate minuteness, the foliage of the trees is so delicate and natural that it almost seems waving before our eyes, the life-like hunter is moving along through the underbrush, the smooth sward gives a charming view before the door of his home, and though the hue of the water may be whiter than the original, the bluff in the distance too bleak, and some points too sharply defined, there is a graceful proportion in the perspective, and the clouds seem floating on a flood of light. This we consider a fair representation of the general character of the "Beautiful River." The painting was made from a sketch taken on the spot by the distinguished *Bingham* whose faithful genius is above our praise.

From this description and from the woodcut it is clear that the picture of the similar title now in the library of the State Historical Society of Missouri is not the one copied by Bauer.

Candidate Electioneering—better known today as *Canvassing for a Vote* (25⅛″ x 30⁹⁄₁₆″)—he had engaged to paint for Goupil and Company during this summer (Plate No. 38). "Publication by such a firm will be calculated to extend my reputation, and enhance the value of my future works," he had written to Rollins from New York on March 30, 1851.[11] He carried the unfinished painting, begun in New York, to St. Louis in November, but portraiture and *County Election* had, he wrote to Goupil and Company on January 31, 1852, "caused me to delay the Completion of your picture, the 'Canvassing for Votes'. I hope, however, that I will be able to forward it to you shortly, and that you will find it much improved by *time,* and the additional touches it has received since you saw it."

"Shortly" lengthened out into months. Probably Bingham carried the picture with him when he went in June to the national Whig convention at Baltimore. The next positive word of it is found in the

10 Vol. VII (November, 1851; January, 1852), 218, 289.
11 "Letters," *Mo. Hist. Review,* Vol. XXXII, p. 21.

New York *Mirror* in September, where the writer described it as "a small cabinet piece of some four or five figures, forming an out-of-door group, which is composed of the candidate or his friend electioneering for him, endeavoring to circumvent an honest old countryman, who has by his side a shrewd old fellow, who cannot be readily taken in."[12] We must assume that the picture at last was on its way to Paris, for the lithograph by Regnier was published in 1835. The painting itself disappeared entirely from the record. Nothing more was heard or seen of it until 102 years after its completion it was acquired by the William Rockhill Nelson Gallery of Art, where, beautifully restored, it hangs today.[13] Differences between the lithograph and *Canvassing for a Vote* are minor: the hotel sign is altered, center background foliage in the painting is not so prominent, the stonework of the building is not identical, the waiting horse in the litho has shifted his position slightly, and the group of men has been brought forward.

Three of the figures are represented in the Mercantile Library collection. The voter being subjected to persuasion (Sketch No. 72) Bingham made a rather younger man in the painting. The other sketches are like but not identical with the figures in *Canvassing for a Vote*. The middle figure (the landlord of the hotel) in pose is certainly the same as Sketch No. 48, whom I have suggested for the landlord in *Country Politician;* since he is now outdoors, Bingham has put a hat on his head; he has also shifted the pipe to the left hand and the gaze in that direction, too. The candidate is likewise the man in Sketch No. 49 whom I have chosen as the talkative country politician himself; he now has on a hat and has a bag by the side of his chair. There are also slight differences in the position of the chair and the portions of it showing. All these little differences suggest that Bingham almost certainly had two more variant sketches showing these persons as they appear in *Canvassing for a Vote*.

Belated Wayfarers (25″ x 30″), depicting two men asleep before a campfire in a forest, is signed and dated 1852, but there is no contemporary reference to confirm this date (Plate No. 39). Very

[12] Reprinted in the *Missouri Statesman*, September 10, 1852; here quoted from Rusk, *Bingham*, 54.

[13] This painting, signed and dated 1852, was first published by Ross Taggart in *The Art Quarterly*, Vol. XVIII (Autumn, 1955).

much in the style of *Captured by Indians*, it was almost certainly painted at the same time as that canvas, and the dates now on them (1848 and 1852) are quite possibly both incorrect. For a century these two little pictures have passed as companion pieces from owner to owner in St. Louis. In 1859, Charles Derby of St. Louis exhibited *Belated Wayfarers* at the Agricultural and Mechanical Fair under the title *In Camp*. It was later owned by a Mr. Pearce, next by J. J. Conroy. In 1902 it was in the possession of Mrs. Conroy, according to the Matt Hastings letter of December 13, 1902, already quoted, where it was called *The Halt in the Forest* and was said to represent "two lone travellers sitting near a camp fire." Miss Simonds knew it as *Emigrants Resting at Night* and referred to it as a "firelight scene." McCaughen and Burr, St. Louis art dealers, acquired it with *Captured by Indians* in 1917, and from them these pictures passed to their present owner.

It will be convenient before turning to the election series, to sum up Bingham's relations with the American Art-Union. In 1849 he had readily acknowledged the importance of the "assistance" of that organization in his attempting "that peculiar class of subjects which has given him his reputation." But as time passed he began to feel dissatisfaction, partly perhaps because some of his pictures were declined, partly because, he wrote to Rollins on March 30, 1851, "I have discovered since I have been here that the present managers of the Art Union display in some cases gross favoritism in the purchase of their pictures, and in my transactions with them hereafter, I shall act as if I were dealing with a Jew."[14] Perhaps he had been upset by discovering that the Art-Union had paid Henry Peters Gray $2,000 for his *Wages of War* and *Apple of Discord*, whereas Bingham had received only $350 for *Shooting for the Beef*. However irritated he had become, he was in the summer of 1851 still contemplating sending on more pictures.

The break came abruptly early in 1852. "I have perceived marks of decided hostility towards myself, in a recent number of the American Art Union Bulletin," he wrote to Goupil and Company on January 31, 1852. "If I am not mistaken, the sins of the institution of

[14] "Letters," *Mo. Hist. Review,* Vol. XXXII, p. 21.

which it is the organ, have accumulated to such an extent, as to render its speedy dissolution inevitable, unless prevented by a timely reformation." That same day he dashed off a sharp letter to Colonel Warner demanding to know whether "the Columns of the Bulletin" would be at his service for an answer to a paragraph in a leading article "which a due regard for my professional reputation impels me to controvert."

What aroused the indignation of Bingham was an article in the December *Bulletin* by a writer signing himself "W.," who, discussing "the development of nationality in American art," declared "Mount is the only one of our figure painters who has thoroughly succeeded in delineating American life. . . . Bingham has made some good studies of western character, but so entirely undisciplined yet mannered, and often mean in subject, and showing such want of earnestness in repetitions of the same faces, that they are hardly entitled to rank." Warner gave Bingham a soft answer, saying that he had not seen the article in question until he read the Missourian's letter and pointing out that it had not been written by the editor, but was a communication. He then offered space in the April issue (generally the largest circulation of the year), but by the time Bingham received this letter he had changed his mind and replied that he had determined to sue the Art-Union:

Upon subsequent reflection, however, I became convinced that the attack upon my works, so uncalled for, unprovoked and unsustained by the slightest evidence, should justly subject those who are responsible for its appearance in the Bulletin to a prosecution for damages; And I have already written to New York to engage the Services of an Attorney for that purpose.

Ardently desiring the advance of Art, I have been a sincere friend of the Art Union, but when its instruments are perverted from their proper office; and used to inflict upon me a wanton injury, I know no paramount consideration which should deter me from pursuing such mode of redress as I may deem most effectual.[15]

Of this suit nothing more is known. Probably the court order dissolving the American Art-Union as a lottery left nothing to sue.

[15] Bingham to Warner, St. Louis, January 31 and March 1, 1852. See also McDermott, "George Caleb Bingham and the American Art-Union," *New-York Hist. Soc. Quart.*, Vol. XLII (January, 1958), 60–69.

10. THE POLITICAL SCENE: COUNTY ELECTION, 1851–1854

Without doubt it was working on that masterly study of one facet of the political scene, *Canvassing for a Vote,* that stirred Bingham to undertake *County Election* (49″ x 63″), that made him rush from an electioneering to an election itself. We have seen how the new subject delayed completion of the picture begun in New York for Goupil. By midsummer, in Missouri, Bingham had put *Canvassing for a Vote* aside to work energetically on his best-known picture.

It must be noted in passing that elections in Missouri in the mid-nineteenth century were not conducted as they are today. The ballot was not secret, precinct workers were not kept at a distance from the polls, and the voting lasted for three days. Elections were held viva voce, and a man could vote in any township in the county, but he had to swear that he had not and would not vote elsewhere. The voting scene, consequently, was far richer in variety of incident and character than it is in our time. This richness Bingham was to exploit fully.

The Columbia *Missouri Statesman* on October 31, 1851, was enthusiastic in its first report of "the day of election," a picture "composed of upwards of sixty figures," on which the artist had been engaged "constantly for three months." Though not finished, the whole composition was then clearly laid out:

Prominently on the right, on the main street of a western village, we have the place of voting, the court house, in the porch of which the clerks and judges are assembled—one of the judges a thick pursy looking citizen, being engaged in swearing a voter, a well-set Irishman in a red flannel shirt. Near by a political striker, distributer of tickets, *very* politely tendering his services in that regard to an approaching voter. Around and in front is the crowd, composed of many large and prominent figures—some engaged in earnest conversation, some drinking at a cake and liquor stand, some smoking, and some hearing a paragraph read from a newspaper.[1]

Intending to devote much of his time in the coming winter to portraiture in St. Louis, Bingham carried with him the genre and landscape paintings on which he was working. "The Mis-

[1] Reprinted in the St. Louis *Evening Intelligencer,* November 3; in the *Missouri Republican,* November 4; and the Jefferson City *Inquirer,* November 15.

souri Artist, George Bingham, has arrived in our city," announced the *Missouri Republican* on November 12, "and we are gratified to say, intends to remain with us this winter. He has taken rooms in Blow's buildings opposite the Court House. We do not know what crochets of Western scenery and peculiarities he may have in his head, which he intends to work at during the winter, but we will answer that he has some thing novel. He has now an incomplete, but very expressive picture, 'the last day of the election.' "

Before Christmas the *Evening Intelligencer* "called in at the studio of our old friend," and found him "engaged principally in portrait painting. . . . We saw the unfinished portraits of several ladies [Mrs. John Darby (Plate No. 40) may have been one] and gentlemen, residents of St. Louis, which could not be surpassed for fidelity of feature, and expression. That of a distinguished State Judicial officer is remarkable for conveying an impression of *identity* rather than of mere resemblance. The old Judge himself is there, with his benevolent and intellectual face, looking as much at home in a gilt frame as if he had never been any where else."[2] The election canvas was even then not finished, but the writer was struck by the fact that

whoever looks at it seems to recognize at once some old acquaintance in the various groupings, and is disposed to fancy that the portrait was taken from the life. We saw most unmistakeably an old County Court Judge, of the interior, who may invariably be seen on "election day" perched upon the court house fence, discoursing with the learning and authority which are inseparable from high official position, upon the infallibility, and super-excellence of the "dimmicratic" party. There he sits, in the identical place and attitude in Bingham's picture, so true a copy that we are sure, were the original to see it, he would feel insulted at the artist's presumptuous transfer of such unapproachable greatness to vulgar canvass. . . . All who have ever seen a country election in Missouri, are struck with the powerful accumulation of incidents in so small a space, each one of which seems to be a perfect duplication from one of those momentous occasions in real life.[3]

2 "I have been engaged in painting portraits since I came down, and perhaps will be so employed during the greater part of the winter" (Bingham to Rollins, St. Louis, November 24, 1851, in "Letters," *Mo. Hist. Review*, Vol. XXXII, p. 23). The Supreme Court judges at this time were William Scott (1804–1862), John F. Ryland (1797–1873), and Hamilton R. Gamble (1798–1864); all were Boon's Lick country men.

3 Reprinted in the Columbia *Missouri Statesman*, January 9, and in the Jefferson City *Inquirer*, January 17, 1852. County court judges in Missouri were not judicial

The Political Scene: County Election, 1851–1854

Among local visitors to Bingham's studio at this time was Edward Bates, himself in the midst of a long political life. "I was greatly struck with—The last day of the Election—," he wrote in his diary on December 29, 1851. "I saw at once that a single view will not suffice for this picture. To bring to view its many & varied excellencies, it requires to be studied often & for a long time. It is complicated & various in its conception, & its execution seems to be as perfectly & as minutely true to nature, as the design is clear & bold" (Plate No. 41).

Bingham's original sketches illustrate again the care with which he worked to attain this "perfect duplication" of an occasion in real life. Of nearly forty figures so prominently placed as to be recognizable in face or body, at least nineteen are to be found, expressively posed and "minutely true to nature," in the Mercantile Library collection of drawings. The two boys playing mumble-the-peg are there (Nos. 73 and 74), the first being a sketch of Bingham's son Horace. The smiling Negro pouring the cider royal wears a hat and apron in the painting, but he is otherwise reproduced from No. 75. The jovial man holding up his glass for the drink (No. 76) has his left leg no longer out straight, but slightly bent, with the foot flat on the ground. Directly beyond the table, the "sovereign" in the red shirt and blue vest, with his arms stretched out, is from No. 77. In front of him in the painting the drunk about to collapse is exactly that in No. 78. The party worker bodily delivering this vote to the polls, however, is apparently better dressed than in the sketch and has his face turned somewhat anxiously toward the place of voting on the courthouse porch (No. 79 shows these two in a variant pose).

As our gaze moves to the right of the drunken man, we face an

officers, but formed a board of managers for the county. It is always a local sport to identify the characters in such a picture as *County Election*—and a profitless one. Thomas Shackelford, for example, born in 1822 and living on the scene in the Boon's Lick country, in 1901 declared that Bingham "immortalized" his defeat by Sappington "by a painting called the 'County Election.' . . . The man administering the oath in the picture is the likeness of Col. M. M. Marmaduke, brother-in-law of Darwin Sappington, who stands to the left and has his hat off bowing to the voter who is casting his vote for him. The man with the stoop shoulders is O. B. Pearson, trying to convince the voter to vote for his friend Sappington . . . ("Early Recollections of Missouri," 5–6)." It is unlikely that Bingham was doing anything of the sort; certainly in painting *The Stump Orator*, he had particularly stated that he was not introducing local persons. The "recognition" of the county court judge by the St. Louis *Evening Intelligencer* was not intended to be identification of an actual person, but a recognition of the vividness of Bingham's work, his skill in capturing the quality and spirit of the occasion, so that one seems to recognize known persons.

earnest citizen striking his right forefinger emphatically in his open left hand as he talks persuasively (he hopes) to a man in a blue coat whose back is to us; the origin of this pair is seen in No. 80. Next we come to the man in the short jacket with his hands in his pockets and his right foot on the first step as he approaches to cast his vote; in No. 81 he shows a bit of beard which is cut from sight by the brim of his hat in the painting. Coming down the steps after voting is a toothless ancient (No. 82) on the front of whose hat are the proud numerals "76"; in the painting the full figure has not been used, only the head and shoulders are to be seen.

On the steps behind the Irishman taking his oath stands a shirt-sleeved voter to whom the *very* polite striker (No. 83) is offering a card; in the drawing the striker's hat is on his head and his left hand is raised in the manner of a man stopping another, but faintly in one corner is a rough sketch illustrating the position of a hand in the act of raising a top hat just as in the painting. In the rear of the porch an election clerk sharpens a quill pen; he is younger than No. 84, but the position of the hands on the quill, the shape of the coat collar, and other details are identical. The man sitting on the step writing (a newspaperman?) does not have his legs crossed in No. 85, but otherwise he is the same figure. No. 86 is the man looking to see what the representative of the press is writing. Immediately beyond this curious fellow, to our right, we see another voter with strong political opinions talking to an old man who seems a bit quizzical and to a second man with a stern and fixed expression on his face (Nos. 87 and 88).

Edward Bates had expressed in his diary the hope that Bingham would have *County Election* engraved, "for I am persuaded that the multiplication of copies would be sure to spread his fame & fill his pocket." Such thoughts ran freely through the mind of the painter, too. "My '*County Election*' has excited more interest than any of my previous productions," he wrote from St. Louis to Goupil and Company on January 31, 1852,

and my friends, here, propose to raise a Sum which will enable me to publish it, in Superior Style, upon a large Scale. As I would prefer to have the design accomplished, if possible, through your agency, I would be pleased to recieve information as to the probable cost of a plate about 22 by 30

94

inches in Size, containing between 40 and 50 heads and figures, and executed in the best Style of line and Mezzotint. It is my intention, as soon as the picture is entirely completed, to send you a Deguereotype, which will give you a correct idea of the grouping, expression &c.

Plans for the engraving went forward so well that a prospectus appeared in the *Missouri Republican* on March 8, proposing the publication by subscription of an engraving at least twenty-two by thirty-two inches at $10 the copy—the engraving to require two years. The completed picture at this time was on view in the studio between 2:00 and 5:00 P.M. daily. Goupil, however, was not destined to handle the engraving.

Bingham stayed on in St. Louis through the Whig convention in mid-April and then went back to Boonville and Columbia. On June 3, he left for Baltimore as delegate from the Eighth Missouri District to the Whig national convention.[4] "Such a political *tug*," he wrote to Rollins afterwards from Philadelphia, "was perhaps never witnessed before. One would have supposed from the patriotic *talk* of many of the prominent delegates representing the friends of the diferent aspirants for the nomination, that once having settled upon a platform of principles there would have been but little subsequent difficulty. The event however proved that *men* rather than principles, furnished the controling motive to the members of the Convention."[5] Political duties, however, did not occupy all his attention in Baltimore, for he exhibited *County Election* there, with a subscription book open.[6]

At the close of the convention the artist went to Philadelphia, intending to stay for a month, and there he interviewed two engravers about *County Election*. John Sartain made an offer which

[4] Liberty *Weekly Tribune,* April 30, June 18, 1852; *Missouri Statesman,* June 4, 1852.

[5] June 27, 1852 ("Letters," *Mo. Hist. Review,* Vol. XXXII, p. 24).

[6] "We note in the window of Mr. S. Cariss' store, on Baltimore street, a large size original oil painting, executed by Mr. George T. [*sic*] Bingham, an artist who has established a high reputation for his lively delineation of Western scenes.... The picture above alluded to is designed to represent 'A County Election,' and contains a great many figures, among them some of the strange and eccentric characters known as village politicians. The whole picture, which is quite a large one, is full of animation, and will, we think, be considered the artist's *chef d'oeuvre.* We learn it is to be engraved, and that a list is at Mr. Cariss' store for the reception of the names of subscribers" (Baltimore *American,* June 18, 1852).

Bingham was inclined to accept. "He is very ambitious, the painter wrote to Rollins, "and his anxiety to add to his already extended reputation by engraving such a work, has induced him to propose terms far below what I had anticipated, and which he says will merely enable him to live while the work is in progress. He agrees to finish the plate in the best Style of line and Mezzotint for two thousand dollars, twelve hundred to be paid in installments as the work proceeds, and the ballance from the first funds realized from subscriptions. . . . He promises to devote himself to it exclusively." In a postscript Bingham added: "The low price at which Mr. Sartain proposes to engrave my picture, I wish to be kept from the knowledge of the public. $4,000 he says he would charge at the rate he is paid for other works, but will engage upon mine as a work of love." For the needed $1,200 Bingham turned to his ever helpful friend, offering his Arrow Rock property as security. The contract drawn up six weeks later between Bingham and Samuel Sartain (John's son) provided for a steel plate twenty-two inches by thirty, engraved in the line, stipple, and mezzotint manners combined, to be completed fourteen months after delivery of the painting. Bingham signed on August 24 and put *County Election* into Sartain's hands on October 20.[7]

Bingham's plan was to handle the entire business of publication and sale by himself, paying all expenses and taking all profits. It was to work out otherwise—and to his advantage—but one immediate result was the painting of the second *County Election*. He determined to stump the country for subscribers to the print: to be able to show his wares he painted a replica of the picture. The delay in delivering *County Election* to Sartain is probably explained by the fact that he must have been painting the copy. Except for the addition (or elimination) of two figures it was a close duplicate of the first canvas. Immediately on completing it, Bingham must have left Philadelphia, for he was in Columbia, Missouri, before October 28, 1852, exhibiting *County Election No. 2* (Plate No. 42). On that day the *Weekly Missouri Sentinel* pointed out that "The 'County Elec-

[7] Bingham to Rollins, Philadelphia, June 27, 1852; Philadelphia, November 7, 1853 ("Letters," *Mo. Hist. Review*, Vol. XXXII, pp. 24–26, 166). The contract is a manuscript in the Historical Society of Pennsylvania. The *County Election* plate is owned by the Boatmen's Bank of St. Louis; the bank has also a collection of thirteen proofs pulled as the engraving advanced.

tion' is a copy of the *original,* which is now being engraved, on steel, by that eminent Artist, Jno. Sartain, of Philadelphia."[8]

After showing *County Election* and *The Emigration of Daniel Boone* in the grand jury room of the Columbia courthouse for a few days, Bingham moved on to Glasgow and no doubt to other towns in western Missouri. By Christmastime he was in St. Louis, where he remained until March 10, 1853. After "a very close winter's work" painting portraits, he found himself "five hundred dollars the better by it clear of all expenses."[9]

Having completed all his local engagements, he now set out for New Orleans as his own traveling agent for the *Election* print. The *Daily Picayune* supplement for March 18 gave him an encouraging and appreciative notice:

A number of our readers have no doubt already seen in the window of H. D. Hewitt's music store, at No. 39 Camp street, a large oil painting representing an election day in a Western American village, the scene about the polls being the chief feature. It is a copy by the artist of his own original, and is called the "County Election." The picture is an admirable one, as every one will readily believe when we state the painter's name, G. C. Bingham. He is to the Western what Mount is to the Eastern States, as a delineator of national customs and manners.

One no doubt surprising result of this visit to the South was the selling of the replica. Robert J. Ward of Louisville, seeing the picture "by accident," was so taken with it that he offered the artist $1,200—an irresistible offer.[10]

The sale of the painting apparently determined Bingham's next move. Ward carried his prize home to Kentucky, where he permitted it to be exhibited at Hegan's store in Louisville. In mid-May the artist arrived there to take subscriptions.[11] The local press could not have been more enthusiastic. The *Daily Times* (April 6, 1853), on the first showing of the painting, told its readers, "If you wish to

[8] A prospectus for the engraving was published the same day; on the twenty-ninth the *Missouri Statesman* carried a story.

[9] Glasgow *Weekly Times,* November 11, 1852; St. Louis *Missouri Republican,* December 25, 1852; Bingham to Rollins, St. Louis, March 9, 1853 ("Letters," *Mo. Hist. Review,* Vol. XXXII, p. 29).

[10] Louisville *Daily Times,* April 6, 1853. The St. Louis *Evening News,* June 1, 1853, gave the price as $1,000.

[11] Louisville *Daily Times,* May 14, 1853.

enjoy the most delightful treat you have had for years, go take a look
at" *County Election.* Its fifty figures were all "distinctive, and yet
so perfectly natural and life-like in their appearance and features
and expression, as to impress the most uninitiated spectator with the
extraordinary resources of the artist, who was able, with a brush and
a little oil, to so completely mirror nature." Was there ever a painting
so exquisitely life-like? asked the writer:

Those groups of sturdy old farmers who have come to town with a grave
sense of their responsibility as citizens . . . how serious and honest and
sensible they look, as they gravely discuss the affairs of the country, and
the questions of the day! . . . See the scene at the polls—an old man's vote
is challenged and the Sheriff is swearing him on the book, while the Judge
of the election searchingly scans his countenance. . . . The clerk takes
advantage of this interruption to mend his pen, and you can see his brow
and pupil most naturally contracted to the nib of his quill. That very com-
plaisant, officious and lawyer-looking personage, who stands near the
place of voting, and is incessantly smiling, bowing, and shaking hands
with the voters as they come up the steps to the place of voting—you will
know him at once as a candidate by his excessive politeness and his uni-
versal intimacy. . . . There is a group of quiet and intelligent gentlemen
sitting under the eaves of the house, reading the newspaper, and enjoying
an agreeable chat and some amusing anecdotes, while hard by on a log,
an ominous rag, spotted with red-colored stains, encircling a drooping and
"damaged phyzimahogany," and a rent or two in his shirt and trowsers,
tell the sad story of a rash freeman [voter], who, having taken several
"horns," fancied he could "whip his weight in wild-cats," until a sound
drubbing dispelled the flattering illusion. Yonder the friends of one of the
candidates are bringing up on their shoulders a chap whom they have been
treating at the grocery over the way, until his legs would debar him the
exercise of the great franchise, and his memory has to be frequently rein-
forced with the name he must vote for when he reaches the polls. . . . And
there is another rum customer sitting there at the table with a countenance
beaming with the gladness of a full stomach and any number of glorious
"horns."

The *Daily Journal* was quite as responsive to the charms of
Bingham's art. Its writer saw, as anyone who ever attended a county
election must see, "the same bowing and smiling candidate, whose
benevolent countenance" manifests "such a lively interest in the
welfare of each voter . . . the same wise politician whose very nose

says he is not to be imposed on . . . the same individual who is convincing his neighbors that the interests of the world depend upon this particular vote. . . . The houses and the sky are full of the occasion." For its part the *Daily Courier* two days later (May 18) regretted only "that the figures are not made of life size . . . for the subject has the full dignity and interest requisite for a great historical painting."

On May 20, Bingham arrived in Lexington, carrying with him the second *County Election,* which the generous purchaser was permitting him to show for a time. At Louisville he had added thirty-five subscribers to his books. He planned a week's stay in Lexington and, from there, visits to Paris, Richmond, Harrodsburg, Danville, and Frankfort.[12] The Lexington *Kentucky Statesman* on May 24 spoke well of the picture, but in one citizen at least the contemplation of it roused great indignation. A week later "Public Weal" expressed himself vigorously in the columns of the *Statesman.* Whatever praise it might deserve as a "fine painting," there was "another and more elevated view of the subject for the consideration of the public." This painting "supposed to represent correctly our county elections . . . is not only a slander on the present, but places weapons in the hands of the enemies of Republics, to injure them and defame us to the latest ages." This outraged citizen fumed on:

There may be small precincts, in remote parts of some of the States, approaching the view given by this picture; but it is called a County Election, and from the costume of the characters on the ground it is intended for a *slave State.* The Judge, candidates and voters, are a reproach to any precinct or county. For the appearance of the voters, as represented, are miserable loafers; one is placed in a large arm chair, a negro filling his glass, and he too drunk to rise. Even men of sense and refinement sometimes forget what they owe to themselves or their country. . . . Who could believe that a liberal patronage would have been extended to a painting, (which is the most durable of all history,) that defamed one of the most valuable of our political institutions. The paintings of Egypt, Babylon, and Ninevah have lately been found to give information where history failed to do so. It is a mortifying reflection that neither our religious or political institutions remain as pure as when they came from the hands

[12] Bingham to Rollins, Lexington, May 22, July 5, 1853 ("Letters," *Mo. Hist. Review,* Vol. XXXII, p. 30–34).

of the founders of them, but do let the world struggle on in defence of them, with the cheering hope which the bright side affords, and never surrender, as we must do if we believe in such dark views as are given by this picture.

Who so lost to a laudable pride as to desire to have a picture in his possession, or to see it in the possession of others, of a member of his family who was a disgrace to it. . . . There is still a redeeming hope that if this age should be so degenerated as to purchase the engravings from this picture, the next, or some future generation, will not give them a place in the garret much less the parlor; but cast them out on the street or yards, for destruction with other worthless rubbish.

This violent attack probably did Bingham no harm: in the "principal towns in the vicinity of Lexington" he obtained more than one hundred additional subscriptions.[13]

Joined in Kentucky by his wife and daughter Clara in midsummer, Bingham went on to Philadelphia, by way of Cincinnati, early in September. Somewhat distressed by the slow progress Sartain seemed to be making, he could only take comfort in the engraver's assurance that the plate of the *County Election,* as he was completing it, would make eighteen to twenty thousand prints. After a brief visit to New York, where Goupil made him an offer to publish prints after the original subscribers had been satisfied, Bingham returned to Philadelphia for the winter.[14]

During the fall months Sartain was "indefatigably engaged" upon the plate. So far as Bingham could determine without a proof, the engraver was "executing his work in a superb and masterly manner, and I have a strong hope that he will realize his expectations in the production of the best print that has yet been published on this side of the Atlantic." By December 12, he was reconciled to delay in completion of the work. "As in a painting, so in an engraving, there is a great deal to be done in *finishing* which appears, as it were, to *turn up* contrary to the calculations of the artist." Still further delays loomed up as he learned more about the next step of the process:

The *printing* from a plate of such magnitude as the "County Election" I

[13] Bingham to Rollins, Lexington, July 5, 1853 ("Letters," *Mo. Hist. Review,* Vol. XXXII, p. 32).

[14] Bingham to Rollins, Philadelphia, October 3, 1853 ("Letters," *Mo. Hist. Review,* Vol. XXXII, pp. 164–65).

find, upon enquiry, to be a more tedious process than I had anticipated. Not more than twelve or fifteen impressions can be averaged per day. Unlike the ordinary printing press, that of the engraver makes its impressions from the interstices of the plate, and in order that they may be pure and distinct, very careful labor by the hand is required, in removing, without friction, every particle of ink from the surface. Two or three months therefore must be consumed after the plate shall be ready, before the last on my present subscription list can be supplied with prints. The first will be due in St. Louis. As soon as they are ready, I shall set out with them, and have the remainder forwarded as rapidly as possible.

Writing again to Rollins the day after Christmas, Bingham was hopeful of having prints for the first of his subscribers by March, but two or three weeks' illness in January set Sartain back in his work. He was presently hard at the job again, but Bingham noted that "there is a singularity about engravers, from which I find that Mr. Sartain is not exempt. They invariably promise work in less time than it can possibly be performed." The plate was still continuing to "progress" in mid-April, but Bingham was "quite sure that at least two months will yet be needed to give it that perfection which I intend it shall have."[15]

Goupil now made Bingham an offer with which he closed rather quickly. Perhaps his experiences as a print salesman and the long delay over the plate had led him to feel that it would be better for him to "occupy [his] time in *producing* rather than in selling pictures." He now had 804 subscribers on his list, not including 100 more "engaged in Philadelphia." By the contract with the French art dealer he would secure $7.33⅓ upon each of these, and for any other prints that he might thereafter sell, he would get $6.33⅓ each. For each print sold by Goupil he was to receive $3, for each plain proof $6, and for each artist's proof $12. All expenses of printing and publishing were to be borne by Goupil and Company, and in addition the latter was to pay, within a year, $2,000 to the painter for the plate. As Bingham was aware, the only advantage moneywise for him in such an arrangement would result "from the *extended sale* which would thus be secured for the work" and the freedom of his time for painting. Goupil obviously was risking nothing: if none of

<hr/>

[15] Bingham to Rollins, Philadelphia, November 7, 23, December 12, 26, 1853; February 1, April 16, 1854 ("Letters," *Mo. Hist. Review*, Vol. XXXII, pp. 166, 168, 170–71, 173, 176, 178).

Bingham's subscribers went back on his word, the dealer would receive more than $2,400 as his share. On the other hand, Bingham would get back his investment in Sartain and would have the hope of future income from the Goupil sales without "intervention" on his own part.[16]

By the time the painter wrote to Rollins about the contract with Goupil (May 29) the printing from the plate was in "successful progress. . . . Judging by what we are now doing, my entire list will be completed about the first week in September. . . . I now deem it safest to superintend the entire work as far as I am concerned, trusting as little to others as possible." A proof was on display in the Rotunda of the Pennsylvania Academy of the Fine Arts, and an announcement was published by Bingham in the local papers that the engraver had given the "finishing touches to his work." Throughout the summer the printing continued with "but very slight interruption." It is probable that Bingham left Philadelphia for Missouri early in September, for he was in St. Louis before the fifteenth and on Monday evening, the eighteenth, he passed through Columbia on his way to Boonville.[17] But though he had come West with a supply of prints, he was not yet through with the nagging details of this business. Time had to be given to delivering the engravings. In one instance he turned twelve over to a Mr. Cordell for distribution in Jefferson City and vicinity. The Kentucky list ("112 subscribers, twenty per cent of which number may be reasonably deducted for deaths removables &c") he sold to Hegan, Escott and Moore of Louisville for $800, payable in four and six months.[18]

In filling out the story of the engraving (Plate No. 43) of *County Election*, we must consider the curious and difficult question: Which

[16] Bingham to Rollins, New York, May 17, 1854; Philadelphia, May 29, 1854 ("Letters," *Mo. Hist. Review*, Vol. XXXII, pp. 181–85). The contract was signed May 25, 1854 (Bingham to Rollins, Kansas City, May 19, 1873, *ibid.*, Vol. XXXIII, p. 222). How many more were sold remains unknown; in the destruction of the Goupil establishment in 1870 during the siege of Paris, all records were lost.

[17] Bingham to Rollins, Philadelphia, May 29, 1854 (*ibid.*, Vol. XXXII, p. 184); Rusk, *Bingham*, 59; St. Louis *Pilot* as quoted in Columbia *Missouri Statesman*, June 30, 1854; Bingham to Rollins, Philadelphia, July 15, 1854 (*ibid.*, p. 185); *Missouri Statesman*, September 15, 1854; Philadelphia *Register*, September 7, as reprinted in *Missouri Statesman*, September 22, 1854; Boonville *Weekly Observer*, September 30, 1854.

[18] Bingham to Rollins, Philadelphia, January 12, 1855 ("Letters," *Mo. Hist. Review*, Vol. XXXII, p. 188).

of the two *County Election* paintings is the original, that owned by the Boatmen's Bank of St. Louis or that in the St. Louis City Art Museum?[19]

Bingham's correspondence places the original *County Election* in the hands of Sartain in October, 1852.[20] It remained with him, necessarily, until the engraving was finished in the late spring of 1854 and then must have been returned to the painter. We next find reference to it in 1860: "I will have my election pictures here in a few days," he wrote to Rollins from Washington City on January 9, "and will endeavor to dispose of them to the Library Committee of Congress, though such is the depleted state of the treasury, that my hopes of success are not very sanguine at present."[21] He was unsuccessful in selling the three canvases, but he did show them in the Fourth Annual Exhibition of the Washington Art Association and a little later in the Thirty-seventh Annual Exhibition of the Pennsylvania Academy of the Fine Arts at Philadelphia. In September, *County Election* and its companion pieces were hanging in the First Exhibition of the Western Academy of Art in St. Louis. In all these shows it was announced as belonging to the artist.

At some time in 1861 the three pictures were hung in the St. Louis Mercantile Library on loan. The board of the library somewhat hopefully announced in its report for that year that "Mr. Bingham [has] intimated to us that he will never remove them." But the artist, on reading this statement, wrote to the board on March 25, 1862, "I do not feel willing to surrender my rights to them at this time." In 1865, John H. How is said to have bought the paintings for the new O'Fallon Polytechnique Institute and two years later sent them to its newly completed building. On the sale of that building

[19] Dr. Rusk further complicated this (*Bingham,* 60) by suggesting that there may have been two replicas. She called attention to a story in the Columbia *Missouri Statesman,* March 7, 1879, which reported that among paintings to be seen in Bingham's studio was *The County Election.* But this was almost certainly the recently completed *Verdict of the People No. 2,* not otherwise mentioned in this news story. She also cited a reference from the Boonville *Missouri Democrat,* May 3, 1895, to the effect that a painting called "*Election Day in Independence, Missouri*—an illustration of western life before the war" was on exhibition and offered for sale in Boston. This, I suggest, was very likely *Verdict No. 2* once more. At the Louisville Exposition in September, 1873, a picture by Bingham entitled *An Election Scene* was exhibited; in all probability this was the *County Election No. 2* owned by Ward.

[20] "Letters," *Mo. Hist. Review,* Vol. XXXII, p. 166.

[21] *Ibid.,* p. 494.

the following year to the St. Louis School Board, How replaced the Bingham paintings in the Mercantile Library. Soon after, How lost his fortune and left St. Louis, but first sold the pictures to John H. Beach, who allowed them to remain on exhibition in the library until 1879, when he formally presented them to the library. There *County Election* and its fellows remained until 1941, when *Stump Speaking* and *Verdict of the People* were sold to the Boatmen's National Bank in St. Louis, and three years later *County Election* and *The Jolly Flatboatmen in Port* (a constant companion of the *Election* pictures since 1860) were sold to the City Art Museum of St. Louis.[22]

The replica which Bingham had painted in the summer of 1852 he exhibited in Columbia, Missouri, late in October of that year. The *Weekly Missouri Sentinel* and the *Missouri Statesman* of that town both asserted it to be a copy of the original, whereas they described *The Emigration of Daniel Boone*, shown at the same time, as "the original" of that painting. The New Orleans *Picayune* in March, 1853, likewise specified the picture on tour to be a copy of the original *County Election*. It was this copy that Robert J. Ward saw in New Orleans and bought on the spot. In Louisville a few weeks later some confusion arose over the two canvases, but the *Journal* on May 19, at Bingham's urging, clarified the matter:

It might be inferred, from the manner in which the *Journal* and the *Courier* have spoken of Mr. Ward's purchase of "The County Election," that the artist had parted with the *original* painting to Mr. W., and that it is a *duplicate* which is in the hands of the engraver in Philadelphia.—We are requested by Mr. Bingham to state, that the reverse is the case. . . . The original painting of "The County Election" was committed to the charge of Mr. Sartain in October last, since which time he has been at work on the plate. *This* picture is still the property of Mr. Bingham.

The *Daily Times* on the same day carried a similar story emphasizing that Ward's was the duplicate picture.

The further history of *County Election No. 2* has been traced by Albert Christ-Janer on the basis of information from the late C. B. Rollins. Having come to suspect as early as 1923 that the painting in the Mercantile Library (now in the City Art Museum) was not

[22] *Annual Reports of the St. Louis Mercantile Library Association for* 1861, 1862, 1865, 1867, 1868, 1879, 1941, 1944.

the original, Mr. Rollins made an investigation which eventually resulted in his finding and buying the Ward picture. It had passed from the widow of the first purchaser to a steamboat operator named Irvine and from his widow to her pastor, Rev. Dr. Charles J. Hemphill, dean of the Presbyterian Theological Seminary at Louisville. In 1926, Mr. Rollins tried to buy the picture for the University of Missouri, but a price could not be agreed upon. Five years later James Hemphill, a son of the dean, offered to sell, but again no action was taken. On renewed inquiry in 1934, Rollins was told that the picture had been lost. Stored in a warehouse, it could not be found. But in 1937 it was discovered once more, and Rollins bought it.[23] The painting hung in his home until, after his death, it was acquired by the Boatmen's Bank in 1941.

From this marshaling of facts it seems beyond question that the Mercantile Library–City Art Museum painting is the original *County Election* and that the Ward-Rollins-Boatmen's Bank version must be *County Election No. 2.* But the matter has been complicated by Christ-Janer's calling attention to one important detail in which the Boatmen's Bank picture corresponds to the engraving while the City Art Museum one does not: "In Mr. Rollins' picture and in the engraving there are no figures immediately above and behind the trio of men, engrossed in serious conversation, in the right lower part of the painting. In the later Mercantile Library-owned painting two figures have been added." Sartain's engraving seems to say, then, that the engraver worked from the Ward-Rollins-Boatmen's Bank picture, but the contemporary documentary evidence says positively that he worked from the Mercantile Library–City Art Museum painting. Short of a deliberate substitution (when could it have been worked?), short of calling Bingham an outrageous liar, it is impossible that the engraving could have been made from any other than the painting now in the City Art Museum. One can only suggest that the engraver omitted the two figures or that the painter added them after the picture returned to his hands.

Close comparison of the two paintings with Sartain's print tends to support the conclusion that the engraver worked from the City Art Museum canvas. In several instances details in the engraving

[23] Christ-Janer, *Bingham,* 61–63.

differ from both paintings. Of thirteen more points of difference (other than the two additional figures) four show close likeness between the print and the Boatmen's Bank picture. In both the sign on the hotel is inscribed "Union Hotel," the peg for the boys' game of mumble-the-peg is clearly seen, and the shadow of the legs of the dog standing near the steps is carefully indicated. Faint patches of color on the forward pillar of the porch in the painting suggest the bills so obviously posted there in the engraving. None of these details is found in the Art Museum painting.

To counter these, however, are at least nine instances in which the engraving follows closely the Museum picture. With the exception of the trees immediately behind the hotel, all foliage, and particularly of the trees most prominently placed, is like that of the Museum canvas. The folds of the banner resting against the porch pillar, the shadow of the boy on the right, the shadow of the man seated on the steps writing, the hat lying on the ground in front of the drunk on the bench, the shape of the piece of board in the right foreground are treated in the engraving as they are in the painting. The one little chimney on the grocery, the panes of glass above the door into the courthouse on the extreme right, the door frame seen behind the oath-giving judge, the peg beside the piece of loose board are details in both the Museum painting and the engraving, but are not found in the Boatmen's Bank picture.

The new details in the bank's painting could be explained as afterthoughts or corrections; the differences brought out by studying the Museum canvas could suggest that Bingham, working rapidly to finish his copy, overlooked some minor details. In spite of the confusion caused by the missing figures in the engraving, I must regard the City Art Museum painting as *County Election* and the Boatmen's Bank picture as *County Election No. 2*. This is a decision of priority, not a judgment of values.

11. THE POLITICAL SCENE: STUMP SPEAKING AND VERDICT OF THE PEOPLE, 1853–1869

While he was on tour soliciting subscriptions for the *County Election* print, Bingham began his next picture, *Stump Speaking*

(42½″ x 58″). On May 19, 1853, the Louisville *Daily Courier* reported that he was then "making studies for another work, to be entitled the 'County Canvass.'" During the months spent hovering at Sartain's shoulder he was not "idle," he assured Rollins in a letter from Philadelphia on November 7. He had by that time finished the drawing and was proceeding rapidly with the painting of the new picture. Much as his friend had admired *County Election,* he was expected to "be still better pleased with the present work," the artist declared. "I have found less difficulty in the management of the subject, admitting as it does of a much greater variety of attitude, if not of expression. Sartain is very much pleased with the drawing and grouping of the figures. . . . I expect to have my 'County Canvass' ready for exhibition by the time Sartain terminates his labors upon the Election, and be obtaining subscribers for *that* while distributing the print of the other."[1]

Sixteen days later he thought he might have the painting finished by the new year. He was well satisfied with it and with himself. "I should like much for you to see it in its present state," he told his Missouri friend. "I do not think you would counsel any change in the design, and if you did, I scarcely think your advice would be followed. The fact is that I am getting to be quite conceited, whispering sometimes to myself, that in the familiar line which I have chosen, I am the greatest among all the disciples of the brush, which my native land has yet produced. When I get this picture completed, and published in conjunction with the 'County Election,' I think I shall have laid the foundation of a fortune sufficient to meet my humble expectations, and place my little family beyond the reach of want, should I be taken away from them."[2]

Bingham's enthusiasm continued to run high. As he described the picture to Rollins in another letter we can watch it grow:

The gathering of the sovereigns is much larger than I had counted upon.

[1] "Letters," *Mo. Hist. Review.* Vol. XXXII, pp. 166–67. Rollins, meanwhile, was looking after Bingham's publicity at home. A story in the *Missouri Statesman* (November 18), reprinted in the Liberty *Weekly Tribune* a week later, announced that Bingham, in Philadelphia to superintend work on the engraving, was engaged on *County Canvass* and was thinking of painting Senator Thomas Hart Benton appealing to the people of Missouri (see p. 120, below).

[2] "Letters," *Mo. Hist. Review,* Vol. XXXII, pp. 169–70.

A new head is continually popping up and demanding a place in the crowd, and as I am a thorough democrat, it gives me pleasure to accommodate them all. The consequence, of this impertinence on one side and indulgence on the other, is, that instead of the select company which my plan at first embraced, I have an audience that would be no discredit to the most populous precinct of Buncomb.

I have located the assemblage in the vicinity of a mill, (Kit Bullards perhaps) the cider barrel being already appropriated in the Election, I have placed in lieu thereof, but in the background, a watermellon waggon over which a *darkie,* of course presides. This waggon and the group in and around, looming up in shadow, and relieved by the clear sky beyond, forms quite a conspicuous feature in the composition, without detracting in the slightest degree from the interest inspired by the principal group in front.

In my orator I have endeavored to personify a wiry politician, grown gray in the pursuit of office and the service of party. His influence upon the crowd is quite manifest, but I have placed behind him a shrewd clear headed opponent, who is busy taking notes, and who will, when his turn comes, make sophisms fly like cobwebs before the housekeepers broom.[3]

On February 1, 1854, Bingham was still giving the "last touches" to *County Canvass.* "It will be a more imposing and effective picture than the Election, the figures are larger, more varied in character, and also much greater in number," he wrote to Rollins. "Mr. Sartain thinks its exhibition will produce quite a sensation here. I wish to take it west with me as soon as my engraving is ready for distribution."[4] Missourians, however, were to wait three years before seeing this new work by their favorite artist. On April 14, Bingham sold the copyright of *County Canvass* to Goupil "upon terms perhaps as favourable as any artist ever obtained from a publisher." The prints were to be like those of *County Election* in size and price. For each of the first fifty proofs before letters, to be sold at $40, Bingham was to receive $12; for the second fifty at $20 he would have $6. For each plain print sold by Goupil he would have $3; for colored, $5. For prints he himself sold, Bingham was to be paid $6.33⅓ and for proofs in proportion. All expenses of engraving, printing, and selling were to be borne by the publisher. The painting was to remain the property of the artist "unless sold and accounted for at the price of two

[3] Philadelphia, December 12, 1853 (*ibid.,* pp. 171–72).
[4] *Ibid.,* pp. 176–77.

thousand dollars." On terms like these Bingham was well out of the print-selling business.[5]

Still known as *County Canvass,* the painting was on exhibition for a short time at the Gallery of the Philadelphia Art Union.[6] It was soon sent to Paris and placed in the hands of the engraver, Gautier. Bingham expected the engraving process to require at least two years.[7] We next hear of the picture, its title changed to *Stump Speaking* (Plate No. 44), in the spring of 1857, when it was placed on exhibition in St. Louis and a subscription book opened.[8] In 1860 it was shown with the other election pictures in Washington by the Art Association and thereafter it traveled with its fellows as already traced until it was acquired in 1941 by the Boatmen's Bank of St. Louis.

A number of the original figure sketches for *Stump Speaking* have been preserved in the Mercantile Library collection. The "wiry politician" speaking his persuasive best I have already presented in my reconstruction of the lost *Stump Orator* (Sketch No. 21). Seated immediately behind him is the "shrewd clear headed opponent, who is busy taking notes"; the sourness of his expression in Sketch No. 89 has been toned down in the painting. The stout man to his right— another important personage obviously active in affairs political—is perhaps a trifle less grim in the superbly drawn No. 90. No. 91 is the old man sitting on a log directly in front of the speaker, resting chin on his cane, with his dog at his feet. Other original sketches show: to the extreme left, near the feet of the man with the expansive abdomen, the gentleman (No. 92) looking back over his shoulder at the speaker; the boy counting pennies in his right hand (No. 93); the young man (No. 94) lying back on his right elbow in the center foreground (in the sketch he wears boots, not shoes, and has his trousers rolled); the rather stern and impressive gentleman who captures the eye on the right of the picture (No. 95); the smiling man seated in the exact center of the picture (No. 96).[9] The cheerful

[5] Bingham to Rollins, Philadelphia, April 16, 1854; Kansas City, May 19, 1873 (*ibid.,* pp. 178–79; Vol. XXXIII, p. 222). There are no figures on the ultimate sale.

[6] Philadelphia *Sun,* April 7, 1854.

[7] Bingham to Rollins, Philadelphia, January 12, 1855 ("Letters," *Mo. Hist. Review,* Vol. XXXII, p. 187).

[8] Samuel Spencer advertised the picture in the *Missouri Republican* from February 7 to April 28, 1857.

[9] Sketch No. 97 is a variant pose of the same figure.

drunk standing near the speaker's left has already been suggested as appearing in *The Stump Orator* (No. 39); perhaps he was featured in both.

While the negotiations with Goupil and Company were being discussed, Bingham had "commenced thinking" about *The Verdict of the People* (46" x 65"). "I intend it to be a representation of the scene that takes place at the close of an exciting political contest, just when the final result of the ballot is proclaimed from the stand of the judges. The subject will doubtless strike you [Rollins] as one well calculated to furnish that contrast and variety of expression which confers the chief value upon pictures of this class."[10] By the middle of May he had begun the studies for the new painting. "I desire it to 'cap *the clymax,*'" he wrote to Rollins.[11] *The Verdict of the People* was "still growing" two months later. He expected to have it "sufficiently completed to exhibit to advantage" by the time he left Philadelphia with his *County Election* prints, for he was planning to add the new picture to his series of engravings and was anxious to open a subscription book.[12] By September 7 it was far enough advanced for the *Philadelphia Register* to declare that "the remarkable power of this artist in seizing and transferring to his canvass the peculiarities of individuality is well known, but his infinite variety has never been so strikingly exhibited before."[13] Progress, however, was slower than Bingham had expected and he went home to Missouri a few days later without the picture. Disposing of his *County Election* print business, he returned to Philadelphia on the first day of 1855, resumed work on the *Verdict,* and finished it sometime during the spring (Plate No. 45).[14]

On completion of the picture, Bingham sent it to the New York office of Goupil and Company, where it remained for some months while terms of publication were being considered. In the meantime

[10] Bingham to Rollins, Philadelphia, April 16, 1854 ("Letters," *Mo. Hist. Review,* Vol. XXXII, p. 180).

[11] New York, May 17, 1854 (*ibid.,* p. 182).

[12] Philadelphia, July 14, 1854 (*ibid.,* p. 186).

[13] Quoted in the Columbia *Missouri Statesman,* September 22, 1854. No doubt, Bingham left the clipping with the editor in passing.

[14] Bingham to Rollins, Philadelphia, January 12, 1855; Independence, Missouri, June 15, 1855 ("Letters," *Mo. Hist. Review,* Vol. XXXII, pp. 186–87, 188).

the painter returned to Missouri early in the summer. In June, 1855, he was stopping in Independence to collect from his subscribers to *County Election,* "some of whom are rather slow." While "waiting upon them," he expected "to paint a few portraits to pay expenses &c."[15] He did not reach an agreement with Goupil, and in September, *The Verdict of the People* was returned to him. He had now opened a studio in the grand jury room of the courthouse at Columbia and was engaged in painting portraits.[16] Two months later he was in Jefferson City, and his sitters there had the pleasure of seeing the *Verdict,* which he was carrying with him.[17] He returned later in the winter to Columbia, where he remained until spring. On May 6, 1856, the *Missouri Republican* announced that Bingham had just arrived in St. Louis with *The Verdict of the People.* It was to be exhibited for a few days only because he intended to leave shortly for Europe and would take the painting with him to be engraved in Paris. On his way east he stopped at Louisville, where the *Verdict* was "highly relished" by those who saw it. Bingham did not open a subscription book there but engaged to deliver to one house in the city $400 worth of prints.[18]

When he sailed for France in August, Bingham carried *The Verdict of the People* with him and in Paris had further talk with Goupil about publishing it. He found that the best engravers there were all too busy to undertake the work immediately. By the time he moved on to Düsseldorf, Bingham was strongly disposed, he wrote to Rollins on November 4, to become his own publisher. He now considered an engraver from Berlin whom Emanuel Leutze recommended.[19] On June 3, 1857, he told his Missouri friend: "I have made arrangements for Publishing the 'Verdict of the People' and intend to be the exclusive proprietor of the print." He had decided on a lithograph rather than an engraving:

. . . it can be done here in the very best manner, and with an effect supe-

[15] Bingham to Rollins, Independence, June 15, 1855 (*ibid.,* p. 190).
[16] *Missouri Statesman,* September 14, 1855.
[17] Jefferson City *Inquirer,* November 14 as quoted in *Missouri Statesman,* November 23, 1855.
[18] Bingham to Rollins, Louisville, June 2, 1856 ("Letters," *Mo. Hist. Review,* Vol. XXXII, p. 196).
[19] *Ibid.,* pp. 344–45.

rior to any Mezzotint engraving that I have ever seen. My contract with the Artist who undertakes the work secures me the privilege of rejecting it when completed, should it not meet my approbation fully. I am to be furnished with a proof of the finished work in six months from this date. The entire cost of the publication of two thousand copies including paper printing, lithographing and incidentals, will not quite amount to $ [*MS torn*]. The same number of copies including engraving of the *County Election* cost $3,500. An immense difference as you will perceive in favour of the publication here, but which you can keep all to yourself. If when the work shall be completed, any one sees proper to purchase it upon good terms, I will sell out entirely, but will not divide the interest by a partnership.[20]

Some hitch presently developed over this ill-fated reproduction. "Owing to some misunderstanding" between Bingham and the lithographer, the stone had not been finished by August, 1858, but "it may possibly be completed in a few months," a Düsseldorf correspondent of *The Crayon* hopefully but mistakenly predicted.[21]

Not until a decade later was any progress made on the publication of *The Verdict of the People*. In 1869, C. B. Rollins remembered, the picture was lithographed by Goupil and Company in Paris "and two impressioins were sent to Bingham, who brought them to my father's house. I remember my father and Bingham discussing the impressions in the library at La Grange. They were found satisfactory, and Bingham ordered a large number of impressions. By the time his order reached Paris, the Goupil establishment had been destroyed during the disorders of the Franco-Prussian war. Bingham gave my father one of the impressions, which I own and which now hangs in the periodical room of the University Library. The other impression I have tried for years to trace, but without success."[22]

The 1869 lithograph is a close duplicate of the 1855 painting (Plate No. 46). The principal difference is in the happy citizen prominently placed at the left of the picture directly beyond the Negro

20 *Ibid.*, p. 352.
21 A news letter from "L" at Düsseldorf, August, 1858, published in *The Crayon*, Vol. V (October, 1858), 292.
22 "Letters," *Mo. Hist. Review*, Vol. XXXII, p. 179 n. There are no Bingham letters extant between July 10, 1867, and March 8, 1870. Bingham had brought the painting home when he returned from Düsseldorf and later sent a photograph to Goupil for the lithograph (Rusk, *Bingham*, 62).

pushing a wheelbarrow. In the painting his right arm is not in sight, and his left hand rests on a cane; in the engraving he has raised his right hand up to his head, and his left holds his hat as well as the walking stick.

It is interesting to note that Bingham did not make the scenes of *County Election* and *Verdict of the People* identical. They bear close resemblance, and *Verdict* at first glance seems to give a view down a street at right angles to that in *County Election*. As one looks at the two pictures together, however, he sees that the steps in *Verdict* are stone with stone abutments, not open wooden steps as previously painted, and that the porch pillars now are round, not square as in the first picture.

None of the actual sketches for *Verdict* are to be found in the Mercantile Library collection, but many of the figures are variant poses of ones used in earlier pictures. The man with his hat on his knees in the center of the painting, for example, is certainly the one sketched in Nos. 23 and 89. The toothless old man with the long nose and sharp chin, walking away from the courthouse toward the right is the same man, differently posed, who grins so broadly in No. 98; possibly this sketch shows him as he had mingled with the crowd gathered around the stump orator.

Early in 1854, after finishing *Stump Speaking*, Bingham painted in Philadelphia "two small pictures" which he sold for $325.[23] One of these is quite possibly a canvas lately at the James Graham and Sons Gallery in New York. *Raftmen by Night*[24] (24″ x 30″), signed and dated 1854 in the lower left corner, features a group of boatmen. The subject and arrangement of this night scene in green tones is typically Bingham, though it would seem to have been painted in greater haste and with less care than his earlier studies of river life. The laden raft has been drawn up ashore for the night. Four figures are relaxing in varied poses, their faces lit up by a fire to the extreme left. The river fades away to the right distance. A small dog, right, is looking down over the side of the boat into the water (Plate No. 47).

[23] Bingham to Rollins, Philadelphia, April 16, 1854 ("Letters," *Mo. Hist. Review,* Vol. XXXII, p. 179).

[24] My title.

The canvas is further authenticated by the Mercantile Library sketchbook. The man farthest to the left, leaning forward on his right elbow, his face resting against his hand, is certainly not as well drawn as Sketch No. 14, but the effect is essentially the same. The man seated with his back to us, telling a story, is a variant study of the man posed in No. 56; the shape of the body, the costume, and the very sag of his coat pocket are the same. The face of No. 13 is different from that of the seated man with the pipe in his right hand, but the position of the body, the details of dress so far as they can be discerned, and particularly the manner of holding the pipe are identical. No. 99, a torso only, is posed identically with the fourth man.

A somewhat similar composition in the Karolik Collection of the Boston Museum of Fine Arts may be the second of these 1854 river canvases (Plate No. 48). Signed and dated 1854, *Flatboatmen by Night*[25] (29″ x 36″) shows a flatboat alongshore for the night. Four men are talking together on the left. One stands, leaning on a pole; one is seated facing forward; two are sitting with back and profile to us; as in *Raftmen by Night* a fire lights their faces from the left. At the far end of the flat is a fifth man fishing. Water stretches away to the right and mid-distance. Again the composition is strongly reminiscent of Bingham, but the drawing lacks his customary assurance and firmness. Its fuzziness and uncertainty make the painting look more like a rough imitation than an original. This effect may well have been created by a highly incompetent "restoration."

Support for Bingham authorship can be seen in two of the figures. The man seated with his back to us may be another pose of No. 6. The figure in No. 45, resting in a semireclined position on his left forearm with the left leg straight and the right knee raised, is identical with the man to the right in this flatboat group, the only changes being the additions of jacket and cap or hat. Perhaps the most telling detail is the relaxed droop of the right hand over the man's body. A further strong argument for the authenticity of this painting is the long history of its ownership in St. Louis before it passed through the Safron Gallery to its present owner.

[25] My title.

114

12. LANDSCAPES, WITH AND WITHOUT CATTLE, 1851–1864

Owing to the perverse tendency of painters to entitle a landscape merely *Landscape,* it is often extremely difficult to establish a chronological record of their undated scenic pictures. The artist, of course, is not photographing an area or making a topographical report. He is not concerned with factual exactness. But since he is painting from nature, it would be a convenience to the critic and a kindness to the historian if he would add to the general title a locating phrase like *The Mississippi below St. Louis* or admit specifically that his *Mountain View* was actually a *View of Mount Washington.* His dignity as a painter cannot be seriously compromised by this mild concession to the biographer and the historian, but such an identifying title may well help in establishing the chronology of his work and in providing a basis for the study of his development as a painter.

The problem is particularly difficult with Bingham. Although landscape was with him a lesser line of work, he painted at least forty such pictures, with or without cattle. The data concerning them, however, are so meager that it is impossible to describe or identify many with satisfaction. Thus far I have reported his landscapes as they were successively mentioned in contemporary sources. It will be convenient now to carry this recording forward from *Scene on the Ohio near Cincinnati* (1851) through those shown at the Sanitary Fair exhibition at St. Louis in 1864.

Although there is no mention of it in the extant correspondence, at some time in the 1850's not later than the summer of 1856, Bingham made a study tour to Lake George. From this visit came at least two landscapes.[1] *View near Lake George* (29″ x 36″) depicted "a quiet landscape of this romantic spot, abounding with rocks and trees in the foreground, while the beautiful lake is seen in the distance beyond." This picture was bought by the Cosmopolitan Art Association before October, 1856, for distribution in January of the following

[1] The titles of these two pictures are the only evidence of such a trip, but they are sufficient. To establish an exact chronology for Bingham is impossible for lack of documentation, but a close examination of his activities from 1851 until he sailed for Europe August 14, 1856, seems to show August, 1854, as about the only possible time for the Lake George visit.

year. A second painting sold to this association was a little oil (12" x 18") of *Washington's Head-Quarters*, "an old, one-story house, near Newberg, looking out upon the Hudson." Since Bingham had sailed for Europe on August 14, 1856, in all probability this had been painted at the same time as the *View near Lake George*, although it was listed among works to be distributed in January, 1858.[2]

Six or seven landscapes by him are mentioned at St. Louis during this period. At the opening of Wyman's Museum in 1856, three unnamed and undescribed scenic pictures were on view;[3] in the museum's own catalogue a year later landscapes entitled *Morning* and *Noon* were listed. At the Fourth Annual Fair of the St. Louis Agricultural and Mechanical Association in 1859 Manuel De França exhibited a Bingham *Landscape with Cattle*.[4] Donated for sale at the Mississippi Valley Sanitary Fair held in St. Louis in the spring of 1864 were three Bingham landscapes owned by De França, by a man named Oglesby, and by the artist.[5] The last picture, entitled *Mountain Lake*, was possibly another Lake George scene, though it could not have been the *View near Lake George* already mentioned, for that had passed to private hands in 1857. How many of these landscapes have previously been entered in this record cannot be determined, but without a doubt *Morning*, *Noon*, and *Mountain Lake* were new canvases.

With the exception of one painted at Düsseldorf (which I shall mention later) these are the landscapes of record in this period; none have been located. To them must be added several recently returned to public attention. One is a *Scene on the Ohio* (18" x 20") inscribed on the back of the stretcher: "On the Ohio River. G. C. Bingham, 1851." This little picture (Plate No. 49) shows in the middle distance an expanse of water with hills as a background. Two figures are seated in the foreground; two others, standing, with a dog, are seen more distantly. Shocked corn indicates that it is an autumnal scene. The State Historical Society of Missouri, which acquired *Scene on the Ohio* in 1946, traces its provenance from the sale of paintings in the Bingham estate at the Findlay art rooms in Kansas City in 1893.[6]

[2] *Cosmopolitan Art Journal*, Vol. I (October, 1865), 62; II (December, 1857), 61.
[3] St. Louis *Tri-Weekly Missouri Republican*, July 15, 1856.
[4] Possibly the 1850 landscape recorded on p. 78, above.
[5] St. Louis *Daily Countersign*, May 24, 26, 28, 1864.

From the simple realism of the treatment I believe it must have been done not later than the date inscribed. That it was in the Findlay sale, however, is doubtful, for the only picture there entitled *Landscape* without further qualification was sold to Fred C. Hey of Kansas City and remained for many years in his family. Furthermore, *Scene on the Ohio* was not among the paintings inventoried in the estate at Bingham's death in 1879.

For *The Storm* (25″ x 30″), a more exciting work, there is no contemporary documentation at all (Plate No. 50). From an unnamed family in St. Louis it passed to an art dealer there and in 1934 to Meyric R. Rogers, then director of the City Art Museum.[7] It was exhibited for the first time in the Bingham show at the Museum of Modern Art in 1935 and is now in the Wadsworth Athenaeum. *The Storm* has been tentatively dated "about 1850,"[8] but the likeness of treatment to the background of the repainted *Emigration of Daniel Boone* (late 1852) in contrast to the simplicity of *Landscape with Cattle* (1846) and *Scene on the Ohio near Cincinnati* (late 1851) suggests that it belongs to the "Lake George" group of 1853–56. There is here none of the placidity, none of the everyday realism that characterizes landscapes of his earlier period. This scene is charged with excitement. The rocky dell lighted up by a streak of lightning in the midst of a tremendous storm, through which a solitary deer flees, is not intended for the reproduction of a scene, but for the expression of mood. In thus creating the sense and being of a storm, Bingham has been eminently successful.

View of a Lake in the Mountains[9] (21″ x 30″), lately in the possession of the Harry Shaw Newman Gallery, shows (Plate No. 51), to the right a lake receding through a gorge in the mountains; to the left a fisherman walks up a path leading towards a high bluff. On a rock in the lower left appears the signature "G. C. Bingham." A *Mountain Gorge*[10] (24½″ x 29½″) was acquired by the present owner from the sale of the Hugh Campbell estate in St. Louis in 1941: presumably it had been in the possession of the late owner's father,

[6] *Mo. Hist. Review*, Vol. XL (April, 1946), 436.
[7] Rogers to McDermott, April 1, 1957.
[8] Rathbone, *Westward the Way*, 49.
[9] My title.
[10] My title.

Robert Campbell of St. Louis, from an early date (Plate No. 52). It depicts "a swift mountainous stream in the center foreground with a scraggly tree to the observer's right, beyond which occurs a grove of trees in autumnal colors outlined against mountainous hills which join the clouded sky in the distant horizon. A rocky eminence at the observer's left is environed by underbrush."[11]

Two other landscapes, acquired by the Missouri Historical Society in 1947, came from daughters of Charles H. Peck and had been for many decades in the possession of that family. They have been thought Colorado scenes painted possibly about 1872. However, a study of these two pictures, which I have called *Mountain Scene with Fisherman* (Plate No. 53), and *Mountain Scene with Deer* (Plate No. 54) (each approximately 31" x 36") for convenience of reference, leads me to think that they belong to the group of landscapes of 1853–56, along with those mentioned in the preceding paragraph, with *The Storm,* and with the *View near Lake George.* The feel of the Missouri Historical Society landscapes is very much that of *The Storm.* The similarity of the detail of the fisherman in *Mountain Scene with Fisherman* and in the *View of a Lake in the Mountains* and of the detail of the deer in *Mountain Scene with Deer* and in *The Storm* suggests that the pictures were all painted about the same time and in the same vicinity. I conclude that they are Lake George landscapes painted during the middle fifties.

13. THE LURE OF THE HISTORICAL SCHOOL, 1856

With *The Verdict of the People,* Bingham's great decade of genre painting came to a close. There would be a few other scenes of everyday life, but his interest in such subjects was wearing thin. His accomplishment had been notable: six political pictures and more than twenty of life on the river and in the river towns. They had been well received, particularly in his own West, and moderately well paid for. Now he craved wider recognition and greater rewards. Like other painters he suffered from the "grand school" virus: to be a great painter, one must paint great subjects. Besides, the fees were much greater. His first (and best) venture into the

[11] *Catalogue of the Hugh Campbell Estate,* 57.

118

historical, *The Emigration of Daniel Boone,* was successful, for it was a theme that had meaning for the painter of western scenes and western people. This effective rendition of an epic moment led him to think more about the historical subject and the possibilities, artistic and financial, in such painting.

Apparently it was not long after *The Emigration of Daniel Boone* had been returned to him by Goupil that Bingham began talking about another and larger version of that subject. His hope was for a commission to paint a big picture for the rotunda of the Capitol. What could be more appropriate than a Boone of heroic size? Nothing came of the earliest inquiry he made to Rollins, but he kept the thought in mind for a long time. At Düsseldorf in the summer of 1857, he again mentioned that he had it "in contemplation" to paint "a life size figure of the Emigration of Boone, with the expectation of selling it to Congress." Four months later he was seriously thinking of "commencing, shortly," a twelve-by-eighteen-foot version of this subject.[1]

News the following summer that a joint committee on the library of the Capitol had been authorized to expend $20,000 for the purchase of works of art and a story that Emanuel Leutze had indirectly been assured of a $10,000 commission[2] stirred Bingham to write that he intended to enter the competition for an order for a national picture. Since there was not yet any work of art in the Capitol "properly illustrative of the history of the West," it seemed to him that "a western artist with a western subject should receive especial consideration." He was quite willing to present to the committee "a small and complete study for the emigration of Boone, or any other subject of equal interest."[3] Bingham did not persist, however, in his intention to do the oversize *Boone,* for nothing more is heard of the project, nor is any study for it known.

When he was first thinking of the heroic *Boone* for the national capitol, Bingham was also turning over in his mind the thought of

[1] Bingham to Rollins, Philadelphia, December 12, 1853; January 12, 1855; Düsseldorf, June 3, October 12, 1857 ("Letters," *Mo. Hist. Review,* Vol. XXXII, pp. 172, 187, 353, 357).

[2] Leutze's *Westward the Course of Empire Takes its Way* was commissioned in 1860.

[3] Bingham to Rollins, Düsseldorf, July 18, 1858 ("Letters," *Mo. Hist. Review,* Vol. XXXII, p. 365).

a more local historical subject for the state capitol. At Fayette, in Howard County, on September 1, 1849, Senator Thomas Hart Benton had made a stirring speech denouncing the strong proslavery Jackson Resolutions.[4] Now on November 7, 1853, Bingham had "quite a serious notion" to follow James Rollins' suggestion:

and make old *Bullion appealing to the people of Missouri* the subject of a future picture. That passage in the commencement of his speech at Fayette, in which he designates the friends whom he came to address, as those only who had *heads to perceive and hearts to feel the truth,* would afford, I think, the best point of time for pictorial representation, as the action which accompanied it, and gave it such emphasis, would display his fine portly figure to the very best advantage, and also tell with most happy effect in the faces of the audience. The subject possesses an additional recommendation to me, from the fact, that I could introduce into it the portraits of many of my friends who were present upon the occasion, and by a license, which painters, as well as poets can take, I could make others present in the pictures, who were not present in fact. I think an engraving from such a work would sell, and if painted on a large scale it would be well suited for a place either in the Capitol or University of our State. If you see proper you can get Col Switzler [editor of the Columbia *Missouri Statesman*] to throw out a hint of my purpose, although I cannot say that it is yet fully formed.[5]

Late in 1860, when he had about completed his equestrian portrait of Jackson, Bingham was still thinking about the Benton subject. "With your assistance [as a speaker]," he wrote to Rollins, "and my embodiement of the spirit of the old Hero, I think there will be no difficulty in getting a commission for Old Bullion."[6] Possibly it was the war which put an end to these thoughts, for the picture was never painted.

Nor did Bingham get far with a thought "to present the 'Father of his Country,' connected with some historical incident, in a manner that would rival the far famed picture by Leutze."[7] Of this pro-

[4] For these resolutions, see William Nisbet Chambers, *Old Bullion Benton—Senator from the New West,* 349–50. Fayette was the "anti-Benton political capital."

[5] Bingham to Rollins, Philadelphia, November 7, 1853 ("Letters," *Mo. Hist. Review,* Vol. XXXII, p. 167).

[6] Kansas City, November 27, 1860 (*ibid.,* p. 498).

[7] Bingham to Rollins, Philadelphia, January 12, 1855 (*ibid.,* p. 187). Leutze's popular picture had been first exhibited in 1852.

posal nothing more is heard, unless the *Washington Crossing the Delaware* which the Missourian was engaged in painting at Columbia in March, 1856,[8] was intended as a study for a painting of heroic size. That he did not finish this picture at this time is not surprising when we note how occupied he was until the moment he sailed for Europe in mid-August.

If Rollins had been of no help to Bingham in getting a grand commission in Washington, he did obtain for his friend an order to paint full-length portraits of two great Americans for the state capitol at a fee far larger than any he had previously received. With $3,500 in prospect Bingham could at last strike out for Europe.[9] He planned to paint the Washington and Jefferson portraits in Paris. As preliminary he needed to copy heads of the two subjects. At Philadelphia, in the possession of Edward Coles, he found the Stuart portrait of Jefferson that had been painted for Mrs. Madison. The former governor of Illinois was interested and pleased: "He insisted upon my occupying a room in his house while executing the copy." Bingham went next to Boston in July to copy the heads of George and Martha Washington from the Stuart portraits in the Athenaeum (these copies are now in the St. Louis Mercantile Library). On the painter's return to Philadelphia, "Mr. Earle, the principal picture dealer in this city," ordered six copies of his copies of the heads of the Washingtons and paid him $380 for work that required less than two weeks.[10]

It had been a busy summer. In those two months between his arrival at Philadelphia and his sailing from New York for France on August 14, he had been constantly engaged. By July 29, he had "executed private commissions to the amount of four hundred dollars." Two weeks later he stated that in addition to the copies of the

[8] *Missouri Statesman*, March 14, 1856.

[9] As early as 1850, he had been thinking of going to Europe "to pursue and improve himself in his profession" (St. Louis *Missouri Republican*, October 11, 1850). The portraits were authorized by act of the General Assembly on December 4, 1855.

[10] Bingham to Rollins, Boston, July 29, 1856; Philadelphia, August 10, 1856 ("Letters," *Mo. Hist. Review*, Vol. XXXII, pp. 197–200). Auction records disclose that at the sale of the estate of Mrs. Sarah Harrison (Philadelphia), February, 1910, a *George Washington* brought $125 and a *Martha Washington*, $85. In 1941, Mrs. Dwight F. Davis (formerly of St. Louis) sold at Washington, D. C., another *George Washington* for $950.

Washingtons for Earle he had "painted other pictures for different individuals to the amount of $300.00."[11] Most of this, probably, was portrait work. Perhaps one of the pictures was *The First Lesson of Music,* exhibited by its owner, E. P. Mitchell, at the Pennsylvania Academy of Fine Arts the following year. Of this painting nothing is known but its title.[12]

14. PARIS, DÜSSELDORF, MISSOURI—HISTORICAL PORTRAITS AND LOCAL PORTRAITURE, 1856–1862

When Bingham arrived in Paris on September 1, 1856, he expected to stay for a long time. "All that we hear of the splendour of the gay and luxurious city, is fully realized when we enter it," he wrote to Rollins on the seventh. "A large portion of the architecture is erected upon the most magnificent scale, and no portion of the city which we have yet visited appears squalid or mean. As you may suppose I employed my earliest leisure in a visit to the galery of the Louvre. The great collection of works of Art there from all nations and schools, perhaps afford a student advantages which he could not obtain elsewhere." The experience was overpowering. Unless the student "possessed the power to retain a clear perception of nature through the various guises in which she is here portrayed, like a juror bewildered by a mass of conflicting testimony, he might find himself staggering in doubt, scarcely knowing whether he inclined to truth or falsehood. Yet amidst the many conflicting statements presented by the masters of the various schools, there are numerous facts to be found, most forcibly and clearly expressed, which may be laid hold of by a matured judgment—and used to great advantage. I shall be compelled to visit the great gallery often before I can be able properly to appreciate the treasures which it contains."[1]

In spite of the attractions and the importance of the Louvre, he did not long remain in Paris. The expensiveness of life there (he estimated that "by a careful economy" the living expenses of his

[11] Bingham to Rollins, Boston, July 29, 1856; Philadelphia, August 10, 1856 (*ibid.,* pp. 197, 200).
[12] Anna Wells Rutledge, *Pennsylvania Academy of Fine Arts Exhibition Record, 1807–1870,* 26.
[1] "Letters," *Mo. Hist. Review,* Vol. XXXII, pp. 340–42.

wife, daughter, and himself could be held to $100 a month) could be managed, but the difficulty of finding an adequate studio, of making one's way about a city which was "such a wilderness to a stranger that much of what it contains cannot be found," and the awkwardness of not speaking the language led Bingham after two months to leave for Düsseldorf.[2]

He was far more comfortable in this small German city, some five hundred of whose thirty or forty thousand people, he discovered, were artists. On arriving, he called on Leutze, "who received me as cordially as if I had been a brother, and without a moment's delay assisted me in finding a Studio, and introduced me to one of his American pupils through whose guidance I shortly obtained accommodations of the best kind, and upon the most reasonable terms for Eliza and Clara." There were five other Americans then at work in Düsseldorf, he found, but "we look for accessions to our number in the spring." He may have missed Charles Wimar, who left Düsseldorf late that year to return to St. Louis. He did meet another St. Louis acquaintance, Henry Lewis, panoramist and landscape painter, who later in the winter wrote to his brother George in St. Louis: "We have now some 10 Americans studying here Among them *Bingham* who is painting two pictures for the statehouse in Jefferson City." The attitude toward painting in this very popular art-center pleased Bingham. "The striking peculiarity of the school which flourishes here by its own inherent vitality, is a total disregard of the 'old masters' and a direct resort to nature for the truths which it employs. As might be expected, works springing from a principle of execution so simple and so rational are characterized by a freshness, vigor and truth, which captivates those of common understanding and is none the less agreeable to minds of the highest cultivation."[3]

Although his principal work here was to paint the Washington and Jefferson portraits, we find him by June 3, 1857, at work on "a large picture of 'life on the Mississippi' which will not require [he wrote] a great while to complete and which promises to be far ahead of any work of that class which I have yet undertaken." Four months

[2] Bingham to Rollins, Düsseldorf, November 4, 1856 (*ibid.,* p. 343).
[3] Bingham to Rollins, Düsseldorf, November 4, December 14, 1856 (ibid., pp. 343–47). The Henry Lewis letter is in a private collection; for Lewis, see my *Lost Panoramas of the Mississippi,* 81–144.

later he was finishing his " 'Jolly-flat-boatmen in Port' . . . a large picture, containing 21 figures."[4] He probably brought the painting home with him in January, 1859, but there is no further word of it until we hear that it was being shown early in 1860 with the three Election canvases in the Fourth Annual Exhibition of the Washington Art Association. It passed with them into the possession of the Mercantile Library and in 1944 was bought by the City Art Museum of St. Louis.

The Jolly Flatboatmen in Port (46¼" x 69") is not a replica of the 1846 painting but a new treatment of the theme (Plate No. 55). The flatboat has now tied up at the St. Louis landing. Out in the river beyond it another has come up. To the right, at the levee, are two more flats and, farther off, a steamboat. The river flows away in the right distance. The grouping of the three principals on the flatboat is the same, but the picture has been made more complex by increasing the "supporting cast" from five to seventeen, gathered on or near the boat, watching—or ignoring—the dancing figure. All are portrayed in typical and expressive attitudes.

It is evident that Bingham carried his portfolio of sketches with him to Europe, for we instantly recognize many of the figures before us. The tall man leaning against the barrel at the left of the picture is somewhat shadowed in the painting, for the morning light is behind him; in No. 100 we have an admirable preview of him. Although the man beating on the skillet (No. 101) and the fiddler (No. 102) occupy the same positions as in the earlier picture, they are clearly different from their predecessors (Nos. 4 and 5). The man with the sore foot, who figured in *Raftmen Playing Cards* (No. 20), has had the crown of his hat mashed in and has lost his pipe, but is otherwise much the same disconsolate fellow. Other figures make clear once more that the portfolio of sketches must then have been considerably larger than it is today. The seated man on the right, putting down notes on a pad of paper, is a quite different view of the man who posed for either No. 33 or No. 85. The man with the pole, behind the dancer, is certainly from a variant sketch of the subject in Nos. 67 and 68. In all likelihood the man drinking from the jug is the same whose back we have seen in *Lighter Relieving a Steamboat Aground*

4 Bingham to Rollins, Düsseldorf, June 3, October 12, 1857 (*ibid.*, pp. 353, 357).

(No. 15). In the center foreground the man with his back to us could be No. 30, and the man leaning on his right elbow could be a reverse pose of No. 45.[5]

One landscape painted in Germany during this period, depicting a castle perched high on a hill overlooking the Rhine (?) in bright moonlight, is extant (Plate No. 56). This *Moonlight Scene* (14″ x 20″), according to Dr. Rusk, was one of two landscapes painted at Düsseldorf which in 1902 were owned by Mrs. J. M. Piper, sister of the second Mrs. Bingham. The other has not been traced.[6]

It was the historical portrait commissions, however, which filled most of Bingham's working hours during the first visit to Europe. In Paris he executed a small study of the standing figure of Washington. As soon as he had settled in the Düsseldorf studio, he ordered a "canvass 8 by 12 feet, for the portrait."[7] By December 14, he could write to Rollins that he had "the full length of 'The Father of his Country['] standing up six feet and a half" in the studio and that "the arrangement and general effect of the picture as well as the likeness is highly approved by my fellow-Americans."[8] But he soon discovered that he had not room enough to work on pictures of such size and postponed work on the *Washington* until he got possession of a larger studio on June 2, 1857 (it was in this interval that he had begun *The Jolly Flatboatmen in Port*). "In these my new quarters I have a good light and ample space for pictures of almost any size, and on the same floor with the studio we have our family apartments, which puts us all together under the same roof. Leutzes studio is upon the lot adjoining mine, and as he is far the most eminent Artist here who speaks English his vicinity is a matter of considerable

[5] A few of the extant Mercantile Library drawings remain to be listed. No. 103 is obviously a variant of Nos. 24 and 62. No. 105 is the same boy who posed for No. 66 and may have appeared in one of the lost river pictures. No. 106, too, looks like a figure study suitable to a flatboat scene. No. 107 bears a close resemblance to No. 40, whom I placed in the crowd around the Stump Orator. No. 108, smoking his pipe while he reads his paper, is a study for an interior genre picture. Nos. 109, 110, and 111 are all poses by one sitter, such as would do for an interior scene, and No. 112 shows the overcoat of this man thrown over the back of the chair in which he has been sitting.

[6] Rusk, *Bingham*, 127. Now owned by W. Howard Adams.

[7] Bingham to Rollins, Düsseldorf, November 4, 1856 ("Letters," *Mo. Hist. Review*, Vol. XXXII, p. 344).

[8] *Ibid.*, p. 348.

importance."[9] Work progressed so well that by October he could say, "The portrait of Washington receives high praise from all who see it, and I intend to prove that our State is none the loser by employing its own artist."[10]

He had originally thought of painting Jefferson in a "sitting posture surrounded by his library and other accessories, indicating his character both as Statesman and Philosopher." But though he had made "some studies" for the *Jefferson* by October 12, 1857, he had not finally determined the attitude for the figure. By March 8, 1858, however, the portrait was "pretty well advanced."[11]

The attitude in which I have placed him, though erect, is quite different from that given to the portrait of Washington. He stands in a legislative hall with a roll of paper in his left, and a pen in his right hand, and with one foot elevated upon a step of the small platform immediately in front of the speakers desk. His well known personal singularity in regard to costume has given me some little advantage in aid of the picturesque. In conversation with his old and intimate friend Gov. Coles, I learned that when he did not wear the scarlet vest he sometimes draped himself in a long light reddish brown frock coat reaching almost to his ancles, and instead of the then common shoe with the silver buckle, he wore an invention of his own which he styled the *Jefferson* shoe, and which resembled very closely the present gaiters worn by ladies.

His object in useing so much red in his apparel appears to have been to counteract the effect of a similar hue in his hair. Availing myself of these facts of dress, I am enabled to make his portrait, in some respects, a complete contrast to that of Washington and to avoid the repetition in it of any thing contained in the latter.[12]

Both portraits must have been finished by mid-July, 1858, for Bingham at that time ordered frames made for them in Düsseldorf.[13] He intended to ship the pictures to Jefferson City as soon as the

[9] Düsseldorf, June 3, 1857 (*ibid.*, p. 351).
[10] Bingham to Rollins, Düsseldorf, October 12, 1857 (*ibid.*, p. 357). Rollins apparently kept the press informed about the works in progress: the Liberty *Weekly Tribune* of December 18, 1857, and the Fulton *Telegraph*, as reprinted in the Columbia *Missouri Statesman* of the same date, spoke of the two full-length portraits as well as of *The Jolly Flatboatmen in Port.*
[11] "Letters," *Mo. Hist. Review*, Vol. XXXII, pp. 344, 357.
[12] *Ibid.*, pp. 359–60.
[13] Bingham to Rollins, Düsseldorf, July 18, 1858 (*ibid.*, p. 364). "L," writing a letter from Düsseldorf dated August, 1858, to *The Crayon*, Vol. V. (October, 1858), 292, reported "His full lengths of Washington and Jefferson are finished."

frames were ready and expected to be in Missouri as soon as the portraits. He did not, however, arrive in the state capital until late in January, 1859. On opening the box shipped from Germany, he found both portraits in good condition, but the frame for the *Washington* so badly damaged that he had to send it to St. Louis to be repaired.[14] A few days later the *Jefferson* was hung in the lower house and the *Washington* in the senate some weeks after.[15]

In the fire that destroyed the capitol in 1911, the Washington and the Jefferson portraits, as well as those of Jackson and Clay painted in 1860, were burned. The copy of the Stuart head of Jefferson, however, was saved. Floyd C. Shoemaker has told how Senator Michael E. Casey of Kansas City rescued this badly damaged canvas in the fire and how Senator Allen McReynolds traced it many years later and obtained it for the State Historical Society of Missouri, where, cleaned and restored, it now hangs.[16] What happened to the study for the Washington portrait is not known.

In a letter to Rollins from Düsseldorf, March 8, 1858, Bingham had suggested painting Andrew Jackson and Henry Clay for the Missouri capitol. "Perhaps the Legislature if in a good humor, may be induced, when these [*Washington* and *Jefferson*] are seen in their places, to give me an order for a full length of Gen Jackson, on the

[14] Bingham to Rollins, Jefferson City, January 23, 1859 ("Letters," *Mo. Hist. Review,* Vol. XXXII, p. 367). The frames, packed for transportation in Germany, were to cost $71 each, which Bingham estimated to be half their cost in St. Louis. He thought he was not bound by his contract to furnish frames, but the legislative committee insisted he was. Eventually, a bill was passed in the amount of $320 to reimburse him for the frames and for the customs duty imposed ("Letters," *Mo. Hist. Review,* Vol. XXXII, pp. 364, 368, 369, 372).

[15] Jefferson *Weekly Inquirer,* February 5, 1859; Liberty *Weekly Tribune,* March 18, 1859.

[16] "Remarks on Senator Allen McReynolds and the Bingham Portrait of Thomas Jefferson," *Missouri Historical Review,* Vol. XLVIII (October, 1953), 43–44. In 1858, thirteen-year-old Clara Bingham embroidered a bust portrait (24″ x 14″) of George Washington after her father's painting. The proud Bingham carried it to Jefferson City with him. In return for "the many marks of respect and kind consideration" shown him by the legislature, he presented Clara's needlework picture to the House of Representatives on March 12, 1859. He had had it framed in Philadelphia, "in a chaste and beautiful manner, and it hangs," he told Rollins, "just above the chair of the Speaker, a position to which it is admirably adapted." In its turn the House paid Clara the compliment of authorizing a testimonial gift. Clara's *George Washington,* it has been asserted, was saved in the 1911 fire, but its present location is unknown. (Bingham to Rollins, Jefferson City, March 13, 1859, Columbia, March 21, 1859 ["Letters," *Mo. Hist. Review,* XXXII, pp. 372–75]; Rusk, *Bingham,* 70 n.)

back of which, one for Clay will not come amiss."[17] In mid-February, 1859, the legislators, obviously in quite a good humor, commissioned Bingham to paint the western political leaders for a fee of $3,500.[18] Apparently he did not begin these paintings until January, 1860, after his return from the second trip to Europe.

Not a man to be idle, Bingham devoted his spare moments that spring in Missouri to portraiture. "I am very buisy finishing portraits," he wrote to Rollins from Jefferson City on March 13, 1859, "and expect to complete all by next Friday."[19] From the state capital, after a few days in Columbia, he went to Kansas City, where he had "promised to paint some portraits" which he thought might detain him for a month.[20] It must have been at this time that he painted the superbly effective portrait of Dr. Benoist Troost (Plate No. 57), and the commonplace one of Mrs. Troost, now in the Nelson Gallery of Kansas City. Late in April he was reported painting portraits in Brunswick, Missouri.[21] The portraits of Mr. and Mrs. Elijah S. Stephens of Columbia are also assigned to this year.

Besides the Jackson and Clay portraits he obtained this spring another substantial commission. In February, he had given to the St. Louis Mercantile Library his working copies of the heads of George and Martha Washington.[22] In May, he was asked by the library's Board of Direction to paint a full-length portrait of Baron von Humboldt for $1,200. On May 8, he left St. Louis for New York[23]

[17] "Letters," *Mo. Hist. Review*, Vol. XXXII, p. 363.

[18] Bingham to Rollins, St. Louis, February 19, 1859 (*ibid.*, p. 368): *Journal of the Senate* (1858–59), 241; *Journal of the House of Representatives*, 275, 293; *Laws of the State of Missouri, 20th General Assembly, First Session, 1858–1859*, 58–59. Henry Lewis, in Düsseldorf, writing to his brother in St. Louis (March 15, 1859), said: "We have had letters here from Bingham announcing his extraordinary success in obtaining an order for *two more portraits* for 3500$ making together 7000$ for what many a better artist in the States would have been glad to have done for 2000 or 500$ apiece. But I am glad he has got them, he is a good fellow, and has a wife and family to support, &c. He will paint them pictures, that will satisfy the taste of our learned Legislators in Art Matters. The whole affair was managed by lobbying, and thro' the influence of a great friend he has there, a Major Rollins—"

[19] "Letters," *Mo. Hist. Review*, Vol. XXXII, p. 373.

[20] Bingham to Rollins, Columbia, March 21, 1859 (*ibid.*, pp. 373–74).

[21] Columbia *Missouri Statesman*, April 22, 1859, quoted in Rusk, *Bingham*, 70.

[22] "Letters," *Mo. Hist. Review*, Vol. XXXII, pp. 370, 371; *Annual Report of the St. Louis Mercantile Library Association for 1859*, 24.

[23] Bingham to Rollins, St. Louis, May 8, 1858 ("Letters," *Mo. Hist. Review*, Vol. XXXII, pp. 375–76); *Annual Report of the St. Louis Mercantile Library Association for 1859*, 25.

and a month later was with his family, who had remained in Düsseldorf. He planned to put Clara and Horace[24] in school in Belgium to learn French, then to go to Berlin to make studies for his portrait of Humboldt. By a coincidence the ninety-year-old naturalist had died on the very day that Bingham in St. Louis had received the commission to paint him. "I am assured that there will be no difficulty in finding portraits of him there [Berlin]," he wrote to Rollins from Düsseldorf on June 6, 1859. "I will make an original picture in all except the head and intend to place him in his study, engaged upon his last great work, and surrounded by his favorite authors."[25]

It is clear that Bingham did no more than make preliminary studies at this time, for on March 9, 1860, the Liberty *Weekly Tribune* reported his presence in Columbia and his intention "at a very early period to commence the portrait of Humboldt." If this report was true, he now worked fast, for the painting was delivered to the Mercantile Library late in April.[26]

The immortal old man stands erect in an easy and dignified posture, in the plainly furnished library where . . . he spent most of his time. . . . [He is] dressed in a suit of plain black, his coat buttoned closely around his waist; a neck-cloth rivalling in whiteness the snowy hair that crowns his head, wrapped about his neck, and gathered into his bosom, and a cross of honor glittering on his breast. He holds on his left arm and hand a large open volume whose leaves he is quietly turning with his right hand. At his side is a plain oaken desk, on which are laid negligently several volumes, taken from the unobtrusive book case in the room, and behind him is a plain cushioned arm chair, and on the wall to the right is a portrait of Columbus.[27]

The *Humboldt* hung for many years in the Mercantile Library. At some time after the new library building was completed, the portrait suffered such damage from a fall that it had to be discarded. Only the head (approximately 12″ x 13″) was saved; this is now in

[24] Horace had been left at school in Missouri when the Binghams went to Europe in 1856. The following summer, Bingham sent word to the boy to join them. Horace sailed from New York October 5, 1857 ("Letters," *Mo. Hist. Review*, Vol. XXXII, p. 358).

[25] *Ibid.*, p. 485.

[26] St. Louis *Evening News*, April 27, 1860 (Rusk, *Bingham*, 72); *Annual Report of the St. Louis Mercantile Library Association for 1860*, 20.

[27] St. Louis *Evening News*, June 29, 1860 (Rusk, *Bingham*, 72).

the Bingham Collection of the State Historical Society of Missouri at Columbia.[28] The full-length portrait is known today solely through a photograph of the Mercantile Library reference room made soon after the new building was opened in 1888 (plate No. 58).

The death of Mrs. Bingham's father on June 12, 1859, cut short the artist's second visit to Europe. Nothing was accomplished on the Jackson and Clay commissions. The Binghams were home in Missouri early in September.[29] On January 9, 1860, in Washington, Bingham examined the head of the Sully portrait of Andrew Jackson in the home of Captain Samuel P. Lee, U.S.N., brother-in-law of Frank P. Blair, Jr., of St. Louis. Painted "when the old hero was in the prime and vigor of life . . . it suits my design admirably, and as it is kindly placed at my service, I will made a careful copy of it, as soon as I can find a suitable place to work in."[30]

By mid-September, in Kansas City, he had "just completed by far the most difficult work of the two, the eqestrian [*sic*] portrait of Jackson." In it "the old hero, is represented as mounted on a charger, waving his hat, and cheering his army on to victory."[31] Bingham was quite satisfied with what he had accomplished:

My portrait of Jackson will be pronounced by connoisseurs and the public, immeasurably superior to any similar work in the United States, the great Statue in Washington, by Clark Mills, not excepted. The window of my Studio commands the main avenue leading from Kansas City towards New Mexico, through which thousands of horses oxens and mules are almost daily passing, and I have thus had an opportunity for observation by which I have been able to make the Charger of the Old Hero as near perfection as possible. The jockeys who attended our County Fair last week all admit that he would have taken the premium from any animal in the ring. But however perfect in symetry attitude and muscular development the horse may be regarded, the Spectator will perceive, at a glance, that the still nobler rider fully maintains his proper prominence as the chief object of attraction, and that the single spirit of the conquerer of the veterans of Wellington manifests itself in all the subordinate elements of the picture.[32]

[28] *Mo. Hist. Review*, Vol. XLVII (October, 1952), 69–70.
[29] Rusk, *Bingham*, 73, citing *Missouri Statesman*, September 9, 1859.
[30] Bingham to Rollins, Washington City, January 9, 1860 ("Letters," *Mo. Hist. Review*, Vol. XXXII, p. 494).
[31] Jefferson *Weekly Inquirer*, January 12, 1861.
[32] Bingham to Rollins, Independence, September 15, 1860 ("Letters," *Mo. Hist. Review*, Vol. XXXII, p. 495).

Although he had been "compelled occasionally to take temporary leave of 'Old Hal' and 'Old Hickory' to provide the wherewithall to feed and clothe us,"[33] he explained to Rollins on November 27, "I have been now for some weeks constantly engaged upon my portrait of Clay and expect with good luck to have it completed in about three weeks more. I feel very confident that neither of the portraits will fall behind the expectations of my most sanguine friends. . . . These large works I find better adapted to my powers than the small cabinet pictures upon which I had been previously employed."[34]

Bingham was anxious now to have the finished portraits at the opening of the session of the legislature and "to fire the Hickory boys by putting up the portrait of Jackson on the eighth of January."[35] He met his self-imposed deadline. "My Portraits of Clay and Jackson were placed side by side in the Hall of Representatives during the night of the 7th, and from all who loved their country, elicited spontaneous tokens of admiration during the Celebration of the 8th," he wrote to Rollins on the twelfth. Called upon without warning to make a speech, Bingham "made the Union and the *Star Spangled Banner*" his theme. "I have infuriated all the traitors by boldly avowing my love for my Government which they were conspiring to destroy."[36] One result was that "they seem disposed to withhold, as long as possible, a judgment on my pictures, thinking no doubt they are punishing me."[37] Were it not for his indebtedness to Rollins' bank, he was inclined to take the paintings immediately to St. Louis, where "I believe their exhibition for two weeks would yield me more than the sum which the State is to pay me for them."

The legislature granted the permission to exhibit which he presently sought, but he did not get it without an attack by Senator Thompson of Clay County, who made, said Bingham, "an exposition

[33] He had noted one such instance two months earlier; writing from Independence on September 15, he had told his friend: "I am here for the present painting two or three portraits, but will return to Kansas [City] next week (*ibid.*, p. 496).

[34] *Ibid.*, p. 497.

[35] *Ibid.*, p. 498.

[36] *Ibid.*, pp. 505–506 Jefferson *Weekly Inquirer*, January 12, 1861.

[37] A resolution ordering the auditor to pay Bingham was approved on January 19, 1861 (*Laws of the State of Missouri, 21st General Assembly, Regular Session, 1860–1861*, 772–73.

of his ignorance, stupidity, vulgarity and malignancy."[38] Speaking on the floor of the Senate, Thompson confined himself chiefly, reported the Liberty *Weekly Tribune* on February 1, to "equine aesthetics":

Why, sir, this horse of Jackson is not fit to be hired out. If a livery stable man was to hire out to the Senator such a horse, he might sue him for damages and recover it. . . . No man who ever rode a horse expected that Jackson would be put on such a horse as that. We had a right to understand that the artist would make a picture of Jackson as he looked at New Orleans. Now, if my memory serves me, Jackson never had a red cloak flying about him at all. In this picture the horse has stopped, and Jackson is looking back on the enemy. Now, if this battle took place on level ground as it is said to have been, the horse don't stand on the ground at all. The fore leg of the horse looks as if it had been lying out on the prairie for six months and the wolves had been gnawing it. Jackson rode a Pecquotil horse. This horse has a little round leg, with no strength in it, and no room for muscle; it has a little slim neck, not thicker than my arm, and a mane on both sides of it. And I never saw a horse, in good health, that had not hair on his backbone close up to the body; but this horse has not got it. Why, if the Senator from Callaway was to go to the livery stable and have such a horse offered to him, he would turn away in one grand despise.

Of "Old Hal" the critical senator had not much to say except that, though it had been his good fortune to have seen the Kentuckian often, he "had never seen that great statesman painted before, standing with a vermifuge almanac in his hand."

At St. Louis, Bingham found conditions for exhibition not so propitious as he had expected. He informed Rollins that

Every thing appears to be in such a depressed condition that I cannot expect to clear much beyond the expenses of the Exhibition. It will be to my interest, however, to give the public the opportunity to see them. Thompson of Clay is such a low dirty dog that I feel humiliated even at the bare idea of being compelled to handle him in any manner whatever. I made him confess himself a liar in the presence of Newland & Wilson, and it appeared a degradation, to which habit had rendered him so familiar that it had no power to bring even the slightest blush to his face. I regard him as the mere instrument of others—of *traitors* who are plotting the overthrow both of our State and Federal government, and who would

[38] Bingham to Rollins, St. Louis, January 29, 1861 ("Letters," *Mo. Hist. Review*, Vol. XXXII, p. 507).

procure the assasination, if necessary, of any one whom they deemed an obstacle in the way of the accomplishment of their hellish purposes.[39]

In the middle of February, Bingham put up the Jackson and the Clay portraits in the small hall of the Mercantile Library Association, "but in consequence of the daily and nightly political meetings in every part of the City" he deemed it best not to exhibit them until after the election. Arrangements were concluded to open them to the public on the evening of Washington's Birthday in the large hall of the library building "in which there will then be a gathering of the citizens to celebrate the birthday of the Father of his Country." What happened next is not clear. Word reached Bingham that his brother Matthias, a bachelor, had died in Texas, and on March 6 the painter set off for New Orleans to see about the settlement of his estate. Presumably, after a period of display, *Jackson* and *Clay* were returned to the state capitol, for these two portraits, as already noted, were destroyed in the fire of 1911.[40]

Much as he preferred to work on large canvases and much as he was gratified by the fees they brought on completion, immediate necessity, we have seen, forced Bingham to take every sitter who offered. In September, 1860, he went over to Independence to paint "two or three portraits," and in Kansas City in October and November he interrupted work on the Jackson and the Clay commissions to paint fellow citizens who would pay on delivery. At this period, Dr. Rusk suggests, Bingham painted his wife Eliza, Odon Guitar of Columbia, Samuel L. Sawyer of Independence, and James L. Minor of Kansas City.[41]

With the opening of the war, the portrait business fell to nothing. Bingham found himself out of employment. "Art is far below every thing else in such times as these," he wrote to Rollins from Kansas City on June 5, 1861.[42] By 1862 conditions were more stable. Bingham was now state treasurer, but apparently found time occasionally to paint. To this year are credited the portraits of his sister-in-law, Mary

[39] Bingham to Rollins, St. Louis, February 2, 1861 (*ibid.*, p. 509).

[40] Bingham to Rollins, St. Louis, February 17, February 20, March 6, 1861 (*ibid.*, pp. 511, 512, 513).

[41] *Ibid.*, pp. 496, 497; Rusk, *Bingham*, 123.

[42] "Letters," *Mo. Hist. Review*, Vol. XXXII, p. 517.

Piper, and of her husband, James, as well as those of the artist's close friend, R. B. Price of Columbia, of Mrs. Price, and of his father, Dr. Edwin Price.[43] After 1862 few portraits are attributed to Bingham throughout the remaining war years. As the months went by, he found, the "business of my office has vastly increased and keeps me so constantly engaged that I scarcely have time to do, or think of any thing else. Unless the Salary shall be doubled I do not think any one qualified for the office will hereafter seek it."[44]

Certain pictures of women painted during the years reported in this chapter call for particular notice, for they illustrate new ranges in Bingham's portraiture. The use of color in the *Portrait of Susan Howard Hockaday and her daughter Susan* (1859?)[45] suggests that the painter had absorbed new ideas on his recent visits to Philadelphia and New York or during the two months spent in Paris in 1856. This double portrait (Plate No. 59), of half-length, seated figures, so carefully composed in every detail, could as well be called *Study in Pink and Blue.* A year later, at Columbia, Bingham painted a somewhat similar subject, *Portrait of Mrs. Robert L. Todd and Daughter,* in which the prime interest again is in composition. The heads are well if not flatteringly painted, but the attention to arrangement of composition, to drapery and detail, shows the artist more concerned with picture than with likeness of sitters. A third unusual portrait is that of Mrs. Thomas W. Nelson (Plate No. 60), which Dr. Rusk assigned to 1862.[46] As early as 1840 in the portrait of Sallie Ann Camden, Bingham had made use of an outdoor background, but such ventures were rare with him. Mrs. Nelson, in a dark green, close-fitting riding habit, is seated on a horse which is not shown; behind her is an attractive wooded landscape, and to the left we see the head of the horse of her riding companion.

The Thread of Life (1862?) is not a portrait, but an allegorical picture, the only one Bingham is known to have made (Plate No. 61).

[43] Rusk, *Bingham,* 74, 124.

[44] Bingham to Rollins, Jefferson City, December 21, 1863 ("Letters," *Mo. Hist. Review,* Vol. XXXIII, p. 62). For a summary of his service as treasurer see Rusk, *Bingham,* 81–82.

[45] The date assigned to this portrait by the owner (1857) is not possible, since Bingham was then in Europe. It must have been painted very early in 1856 or in the spring of 1859—I think the latter.

[46] Rusk, *Bingham,* 74.

Dr. Rusk has suggested that it was painted sometime after the birth of Rollins Bingham in September, 1861: "It seems probable that the picture may have been suggested by this occasion, particularly as the woman represented, though somewhat idealized, resembles the portrait [1860] of the second wife closely enough that we may consider her to have been the model."[47] The painter shows a woman, in classical drapery, seated on a bank of clouds borne on the wings of an angel. An infant standing on her lap draws a thread from a distaff at her side. The color scheme—pale tints of blue, pink, and ivory—gives charm which is lost in black and white reproduction.[48]

15. CIVIL WAR AND MARTIAL LAW, 1861–1879

In the incident at the time of the hanging of the Clay and Jackson portraits we have seen how outspoken Bingham was against secession. With the outbreak of trouble in Missouri he was quick to work for the Union. Active in recruiting men for a company of volunteer guards in Kansas City, he was elected captain of the unit when it was mustered in, and served until January 4, 1862, when he was appointed state treasurer to fill the place of A. W. Morrison, who had refused to take the oath of loyalty. Although it was not an office particularly to his taste, he served until 1865.[1]

What Bingham actually painted during the war cannot be determined. *General Nathaniel Lyon and General Frank P. Blair Starting from the Arsenal Gate in St. Louis to Capture Camp Jackson* (c. 28″ x 26″) may have been done in 1862 (Plate No. 62). The double portrait presents Lyon in the foreground on a white horse and Blair beside and beyond him on a black horse, with other mounted figures beyond them. The capture of the state militia encamped at St. Louis saved the important United States arsenal there from Southern seizure and kept Missouri in the Union, but this conventional picture

[47] Rusk, *Bingham*, 75.

[48] It is mere speculation to suggest an influence here of Bingham's months at Paris. At the Louvre, for instance, he could have seen Pierre-Paul Prud'hon's *L'Enlèvement de Psyché* and *La Sagesse Ramenant la Vérité;* elsewhere in Paris, his *La Fileuse.* But we do not know what he actually saw, for we have but the one letter from Paris in which he merely mentioned going to the Louvre.

[1] "Letters," *Mo. Hist. Review,* Vol. XXXII, p. 520; Vol. XXXIII, p. 62; *Missouri Republican,* May 25, 1862; Rusk, Bingham, 78–82.

celebrating that important Federal operation is more notable for its patriotic impulse than its artistry.[2]

On August 10, 1861, exactly three months after the capture of Camp Jackson, Lyon was killed in battle. His death was commemorated in another Bingham painting, which unhappily was destroyed in the capitol fire of 1911. Although he contracted on August 1, 1863, to paint an equestrian portrait of the general for the state capitol, he did not actually undertake it until after the war. A small study for it was completed by November, 1865. The finished painting, placed in the Senate chamber in March, 1867, represented "Gen. Lyon at the battle of Wilson's Creek leading his men into action, riding his favorite dapple grey, which was killed under him in the fight." For this canvas Bingham received $3,000.[3]

Another picture derived from the aftermath of war. This was the portrait of a Baptist minister named Dean, "late Major in the army of the Union, as he appeared in his cell in the jail at Independence," where he was imprisoned for preaching without having taken the oath of loyalty. He had been brought, declared the *Independence Sentinel*[4] "to this place from the enlightened county of Cass, and lodged in jail 'because the jail in that county was thought insecure' for so dangerous a criminal." Bingham's indignation at this unjust behavior by the victorious Radicals moved him to action. In his picture, "the preacher, serious and composed, sits in the corner of his cell beside a heavily barred window through which the light falls upon an open book which he reads. At his feet lies a Baptist Journal; and a blanket, together with a bare mattress, fills out the space and completes a well-balanced composition."[5]

The *Sentinel*, in announcing this work in progress, stated that the picture Bingham was then (July, 1866) engaged in painting "will, beyond all doubt, be one of the most popular that has even emanated from his brush." These are large terms to describe a little oil on paper, fourteen inches square, even though, as Dr. Rusk has said, it is "re-

[2] Lyon at this time was still a captain in the United States Army. His appointment by Lincoln as brigadier general of volunteers was not made until May 31.

[3] Rusk, *Bingham*, 81, 89; Liberty *Weekly Tribune*, March 8, March 15, 1867; Bingham to Rollins, Independence, March 26, 1867 ("Letters," *Mo Hist. Review*, Vol. XXXIII, p. 63).

[4] As reprinted in the Liberty *Weekly Tribune*, July 6, 1866.

[5] Rusk, *Bingham*, 87.

markably carefully and minutely finished for work on such scrappy, perishable material."[6] I suggest, therefore, that the small picture called *Major Dean in Jail* (Plate No. 63), is a study for a large, impressive oil that was probably never painted, since nothing more is ever heard of it.

In *Major Dean in Jail*, Bingham used portraiture to carry message. The first indication, however, that he would eventually turn from genre to moral pieces is found a decade earlier. Before leaving for Europe, he wrote to Rollins from Philadelphia (August 10, 1856) that, after he had completed the Washington and Jefferson portraits for the state capitol, he had it "in contemplation to paint a new series of pictures illustrative of 'Squatter Sovereignty' as practically exhibited under the workings of the Kansas Nebraska bill. I shall commence with the March of the *'Border Ruffians,'* and will take pains to give those infamous expeditions of organized rowdyism all those odious features which truth and justice shall warrant."[7] The detachment, the pleasure of seeing people simply as people, the quiet good-nature of the Election series is to give way in the new project to desire to reprove and correct, to editorialize, to lash out at particular evil-doers. "I shall want a portrait of Col Samuel Young, of the big negro that played the violin, and of a certain methodist parson. As I design to give this trio the most conspicuous position upon the canvass, cannot you manage to forward them to me. . . . I wish you also to forward to me all the documents in relation to these affairs in Kansas, the evidence taken by the congressional committee &c."[8]

At Düsseldorf (October 12, 1857), we find that he was still thinking about his "purpose of doing justice in the way of Art, to our *far famed* 'border ruffians.' " Would Rollins send him "enclosed in a letter, the most graphic account, extant of one of their most conspicuous forays."[9] But it came to no more than thinking, for there is

[6] According to Dr. Rusk, a piece of drawing paper about 9 x 11 inches had been so spliced and pasted on cardboard as to make a square of 14 inches.

[7] When the Kansas-Nebraska Act in 1854 left the decision about slavery to the settlers of those territories, both Abolitionists from the East and slaveholders from Missouri rushed in to gain control. This "squatter sovereignty" led to border warfare, the most recent account of which is Jay Monaghan's *Civil War on the Western Border, 1854–1865*. The "Border Ruffians" were from Missouri.

[8] "Letters," *Mo. Hist. Review*, Vol. XXXII, p. 201.

[9] *Ibid.*, p. 357.

no further reference to the proposed *March of the Border Ruffians*. The spirit, however, that moved Bingham to consider it was the same that led him to paint his indignant *Order No. 11*.

It is ironic but not surprising that Bingham, hot against the Missouri Border Ruffians in 1856, should be violently roused during the war by certain activities on the Union side. The Jayhawk raids into western Missouri led by the notorious Colonel Jennison early in the war outraged his sense of justice and right and moved him to furious denunciation of the Kansan. "If Jennison were brought to trial and punished as he deserves to be," Bingham wrote to Rollins, then a member of Congress, on January 29, 1862, from Jefferson City, "it would do more for the Union cause in the western portion of our State than the presence of a Union army. It would be *right* as a matter of Justice to the scoundrel, and an economical aid in weakening and destroying the rebellion. If he were *hung*, [Sterling] Price [Southern commander in Missouri] would lose thereby the best recruiting officer he ever had."[10] Bingham pushed for a Congressional investigation of Jennison. In compliance with a wish expressed by Rollins and William A. Hall, another representative from central Missouri, Bingham on February 12 wrote them a lengthy letter setting forth in detail the record of Jennison's atrocities and concluding that "an authorized inquiry into his conduct, as an officer, will show, that the above statements fall immeasurably short of the full sum of his villanies."[11]

This was but the beginning of the battle. Jennison did fall temporarily into disgrace, though eventually he was restored to service. On reading an article in the St. Louis *Missouri Democrat*, early in May, "lauding the notorious Jennison and denouncing his arrest," Bingham launched a vigorous two-column attack in the St. Louis *Missouri Republican* (May 6, 1862), repeating and enlarging upon what he had written to Rollins and Hall in February. Ten days later the Columbia *Missouri Statesman* noticed with approval that "Mr. Geo. C. Bingham, State Treasurer, and as honorable and loyal a citizen as ever lived, is out in a scathing expose of the robberies, raids, murders and jayhawking of Jennison. It is a long but terribly

[10] *Ibid.*, Vol. XXXIII, p. 46
[11] *Ibid.*, pp. 50–58.

severe and, we doubt not, a truthful document and cannot fail to have a very damaging effect upon this prince of buckanies."[12] Jennison had the effrontery at this time to seek in Washington a commission as brigadier general of volunteers and the command of the Department of Kansas. Bingham's letter was reprinted as a pamphlet and circulated in Washington.[13] Jennison, for his part, sent a strong denial to the *Missouri Democrat* (May 21) and countered with an attack on Bingham. This in turn drew an answer one and one-half columns long in the *Republican* of the twenty-fifth, in which Bingham not merely refuted Jennison's charges but reaffirmed his public denunciation of Jennison, bluntly labeling him liar, coward, and scoundrel.[14]

Jennison, after all, was only a Kansas redleg raiding across the border, a vicious but common criminal as Bingham saw him. General Thomas Ewing, issuing his General Order No. 11 on August 25, 1863, was military authority on the western border. His proclamation ordering from Jackson, Cass, Bates, and Vernon counties all citizens loyal or otherwise, excepting only those living in certain areas near the large towns, with the resulting destruction of their homes and all effects they could not carry away, inflamed Bingham as an act of unwarranted brutality and injustice. Outraged by the severity of the order, Bingham protested to Ewing without avail and is said to have closed the interview by declaring, "If you persist in executing that order, I will make you infamous with pen and brush as far as I am able."[15] Much of his energy in the remaining years of his life Bingham devoted to this purpose. By November, 1865, released from the time-consuming duties of his office, he had "taken as a subject for his brush, Order No. 11, issued by Gen. Ewing."[16]

According to his friend Colonel R. B. Price, Bingham began the painting, which he at first called *Civil War*, on a wooden panel

[12] Rusk, *Bingham*, 79.

[13] *Missouri Republican*, May 18, 1862.

[14] Eventually Jennison's record caught up with him. On July 23, 1865, he was court-martialed and found guilty of arson, robbery, embezzlement, neglect of duty, and disobedience of orders and was dishonorably dismissed from the service (Rusk, *Bingham*, 80).

[15] Rollins, "Some Recollections of George Caleb Bingham," *Mo. Hist. Review*, Vol. XX (July, 1926), 480.

[16] Liberty *Weekly Tribune*, November 24, 1865; Kansas City *Journal*, as quoted in *Missouri Statesman*, November 24, 1865.

(actually on a cloth stretched over a panel), but when it started cracking, he prepared a linen tablecloth for a canvas and set to work anew.[17] The second try was finished and exhibited in 1868.[18] To drive home the bitter lesson which had made him paint the subject, he determined to publish it. He now turned back to the unfinished "wood panel" in order to have a sample to show prospective subscribers. "I have nearly completed my duplicate of the 'Civil War,'" he wrote from Independence to Rollins on March 8, 1870, "and will be ready by 1st of May to exhibit it for procuring subscribers to the engraving."[19]

The "tablecloth" painting (No. 1—54⅞" x 78") presently became the property of James Rollins and eventually passed to the State Historical Society of Missouri (Plate No. 64). The "wood panel" (No. 2—55" x 77½") remained in Bingham's estate until, at the sale held in the Findlay Art Rooms in Kansas City in 1893, it was acquired by J. W. Mercer of Independence. According to the Boonville *Weekly Advertiser* (June 14, 1901), there was "another copy" in St. Louis. Could this last possibly have been the "revised studies" which Bingham had sent Sartain before March 8, 1870, and before the completion of No. 2?[20] Perhaps it was the "replica or study" (No. 3—18" x 24") that Dr. Rusk listed in 1917 as belonging to R. W. Thomas of Kansas City. Nos. 1 and 2, as Dr. Rusk pointed out in her monograph, are closely alike. A "few differences ... do occur, in such details as the position of the head of the prostrate young woman in the foreground and the costume of the woman with her arms about her father,"[21] but these are indeed minor divergences. The engraving (to which I shall return) was made from the "tablecloth" painting.

The intense moral indignation of the artist which caused and characterized *Order No. 11* is apparent in his own description of it:

The principal group in the foreground of the picture chiefly con-

[17] A note by the editor of the *Missouri Historical Review* appended to Simonds, "Missouri History as Illustrated by Bingham," Vol. I (April, 1907), 190.

[18] Rusk, *Bingham*, 84. Bingham's letter in the Jefferson City *Weekly People's Tribune* of December 23, 1868, implies that the painting was on exhibit before Thanksgiving Day, since it served for the subject of a denunciatory sermon delivered that day.

[19] "Letters," *Mo. Hist. Review*, Vol. XXXIII, pp. 65–66.

[20] *Ibid.*, p. 66.

[21] Rusk, *Bingham*, 84.

sists of a venerable patriarch and his family, who have just been ejected from their dwelling, which is about to be committed to the flames.

A daughter clings to the defiant form of the old man, imploring him to temper his language so as not to incur the vengeance of the brutal assassin, who, in the act of drawing a pistol, threatens him in front. Another daughter is on her knees before this wretch, vainly endeavoring to awaken some emotion of humanity in his callous breast. A married son lies weltering in his blood, his young wife bending in agony over his lifeless body. His murderer is seen in the scowling ruffian nearby with a discharged pistol in his hand. The aged mother has fallen in a swoon, and is supported in the arms of a faithful negro woman. A negro man retires weeping from the scene, accompanied by a negro lad, whose face bears the unmistakable marks of fright and horror.

Immediately in the rear of the outraged family the myrmidons of Kansas, aided by their criminal allies in Federal uniform, are busily engaged in the work of pillage. Some of them on horseback, have already encumbered themselves with spoil. Wearing apparel, household furniture and everything portable is being placed in wagons, a long train of which well freighted with plunder, is seen in the distance, wending its way westward, while a melancholy procession of dejected and impoverished refugees fleeing from their desolated homes file off to the right in an opposite direction. The outhouses, barns, &c. of the family mansion are in flames, and dense columns of smoke therefrom cast their broad shadows over the landscape. The military edict thus cruelly enforced was directed not against rebels, or citizens charged with any crime, but against "all persons," regardless of age, sex, condition or character, residing within the designated limits.[22]

Exhibition of the picture (successively known as *Civil War, Martial Law,* and *Order No. 11*) provoked violent controversy. The earliest attack was made at Independence, Missouri, by a Reverend R. S. Johnson, who, on Thanksgiving Day, 1868, declared it "a departure from moral law" and its representation of facts "no better than falsehood." In a rejoinder more than two columns long Bingham denied that he had placed blame on the people of Kansas, but rather on the scoundrels, largely from Kansas, who had formed the supporting force. The picture "simply represents the operation of a tyrannical and brutal military order, and places the chief responsibility, for the outrages resulting therefrom, upon its author."[23]

[22] Louisville *Journal,* September 6, 1873.
[23] Independence *Sentinel,* as reprinted in the Jefferson City *Weekly People's*

Early in March, 1869, Bingham arrived at the Planters House in St. Louis with his *Civil War*. The *Republican* praised the picture.[24] The *Daily Democrat* was violent in condemnation of the painter and undertook to pronounce on the duties of an artist:

Good men should strive to heal all the bitterness of the past, and learn to forget its harsh features. Mr. Bingham, however, has chosen to do differently, and in our view has done no credit to himself as a man, while he has desecrated his art to perpetuate a diseased idea of an historical event. The picture is not true to the sentiment of the times, nor to the facts. Union military men were not the brutal, repulsive and soulless beings he has pictured. . . . The mission of true art is to exalt emotions, kindle pure purposes, and inspire to nobleness. Mr. Bingham's "Civil War" is separated from these ends by the breadth of the moral universe.[25]

Bingham was never a man to take an attack lightly. Having taken a stand in a matter of justice, he was hot in support of it. He now wrote to the *Republican* a "stinging" reply to the *Democrat:*

The writer either wilfully misrepresents or wholly misapprehends my design in placing upon canvass one of the most memorable incidents of the war. Whatever may have been the motive which prompted the promulgation of "Order No. 11," it is very certain that it had no basis in law, justice or humanity. The effect of it was not only the depopulation, but

Tribune, December 23, 1868. Bingham was ready to concede, with his customary bluntness, that on the score of morality Kansas "at present" greatly exceeded Missouri: "Whatever may be alleged to the discredit of the State of Kansas it cannot be said that she has thus been disgraced. Her people have made no laws to protect thieves from the penitentiary, murderers from the gallows, or to close her courts against honest men who seek redress for the wrongs which such characters inflict. Horse thieves have operated extensively within her borders, but when caught they have generally received a short shrift, followed by a speedy elevation on a platform on which their chief dependence for support was from above. Here, in our State, we are abundantly favored with thieves of every variety and description, from those who rob hen roosts and steal horses up to those who steal churches and railroads, and who are elevated, not to such air baised [*sic*] positions as are awarded to their brethern in Kansas, but to State offices of every grade from registrar up to Governor. To steal a horse, plunder a store, rob a negro or a *soldier* evinces just such ability as is required in the office of *registrar*, but to be Governor, a capacity must be exhibited to pocket a prize, equivalent at least to two or three railroads. So you see, Sir, as honest men, we have enough to make us blush at home without going abroad to find fault with our neighbors." The people of Kansas "make laws to punish her rascals," but "the rascals of Missouri make laws to punish her people."

24 March 7, 1869.

25 March 11, 1869.

the desolation of one of the fairest and most highly cultivated districts of our State. The people, indiscriminately, were compelled to abandon their homes—men, women, and children. Their dwellings were plundered and then burned to the ground. Their farming utensils, their household goods, their stock, and every species of portable property, were seized and taken into Kansas, and appropriated to the private uses of their plunderers. . . . the design of my picture is not "to perpetuate a diseased idea of an historical event" . . . but to present its severe and rugged features in the enduring forms of art, and thus hand over to eternal infamy the perpetrators and defenders of outrages which scarcely find a parallel in the annals of the most barbarous ages. . . .

The scene in the picture is but one of hundreds of a similar character, and the charred remains of broken walls and solitary chimneys yet to be seen all over that fearfully desolated region attest the truth of my delineations, and would cause any other than the art critic of the Democrat to blush in attempting to discredit them.

To classify the brutal actors in such scenes as "Union military men" is an insult to every honest soldier who periled his life in defence of his flag. They were the "Red Legs" of Kansas, and their equally demonic associates, known only as thieves and assassins. . . .

I am sorry to perceive that the critic still retains a fraternal regard for the wretches whom he upheld, and whose atrocities he encouraged during the war. He need not fear, however, that his favorites will suffer from any "old passions" which my picture may rouse against them. A large number of them have been hung, and thus placed beyond the reach of any effect which can spring from human passion. Some of them linger in the darkness and solitude of prisons, and the remainder are skulking in remote districts, where, their crimes, being unknown, are not likely to bring upon them the retribution which they merit.[26]

When, in 1873, Bingham was invited to send some pictures to an exposition in Louisville, he decided on *Martial Law* for one. It attracted great attention, he wrote to Rollins on September 9; the crowd "constantly presses before it."[27] The *Courier-Journal* was not to be drawn into a controversy: "The fact is, nobody's heart is going to be fired over this very excellent painting of Bingham's in any way but that of admiration for the skill which has delineated so many different emotions on one canvas."[28]

[26] Dated Columbia, Missouri, March 12; reprinted in the Jefferson City *Weekly People's Tribune,* March 24, 1869.
[27] "Letters," *Mo. Hist. Review,* Vol. XXXIII, p. 226.
[28] September 6, 1873.

But someone can always be counted upon to speak his mind on such occasion. L. L. Pinkerton, "late Professor of Belles Lettres and Political Philosophy in Kentucky University," saw the picture on the ninth, went home to Lexington, and the next day wrote sarcastically to the Louisville *Commercial* about this picture which "professes to represent a scene that might have been witnessed somewhere in Missouri during the war. Martial Law, it would seem, had been proclaimed. . . . Could we bring ourselves to acquiesce in the very questionable propriety of thrusting such a production into the faces of visitors to the Exposition, we should insist on having a mate to the one now on exhibition in Louisville." He sketched in some detail "a scene from East Tennessee under the reign of Confederate Martial Law" and concluded ironically that the "artist would, as a matter of course, be careful to give the Unionists sweet, angelic, or heroic, defiant countenances, according to circumstances, and to all Confederates the countenances of fiends. The picture in your Exposition, I observed, is true to nature in this matter of countenance."[29]

Bingham's reply to Mr. Pinkerton appeared in the *Courier-Journal* on the sixteenth:

Myself and the public would have been more enlightened by this production, from a gentleman of your high-sounding pretensions, had you condescended to give some reasons why a heartless exercise of lawless power, involving the utter ruin of entire communities, living in obedience to the laws of our country, can not be as properly presented to the gaze of spectators in the forms of art, as addressed to the mind through the agency of the pen, as is done by yourself in your lengthy enumeration of alleged Confederate outrages in Tennessee and elsewhere. . . .

As a teacher of Political Philosophy you ought to be fully informed as to the theory and structure of our Federal Government, and, so informed, you ought to know that its powers are clearly defined and strictly limited by a written constitution, which gives no authority whatever for what has been known and enforced as "martial law." . . . My picture was conceived, executed and is now being exhibited in the interest of civil liberty as opposed to lawless military domination. . . .

I think, sir, if you entertained a sincere regard for free institutions and a proper and corresponding hatred of their opposite, you would see nothing in my picture, or its exposure to public view, out of harmony with your very delicate sense of propriety.

[29] September 12, 1873.

However one may sympathize with Bingham in the cause he was fighting, he was using art for propaganda purposes. The editor of the *Louisville Commercial* spoke the final word the next day:

Mr. Bingham, writing to show that his picture should be in the Exposition, gives conclusive reasons why it should not be there. "My picture," says he, "was conceived, executed, and is now being exhibited in the interest of civil liberty." But this collection of pictures was not gathered in the interest of civil liberty, but in the interest of art; it was not intended to illustrate or teach anybody's views of civil liberty, or any other branch of politics but simply to please and instruct and elevate the popular taste in art. Any attempt to use the exhibition to further Mr. Bingham's or anybody else's, notions of civil liberty is perverting it from its true object.

Although Bingham hammered Ewing wherever he exhibited *Order No. 11*, the engraving was to be the principal weapon in the anti-Ewing war; by it the "infamy" of Ewing could be broadcast over the country. It was also, like the Election prints, intended to be a profitable investment. To help Bingham with its publication, James S. Rollins and R. B. Price put up $5,000 to cover the cost of engraving and other expenses.[30] The "tablecloth" canvas was placed in Sartain's hands presumably as soon as the copy was completed.

Once more the painter's patience was sadly tried by the slowness of the engraver. In the spring of 1871, when "a portion of the Ohio delegation in Congress" wanted to know "if they could procure, and upon what terms, 250 copies of our print to be used in defeating his [Ewing's] nomination," Bingham "regretted to be compelled to answer that the print could not be published in time."[31] By mid-June, the time in which the work was to be completed had "nearly transpired," but Sartain had not yet drawn the half-pay to which he was entitled when half-finished, nor had he, in response to an inquiry from Bingham, sent a proof to show the stage of progress.[32] In November, Sartain asked for instructions about lettering the plate. He had pulled one proof, but "found it not so perfect in some of the details as he desired." However, the painter assured Rollins, "a few days work

[30] "Letters," *Mo. Hist. Review*, Vol. XXXIII, p. 204 n.
[31] Bingham to Rollins, Kansas City, June 4, 1871 (*ibid.*, 70). Ewing was defeated, however, without the aid of *Order No. 11*.
[32] Bingham to Rollins, Kansas City, June 19, 1871 (*ibid.*, p. 74).

would give it such perfection as would warrant him in sending me the result in a few satisfactory proofs."[33]

Up to this time both the paintings and the engraving had been known as *Civil War*. Now the name was changed to *Martial Law*, apparently at the suggestion of Rollins. "Yours of yesterday reached me this morning," wrote Bingham on November 21, 1871. "I have written to Sartain requesting him to change the title as suggested. I think it will fit the times[34] and help the sale of the engraving. I am waiting impatiently for a proof."[35] The title now was *Martial Law as Exemplified in the Desolation of Border Counties of Missouri by Military Orders Issued by Brig. Gen. Ewing, of the Federal Army, Aug. 25, 1863.*[36]

Two weeks later there was still "nothing from Sartain." So intense was Bingham over his "war" that suspicions crowded into his mind. "Can it be possible that he is tampered with? I know nothing of his politics, and as Ewing has learned through his friends, that the work is being executed by Sartain, it is just beginning to be a slight suspicion in my mind that he may have stronger inducements to destroy the plate than to complete it."[37] There was nothing for it but to go to Philadelphia to discover what was holding up the work. Arriving there on December 22, Bingham was told by the engraver that the plate would be ready in about two weeks. "But if I were not here," confided the painter to his friend, "I think it likely that his weeks would go into months, as there are continual calls on him for other work." The plate he found in very good condition. "I think it will require very little correction from me. The work to be done is entirely in the finishing. I think the print will make an imposing picture. Sartain has insisted on my staying with him at his residence while here, and I have accepted his hospitality not only because it was tendered so pressingly that I could not refuse it, but because it

[33] Kansas City, November 5, 1871 (*ibid.*, p. 77).

[34] The new title would "fit the times" because the so-called "Ku Klux" bill, passed by Congress in April, carried the threat of martial law.

[35] "Letters" *Mo. Hist. Review*, Vol. XXXIII, p. 77.

[36] The full title will be found in the check list of engravings below. The date of change to the third title (for the painting) has not been established. As late as October 26, 1873, Bingham referred to the picture as *Martial Law;* on August 25, 1878, he used the title *Order No. 11* ("Letters," *Mo. Hist. Review*, Vol. XXXIII, pp. 349, 513).

[37] Bingham to Rollins, Kansas City, December 9, 1871 (*ibid.*, p. 203).

necessarily puts me with him, and thus enables me constantly to press the completion of our work, to the exclusion of other demands made upon him."[38]

Bingham was again a bit too sanguine. Although Sartain worked "unremittingly" on the plate, by January 7 the Missourian thought that at least two weeks longer would be necessary for its completion. Sartain went on "laboring on our plate," but he "invariably fails as to time." The painter worked closely with him. "I labored all last week in retouching and correcting the proof in its then state, so as to make it precisely what I want it to be, and this corrected proof he has now [January 17] before him. . . . He seems to be a thorough gentleman, but one of those who have not the fortitude to say no to friends who continually call upon him for services, which . . . render it impossible for him to comply with his engagements to those at a distance who cannot stimulate him by their personal presence."[39]

Late in January, 1872, Bingham was planning, as soon as the plate was finished, to take "a few good proofs [before letters] and push the sale of the work by subscription in Mo. before presenting it to the public elsewhere. It is a work that will likely be attacked on political grounds and I think it will be better able to meet such attacks after being fortified by a general endorsement at home, where the history which it illustrates is well known. I think it will be well to begin in Kansas City in the midst of the wittnesses who can verify the statements of our art record and begin, by having the vindication[40] published in our Kansas City and Independence papers, openly challenging a contradiction of its utterances from any respectable source. I am confident none will be ventured, or if ventured will be speedily silenced. Sartain considers the plate now almost completed. The proof to day shows that only a few details are imperfect, so that two or three days will have it ready for the lettering. The lettering will take about two weeks time, but before this is done and as soon as the plate is finished I will have several proofs taken without let-

[38] Bingham to Rollins, Philadelphia, December 24, 1871 (*ibid.*, pp. 204–205).
[39] Bingham to Rollins, Philadelphia, January 7, January 17, 1872 (*ibid.*, pp. 205–206, 209–10).
[40] A pamphlet by Bingham entitled *An Address to the Public, Vindicating a Work of Art Illustrative of the Federal Military Policy in Missouri during the Civil War* (Kansas City, 1871). Rollins had corrected proof on it early in November, 1871 ("Letters," *Mo. Hist. Review*, Vol. XXXIII, p. 76).

tering to be used immediately in Mo in canvassing for subscribers."[41]

Although Bingham closed his letter of January 23, 1872, with the hopeful sentence, "In a week from this time I now feel confident that I can leave for home," it was not until early in May that he received from Sartain a package of two hundred engravings and that we can say that the picture was actually published.[42] How many were printed and how many sold remain unknown, but the delay in publication, poor health on the part of Bingham which led him to spend the summer of 1872 in Colorado, and the hard times of 1873 all told against this business venture. Bingham's enthusiastic hopes were not realized; the sale of engravings did not pay expenses. Rollins bought out Price, and eventually Bingham gave the "tablecloth" *Order No. 11* to Rollins as compensation for money advanced.[43]

A final word must be said about the quarrel with Ewing. The story has long been current that, by fiery articles in the newspapers and by touring with *Order No. 11*, Bingham caused Ewing's defeat in a race for the governorship of Ohio. Unfortunately, no evidence can be found to support this claim. We are forced to accept the will for the deed.

It has been seen that on an earlier occasion Ewing had been defeated in an Ohio contest, but that had been without the aid of Bingham, for the artist had not been able to supply the requested engravings. The major struggle over the governorship, if there was any, should have taken place in 1879, for Ewing was nominated by the Ohio Democrats in their party convention on June 4, 1879, and was defeated in the ensuing election. But Bingham spent the months of May and June at the house of Major Rollins in Columbia and on July 5 left for Kansas City, where he died two days later.[44] Certainly he had no share in this defeat of Ewing. In the preceding gubernatorial election he had not been the party candidate; he had, indeed, been elected to Congress the previous November.[45]

[41] Bingham to Rollins, Philadelphia, January 23, 1872 (*ibid.*, p. 211).

[42] Bingham to Rollins, Kansas City, May 10, 1872 (*ibid.*, pp. 212–13). These two hundred engravings were being distributed to subscribers in Kansas City.

[43] *Ibid.*, p. 205 n.

[44] *Ibid.*, pp. 522–23.

[45] It is characteristic of such legends that the date should be confusedly stated. Louella S. Vincent in the St. Louis *Globe-Democrat* (February 20, 1898), May Simonds in "Missouri History as illustrated by George C. Bingham" (*Mo. Hist. Review,*

The source of this legend seems to be a series of attacks that Bingham in his last years made on Ewing. It is not necessary to trace all the skirmishes, but main battle was once more joined when, on January 1, 1877, Ewing wrote to General J. M. Schofield, who had been his immediate superior in 1863, asking for a statement. Publication of Schofield's letter of January 25 in the *Missouri Republican* of February 21, completely exonerating Ewing from all responsibility for his Order No. 11 and demonstrating the military necessity for it, brought a quick reply from Bingham, headlined "A Scorcher" in the *Republican* of February 26. "The General has exercised a caution, characteristic of all great military commanders, in allowing nearly fourteen years to transpire before venturing upon the defence of a measure, which, for heartless atrocity, has no parallel in modern annals. He will be apt to discover, however, that there are those yet surviving who will be able to confront him in the prudently delayed effort to subordinate history to the service of tyranny." Warming to the task, he then proceeded to haul Schofield and Ewing over the coals.

While he lived, Bingham lost no opportunity to belabor the Civil War general. In Washington in March, 1878, he was wholehearted in joining the *Sentinel* in a violent attack on Ewing as the "new leader of the Democracy." A series of lengthy, weekly, front-page articles brought the quarrel again before the public eye. Order No. 11 was reprinted, Bingham again wrote his denunciation of it, Schofield's letter at Ewing's request was reprinted, and the *Sentinel* rounded off with Bingham's "scorcher" from the *Republican* of the year before.

Back in Missouri, on June 13, 1879, Bingham addressed another attack to B. Gratz Brown, former governor of Missouri. Even after he died, Bingham sustained the quarrel. C. B. Rollins declared that an unfinished reply to Brown's response was published after the

Vol. I [April, 1907], 187–90), and T. E. Spencer in *A Missourian Worth Remembering* (p. 32) all gave 1877 as the date. Neither Rusk, *Bingham* (p. 86), citing Rollins as authority, nor Rollins in his "Recollections of Bingham" (*Mo. Hist. Review*, Vol. XX [July, 1926], 480) and "Letters of George Caleb Bingham" (*ibid.*, Vol. XXXIII, p. 76 n.) gave a specific date; both were content to refer to the time when Ewing "was running for the governorship." It may be added that Ewing was not a candidate in 1875 either; in the party convention of that year the incumbent governor was nominated by acclamation on the first ballot. For searching Cincinnati newspapers for reports of the conventions in 1875 and 1877, I am particularly grateful to Mrs. Alice P. Hook, librarian of the Historical and Philosophical Society of Ohio.

painter's death under the headline "A Voice from the Tomb."[46] A collection of *Order No. 11* letters would no doubt fill a small volume.

Ewing's immediate reaction to these many attacks we do not know, but C. B. Rollins late in the 1880's had curiosity enough to ask him his opinion of Bingham. Ewing thought him "a man of the highest ideals but with 'so little understanding of the necessities of war that before he would commandeer a mule or a load of corn from a farmer in the line of his march, he would first have to consult the constitution to see that he was within the law.' "[47]

Two projected historical-moral pictures are to be mentioned even though they never came to fruition, for the very planning of them shows the strong bent of Bingham's mind in these last years. Toward the close of his two-year term as adjutant general of Missouri, he wrote to Rollins from Jefferson City on December 14, 1876, "When I resume the pencil I think I cannot do better than to fill up my time, not employed on portraits, on our often talked of picture of Jacksons submission to the Civil Court at New Orleans."[48] In the new year he was giving serious thought to this and a companion moral picture. A correspondent from Boonville wrote to the St. Louis *Missouri Republican* (January 20, 1877): "I learn that he will commence immediately upon *two great works* illustrating the difference between the Democratic party and Grantism as to obeying the civil powers in times of trouble and turmoil. One picture will represent Gen. Jackson at New Orleans, and the other President Grant usurping authority and placing the military over the civil authorities."

In March the Missouri House of Representatives recommended passage of a resolution authorizing the governor and the presiding justice of the Supreme Court to commission Bingham to execute a "great historical painting" to represent strict subordination of military to civil authority. This painting was to represent Andrew Jack-

[46] "Letters," *Mo. Hist. Review*, Vol. XXXIII, p. 76 n.; Rusk, *Bingham*, 134–45.

[47] "Some Recollections of George Caleb Bingham," *Mo. Hist. Review*, Vol. XX (July, 1926), 480–81.

[48] "Letters," *Mo. Hist. Review*, Vol. XXXIII, pp. 378–79. The *Missouri Republican*, December 18, 1876, picked up a story from the Jefferson City *Tribune* to the effect that as soon as he was relieved from duty as adjutant general, Bingham would devote himself to the production of two great historical pictures, each to be larger than *Order No. 11*. For a summary of Bingham's activities as adjutant general, see Rusk, *Bingham*, 98–101.

son, "the immortal hero of New Orleans, while at the head of his victorious army, bowing in deferential submission to the judgment of a Civil court of Louisiana, in imposing a heavy fine upon him, thus achieving a victory over himself far greater than he had just achieved over the invaders of his country, and by such victory setting an example, which, so long as it shall be remembered and cherished by the American people, will secure the perpetuation of their republic alike from Military usurpation from within and invasion from without."[49]

Amendment of the original resolution, however, chilled Bingham's interest in the "commission." "I did not consider it any compliment," he wrote to Rollins on April 18, 1877, "to be commissioned to devote two or three years of my life in painting a picture for my State, with the understanding that the State was not to be bound to pay for it. If my life and health shall be spared so as to enable me to execute the picture, it will more likely become the property of my native State of Virginia than of my adopted State of Missouri, as I will naturally feel no disposition to subject it to the refusal of our State Legislature."[50] Neither the Jackson nor the Grant project ever got beyond the idea stage.

16. LAST WORKS

Although he devoted much of his energy after the war to *Order No. 11* and the attack on Ewing, Bingham found time and interest in the closing decade of his life to paint in every category to which he had earlier turned his hand—portraits of public persons and private, landscapes, interior genre, river and political life, historical incident, fancy figure, and farmyard pieces.

His greatest satisfaction in these years lay in painting full-length life-size or over life-size portraits, for, since his *George Washington* and *Thomas Jefferson,* he had thought such large works "better adapted" to his powers than the cabinet pictures he had previously done.[1] One important commission of this sort was to paint Senator

[49] Jefferson City *People's Tribune,* March 28, 1877.
[50] "Letters," *Mo. Hist. Review,* Vol. XXXIII, p. 380.
[1] Bingham to Rollins, Kansas City, November 27, 1860 (*ibid., Vol. XXXII,* p. 497).

Frank P. Blair, Jr. Undertaken at the suggestion of Major Rollins, the picture was intended as a gift to the state legislature, but Rollins and other contributors were making up the fee. By March 6, 1871, a small study (probably 30″ x 25″) had been completed. Ten weeks later Bingham wrote from Kansas City to Rollins: "I expect to complete the portrait of our friend Blair this week. I think it is by far the most striking full length portrait that I have painted. I have endeavored to give the head all the rugged force which nature has bestowed upon the original, and I have also given the figure the bearing and attitude which would mark it as Blairs even if the head were out of sight."[2]

Work moves slower than one expects. Early in June we learn that, other employment interfering, Bingham had "not quite finished," but would give the painting the "last touches tomorrow and next day." He thought Rollins would find it "a great improvement even on the photograph," lately sent to Columbia. "*It is my best picture of the kind,*" he reiterated, "and you will hardly dislike even the pantaloons which by letting out a few stitches in some places and taking a few in others, I place my tailorship on a par with my art. His friends here are delighted with the picture, and it will be exhibited to the public in a few days." By the middle of June the painting was finished: "It is the finest work in portraiture ever executed by me," he declared for the third time to Rollins, "and I can candidly say that $3,000.00 would not reach its full value, yet the pleasure of the task and $800.00 I am to receive for it fully compensates me."[3]

The Blair portrait, however, did not go to the state capitol. In the summer of 1874—"lately framed"—it was to be seen in the picture store of Pettes and Leathe in St. Louis. Although the records of the Mercantile Library do not show when or how it was acquired, the portrait was certainly on view there in 1879. For nearly forty years after the new library building was opened in 1888, it hung in the reference room beside the portrait of Baron von Humboldt. Because it was not displayed to their satisfaction, however, the Board of Direction in 1926 gave the portrait to the Missouri Historical Society.

[2] *Ibid.,* Vol. XXXIII, pp. 67, 68.
[3] *Ibid.,* pp. 70, 74, 75. Judging from the Mercantile Library photography the *Blair* canvas was about 96″ x 72″.

On transfer to the Jefferson Memorial Building the canvas was discovered to be in bad condition and in the process of restoration the picture was cut down and the salvaged portion backed with new canvas. After this was completed, the picture disappears from the record. The only visual remains of it today is a photograph (1888?) of the Mercantile Library reference room.[4]

A portrait of Blair (bust size?) was listed in the inventory of Bingham's estate in 1879 and was there valued at $25; this in 1893 was sold to Thomas Mastin of Kansas City for $40. The small study for the full-length portrait is owned by members of the Blair family.[5]

About the time he finished the portrait of Blair, Bingham was commissioned by friends of Major Rollins to paint a life-size portrait of the latter for the University of Missouri. "I intend," said the artist to his friend, "to work for the full length portrait . . . with a view quite as much to my own immortality as yours." Other work at the Kansas City studio (Plate No. 65), as well as Rollins' engagements interfered with commencing the new picture. By October 13, however, Bingham had finished a small study of (30″ x 24″) of the standing figure (Plate no. 66). "The photographer," he wrote from Kansas City on November 5, "succeeded in getting a good negative from your portrait yesterday evening and I will try and get him to finish you a dozen copies to morrow or next day, and will forward them to you by express. The head and figure is very perfect, the accessories, being in colors, take a little uneavenly as is allways the case, but it makes a striking and effective little picture and will please your friends."[6]

After his winter trip to Philadelphia to check on the progress of the engraving of *Order No. 11*, Bingham suffered bad health in the spring and summer of 1872. It was not until November 20 that he wrote from Kansas City to say: "I will order a canvass from the east for your portrait to-morrow and if I remain at home this winter will

[4] St. Louis *Democrat*, August 9, 1874; Boonville *Weekly Advertiser*, July 11, 1879; Minutes of the Board of Direction, St. Louis Mercantile Library, April, 1926; Minutes of the Board of Trustees, Missouri Historical Society, May, November, 1926; Journal of Mrs. N. H. Beauregard, curator, Missouri Historical Society, October, November, 1926.

[5] Information of Mrs. W. D. A. Westfall.

[6] Bingham to Rollins, Kansas City, May 21, June 4, June 19, 1871 ("Letters," *Mo. Hist. Review*, Vol. XXXIII, pp. 69, 70, 74); Rusk, *Bingham*, 93, citing *Missouri Statesman*, October 13, 1871; "Letters," *Mo. Hist. Review*, Vol. XXXIII, p. 76.

finish it so that it can be placed in the University in the spring."
Toward the close of March, 1873, he reported that he had been con-
stantly working on the portrait for five or six weeks. It was now fin-
ished: "As soon as it is sufficiently dry I will roll it up and take it
to Columbia." In mid-April the picture was on exhibition in Colum-
bia and on June 24 was officially presented to the university. This
life-sized portrait of the painter's dearest friend represented "the
Pater Universitatis standing in the attitude of delivering a speech, a
motive suggested by his extended services in the Legislature and
Congress. A window at one side disclosed a view of the University,
so recalling his acts which brought so much benefit to that institu-
tion." The painting was destroyed in the university fire of 1892.
There remain, however, the small study for the full-length and a bust
portrait that obviously was painted about the same time.[7]

In the years after the war, Bingham painted a great many other
portraits. That of Edward Bates, burned in the university fire, was
probably a life-size full-length portrait and must have been done
between July, 1866, and the death of Bates in 1869.[8] Another life-
size portrait, that of Colonel Joseph L. Stephens of Boonville, was
on display in the painter's Boonville studio in January, 1877.[9] Daniel
Read and Samuel S. Laws, successive presidents of the university,
sat to him as their predecessors had. Among other sitters were Thomas
H. Mastin of Kansas City (1869); Mrs. James S. Rollins (1872); his
early friend Washington Adams, lately a judge of the state Supreme
Court (1877 or 1878); and Mr. and Mrs. Thomas W. Nelson of Boon-
ville and their daughter Mrs. James T. Birch (1877). A self-portrait
(Plate No. 67), is thought to have been done in 1877. At his death
he was engaged on a portrait (unfinished) of his namesake, George
Bingham Rollins. Two of his most attractive pictures of male sub-
jects were those of his son Rollins at the age of six (1867) and of
Hugh C. Ward (Plate No. 68), aged seven (1870).

Of Bingham's later pictures of female subjects, four warrant

[7] *Ibid.*, pp. 218, 220; *Missouri Statesman*, April 11, 1873; William B. Smith,
James Sidney Rollins, 296–306; Rusk, *Bingham*, 93.
[8] In the *Diary of Edward Bates, 1859–1866* (ed. by Howard K. Beale), por-
traits by Harding, Cogswell, and Conant were recorded, but none by Bingham; I am
presuming that it was painted after the close of this diary. It was framed by Pettes
and Leathe of St. Louis ("Letters," *Mo. Hist. Review*, Vol. XXXIII, p. 226).
[9] St. Louis *Republican*, January 20, 1877.

special notice. When Bingham as adjutant general went to Washington in 1876 to seek settlement of Missouri war claims, he found time on his hands and undertook to paint a Miss Coleman, granddaughter of John J. Crittenden, and the young sculptress, Vinnie Ream. The latter was a particular pet of Major Rollins, and after the painter called on her, he reported to Rollins that he had "found her everything that you had painted her upon my mind . . . an extraordinary little woman possessing extraordinary genius, and tact enough to exhibit it to the best advantage. She professed to fall in love with me at first sight." He quickly became one of her affectionate admirers and a few weeks later was hard at work on the portrait. "As to your dear little friend Vinnie," he informed Rollins on April 13, "my wife has been in advance of you in the request that I avail myself of the leizure forced upon me here, to paint her portrait. . . . I commenced the work in her own studio. It is now nearly completed. . . . I represent her in her simple working costume, as engaged in modeling the bust of President Lincoln." This portrait is now in the Bingham collection at the State Historical Society of Missouri.[10]

Much of the summer of 1877 Bingham spent at Boonville. There he painted a portrait of Mrs. James T. Birch, who was staying at the home of her parents, the Nelsons.[11] The half-length figure is posed in the garden as if gathering flowers (Plate No. 69). Roses pinned to her dress and a bouquet in her hand represent her children; a bud, the son who was to be born later that year. The portrait, however, is not sentimentalized. It has obviously been painted with a good deal of affection and illustrates well both the technical skill of the painter and his ability to grasp character.[12] The picture, signed and dated "G. C. Bingham—1877," makes an interesting companion piece to the outdoor portrait of the sitter's mother painted fifteen years earlier.

[10] Rusk, *Bingham*, 100; Bingham to Rollins, Washington, March 9, March 16, April 13, 1876 ("Letters," *Mo. Hist. Review*, Vol. XXXIII, pp. 358, 360, 363–64).

[11] The Boonville *Weekly Topic*, August 18, 1877, reported that Bingham was "painting in his studio here, at the residence of Mr. Thomas Nelson. Among other work he has done while in Boonville, is a handsome oil portrait of Mrs. Burch [*sic*] of St. Louis, daughter of Mrs. Nelson."

[12] Bingham thought the portraits of Mrs. Nelson and Mrs. Birch painted in Boonville at this time "the best female portraits that I have ever painted, and may show that my skill rather increases than diminishes with increasing years" (Bingham to Rollins, Boonville, September 9, 1877, "Letters," *Mo. Hist. Review*, Vol. XXXIII, p. 382).

The most striking of all Bingham's works of portraiture is not actually a portrait, but a study in an impressionistic manner. The story that has come down with *The Palm Leaf Shade* (Plate No. 70) is that one afternoon in that summer of 1877 the painter, watching the play of sunlight and shadow on Mrs. Birch as she sat fanning herself in the garden, was moved to try a new subject. A glance at the portrait with the flowers, just described, or at a conventional bust also painted in 1877, makes it immediately clear that this time she was not a sitter but a model. The likeness is no longer of first importance. She is here simply a pretty woman who forms part of a composition. Ross Taggart has pointed out that:

What is exciting about this portrait is Bingham's perception of light. . . . The painting of the white dress and the sparkle of light and shadow over it is not only exceptional for Bingham, but is almost unparalleled in this country. Across this luminous sunlit figure falls the shadow of the fan. But within the shadow on the face and neck are the most delicate lights reflected from the white dress. It is strange to see in Missouri so obvious a *plein-air* painting, so direct an attempt to paint light, so sensitive a handling of colors and forms in light and shadow. Yet there is no mistaking it: it is American and it is Missouri. Bingham here, in a purely personal way, without tutoring, had faced the problems of impressionism.[13]

Begun at the Nelson home in Boonville in the summer of 1877, the picture was finished in Washington about the close of February the following year.[14] Since it had not been commissioned, it remained Bingham's property. In the inventory of his estate it was valued at $100. Eventually in the 1893 sale it was bought by J. W. S. Peters for $90 and later passed to the father of the present owners.

Another unusual portrait study was the painting of Eulalie Hockaday, a granddaughter of Major Rollins, as *Little Red Riding Hood* (Plate No. 71). The first sketch Bingham made for this picture, C. B. Rollins recalled, "represented a little country girl in the woods with a butter-pail in her hand, her tattered sunbonnet hanging carelessly by its strings, her hair dishevelled, shoes shabby and stockings hang-

[13] " 'Canvassing for a Vote' and Some Unpublished Portraits by Bingham," *The Art Quarterly,* Vol. XVIII (Autumn, 1955), 237–38.

[14] Bingham to Rollins, Boonville, September 9, 1877; Washington, February 22, 1878 ("Letters," *Mo. Hist. Review,* Vol. XXXIII, pp. 382, 511).

ing down—a typical little country girl, who, as the story has it, was carrying butter to her grandmother. But Eulalie's mother did not approve of this representation. She wanted her daughter to appear daintily dressed, in direct contrast to the sketch Bingham had begun. She protested. Bingham said nothing, but, revising his sketch, painted the child as her mother desired."[15]

Bingham may have begun this work in 1877. At Washington late in February the next year, he was expecting to complete it by April. The picture was on display in his Columbia studio early in 1879. "The face of the child is a charming one," reported the St. Louis *Post-Dispatch*, "and the dark eyes and still darker ringlets are emphasized by the scarlet hood and cape, which in turn are contrasted with a bright blue dress. She carries a dish covered with a white cloth, which enhances the value of the positive colors. The background is a wooded interior [*sic!*] with an opening throwing a patch of sky and some distant trees in a clear sunlight. The traditionary wolf is peering from behind some gnarled trunk and slyly following down the pathway."[16]

Repeated sickness and a persistent cough led Bingham in the summer of 1872 to visit Colorado for his health, and during these months, it is said, he painted a number of Colorado landscapes. It was his habit, his son Rollins declared years later, to make "many sketches from nature in pencil and oil, representing the scene in the varying effects of atmosphere, and finally from these sketches he painted the pictures in his studio. Portfolios containing a great many such sketches were in existence a short time before the artist's death; but they have since been destroyed or lost." Four Colorado landscapes, the younger Bingham said, were in the possession of Mrs. J. M. Piper in 1902.[17] One of these, *Indian Encampment* (Plate No.

[15] *Ibid.*, p. 511 n.

[16] Bingham to Rollins, Washington, February 22, 1878 (*ibid.*, p. 511); St. Louis *Republican*, February 9, 1879; St. Louis *Post-Dispatch* as quoted in the Columbia *Missouri Statesman*, March 7, 1879. According to the *Catalogue of the Special Exhibition of the Paintings of George Caleb Bingham, "The Missouri Artist"* (Columbia, Missouri, 1910) an engraving of this picture was published; there is, however, no copy of record.

[17] Rusk, *Bingham*, 96–97, citing a letter from Rollins Bingham to May Simonds, June 18, 1902.

72), featuring a tipi beside a mountain lake, is said to be in the Gilcrease Institute.

Two other western landscapes, both views of Pikes Peak, can be identified and dated. On October 26, 1872, "M. G. H." wrote from Denver to the *Missouri Republican* that Bingham had finished a view of Pikes Peak. In this painting, he stated:

The heavy monarch of the mountains, towering far above surrounding elevations, is revealed to the spectator in all his grandeur, just as he appears in clear atmosphere of our mountain region. A few clouds, that seem actually in motion, relieve the deep azure of the sky, one of which, separated from its companions, yields homage to the mountain as passing beneath his summit it casts its shadow far down upon his rugged sides. The subordinate mountains to the right and the left with their outcroppings of primeval rocks . . . are presented with equal fidelity. The artist avails himself of no mist or licensed generalization to escape the labor due to the details of his subject but . . . puts in its proper place and holds in proper keeping all that meets his eye as it scans the magnificent landscape from the immediate foreground to the far distant peaks which fade away in the deep blue of our Colorado sky.[18]

This *View of Pike's Peak* (Plate No. 73), Dr. Rusk described as "a large picture, about three and a half by five feet," and noted specifically the foreground detail:

The sun is pouring a flood of light upon the scene in the foreground, except for a few spots where it is cut off by the fleecy clouds. Down over the rocks at the right flows a stream of water, bubbling and foaming in little cascades, while in the quieter parts the rocks are mirrored on its surface. There is some vegetation visible, particularly at the left; but it is all of a hardy variety, scrubby and sparsely leaved, as we should expect in such bare, bleak surroundings. At the left, on a rock among the trees in a path of sunlight sits an Indian, quietly resting, with a rifle in his hand and feathers in his hair. His form is not made conspicuous, no more so than one of the trees. In spite of all the interest in the foreground, the lofty snow-capped peak towering behind it dominates the picture.[19]

It was this picture, referred to both as *Landscape View in Colorado*

18 St. Louis *Missouri Republican*, November 3, 1872.
19 Rusk, *Bingham*, 95–96.

and as *View of Pike's Peak,* that R. Saunders bought for $61 at the 1893 auction sale of Bingham paintings.[20]

A smaller *View of Pike's Peak* (approximately 30″x48″) Dr. Rusk thought might have been a study for the larger one.[21] However, examination of the painting (Plate No. 74), now available in the collection of W. Howard Adams, proves it to be a finished work in its own right. Although the mountain again dominates the scene, the angle of view is different. The water to the right in the first plays no part in the second view. The Indian near the tree to the left has given place to a white hunter seated on a rock (center) with a dog beside him and a spot of sunlight focused on them.

In June, 1778, Bingham again went to Denver. On his return he painted a *Mountain Landscape* which he traded for 160 acres in Linn County, Missouri, "near Brooklin and near the Hanibal and St Joe Rail Road," he told Rollins.[22] Nothing more is known of this canvas. Another landscape of this western group may be the *Landscape with Cliffs* (22″x26″) owned for many years by the McCaughen-Burr Galleries in St. Louis; according to an old paper attached to the back of the picture, this is a view in the Uinta Mountains near Vernal, Utah. A *Scene in Colorado* is said to be privately owned in Colorado Springs.

The only other extant landscape for this late period is a charming little (Plate No. 75), view of the Nelson home near Boonville, which Bingham painted for his hosts in the summer of 1877. *"Forest Hill—The Nelson Homestead"* (approximately 24″x30″) features a two-story brick house with a colonnaded porch set behind a clump of trees to the right of the canvas, with two riders on horses in the foreground, a group of an adult and three small figures in center foreground, a two-horse carriage waiting at the gate in the center of the picture, and a glimpse of the Missouri beyond it. The family story is that the carriage was that of the doctor who had come to attend Mrs. Birch at the birth of her son James, the foreground

[20] Kansas City *Star,* March 18, 1893; Kansas City *Journal,* March 25, March 26, 1893.

[21] Rusk, *Bingham,* 96, 125.

[22] Bingham to Rollins, Lykins Institute (Kansas City), October 4, 1878 ("Letters," *Mo. Hist. Review,* Vol. XXXIII, p. 517). This land, said Bingham, had cost its owner $2,000.

group is composed of the Negro nurse, Polly, with the three youngest of the Birch children, the riders are Kate Nelson, a sister of Mrs. Birch, and a friend.[23]

Three other landscapes are to be listed though little is known about them. A painting called *A Winter Scene* was among those on display in the artist's studio in March, 1879.[24] This must certainly have been the *Winter Scenery* appraised at $50 in the inventory of Bingham's estate in September of that year. There is no further record of it. In the auction sale at the Findlay Art Rooms in 1893 a *Moonlight View* went to R. Saunders for $22; Dr. Rusk described it as a "hilly scene on the south part of the Gasconade River," dated it "probably 1872," and gave its owner in 1917 as R. W. Thomas of Kansas City. A third painting was listed in the 1893 sale simply as *Landscape*, sold to Fred Hey of Kansas City for $33.50.[25]

The depression of 1873 made the search for subscribers to the *Order No. 11* print quite a depressing business. So little was being accomplished that Bingham turned to thoughts of other work and particularly to painting scenes of everyday life. His brother-in-law, Dr. Joseph B. Hutchison of Brooklyn, was urging him to set up a studio in New York: "His general acquaintance there would be of great service to me," the artist pointed out to Rollins in September, "both in having my works brought into notice, and in securing me business as a portrait painter." But he had more in mind than portraiture. His health remaining good, he wrote a month later, he hoped he would "yet be able to make many pictures which will afford pleasure to others after I am called hence." Towards this end, he declared, "I employ all my leizure in making drawings to be elaborated into pictures which I intend as my winter work in New-York. While there I will try to make arrangements with the Harpers and others to supply them with illustrations of western life and manners, as exemplified upon our rivers plains and mountains."[26]

[23] Information from Mrs. Fulton Stephens, owner of the picture, daughter of James and granddaughter of Margaret Nelson Birch. The second youngest of Mrs. Birch's children was named for Bingham; George Bingham Birch owns a photograph taken of the painter and his namesake about this time.

[24] Columbia *Missouri Statesman*, March 7, 1879.

[25] Kansas City *Star*, March 18, March 25, 1893; Kansas City *Journal*, March 25, March 26, 1893; Rusk, *Bingham*, 125.

This is no evidence that he did go to New York, but it was probably out of this revived interest in genre that *The Puzzled Witness* (approximately 23″ x 28″) came. First announcement of this picture is in the St. Louis *Missouri Republican* of November 29, 1874:

"Puzzling a Witness" is one of those pictures of western life, recognizable at once as faithful to the circumstances as art could make it. We are in the office of a country justice of the peace. There is the "court," the opposing lawyers, the defendant, the jury and the witness on the stand, all taken from the streets of a country town, as familiar as the post office itself, and in the homespun which we all know so well in the land of the granger. The artist has seized upon the strong moment. The witness for the prosecution is up, and the attorney for the defence has just put a puzzler to him. It is a stunner. The witness is, in point of fact, stumped. He scratches his head for the answer, but it don't seem to be there, or perhaps it is a neat bit of acting. There is a dog belonging to the witness. That dog looks as if he would be gratified in going for a pound or two of that prosecuting attorney who has stumped his master. Then there is the lawyer on the other side. He is well satisfied with his witness, and smiles as if to say, "well, when you have made anything of that witness, just call around and tell me, will you."

The picture (Plate No. 76), which had been on view a few days earlier in Harding's Gallery, by the date of the story in the *Republican* had been taken to Kansas City because it yet "required a few finishing touches." Bingham, however, proved in no hurry to complete it. More than four years later, the Columbia *Herald*[27] reported it "just finished" and on display in his studio. Valued in the inventory of Bingham's estate at $50, it brought $165 in the 1893 auction.

When Bingham began *The Jolly Flatboatmen No. 2* (approximately 28″ x 38″) cannot be said, but he was "about finishing" it late in February, 1878. Remaining in the painter's estate at his death, the picture (Plate No. 77), was bought by Thomas Mastin for $200 at the 1893 sale. Although Bingham repainted the 1846 subject, the second canvas is by no means an exact copy of the picture that had established his reputation one-third of a century before. One figure

[26] Bingham to Rollins, Kansas City, September 28, October 26, 1873 ("Letters, *Mo. Hist. Review*, Vol. XXXIII, pp. 229, 349). The latter part of the first of these letters, in which apparently he elaborated on these plans, is unfortunately missing. The drawings referred to are not known to exist.

[27] As reprinted in the St. Louis *Missouri Republican*, February 9, 1879.

has been eliminated from the original group of eight: the smiling man immediately behind the dancer, so that the steersman is clearly seen at his employment. The dancer, the fiddler, and the "tympanist" are those of *The Jolly Flatboatmen in Port*. The three figures in the foreground are posed essentially the same as in the 1846 painting, but the man on the left has a pipe in his hand and the one on the right has a different face and hat. The righthand sweep no longer extends over the water but has been drawn up lengthwise on the boat. A bucket and a jug fill part of the open space in the fore part of the deck; all the characteristic details below deck have been omitted. The river background has been varied and the scene is hazier. The predominant blue tone is less effective.[28]

Among the paintings "just finished" and on display in Bingham's studio at the University of Missouri in February, 1879, was a second version of still another genre painting: " 'The Result of the Election,' intended as a sequel to his famous picture, 'The County Election.' "[29] *The Verdict of the People No. 2* ($22\frac{7}{8}'' \times 30\frac{5}{16}''$), though a much smaller canvas, retains almost all the detail of the original, but with a number of minor alterations (Plate No. 78). The Negro pushing the wheelbarrow has changed his headcloth for a hat. The man behind him wears a coat and a hat and has different features. The man who has won and collected a couple of hats in the first *Verdict* wears only his own in the late version. The foliage is varied. Some background architectural details have been changed. The principal difference has been the placing of a table behind the two men sitting on a bench in the center foreground and the introduction of a Negro woman, beyond the table, kneeling to look into a basket on the street, with a child beside her. The crowd in the street is much thinner. In painting *Verdict No. 2*, Bingham was certainly working from the lithograph (he had retained one of the two prints). One detail he adopted from it. In the first painting the flag flies from a pole extending from the upper floor of the courthouse.

[28] The Columbia *Herald* (reprinted in the St. Louis *Republican*, February 9, 1879) and the *Missouri Statesman*, March 7, 1879, were both mistaken in referring to this *Jolly Flatboatmen* as the original painting bought by the American Art-Union. Bingham's letters to Rollins from Washington, February 22, 1878 and from Kansas City, August 25, 1878 definitely establish the date of its painting as 1878 ("Letters," *Mo. Hist. Review*, Vol. XXXIII, pp. 511, 513).

[29] Columbia *Herald* (as reprinted in the St. Louis *Republican*, February 9, 1879).

The lithographer placed it on a cord stretched across the street to another building. So it flies in the *No. 2*. Valued in the estate at $50, *The Verdict of the People No. 2* in the auction went to J. W. S. Peters for $200. It now hangs on loan in the National Gallery of Art.

It has already been recorded that in March, 1856, Bingham was engaged on a painting of *Washington Crossing the Delaware*. No more is heard of this piece for nearly sixteen years until, on January 7, 1872, the painter wrote to Rollins from Philadelphia that it was "now finished" (Plate No. 79). Sartain "seems quite anxious to engrave [it]. . . . He thinks it would find a large sale here and in New York, and is disposed to engrave it as a partnership matter or a half interest in the copyright. He things it far superior to Leuitzes picture of the same subject."[30] Nothing came of Sartain's proposal.

In September, 1873, Bingham, invited to send some of his pictures to an exposition in Louisville, showed *Washington Crossing the Delaware* (approximately 38″ x 59″).[31] The Louisville *Commercial* (September 17) was not entirely complimentary in its notice:

With a strict regard to the truth of history, Washington and his army are represented as crossing the stream through a thick mass of remarkably blue ice, in flat boats, the whole scene being full of life and bustle. The anxious face of the great patriot-General, and the busy, excited countenances of his men, are well represented, and the almost vicious fault of the coloring is not so apparent in this scene [as in other of Bingham's paintings on view].

In the estate inventory, *Washington Crossing the Delaware* was valued at $500; Thomas Mastin bought it in 1893 for $375.

One subject painting was found unfinished in Bingham's studio at his death. Of *The Pleague of Darkness* nothing is known but the title. It has been said that after the death of the second Mrs. Bingham in November, 1876, the painter became "somewhat interested . . . in the prevailing excitement over spiritualism."[32] Perhaps this picture was an expression of that interest. Perhaps it was a biblical subject.[33]

[30] "Letters," *Mo. Hist. Review*, Vol. XXXIII, p. 206. Leutze's well-known picture was painted in 1852.
[31] Bingham to Rollins, Kansas City, August 3, 1873 (*ibid.*, p. 225).
[32] Rusk, *Bingham*, 102.
[33] Exodus, 10:21–23 or Matthew, 24:29–34?

Four other pictures mentioned in the 1893 sale remain to be entered in this record. Whether they were painted in the last year or two before his death or were works done years earlier which he had never disposed of cannot be determined. *The Bathing Girl,* reported the Kansas City *Star* on March 18, was "the only nude in the collection. It represents a girl at the side of a forest stream ready for a bath." Identification of the subject becomes possible when we find in the inventory list *Musidora about to Take a Bath* (valued at $100). Recalling that Bingham at Washington in 1842 had painted, among other unnamed fancy pieces, an *Ariadne* after Durand's engraving of Vanderlyn's popular painting, I suggest that *Musidora* may have been another of those fancy pictures and quite possibly was painted after Durand's engraving of the subject.[34] It was purchased by J. N. Goodwin for $45 and has not been heard of since.

The three remaining canvases are no more than descriptive titles: *Feeding the Cows, Flock of Turkeys,* and *Bunch of Letters.* The first of these went to Fred Hey of Kansas City for $30. Sale of the others was not reported in the newspapers.

Painting in these years did not absorb all Bingham's energies. He continued to be active in party politics and public life, but he had changed his party. A strong Whig and Union man through most of his life, the extreme measures of the Radical Republicans after the war so offended his sense of judgment and principles of behavior that he turned Democrat. At local and state meetings of his party he was frequently a speaker. At every opportunity he denounced the Radical Republicans. Enthusiastic friends put his name up for Congress in 1866 and in 1868, but each time he withdrew it. In the latter year he was named a Democratic Elector. Twice he did fill important positions. In 1874, he served vigorously as president of the Board of Police Commissioners for Kansas City. During 1875 and 1876, his time was largely given over to fulfilling the duties of his office of adjutant general of the state.

He was not without professional honors in these last years. Al-

[34] A favorite subject for painters from James Thomson's poem. *The Seasons—Summer,* ll. 1269–1370. Gainsborough, Benjamin West, and Thomas Sully were among those who portrayed her bathing her "fervent limbs" before her unseen lover.

though he failed to get an appointment as honorary commissioner to the Paris Exposition in 1878 (neither of those named from Missouri was an artist), he was chosen by the governor as Missouri's representative on a commission to determine the nature of a monument at Richmond, Virginia, to Robert E. Lee.[35] When a department of art was established at the University of Missouri in 1877, he was made its first professor. It was, in effect, an honorary appointment (i.e., unpaid), but the duties were not onerous. Although he was installed in a studio at the university in October, 1877, in the two years of his service he seems to have been absent from Columbia a great deal of the time. The principal result of his professorship was the preparation of a lecture on the nature of art;[36] actual delivery of this address, however, was by Rollins, for on the date set, March 1, 1879, Bingham was sick in Kansas City.

His private life was saddened in 1876 by the mental illness and death of his second wife, Eliza Thomas Bingham. Earlier in this year he had declared to Rollins that in winning her love, "a boon was confered upon me which I have learned by twenty-six years experience to regard as second only to my eternal salvation. I shrink from thinking what would have been my fate and that of my motherless children, if this rare and excellent woman so precisely adapted to my wants, and allways adapting herself to my eccentricities, had not been given to me. I can honestly say that my love has been so watered by her goodness, that it has increased tenfold since we were wed."[37]

Moved as he was by Eliza's death, Bingham was not a man who could live without a wife. By January, 1878, he was referring to Mrs. Mattie Lykins, principal of the Lykins Institute (an orphan asylum at Kansas City)—an old friend and the widow of Dr. Johnston Lykins, whose portrait he had painted—as his "more than friend." They became engaged shortly after this and were married in Kansas City on June 18, 1878. After a wedding trip to Denver, they returned to live at the Lykins Institute.[38]

[35] Columbia *Missouri Statesman*, November 8, December 6, 1878.

[36] Reprinted in the appendix below.

[37] Bingham to Rollins, Washington April 13, 1876 ("Letters," *Mo. Hist. Review*, Vol. XXXIII, p. 365).

[38] Bingham to Rollins, St. Louis, January 3, 1878 (*ibid.*, p. 500); Columbia *Missouri Statesman*, June 21, 1878.

In February, 1879, Bingham suffered a severe attack of pneumonia. He recovered from this, however, and resumed portrait work. Early in May he went to Columbia and stayed with Major Rollins for nearly two months. He left Columbia in apparent sound health on July 5, but two days later died in Kansas City of cholera morbus. The considerable collection of paintings in his studio was left to his wife and following her death was dispersed at auction in 1893 for the benefit of the Confederate Soldiers Home at Higginsville, Missouri.

❧ III ❧

The Achievement

1. BINGHAM'S CONCEPT OF ART

I F BINGHAM ever talked much about the art of painting, little of his opinion has come down to us. He wanted to paint, not to theorize. "I have never been able to write any thing about Art in a manner satisfactory to myself," he said late in life, "and I believe the same is the case, to a great extent, with nearly all Artists. Ruskin became the popular writer on Art only after he had totally failed as a painter, and notwithstanding his captivating style some of the best artists regard his writings as barren of truth as his pictures."[1]

From the time he began portraiture, Bingham was intensely concerned with painting, but he poured his energy into practice. On rare occasions something of what he felt slipped out in his intimate letters. After three years of portrait work, he wrote to his fiancée: "No work has ever yet [go]ne from my hands with which I have been perfectly satisfied. Very few are aware of [the] mortification and anxieties which attend [the work?] of a painter; and of the toil and study it requires to give him success and raise him to distinction."[2] To Rollins eighteen months later he declared, "There is no honourable sacrifice which I would not make to attain emminence in the art of which I have devoted myself."[3]

These are but indications of his sincerity as a painter. Of the ideals before him early in life we know only that in the letter to Rollins just quoted Bingham cited Harding and Sully as men to be emulated in their struggle to eminence. Of his association with fellow artists we know almost nothing. For a time in Washington he

[1] Bingham to Rollins, Kansas City, June 19, 1871 (*ibid.*, p. 72).
[2] November 30, 1835 (p. 22, above).
[3] May 6, 1837 ("Letters," *Mo. Hist. Review*, Vol. XXXII, p. 7).

shared a studio with John Cranch. That he was acquainted with William S. Mount we know from the postscript he added to a letter to Goupil and Company in 1852.[4] But that he was well aware of the work of his contemporaries is evident in a private judgment expressed to Rollins while he was working on *Stump Speaking:* "The fact is that I am getting to be quite conceited, whispering sometimes to myself, that in the familiar line which I have chosen, I am the greatest of all the disciples of the brush, which my native land has yet produced."[5]

Bingham's judgment of contemporary American painters some eighteen years later is summed up in another letter to Rollins. The latter, being asked to make the 1871 alumni address at Indiana University, determined on "the progress of our country" in the preceding four decades as his theme and asked Bingham for some suggestions on progress in the arts. The painter replied:

In Historical painting, the works of West, Trumbul, Copley and Alston rank with the most successful efforts of European Artists. In portraiture, Stewart, and lately Elliot and many others have left us delineations of the "human face divine" which come fully up to all that can be required in that department. The productions of our Landscape painters will not suffer in a comparison with any that the pencil of Claude or Turner has left to the world. You can indeed almost safely assert that in our Church we have the *greatest* of Landscape painters whether of the old or modern masters. His "Heart of the Andes" and "Falls of Neagara" seem literal presentations of Nature as she appears in all her transcendant beauty and sublimity. They are scarcely pictures, but rather Nature herself as seen through the eyes of her most devoted worshiper. We have also our Hogarths and our Wilkies. The graphic outlines of Darley. The humorous productions of Mount and others as seen in the "bargaining for a horse" "The Jolly flat Boatmen" and "County Election," assure us that our social and political characteristics as daily and annually exhibited will not be lost in the lapse of time for want of an Art record rendering them full justice.[6]

Bingham's principal statement about painting was made in the last months of his life when, as professor of drawing at the University of Missouri, he prepared a public lecture on "Art, the Ideal of

[4] "Please present my best regards to Mr. Mount when you see him."
[5] November 23, 1853 ("Letters," *Mo. Hist. Review,* Vol. XXXII, p. 170).
[6] June 19, 1871 (*ibid.,* Vol. XXXIII, pp. 72–73).

Art and the Utility of Art."[7] For him, art was the imitation of nature, as true a representation of the objective scene before him as he could make it. The story of Zenxas and Apelles, engaging in a trial of skill, served as apt illustration. "One painted a picture of grapes so perfect in its imitation of that luscious fruit, that the birds of the air flocked to partake of them as a servant was carrying the picture to the place of exhibition. The other merely painted upon his canvass a curtain, but so perfect was its resemblance to a real curtain, that his rival stretched forth his hand to remove it in order to get a view of the supposed picture beneath." Said Bingham, "Such an adherence to nature, and I may say to the truth of nature, constitutes what should properly be called the truth of Art; that Art only which belies nature is false Art."

Imitation was not to be photographic: it must get to the truth of nature through the artist. "What I mean . . . is the portraiture of her charms as she appears to the eye of the artist." The painter "must study nature in all her varied phases, and accept her both as model and teacher. He may consider every theory which may be advanced upon the subject nearest to his heart, but he must trust his own eyes and never surrender the deliberate matured conclusions of his own judgment to any authority however high."

The ideal in art Bingham thought "to be in that general and much embracing idea necessarily derived from the love and study of nature in her varied and multitudinous aspects, as presented in form and color . . . necessarily limited by the taste of the artist, which may confine him to what is special rather than to what is general in nature. . . . Artists permit themselves to be absorbed only by what they love. And as nature presents herself to them in a thousand phases, they may worship her in few or many. . . . All the thought which in the course of my studies, I have been able to give to the subject, has led me to conclude that the ideal in Art is but the impressions made upon the mind of the artist by beautiful or Art subjects in external nature, and that our Art power is the ability to receive and retain these impressions so clearly and distinctly as to be able to duplicate them upon our canvass."

[7] *Missouri University Lectures, 1879,* 311–24. The lecture is reproduced in full in the appendix below.

To this concept of realism—of making the picture so perfect a representation that it seemed scarcely a picture, but Nature herself —he adhered closely through most of his life. It was bitter hatred of injustice and cruelty that made him lose critical perspective in his pictorial denunciation of Ewing. Under such pressure of passion in 1871 he named art "the most efficient hand-maid of history . . . its power to perpetuate a record of events with a clearness second only to that which springs from actual observation." He now publicly declared: "I could not find a nobler employment for my pencil, than in giving to the future, through its delineations, truthful representations of extraordinary transactions indicative of the character of the military rule which oppressed and impoverished large numbers of the best citizens of our State during the late sectional war."[8] This artistic heresy he reiterated in Louisville two years later when he insisted, "My picture [*Order No. 11*] was conceived, executed and is now being exhibited in the interest of civil liberty as opposed to lawless military domination."[9]

Happily this polemic strain was confined to the one subject among his many works. Even in those years when passion moved him too strongly, in his portraiture he continued to exemplify the principles which he eventually stated in his lecture.

2. THE CONTEMPORARY RECEPTION OF BINGHAM

At the height of his creative power Bingham was denounced for the lowness of his taste. The West liked his delineations of the West. With the exception of the American Art-Union, however, the East, though sometimes allowing that his work was not bad, disapproved of his choice of subject and found fault with his use of color.

Missouri newspapers, we have seen, lauded the successive works of "the Missouri artist." Louisville and Lexington papers could not have been more enthusiastic about the merits of *County Election*, the most widely exhibited of all his paintings. The New Orleans *Picayune* found it admirable and thought Bingham was "to the West-

[8] *An Address to the Public Vindicating a Work of Art Illustrative of the Federal Military Policy in Missouri during the late Civil War.*
[9] Louisville *Courier-Journal*, September 16, 1873.

ern what Mount is to the Eastern States, as a delineator of national customs and manners." The Baltimore *American* spoke of the "high reputation" Bingham had won for "lively delineations of Western scenes"; *County Election,* it reported, "was full of animation, and will, we think, be considered his *chef d'oeuvre.*" In Philadelphia, the *Register* declared that "the remarkable power of this artist in seizing and transferring to his canvass the peculiarities of individuality is well known, but his infinite variety has never been so strikingly exhibited before."[1]

In New York the American Art-Union showed its approval of Bingham not merely by purchasing twenty paintings in a seven-year period but by speaking enthusiastically of him in its publications. The *Bulletin* of the Art-Union for August, 1849, featured the artist and his work thus:

A clever picture by Bingham, the Missouri Artist, has been added to the purchases since our last publication. One or two other works by him will probably be upon exhibition during the present month, and attract much attention by the fidelity of their representations of Western life and manners. Most of our readers may remember that *"The Jolly Flat Boatmen,"* which was engraved for the subscribers of 1847, as well as the *"Raftsmen Playing Cards,"* and the *"Stump Orator,"* which were included in late distributions, and greatly admired, were from the easel of this artist. All these works are thoroughly American in their subjects, and could never have been painted by one who was not perfectly familiar with the scenes they represent. It was this striking nationality of character, combined with considerable power in form and expression, which first interested the Art-Union in these productions, notwithstanding the existence of obvious faults. This assistance of the Society was of material importance to the artist. Indeed, according to his own statement, if it had not been bestowed, he would never perhaps have attempted that peculiar class of subjects which have given him all his reputation. It is pleasant to see that this encouragement was properly bestowed, and that observation and study have already corrected, to a considerable degree, those defects in color, in the distribution of light and shadow and in specific form, which formerly diminished the value of his works; while the higher qualities of character and expression and general form which first attracted the attention of the Committee, are still preserved. His figures have some *vitality* about them. They look out of their eyes. They stand upon their legs. They

[1] These newspapers have been previously cited in Chapter II, Section 10.

are shrewd or merry or grave or quizzical. They are not mere empty ghosts of figures—mere pictures of jackets and trowsers, with masks attached to them.[2]

More typical of the eastern attitude, however, was the series of attacks made on Bingham by the New York *Literary World* in 1847 and 1848. In the 1846 annual meeting of the American Art-Union, William J. Hoppin introduced a resolution to the effect that it was "the duty of this Association to use its influence to elevate and purify public taste, and to extend among the people, the knowledge and admiration of the productions of HIGH art" and offered "some pertinent and eloquent remarks" in support of his motion. The *Literary World,* fully in accord with the spirit of this resolution, regretted that the Committee of the Art-Union had not selected "some other subject for engraving than the 'Jolly Flat Boatman'—the very name of which gives a death blow to all one's preconceived notions of 'HIGH ART.'" The picture, allowed the writer, "was tolerably well in its way," but it was "by no means what a student of art would select as a standard of taste, and it contains no redeeming sentiment of patriotism." Nevertheless, he continued patronizingly, it would "please a portion of the subscribers, whose tastes are yet to be formed." What the student of art would have selected in preference to Bingham's picture was Huntington's *Sybil,* the second engraving for 1847, a work which would "amply atone for all the other may lack."[3]

Reviewing the 1847 Art-Union exhibition six months later, the *Literary World* reiterated its disapproval of *The Jolly Flatboatmen* which had

by some fatuity been selected by the committee, to be engraved for distribution to the members of the present year. The painting is not now on the walls, and as few probably of the members have seen it, we are sorry to inform them that the opinion we formed of it last year, when it was exhibited at the rooms for a few days, was that it was a vulgar subject, vulgarly treated, that the drawing was faulty and the composition artificial,—altogether a most unworthy and unfortunate selection. Were it not

[2] The remaining one and one-half pages of this notice were devoted to a biographical sketch of the painter "from a reliable source."

[3] Vol. I (April 3, 1847), 209. If the reader recalls the sweet sentimentality of the Huntington figure, he will form his own critical opinion of the critic.

somewhat redeemed by the engraving of Huntington's Sybil, we should feel great commiseration for the members, that to the possibility of drawing some of the bad pictures was added the certainty of getting a print of so low a character.[4]

On the same occasion this writer undertook to point out Bingham's failure in *Raftmen Playing Cards* and in "another subject yet unpurchased," pictures which offer him sufficient example of Bingham's qualities as a painter:

In color they are disagreeable, a monotonous, dull, dirty pink pervades every part; and in texture there is the same monotony. Flesh, logs, and earthen jug have the same quality of substance, the same want of handling. We think this must be produced by going over the colors when wet with a "softener," in order to avoid hardness; but we would rather see the figures as hard as statues than see light, shade, color, and texture swept thus into a mass of soft confusion. In composition, Mr. B. should be aware that the regularity of the pyramid is only suitable to scenes of the utmost beauty and repose; that when motion and action are to be represented, where expression and picturesqueness are objects sought for, proportionate departures must be made from this formal symmetry. A little study of the compositions of any of the great men of old, would do much towards correcting the artist's faults in this respect.

The exhibition of *The Stump Orator* at the National Academy of Design the following April brought forth still another harsh comment from the *Literary World*. The picture "makes one's eyes ache to look at it. All the laws of chiar' oscuro are set at defiance, so that the eye is distracted and carried all over the canvas, without a single resting-place. He has evidently no idea of the value of light, and how sparingly it should be used in a picture. In color it is unmistakably bad; its only merit is in the broad exaggerated character of the heads, which look as if painted from daguerreotypes."[5]

The *Literary World* was not alone in its opinion of Bingham's use of color. The New York *Express* had found *Raftmen Playing Cards* "almost a first rate picture . . . truly American . . . and decidedly

[4] Vol. II (October 23, 1847), 277. This writer returned for a fourth sharp reference to *The Jolly Flatboatmen* on November 13, 1847: "There are subjects and pictures enough that would engrave equally as well as the Jolly Flat Boatmen, and tend far more to elevate taste for Art amongst us" (clipping in American Art-Union scrapbook).

[5] Vol. III (June 3, 1848), 350.

original. . . . The power of expression displayed in these figures is, indeed, remarkable, nearly, if not quite equal to Mount. The drawing of the picture, for the most part, and the design are graceful, though without much method." But it was of the coloring that the writer was "disposed to complain. The flesh tints are all too heavy, and not in keeping with the surrounding effects of sunlight; the lights of the picture are too heavy and dead-like; and all the deeper shadows are nearly of one hue." Mr. Bingham, he concluded, "is the only man in this country who has it in his power to rival Mr. Mount, but he must change the tone of his pictures."[6]

Even the very friendly Art-Union thought the same. "Bingham's chief merit," said the *Bulletin* in December, 1850, "is his decided nationality and accurate reading of character. His works have certain faults in color and handling, which we think his residence here will enable him to correct, and which, by the way, are much less conspicuous than his want of advantages would have led one to expect." This criticism of Bingham's use of color continued to dominate discussion until very recently.

How much of this comment came to Bingham's attention we cannot say, but one criticism certainly did rouse a reaction from him and led to a determination in 1852 to sue the American Art-Union for permitting the publication of derogatory remarks. An article entitled "Development of Nationality in American Art," signed "W.," declared that "Mount is the only one of our figure painters who has thoroughly succeeded in delineating American life. . . . Bingham has made some good studies of western character, but so entirely undisciplined yet mannered, and often mean in subject, and showing such want of earnestness in the repetitions of the same faces, that they are hardly entitled to rank."[7]

The enthusiasm for Bingham today, based on these delineations of American life, would be entirely incomprehensible to his contemporary critics in the "sophisticated" East.

[6] Reprinted in the Jefferson City *Metropolitan*, August 17, 1847; I quote from Christ-Janer, 42–43.

[7] American Art-Union *Bulletin* (December, 1851), 139. Andrew Warner, the corresponding secretary of the Art-Union, assured Bingham that he was not the author.

3. BINGHAM AS PORTRAIT PAINTER

Bingham's achievement as a painter must be considered in five different areas—portraiture, landscape, historical painting, figure sketching, and genre.

He began and ended life as a portrait painter. It was a way of bread-and-butter and a way of art. "By becoming an itinerant," noted the American Art-Union *Bulletin,* "and painting upon moderate terms, he [early] found himself full of business, and though in total darkness in regard to color, his drawing generally gave so strong a likeness that many of his unsophisticated patrons looked upon his productions as the perfection of the 'divine art.' " Like many another portraitist he astonished his patrons by his facility of execution, "frequently commencing and finishing a portrait in the same day." It was even said (on his authority) that he painted "in this manner, twenty-five, in the course of thirty days."[1]

Some of his portraits do indeed show evidence of such rapid production. Nevertheless, it is true that he was a serious portrait artist, whatever the necessity that drove him to taking likenesses. Late in life he declared that a portrait should be "a true delineation of the form and features of his subject, with all the lines of his face which mark his individuality."[2] And this is the key to his intention all his life. His earliest critic, while praising the delineation, suggested that "the pencil of our artist, might be permitted occasionally, a stroke or two of flattery, with advantage. In some instances too faithful a copy of features is unfavorable in effect."[3] But Bingham was not able to flatter his patrons. The portrait had to be as true a representation of the sitter as it lay in his power to make.

A self-taught artist, Bingham went on teaching himself all his life long. His young friends could smile over his first portraits—stiff black-and-whites posed in the same manner with variations only in the features of the sitter. But even in this beginner's work there was sureness of drawing, there was grasp of character. Primitives they were, but they had force and strength and skill of modeling. *Mrs. John*

[1] Vol. II (August, 1849), 10–11.

[2] *Missouri University Lectures, 1879,* 321.

[3] Columbia *Missouri Intelligencer,* March 14, 1835.

Sappington, James S. Rollins, Josiah Wilson, and *Meredith M. Marmaduke* in 1834, the *Self-portrait* in 1835, seem to be chiseled out of blocks, but nevertheless they are expertly cut. In the smooth faces of the young men there are not many lines which mark their individuality; the painter's opportunity has been in the eyes and these he has made to speak. In elderly Mrs. Sappington he has captured a certain sourness and petulance—obviously he has not tried to flatter but to express what he saw. She is a living person. In these earliest works an uncommon talent for likenesses is displayed.

Ross Taggart has analyzed Bingham's portrait style perceptively. Of *Mrs. John Sappington* he has pointed out that:

The dust cap, the matching transparent lawn collar, the black bows with their satin stripes are painted with sureness, economy of means, and a striking feeling for design. . . . The drawing [of the head] is firm and competent, while the sense of structure betokens a keenness of observation and an ability to record what the eye has seen. The solid dome of the forehead, the soft fleshy quality of the cheeks, the recesses of the eye sockets, the sagging mouth, and the sharp chin contrasted with the flabby double-chin all are masterfully delineated. The artist's technical ability is obviously adequate to record his visual impressions. Yet above and beyond the mere technical facility there is an incisive character interpretation in Bingham's handling of the portrait of Mrs. Sappington. . . . one feels that here is a keen perception . . . the painting transcends that of a primitive and becomes the first step of an artist of unusual ability.

John Thornton (1835), Taggart continues, displays "the same intensity of observation and penetrating delineation of character." In this head "Bingham has shown his masterful feeling for form, light, and color in such a tiny detail as the edge of the forehead, where a progression of tones from a warm reflected light through a cool, almost green half-light, to a warm full light constructs a form that has real existence in space." But "despite the quality of painting of this head," the artist shows his lack of training in the awkward management of the thumb of the hand protruding from under the coat.

Taggart also focuses attention on the important use of color in the portraits. "One of the most typical of his chromatic idiosyncracies is the use of an almost transparent red in the shadows . . . most noticeable in his portraits, whether they were painted as early as 1834, or

as late as 1877. This luminous, hot red shadow is most apparent under the nose and around the ears and hands. In strong contrast is the painting of cool, greenish half-lights in the flesh tones. This strange opposition of warm shadows, cool half-lights, and warm high-lights fills the color with a vibrant energy and is so personal with Bingham as to amount almost to a signature."

In *Mrs. Eliza Pulliam Shackelford* (1839), Taggart finds "a maturing style, softer and less primitive brush work, and more sophisticated design than had previously been the case. But there is no relaxation of the incisive portrait style. . . . There is an exciting vitality to the picture and a force of character that make this rather plain pioneer mother truly handsome. The chisel-like modeling of the earlier pictures, although softened greatly, has lost none of its accuracy in detail, and is pleasantly relieved by the soft pink and silver bows of the fluffy white cap." Interesting, too, in this painting is Bingham's use of an arbitrary light. "Judging from the direction of the light which falls upon the face, there is no particular reason for the spotting of the hands and the high-light on the collar between the ribbons—areas which become, as it were, islands of light. This mannerism . . . is one which is increasingly characteristic of his later portraits."

Within a decade and a half, Taggart concludes, "Bingham's portrait style was fully evolved and except on rare occasions remained relatively unchanged for the next thirty years. It was a style sufficiently based on form, structure, and visual perception, however, that endless could be the appealing portraits produced."[4]

Many appealing portraits Bingham did paint. It has been pointed out by more than one writer that his best portraits were of subjects in which his interest had been particularly aroused. To paraphrase his own words: he permitted himself to be absorbed only by what he loved. It was, of course, as much absorption in the painting as in the person. His variations from the conventional bust, painted with no more background than the back of a chair, began early. In *Samuel Bullitt Churchill* (1837), the standing half-length figure is placed before a large window opening out on a landscape

[4] " 'Canvassing for a Vote' and some Unpublished Portraits by Bingham," *The Art Quarterly*, Vol. XVIII (Autumn, 1955), 231–37.

which is perhaps intended for a view in Churchill's native Kentucky. In *Governor John Cummings Edwards* (1844), the subject is posed standing on a bluff with his back to the Missouri River, a long black dress cape hanging from his shoulders, and his silk hat in his hand. In the left of the picture in mid-distance is the state capitol. The size of the figure, which fills much of this 40x34½-inch canvas, in relation to other details, gives a startlingly dramatic quality to this most unusual of Bingham's portraits, making Edwards seem gigantic.

Bingham's most appealing portraits were of women. Contrary to what has been said by others, Bingham was unusually successful with women. They made him extend himself as a painter in a way that men seldom did.

The world that Bingham portrayed in his genre paintings was entirely masculine. Women had no place in political life or flatboating, in shooting matches or woodyards. In only four of the extant pictures do we find women: one is featured in *Captured by Indians*, one bends over a tub in the background of *The Squatters*, two are seen in the central group in *The Emigration of Daniel Boone*, and four are theatrically posed in *Order No. 11*. We can feel sure that in the lost pictures women played no greater part. Two of these were nudes, painted, not from life, but from engravings of *Ariadne* and *Musidora*. Not a single female figure is represented on the 110 leaves of the Mercantile Library sketchbook. The few drawings of nudes in the Rollins scrapbook at the State Historical Society of Missouri are obviously from the antique.

All this might seem to argue lack of interest in the female subject. Quite the opposite was true. Women had real attraction for Bingham, and in proper places he enjoyed painting them. If a sense of propriety or a feeling for a man's world excluded them from the genre paintings, portraiture offered opportunity to study such subjects and to realize fully their charm. Men sat to have their likenesses taken. Significance for them was in the face, and the painter's force was concentrated there. The piercing eyes and the tight, set mouth put the living John Quincy Adams before us. Although the books beside Dr. Benoist Troost add picture interest, it is the expression that distinguishes this marvelously speaking portrait. Women, though their likenesses were often as striking as those of the men, frequently

became the subjects of composition. Bingham painted portraits of the men and made pictures of the women.

This interest in women more as subjects than as sitters is evident in Bingham's earliest work. The painting of Mrs. Sappington's collar and cap allowed him more picture interest than was possible with Dr. Sappington, presented in the conventional black and white attire of the gentleman of the day. *Mrs. Robert Aull* (1837?), painted when the sitter was not more than half the age of Mrs. Sappington, has the appeal of youth and the benefit of youthful costume, and Bingham has responded to them. The elaborate arrangement of the hair, the long earring, the bare neck, and the gossamer scarf over the shoulder made a picture where none would exist if the painter had been limited to the pleasant but unexciting face of the young woman. Clearly Bingham has learned that a picture is more than a likeness. The portrait of mature, well-mannered, self-contained Mrs. Shackelford (1839) is a likeness even to the mole beside her mouth, but the great care to the details of the dress make the portrait more than just another "head."

By 1840 we can sense a new development when Bingham sent to the spring show of the National Academy of Design paintings entitled *Sleeping Child* and *Group, Two Young Girls*. Quite possibly the subjects of these lost pictures had sat for formal portraits, but for exhibition he wanted his works judged as pictures rather than as likenesses. In this same year he painted *The Dull Story*. Comparison with known portraits of Elizabeth Hutchison Bingham leaves no doubt that she sat (or slept) for this picture, too. But the face here is merely a conventionally pretty and placid one. The interest lies in the subject, a woman sleeping in a chair with an open book in her lap. The painter has been concerned not with character, but with composition. In his careful attention to color—the satin gown, the rose at the bosom, the pink and white skin, the black hair, the green cushions—he has produced not a portrait of his wife, but a picture of an attractive woman who is part of a scene. One other painting of 1840 illustrates this impulse to go beyond likeness with the female subject. No doubt the picture Bingham made of six-year-old Sallie Ann Camden resembled her, but the charm of this little girl has been enhanced by the background provided for her. The glimpse of trees

and water in this open-air picture suggests that the title *Young Girl near a Stream* would be more significant of the artist's intention than *Portrait of Sallie Ann Camden.*

This responsiveness to women, this characteristic of seeing picture possibilities, grew during his life. It is true that many of the pictures he later painted of women proved no more than good or indifferent likenesses. But he was frequently moved to go beyond likeness. The half-length portrait of Sallie Cockran McGraw (1852?), the exquisite double portrait of Mrs. Susan Howard Hockaday and her little daughter Susan (1859?), the portrait of Mrs. Robert L. Todd and her small daughter (1860), the outdoor portraits of Mrs. Thomas W. Nelson (1862) and Mrs. James T. Birch (1877), and the astounding *Palm Leaf Shade* are among the most notable of his later portrait productions.

Examination of his works shows Bingham to be an able and effective portrait painter who has not yet come into his proper reputation. Recognition of him in this line of painting will grow, not diminish. Ironically, he suffers from the high regard which owners have for his work. Few portraits have been available for the museums. When his portraits can be seen and studied, his skill will win far more attention than it has yet had.

4. BINGHAM AS LANDSCAPE PAINTER

When of forty titles not more than ten at best are known to be extant, it is not possible to say much about their author as landscape painter. When only two are *positively* dated (the 1851 Ohio River scene represented by the Bauer woodcut and the 1872 *View of Pike's Peak*), it is not possible to say much about the painter's development. Nevertheless, we can assert that Bingham showed at least a modest talent in this line. His principle of representation of nature as his eye saw it is effectively adhered to.

Certainly his earliest painting of this sort, *Landscape with Cattle* (1846), is his most attractive. This placid scene has almost a classical effect in its arrangement of composition and in its feeling of calm. Perhaps here is the influence of Claude Lorrain. We can applaud Bingham, however, for omitting the classical architectural

details that many of his fellows would have inserted. *Landscape with Cattle* remains a scene in the painter's own western country: it is not an imagined landscape but a real one. It is not a romantic conception but nature herself as Bingham had seen or we might see her.

In the middle period of his landscape work the influence of the Hudson River School is clearly seen. *The Storm, Mountain Scene with Deer,* and *Mountain Scene with Fisherman* show the heightened emotional tone characteristic of much American landscape painting of the second quarter of the nineteenth century. These canvases are not the less true to nature, but they present a less usual aspect of it than does *Landscape with Cattle.* Late in life Bingham reverted to his earlier, simpler, and more direct representation of nature, if we may judge by the known views of Pikes Peak, but in them he did not again achieve the charm of *Landscape with Cattle* nor impress us with his capture of the uniqueness of the commonplace. Pikes Peak, after all, is not an everyday kind of sight; the wooded pasture land near the Mississippi is.

Though the few landscapes we know by Bingham would make us look with interest on the lost ones refound, his finest work of this kind is in the background of his river pictures—some of which might almost be described as *Landscape with Figures.* In his river vistas, in his misty river banks, in his bright sunlight on water and shore, he has exceeded his contemporaries. This is not picturesque landscape painting; it is reality itself. As Meyric Rogers pointed out twenty-five years ago, "the remarkable atmospheric quality" of a picture like *Fur Traders Descending the Missouri* is "less a convention than evidence of Bingham's keenness of observation and feeling. This quality is particularly true to the soft brilliance of the humid atmosphere which is today characteristic of the Missouri Valley when untainted by coal smoke."[1]

Fur Traders Descending the Missouri and *The Trappers Return, Raftmen Playing Cards, The Jolly Flatboatmen, Fishing on the Mississippi, Watching the Cargo*—quite apart from their evocation of life on the river—are the evocation of the river itself. Here Bingham has displayed genius as a landscape painter.

[1] "An Exhibition of the Work of George Caleb Bingham, 1811–1879, 'The Missouri Artist,' " *Bulletin of the City Art Museum of St. Louis,* Vol. XIX (April, 1934), 9.

5. BINGHAM AS HISTORICAL PAINTER

All his life Bingham longed to paint a great historical picture, but of the many kinds of painting to which he set his hand his historical works, with the exception of *The Emigration of Daniel Boone*, are of least significance today. The over-life-size, full-length portraits of Washington, Jefferson, Clay, Humboldt, and Blair are to be thought of as historical work rather than portraiture, for only Blair sat to Bingham, and all were conceived as historical subjects more than as likenesses. Since these works, which the painter thought his greatest, have been destroyed, we can neither confirm nor deny his judgment. The Humboldt and the Blair subjects as seen in the only extant photograph are not impressive, though to judge them on this basis may well be unfair.

From painting such figures in characteristic speaking positions Bingham went a step further in the more dramatic equestrian portraits of Andrew Jackson at the Battle of New Orleans and Nathaniel Lyon at the Battle of Wilson's Creek. These, too, are gone, and we have no evidence to support a feeling that they may not have been more than conventional soldiers-on-horseback pictures. Certainly, the one extant canvas of this type—*General Lyon and General Blair Starting from the Arsenal in St. Louis to Capture Camp Jackson*—is nothing more than two not very striking portraits with the sitters posed on horseback rather than on studio chairs. The interest of the picture rests on our knowing the occasion. *Washington Crossing the Delaware* inevitably brings to mind Leutze's similar piece which Bingham intended to rival, but like the picture of the Missouri generals, this more complex work holds our attention for its patriotic expression, not for its effectiveness as painting.

Order No. 11 is as great a failure as a work of art as it is a success as polemic. The passionate drive that produced it robbed the painter of the detachment that an artist must maintain from the materials upon which he is drawing. The picture is static, not vital; theatrical, not dramatic. It is not the evoking of human experience, but a tableau staged to illustrate a theme. These are not people caught in a moment of time, but posed to express a particular idea, to create a specific pre-determined impression.

Only in the *Emigration of Daniel Boone* can we say that Bingham is successful as a painter of history. Historical painting, like the writing of historical fiction, is extremely difficult. It is far easier for an artist to express his own times, for he lives and breathes in them. The quality of life in a past age is almost impossible to realize, however one may strive for accuracy. In the Boone picture Bingham succeeds because he is painting his own kind of people in a characteristic moment that occurred but a long generation before his own boyhood. It is in effect a genre picture which is at the same time a historical subject. We are not looking at famous people acting on a famous occasion, as in so much historical painting, but at ordinary people behaving in their ordinary way on an occasion which later became famous.

Bingham's paintings of western life in his own time have become the finest of historical work, for they form a vivid record of a way of life that existed and has ceased to exist. His attempts at "historical" painting, except for *The Emigration of Daniel Boone*, are mere exercises in a convention.

6. BINGHAM AS DRAFTSMAN

Bingham's finest monument is the Mercantile Library sketchbook. These "graphic and revealing sketches . . . of pioneer life and psychology," these carefully made drawings presenting a "lively pageant of talkative politicians, loutish backwoodsmen, solid citizenry, staggering drunks, and roistering boatmen"[1] are sufficient in themselves to win immortality for their author, even though no paintings existed.

The absolute authority of these sketches is immediately evident. It lies not merely in the authentic representation of a considerable gallery of characters in the artist's world; it lies in sharp observation and in precision of drawing. The superb depiction of expression, the ability to compact the essence of a man into a single sketch of his countenance—the quick grasp of characteristic pose, the utter naturalness of body contours, erect, slouching, bent, relaxed,

[1] James B. Musick, "Praise the Lord and Pass the Ammunition," *Antiques,* Vol. XLIII (February, 1943), 60.

sprawling, nonchalant—every detail expressive of individuality is closely observed and expertly reported. The hats have the shapelessness of long use. Shirts, coats, and trousers have accommodated themselves over many a day to the bodies they clothe; their wrinkles and folds are their own absolutely. The pipes clamped in jaws or held in hands, the bulge in the coat pocket at this moment empty but long accustomed to hold a pint of whiskey, a plug of tobacco, or a large bandanna, the hands grasping a paddle, bowing a fiddle, sharpening a quill pen, resting on a walking stick, doubtfully drawing a card from a three-up hand, baiting a fishhook, gesturing to a listener, or drooping casually from a resting figure are rendered by a master eye and a master hand.

But the drawings are all published here—they need no explanation, no commendation. As the American Art-Union *Bulletin* pointed out 110 years ago, Bingham's figures have vitality. They look out of their own eyes and stand on their own legs. They are not ghosts of figures or pictures of jacket and trousers with masks attached, but living men.

In the transfer of these figures to canvas Bingham displayed extraordinary skill. That some of them in extant paintings have been blurred by bad restoration is obvious. But in *Fur Traders Descending the Missouri, The Jolly Flatboatmen, Raftmen Playing Cards, The Trappers' Return, Fishing on the Mississippi, The Wood Boat, Canvassing for a Vote, Stump Speaking*, and a dozen other paintings, the clarity, firmness, precision, and feeling of the drawings have been superbly realized on the canvas.

Whether his pencil sketches or his portraits or his genre paintings are considered, it is readily seen that Bingham was a draftsman of great ability.

7. BINGHAM AS GENRE PAINTER

The *Missouri Republican* was discerning enough in the spring of 1847 to note that Bingham had "struck out for himself an entire new field of historic painting" in taking "our western rivers, our boats and boatmen, and the banks of the streams, for his subjects." He had studied these people closely "with the eye and genius of an

artist and the mind of a philosopher" and had "seized the character-
istic points, and gathered up their expressive features, and trans-
ferred them to his canvass with a truthfulness which strikes every
observer. To look at any of his pictures, is but to place yourself on
board of one of the many crafts which float upon our streams."
Furthermore, and this was peculiar to Bingham, he had "not sought
out those incidents or occasions which might be supposed to give
the best opportunity for display, and a flashy, highly colored picture;
but he has taken the simplest, most frequent occurrences on our
rivers—such as every boatman will encounter in a season—such as
would seem, even to the casual and careless observer, of very ordi-
nary moment, but which are precisely those in which the full and
undisguised character of the boatman is displayed."

When in the fall of that year Bingham displayed *The Stump
Orator,* the *Republican* found the same qualities in this "unexag-
gerated representation of an assemblage which is familiar to every
one in the West." In every one of the figures was "evidence of a deep,
thoughtful and comprehensive understanding, on the part of the
painter, of the feelings, motives and impulses which act upon crowds
and upon individuals." As admirable as his representation of figures
was the "ease and naturalness with which he has grouped this large
number of figures together, upon a small canvass—preserving all the
characteristics of dress and countenance and . . . the usual posture
of those who attend such meetings."[1]

This judgment can stand, for it gets to the heart of Bingham's
achievement. It did not pretend to technical criticism or to place
him in the stream of painting history. For these we turn to the sound
analysis of Bingham's style made by Arthur Pope in 1935:

> If one were to see only a small portion of one of Bingham's paint-
> ings, perhaps a bit of drapery and a little landscape, in which the nine-
> teenth century character of the subject matter was not apparent, the
> quality of the surface might easily lead one to think it French work of
> the seventeenth century. Examining the whole picture from this point
> of view, one finds the paint put on in a firm deliberate fashion, often over
> a red ground, producing a clean transparent character that distinguishes
> it sharply from the usual painting of the middle of the nineteenth cen-

[1] April 21, November 30, 1847.

tury. Moreover, the painting is evidently carried out on the basis of a clearly thought-out design and with reference to careful drawings in the regular Renaissance way, entirely distinct from the imitative manner of painting directly from nature which had been rapidly coming into vogue in Europe at this time. It reminds one of the general manner of painting employed by Poussin in his more classical pictures, although its contemporary subject matter suggests rather a comparison with the paintings by the brothers Le Nain. . . .

Not only in quality of surface but also in composition Bingham's paintings belong in the Renaissance tradition. If one were to consider merely the general arrangement of a picture like the *Verdict of the People,* one might say that it was done by some follower of Poussin. Bingham must have got his lessons in composition from engravings after Renaissance-Baroque masters, for there is constant use of pictorial forms from sixteenth and seventeenth century painting. In the *Verdict of the People* one finds a screen of architecture brought across the upper left portion of the central vertical axis of the picture, leaving the upper right portion for distant background, in the manner inaugurated by Giorgione, Titian and Talma and continued by Poussin and Claude and other painters of the seventeenth and eighteenth centuries. This screen is used also in the *Stump Speaking* and in its companion *The County Election.* In the *Raftsmen Playing Cards* there is a pyramidal building up of figures in the traditional Poussin-Raphael manner. At the same time there is in most of these pictures an arrangement in three-dimensional space to suggest a series of planes parallel with the picture plane; and the main action is thrown back into a second plane framed by foreground figures in the usual fashion of Baroque painting.

But what gives Bingham's painting particular interest is that he does not use these forms in a mechanical fashion; into the framework of his general scheme he masses and groups his figures with great skill, at the same time keeping the action convincing from a naturalistic point of view. . . .

All the pictures which I have mentioned show extraordinary skill in the distribution of the many figures which each contains. One can think of few painters who have handled this particular problem so well. Bingham knew how to use light and shadow to clarify the grouping of the figures. In the *Verdict of the People* the main mass of figures at the left is brought out in light against a moderately darker background, while the mass of figures on the right is thrown into shadow against light beyond; the central axis is accented by the group slightly separated from the rest of the foreground action and yet belonging to it; one proceeds from large masses down to smaller groups in a perfectly clear and orderly manner. Ability to handle large numbers of figures in this way is one of the rarest things in the history of painting. Some contemporary renderings of the

American scene seem rather poverty-stricken in comparison with Bingham's orderly procedure and fertility of invention.[2]

Recent criticism has found interest not merely in Bingham's fertility of invention and skill in arrangement of masses of figures, but also in his use of color, once strongly disapproved of. John I. H. Baur has noted the Missouri artist's "unusual color sense," manifest in "his consciously arranged sequences of muted browns, blues and reds that combine like chords in the ragged costumes of his figures."[3] Ross Taggart has expressed a similar appreciation more fully: "In the genre pictures, where there is more opportunity to use color than in the portraits, his tones can perhaps best be described as smoky, for all his colors are muted off-shades—blue-greens, sage-greens, plums, cerises, and cool pinks. Despite the unusualness of these tones, they are carefully ordered and sensitively related. In *Canvassing for a Vote*, the flagstone walk and the dirt road are painted in a delicate juxtaposition of varying shades of gray, green, pink and lavender. These hues function together in a way that shows a refined artistic control."[4]

Bingham well deserves this perceptive recognition of his craftsmanship; but, finally, as Thomas Hart Benton observed in his preface to Albert Christ-Janer's *George Caleb Bingham,* it must be remembered that "he lived in a day when it was the picture rather than the way it was made which occupied the amateur's attention." Bingham was painting not for other painters but "for a living world and painted what that world could understand—its life." He was an artist "who, though technically allied to the High Renaissance, was able like his great contemporary, Daumier, similarly allied, to direct his procedures to the life he knew. Instead of fitting life to his processes, he fitted these to his life and made thereby a unique and original series of forms."[5]

[2] "Bingham's Technique and Composition," in *George Caleb Bingham, the Missouri Artist, 1811–1879,* 15–16.

[3] *American Painting in the Nineteenth Century,* 12. The word "ragged" may be objected to as inaccurate: the clothes on Bingham's people are often well worn and sometimes patched but almost never ragged, which would have been out of tone for Bingham.

[4] "'Canvassing for a Vote' and some Unpublished Portraits by Bingham," *The Art Quarterly,* Vol. XVIII (Autumn, 1955), 231.

[5] Christ-Janer, *Bingham, viii–ix.*

Appreciating fully the excellence of the procedures of the painter Bingham, we turn back to intention and result, matters of first importance to the non-painter viewer in 1847 or today. Bingham's desire was to paint the world in which he lived, of which he was a part. Here again he was absorbed by what he loved, and the enduring satisfaction we feel in his work is the result of his disinterested devotion to his chosen task.

He approached his work as a free, uncommitted man. Growing up on the frontier untrained in any school of art or criticism, out of love he painted his world as he saw it. He did not seek to interpret that world or to explain it. He had no theory of society or painting to advance, no message to deliver, no self-conscious philosophy to urge. He did not embrace the common as spiritual or moral adventure; he did not set out to "explore and sit at the feet of the familiar, the low." He was already alive in a real world. To borrow a phrase from Virgil Barker, he was simply expressing "the recurrent rhythms of common life"[6] and this he was doing without the self-consciousness of Emerson or Whitman. He was successful because he combined the experience of shared life with the detachment of the observer.

His paintings of river and country and political life in the West were intended to be objective reporting of everyday scene and everyday occurrence, and this he accomplished better than any other painter of his time. In every extant picture from *Fur Traders Descending the Missouri* through *The Jolly Flatboatmen in Port*, he maintained his objective approach. It is not merely that he sketched with authority and that he painted brilliantly the immediate life about him: he never intruded on his work. He has sometimes been likened to Hogarth, but the Missourian was not a satirist, a reformer, or a moralist. To him people were interesting as people. He was not concerned with their failings; he was not moved to correct their ways and manners. Even in *The Stump Orator*, painted soon after a bitter experience, he remained entirely objective, if we can trust contemporary descriptions. Strongly as he felt on political questions, he did not use his art to express his private opinions or personal feelings.

He has humor and warmth, sympathy and understanding, but he never descends to sentimentality or the comical. He does not bid

[6] *American Painting: History and Development*, 477.

for laughter or for tear. He is not side-tracked into story-telling. With the possible exception of *In a Quandary,* no existing genre picture of his between 1844 and 1857 can be dismissed as anecdote. He is not concerned with little stories or illustrations of behavior. *Fur Traders Descending the Missouri* "means" nothing: it is only a record of life. There is no anecdote in *The Jolly Flatboatmen:* the dancer is kicking up his heels, the fiddler is playing, the other boatmen are lounging idly, but they have no story to tell. The painter has simply caught them in a moment of life.

He has avoided the pitfall of the picturesque. He has not gone in search of the strange and the new. He has not sought to fulfill the romantic dreams of stay-at-home people. The patches on the worn clothes of his country men are not a bid for attention: that clothes rub into holes and are patched is merely a fact of life. He painted a world he lived in, not a place he visited. It cannot be too much insisted upon that he has taken "the simplest, most frequent occurrences" of western life for his subjects—subjects, E. P. Richardson has underscored, "which now seem beautiful and original, [but] were then as commonplace as is the sight, today, of a filling station attendant putting ten gallons of gas in a car or changing an inner tube."[7] However we respond to the poetry of the river that pervades so many of Bingham's paintings, the boatmen were no more aware of it than we are today of the street or highway down which we drive.

Bingham did indeed portray his world with singular power and understanding. It is true that there were incidents and appearances and qualities he did not paint, but, as he declared in his lecture, nature presents herself in varied and multitudinous aspects and the artist is free to respond to few or many of them. He can be fairly charged only with the pictures he chooses to paint, not with those others in his situation might have painted. The only mission Bingham set himself was to transfer to canvas such aspects as appealed to him and to adhere to the truth of nature as he saw it, without the influence of any mind or eye other than his own. The degree of his success is obvious in more than twenty extant genre canvases painted between 1844 and 1857.

When we look at Bingham's scenes of everyday life beside those

[7] *Painting in America: the Story of 450 Years,* 176.

of his contemporaries, we are the more strongly impressed by the work of the Missourian. The essence of genre is to discover and disclose the quality of ordinary experience, to express what Richardson calls "the grand meaning of the commonplace."[8] Bingham, without striving to be original, displayed his originality in the very choice of the commonplace subject, in the naturalness of his approach, and in the simple directness of his treatment. The result is the full realization of those aspects of life he chose for painting.

Too many of the genre artists of his time, in search of life, were misled by their "discovery" of an unexploited area; too often the study of the local scene was external and superficial. Charles Deas, for instance, was drawn to the West by the excitement of the frontier. For seven years he lived and worked in St. Louis and in the Indian country. His frontiersmen are accurately presented, but the effect of his paintings is generally melodramatic: he sees and is excited, but he does not feel with his subject. His pictures are vivid illustrations of the frontier West, but not evocations of it. William Ranney, Connecticut-born, fought beside Texans and studied them carefully at first hand before he returned to paint them in New York. An excellent draftsman, he is probably our best painter of such scenes before Remington, but the feeling remains that he is an outsider giving us what he sees but never quite feels himself. Bingham, too, could slip in such a picture as *The Concealed Enemy* for the same reason: his Indian figure is picturesque rather than real; only the river scene so typically Bingham and so typically the Missouri could redeem it. But his boatmen and his farmers and his politicians—his boys and his dogs and his gatherings of the "sovereigns"—to look upon them is to be with them. In countenance and costume, in posture and expression, they are absolute reality. Too many went out searching for the typical, not knowing that the typical was what lay about them. Bingham, happily, stayed home.

The eastern states produced many capable painters of familiar life, but none expect William S. Mount can approach Bingham. John Lewis Krimmel's *Election Day at the State-House* with its variety of incident and character and its detached observance might well have suggested to Bingham his own election subject, but it is by no

[8] *Ibid.,* 176.

means the equal of the Missouri painting in control of composition, in painting skill, in its recognition of "the feelings, motives and impulses which act upon crowds and upon individuals." Krimmel's outdoor scenes and his interiors earn him a respected place in the history of American genre, but he cannot match Bingham in figure drawing, nor can he seize the moment with the same effectiveness. David Blythe, satirically inclined, frequently verged on caricature; James Clonney too often gave way to self-conscious humor; John G. Chapman was primarily an historical illustrator; Richard Caton Woodville's production was much slighter; Thompkins Matteson tended to the sentimental. Francis Edmonds, John Ehninger, Eastman Johnson, and many others contributed to a lively and valid record of life in nineteenth-century America. But none of them, Mount excepted, can approach Bingham in quantity and consistency of production, in freshness and keenness of observation, in sincerity and seriousness of treatment, in vitality of effect, or in talent as a painter.

Perhaps this leaves too much emphasis on the faithfulness of Bingham's delineations of western life; perhaps it seems to reduce his paintings to documents of western history. No impression could be more false. Rather let us say with Edgar Richardson that Bingham had "a remarkable sense of what was grand, essential, typical" and out of a "meager experience of pictures and his own sensibility" created a style of "great visual poetry."[9] Through his genre paintings a lost world lives forever. This is the magic of painting.

8. THE MAN AND THE PAINTER

How Bingham learned to paint so brilliantly and originally remains a very deep mystery. Some understanding, nevertheless, can be reached through the man, for between his life and his work there is a notable accord. Partisanly active as he was in politics, pressed as he was to make a living by his art, Bingham remained at ease with his world. Neither an optimist nor a pessimist, he accepted life as he found it. He was not an artist standing aloof, immersed in his own emotions and reactions, but a man well rooted among people, responding to life. Tranquillity, assurance, a sense of belonging are

[9] *Ibid.,* 176.

everywhere seen and felt in his work. The tall man leaning on his setting pole in *The Wood Boat*, the fisherman baiting his hook in *Fishing on the Mississippi*, the gentlemen in the political scenes, the farmers shooting for a prize, the checker players considering their moves, the returning trappers, the loafers and the hangers-on—all have an air of calm acceptance: this is the way life is, they seem to say, and why not? They are not whining or whimpering, beating their breasts, complaining of ill-usage, bewailing the morrow, or exhorting their fellows to action and great deeds. A simple, open, natural, serene man, Bingham has created a world filled wtih people natural and at their ease before the universe. It is this unity of tone pervading his work that is one of its most marked characteristics. Wherever we turn—throughout the genre pictures, in the landscapes, in the portraits painted over forty-five years—there is everywhere this same quality of being at one with the world.

Critics have placed Bingham among the romantics presumably because he painted the common man and nature, but he was, in fact, a classicist. His intention was not to elevate or glorify the common man. It was to study man. Late in life he made this clear by asserting to Rollins that his purpose had been to record "our social and political characteristics as daily and annually exhibited."[1] To Bingham men were not high or low, aristocratic or common. They were men, behaving as men behave. The likeness that has been seen in his work to that of Poussin and Claude Lorrain was no chance development that happened because the earliest pictures falling into his hands were engravings after these masters or their followers. It is the expression of Bingham's spirit, his controlling force. He painted the world as he saw it—who can do otherwise?—and he saw it with the moderation, the sense of proportion, the restraint of emotion, the good humor and good sense that characterize the true classical tradition. He is a conservative in the best sense—a tolerant observer able to look on his fellows without personal passion or prejudice.

In *Stump Speaking*, for instance, we see the stupid fellow—his back is turned to us, but we know his vacant face—asking a pointless question with earnest importance. We see the speaker, wishing to be all things to all voters, striving to make a reply that will not cause

[1] "Letters," XXXIII, 73.

another "sovereign" to ask an opposing question. Bingham is not savage with this self-important dull clod; he expresses no sympathy with or antipathy to the office seeker. He does not turn with disgust from the grinning drunk. Each man in this crowd is a man living his own life. Bingham only looks at them with knowledge and understanding, with geniality, humor, and a certain kindliness. He calls this mixed lot of humanity "the sovereigns of the people," but he is not mocking them or sneering at them any more than he is holding them up to admiration as the representation of the institution of democracy. It is his concern to present and not to judge.

Bingham's paintings are a direct result of his own naturalness and simplicity, of his tolerant understanding, of his honesty of observation and sincerity, of his controlling sense of balance and proportion in life. But beyond all this, they are pervaded by another quality of which Bingham would not have been aware. That quite real and actual world which he painted so objectively—and this is particularly true of the river scenes—was at the same time a world remembered; it was the world of his boyhood, of his youth, a world slipping away from him. Without his knowing it, a nostalgic glow of boyhood remembered is diffused over all his marvelously accurate delineations of western life. He has not merely recorded magnificently his place and his people, but he has evoked life itself. He is not merely a reporter: he is a poet.

✥ IV ✥

Paintings

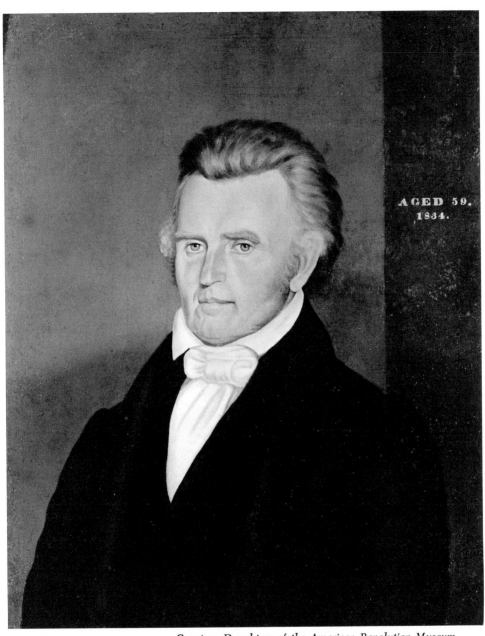

AGED 59.
1834.

Courtesy Daughters of the American Revolution Museum
Arrow Rock, Missouri

1. Dr. John Sappington, 1834

197

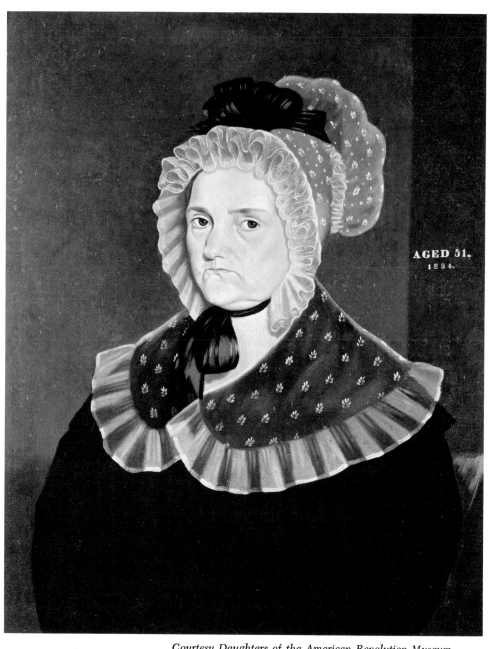

AGED 51.
1834.

Courtesy Daughters of the American Revolution Museum
Arrow Rock, Missouri

2. Mrs. John Sappington, 1834

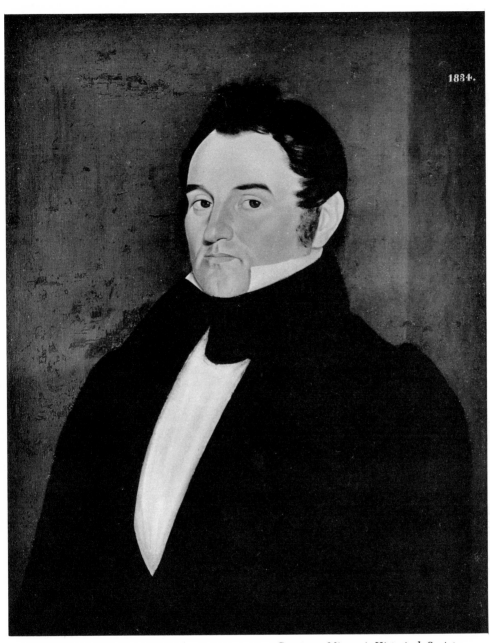

1834.

Courtesy Missouri Historical Society
Photograph by Piaget

3. Meredith M. Marmaduke, 1834

199

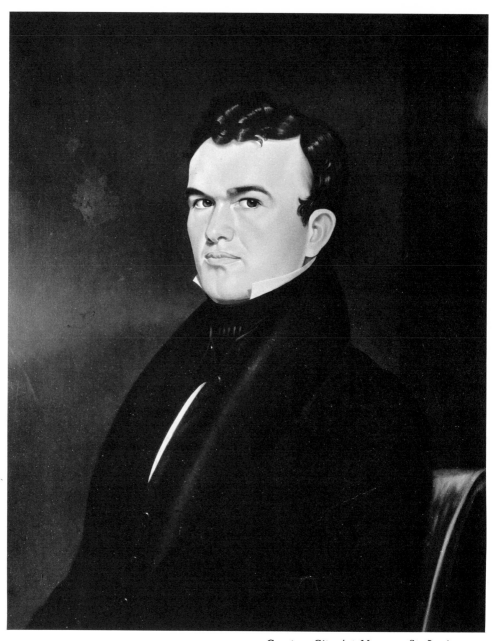

4. Self-Portrait, 1835

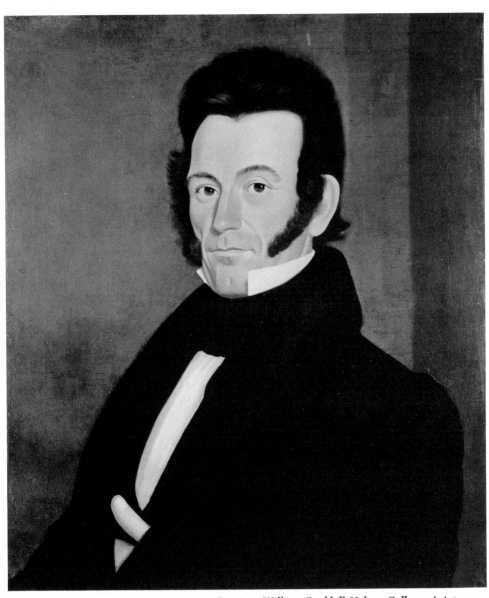

Courtesy William Rockhill Nelson Gallery of Art

5. John Thornton, 1835

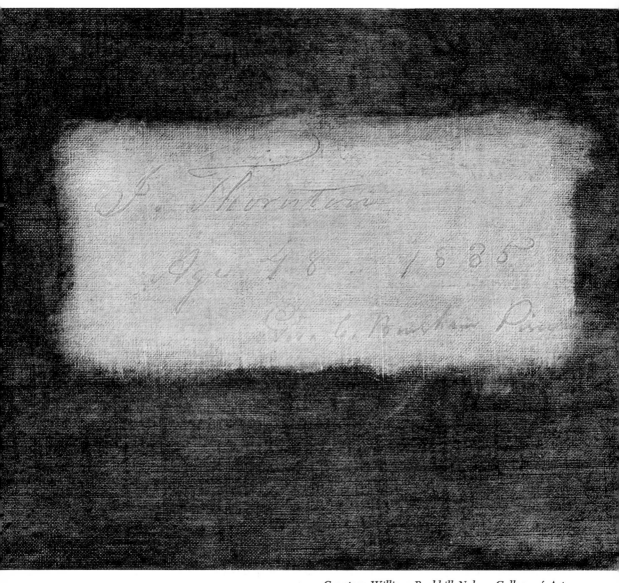

6. Bingham Signature on Back of Canvas
of Thornton Portrait

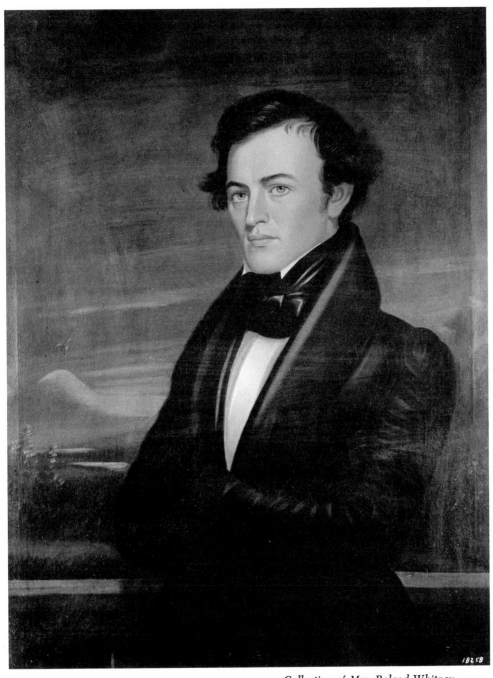

Collection of Mrs. Roland Whitney
Photograph courtesy Frick Art Reference Library

7. Samuel Bullitt Churchill, 1837

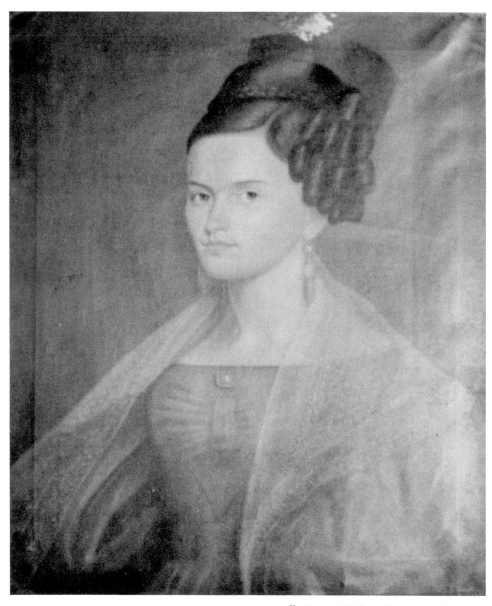

Collection of Walter Henderson, Jr.

8. Mrs. Robert Aull, 1837

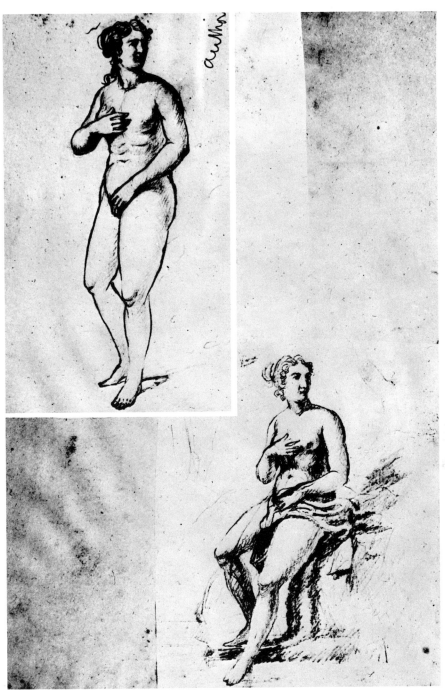

Courtesy State Historical Society of Missouri

9. Sketches from the Rollins Scrapbook

205

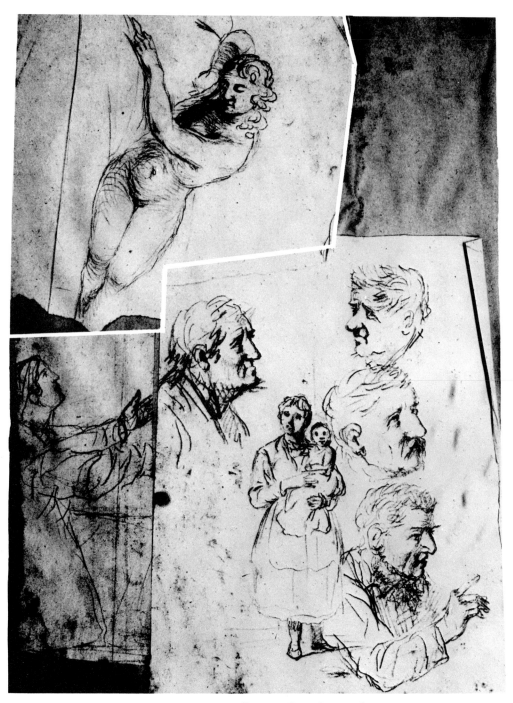

10. Sketches from the Rollins Scrapbook

11. Sketches from the Rollins Scrapbook

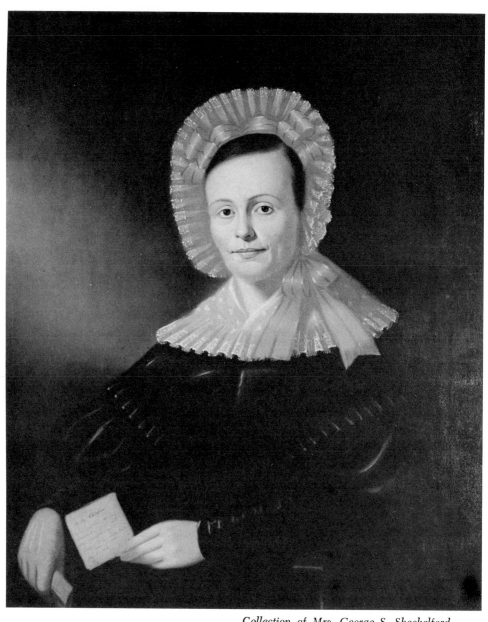

12. Mrs. Eliza Pulliam Shackelford, 1839

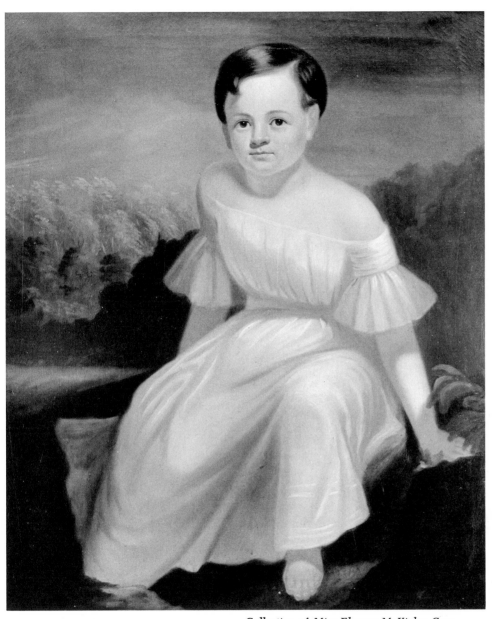

13. Sallie Ann Camden, 1840

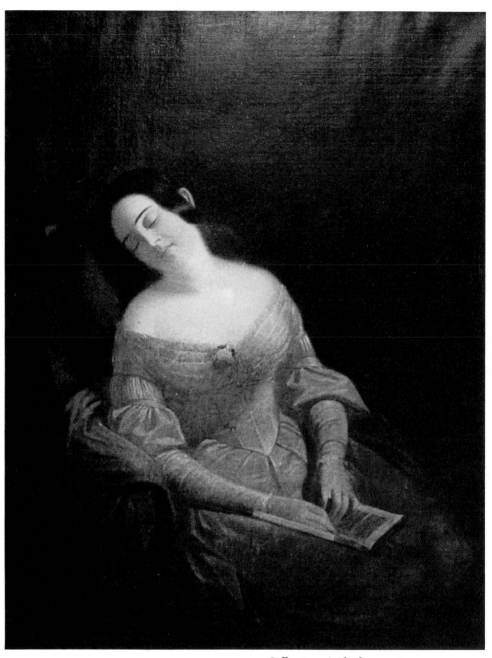

Collection of Charles van Ravenswaay
Photograph by Toennes

14. The Dull Story, 1840?

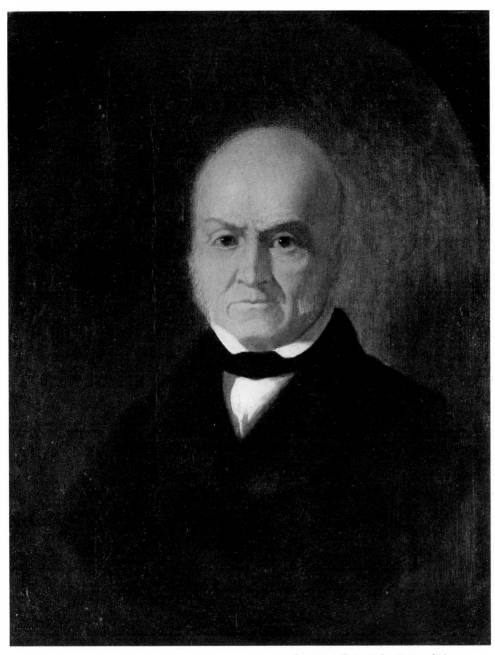

Courtesy Detroit Institute of Arts

15. John Quincy Adams, 1850

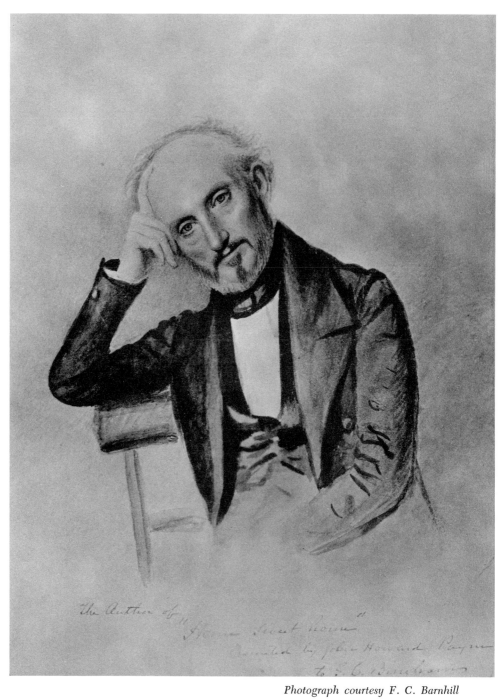

Photograph courtesy F. C. Barnhill

16. John Howard Payne, 1841–1842

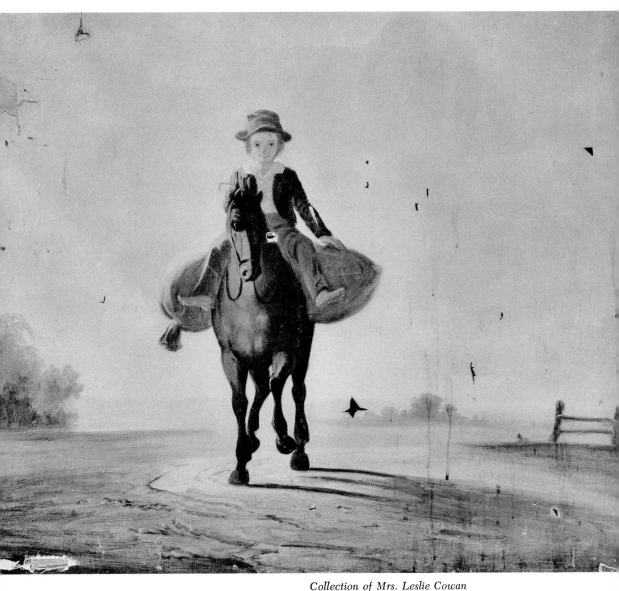

Collection of Mrs. Leslie Cowan
Photograph by Piaget

17. The Mill Boy, 1844

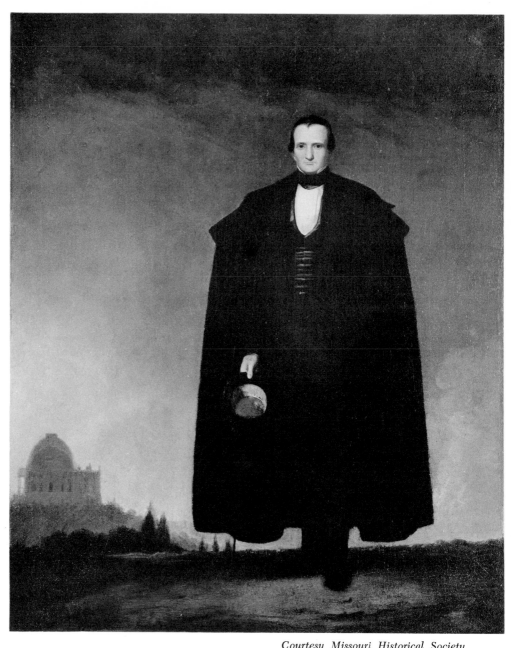

18. John Cummings Edwards, 1844

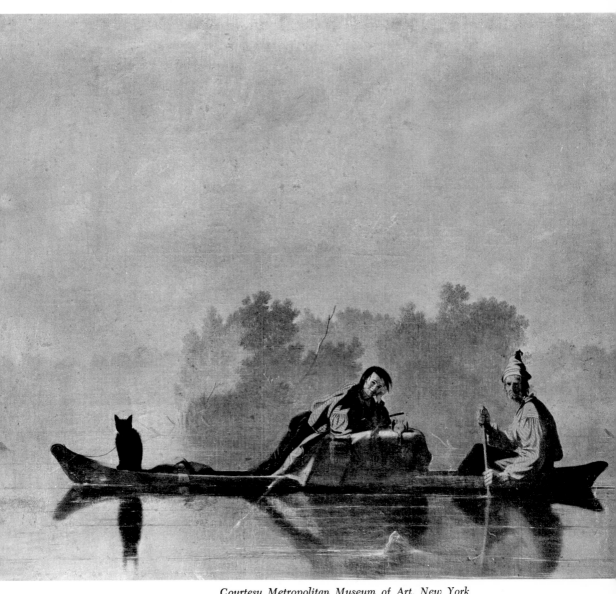

19. Fur Traders Descending the Missouri, 1845

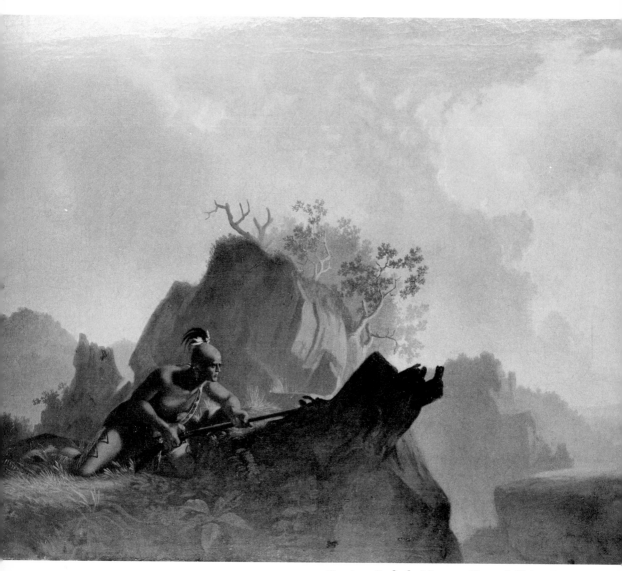

20. The Concealed Enemy, 1845

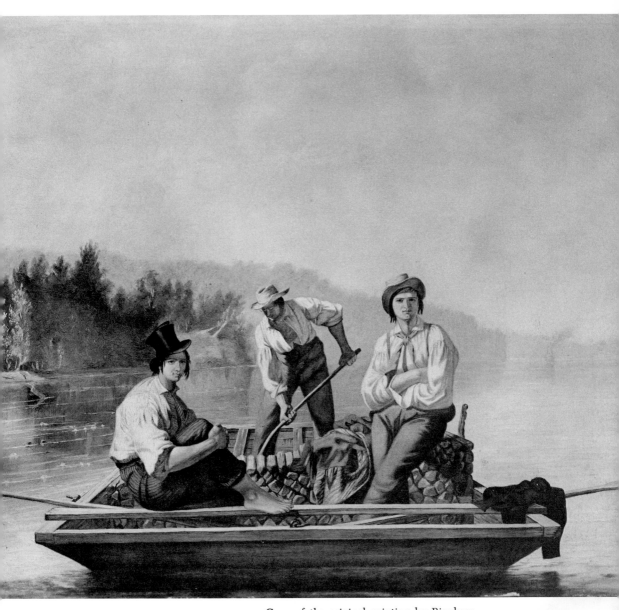

Copy of the original painting by Bingham
Courtesy Henry Francis Du Pont Winterthur Museum

21. Boatmen on the Missouri, 1846

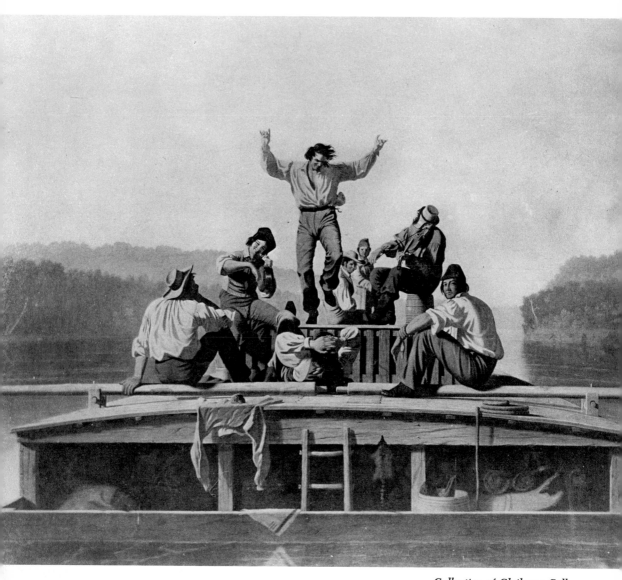

22. The Jolly Flatboatmen, 1846

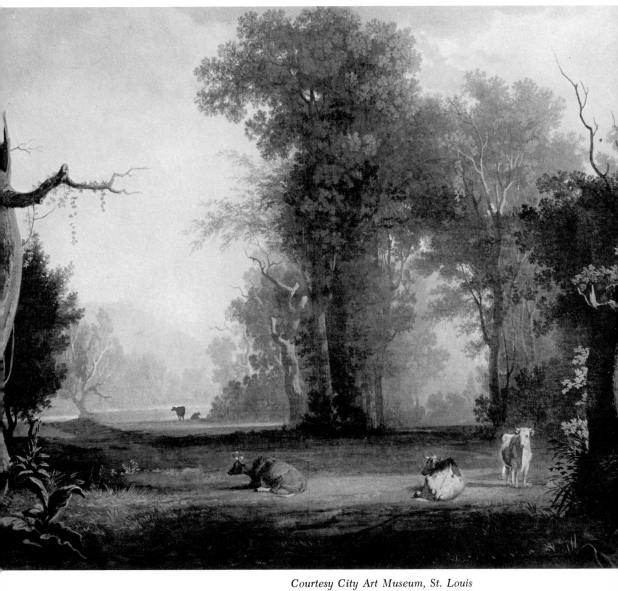

23. Landscape with Cattle, 1846

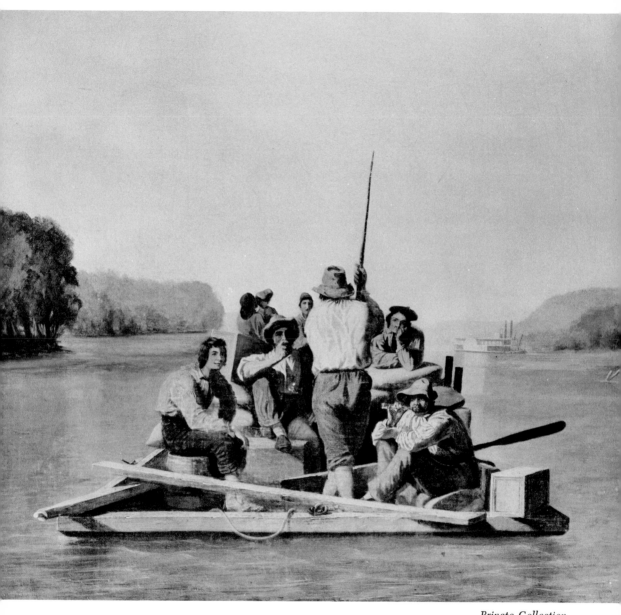

24. Lighter Relieving a Steamboat Aground, 1847

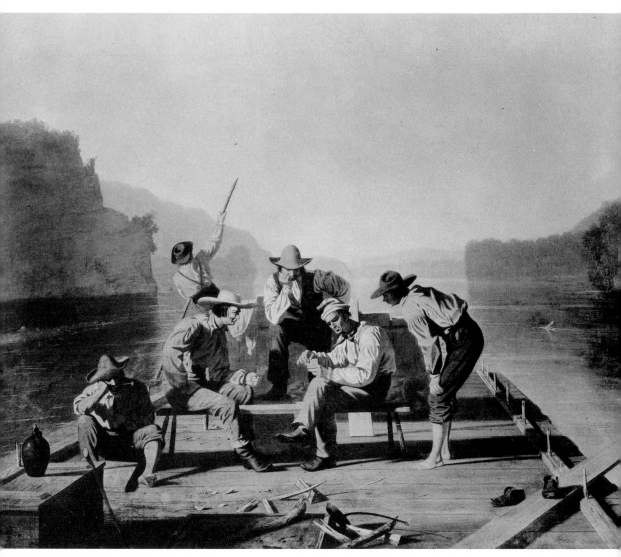

25. Raftmen Playing Cards, 1847

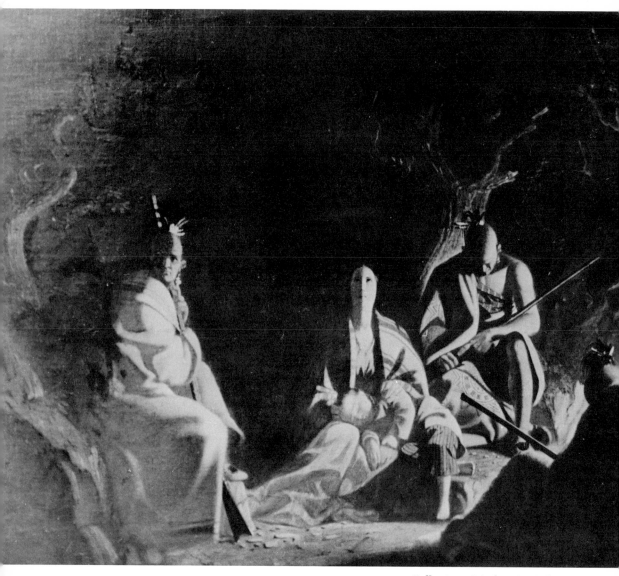

26. Captured by Indians, 1848

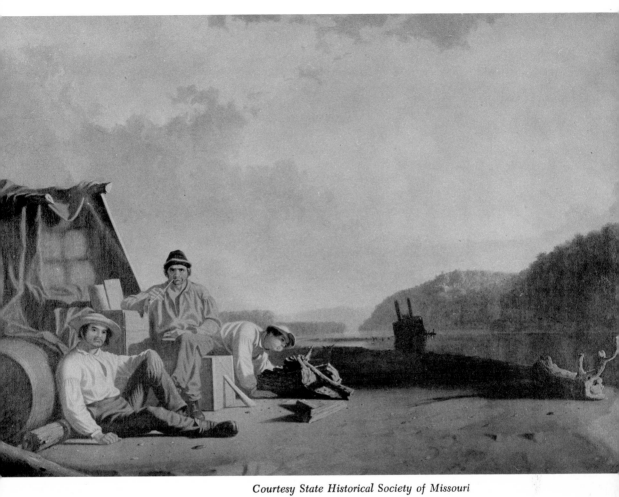

27. Watching the Cargo, 1849

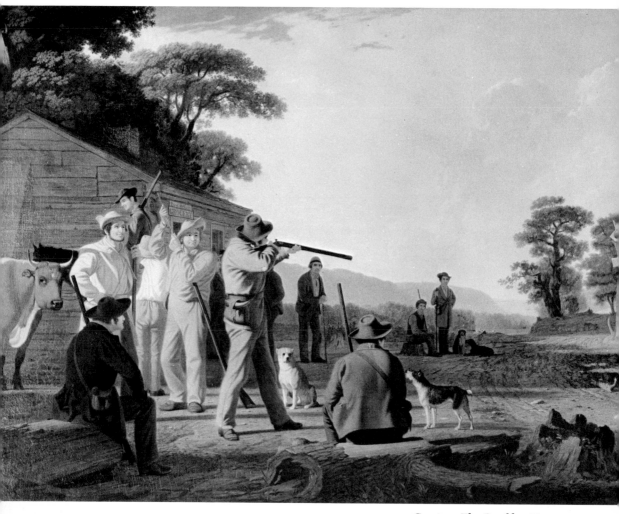

28. Shooting for the Beef, 1850

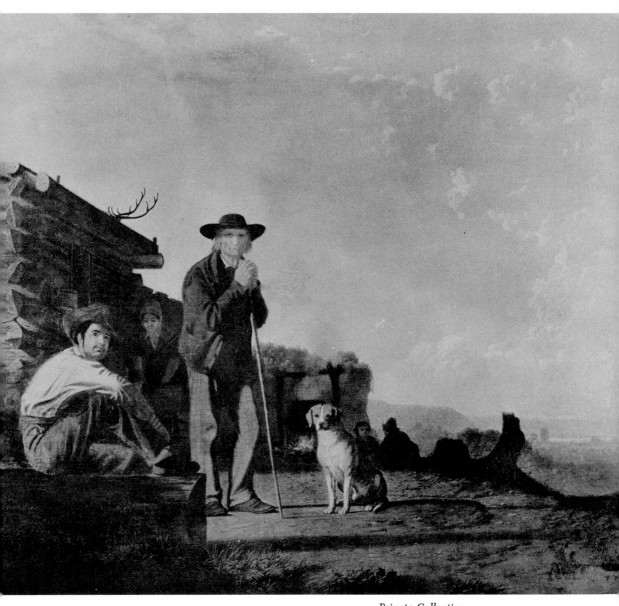

Private Collection

29. The Squatters, 1850

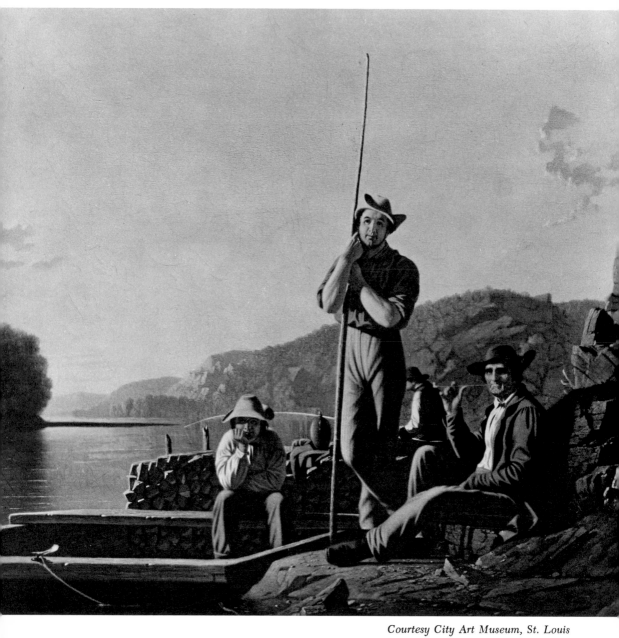

30. The Wood Boat, 1850

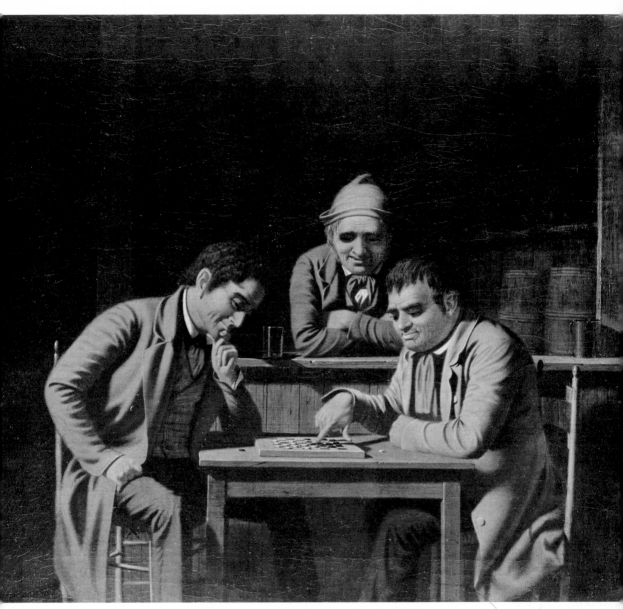

31. The Checker Players, 1850

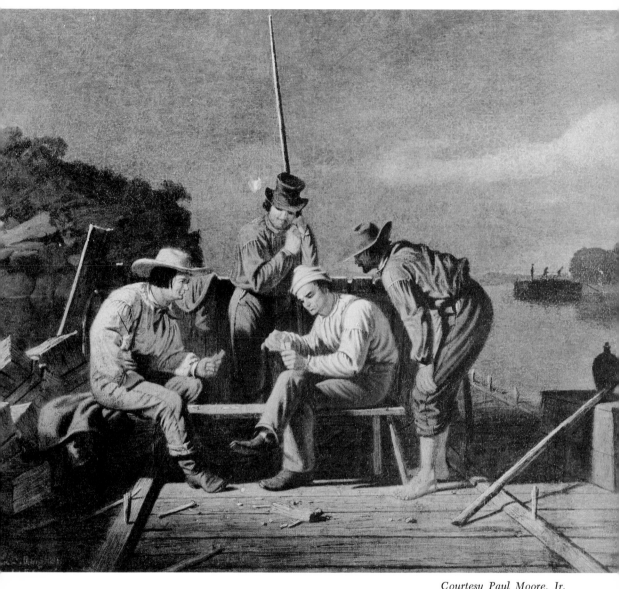

32. In a Quandary, 1851

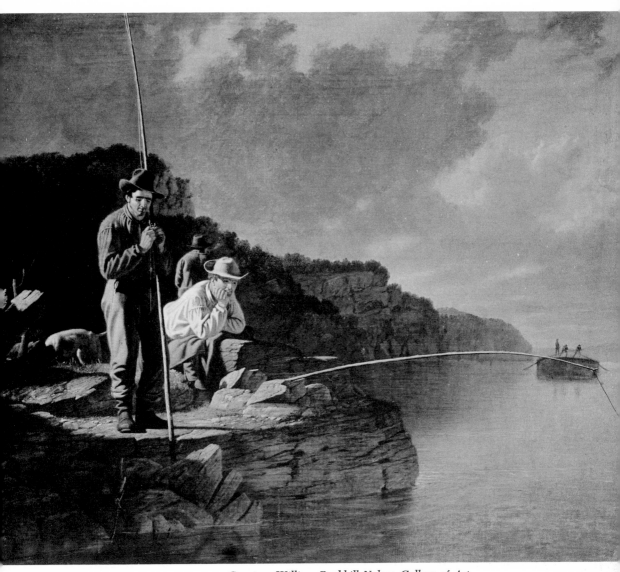

33. Fishing on the Mississippi, 1851

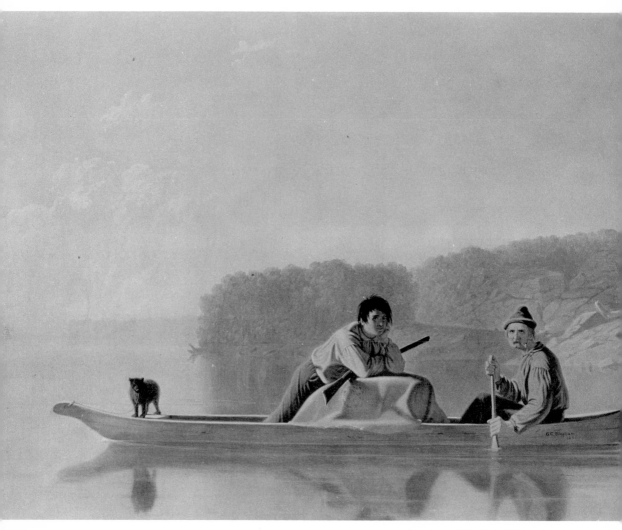

34. The Trappers' Return, 1851

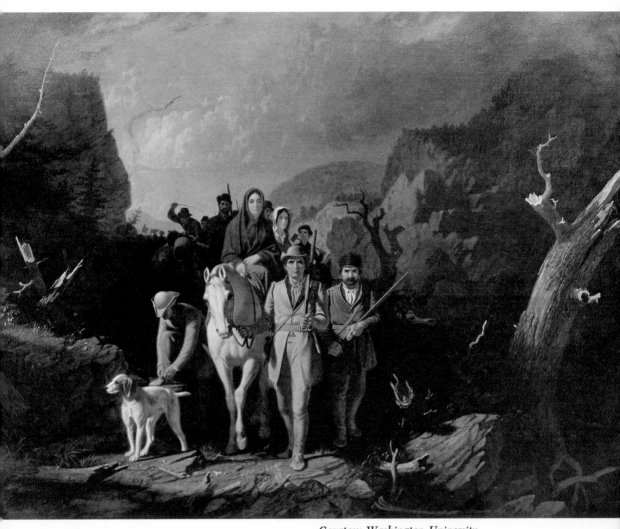

35. The Emigration of Daniel Boone, 1851–1852

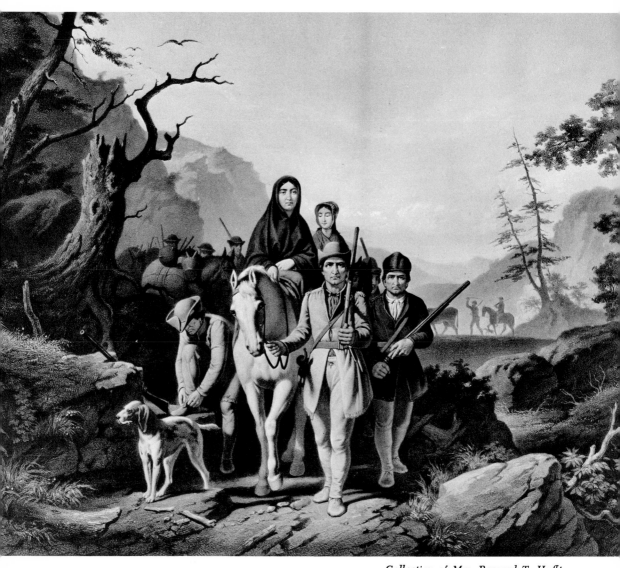

36. Lithograph after *The Emigration of Daniel Boone*

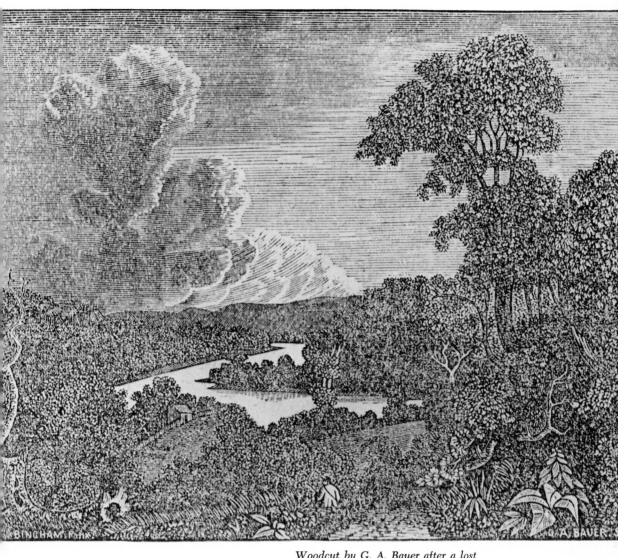

Woodcut by G. A. Bauer after a lost
painting by Bingham

37. Scene on the Ohio near Cincinnati, 1851

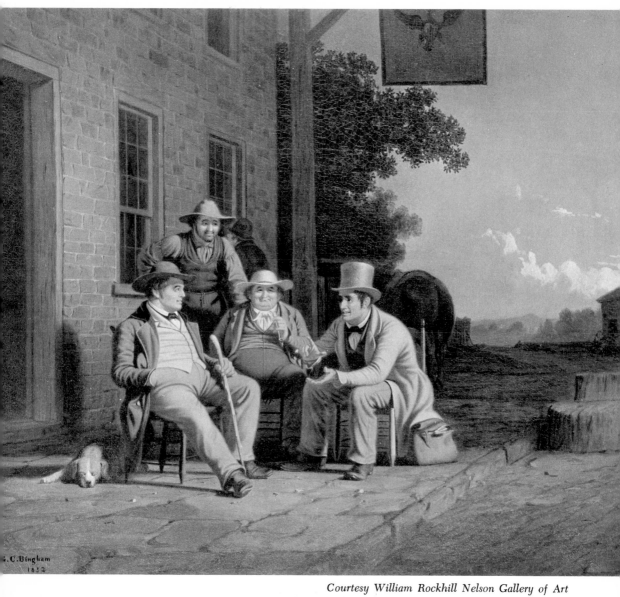

38. Canvassing for a Vote, 1852

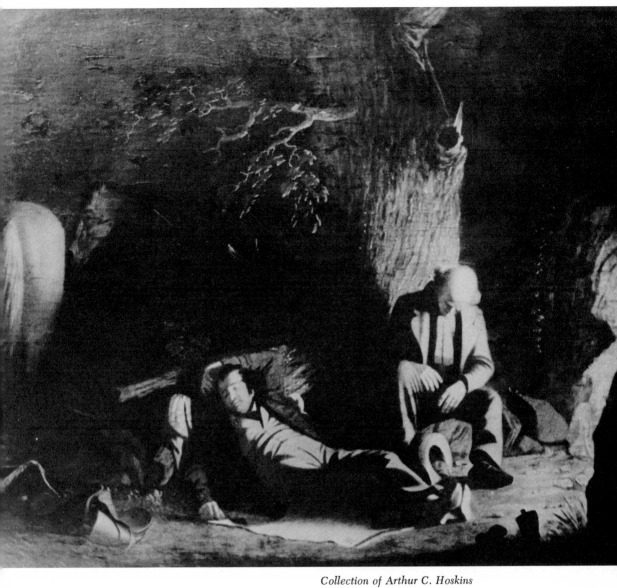

39. The Belated Wayfarers, 1852

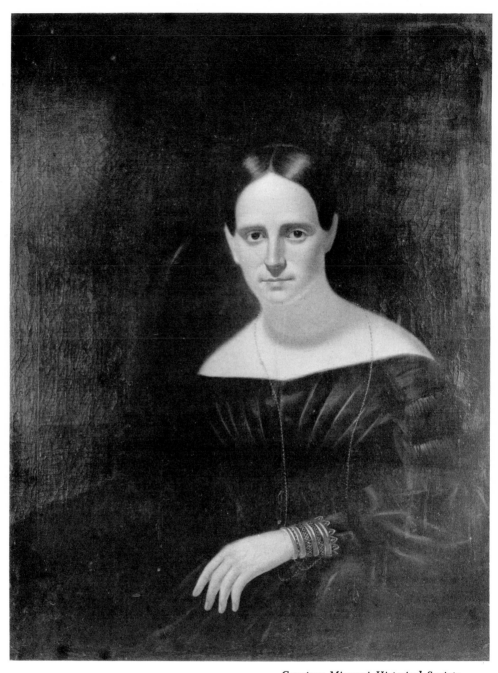

40. Mrs. John Darby, about 1852

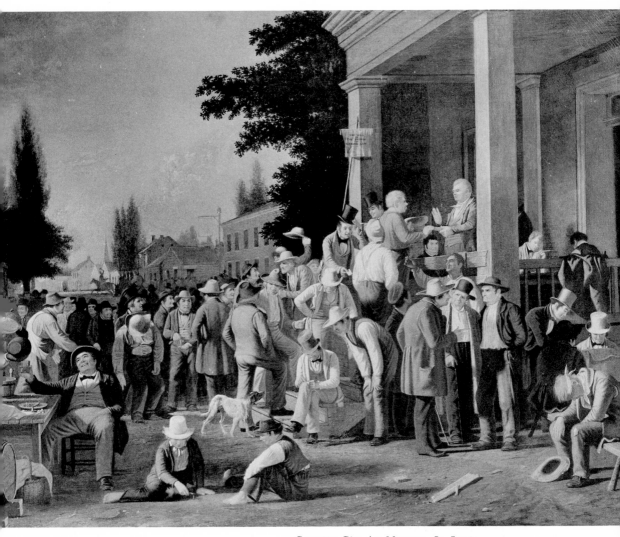

41. County Election, 1852

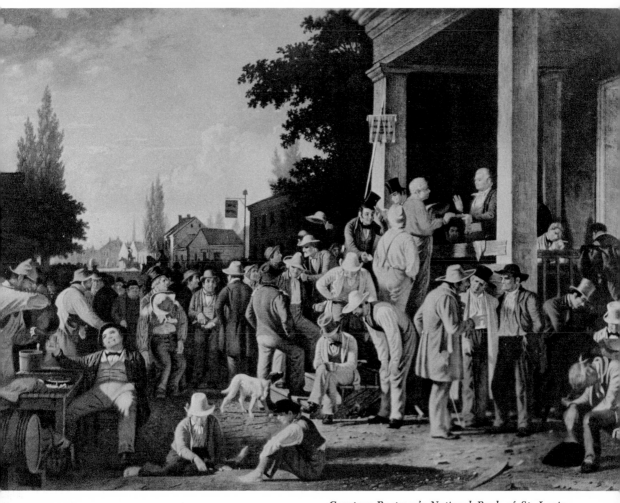

42. County Election—No. 2, 1852

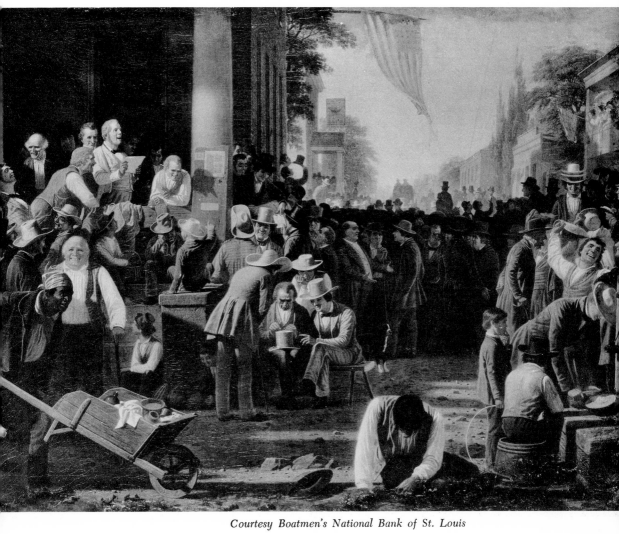

Courtesy Boatmen's National Bank of St. Louis

45. The Verdict of the People, 1855

241

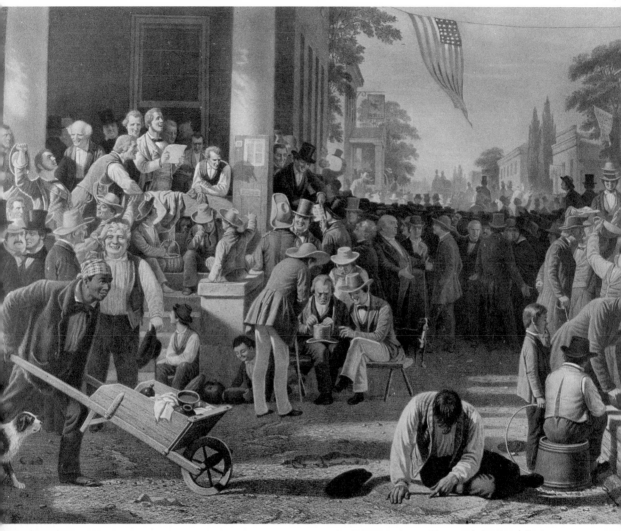

Courtesy State Historical Society of Missouri

46. Lithograph after *The Verdict of the People*, 1869?

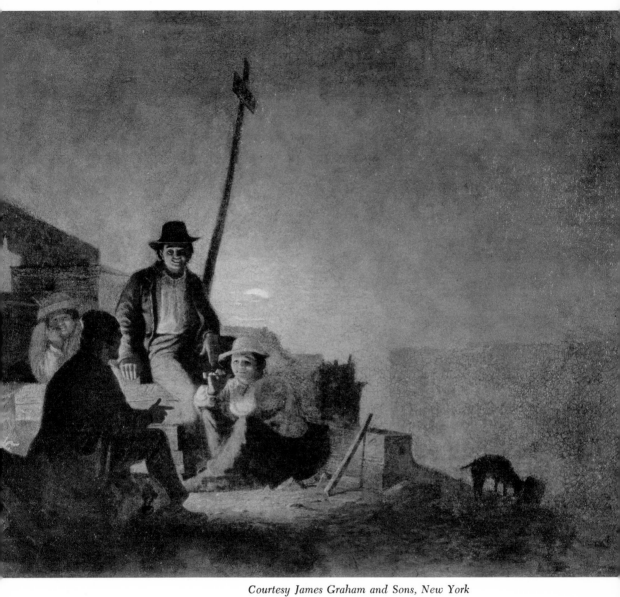

Courtesy James Graham and Sons, New York

47. Raftmen by Night, 1854

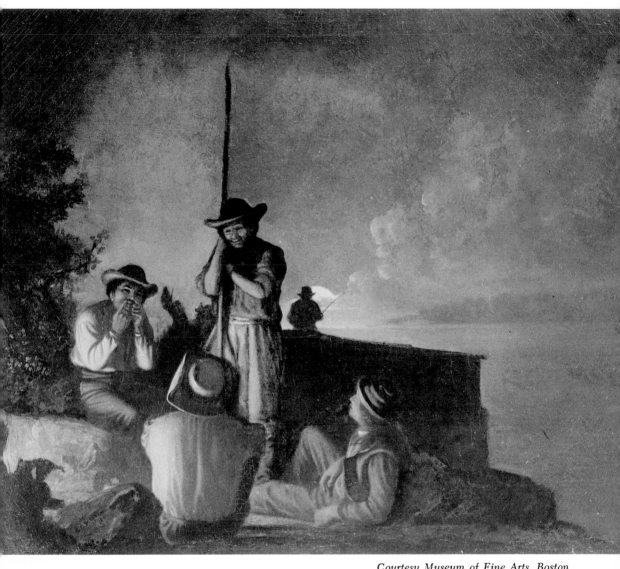

48. Flatboatmen by Night, 1854

244

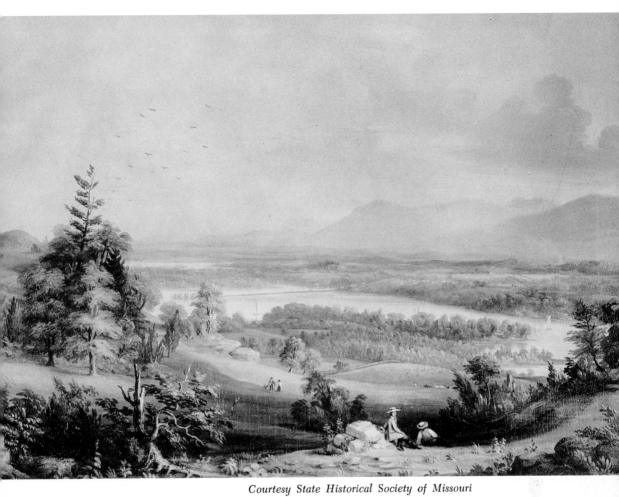

49. Scene on the Ohio, 1851

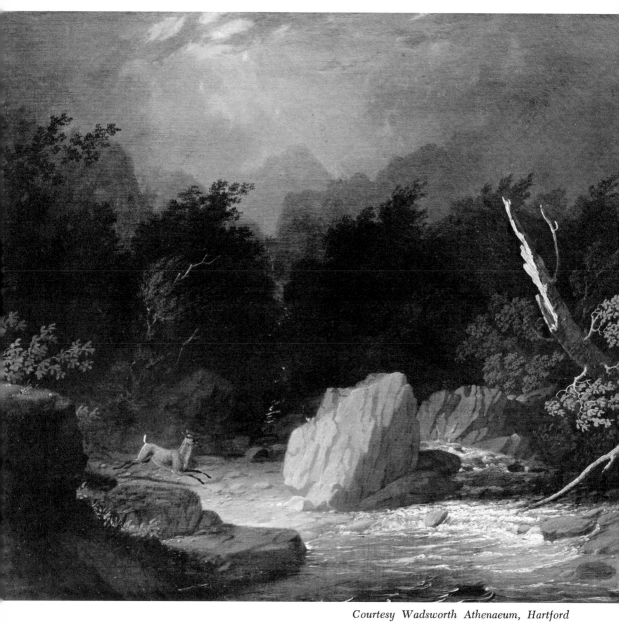

50. The Storm, 1853–1856?

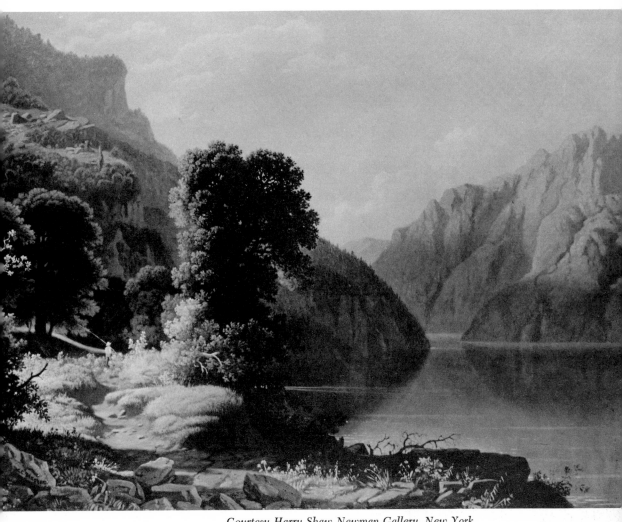

51. View of a Lake in the Mountains, 1853–1856?

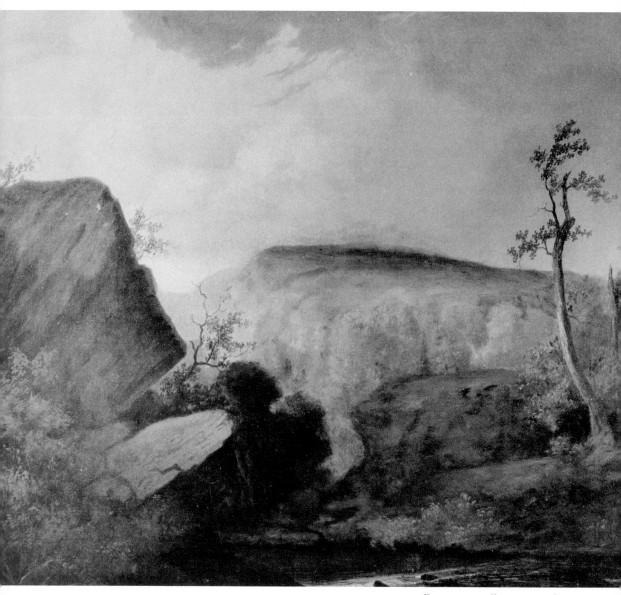

Collection of William A. Hughes

52. Mountain Gorge, 1853–1856?

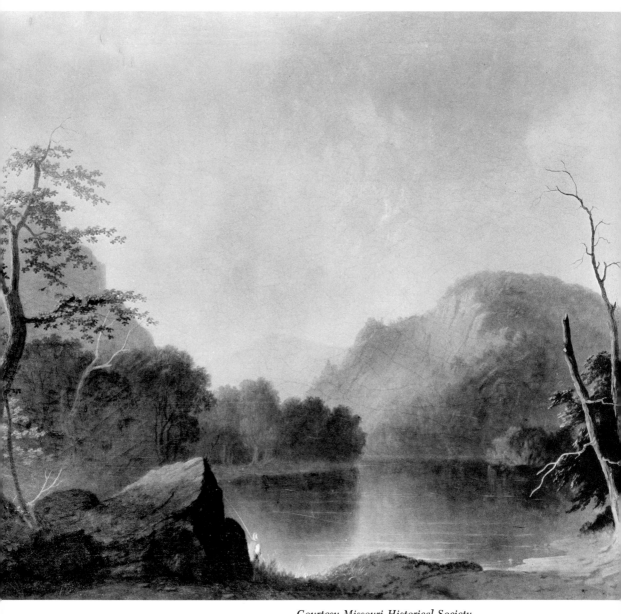

53. Mountain Scene with Fisherman, 1853–1856?

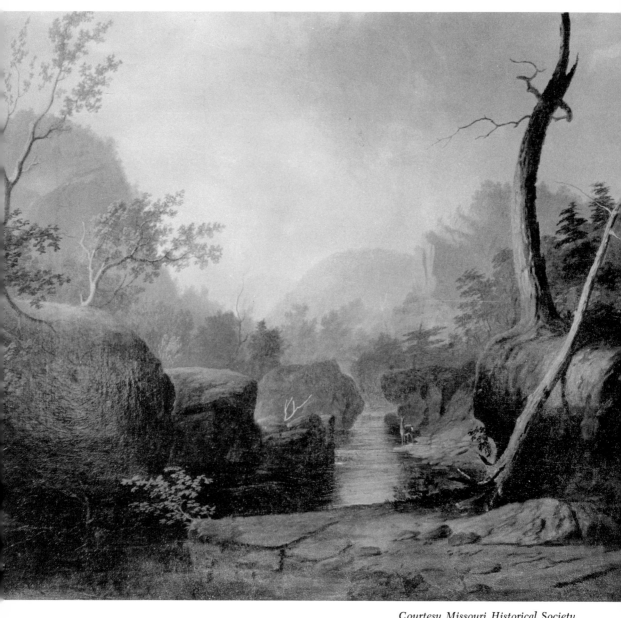

54. Mountain Scene with Deer, 1853–1856?

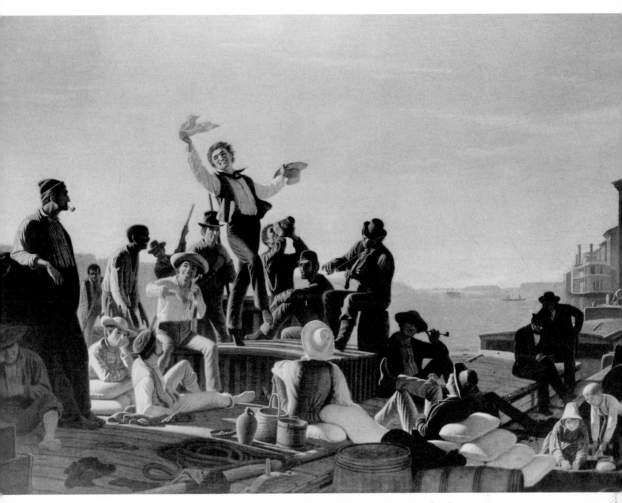

Courtesy City Art Museum, St. Louis

55. The Jolly Flatboatmen in Port, 1857

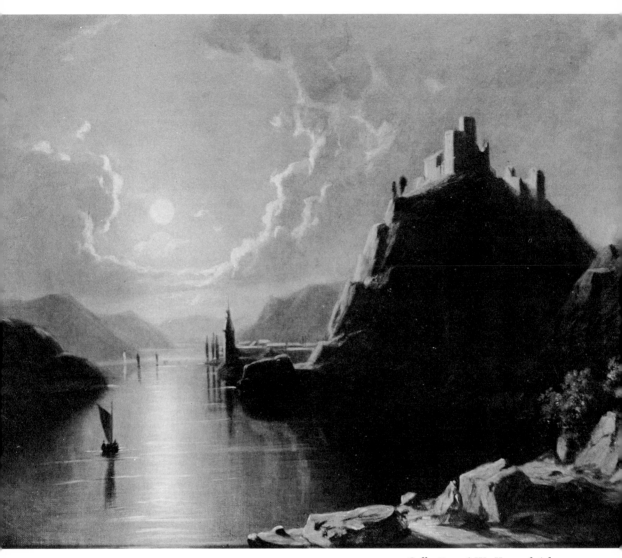

56. Moonlight Scene, 1857–1858?

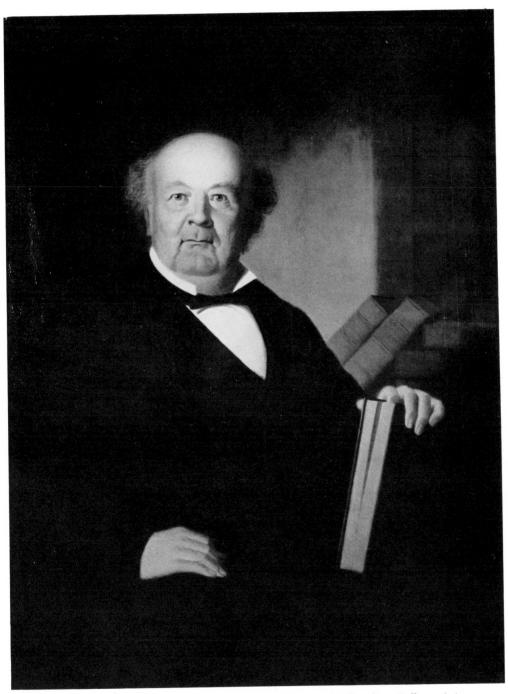

57. Dr. Benoist Troost, 1859

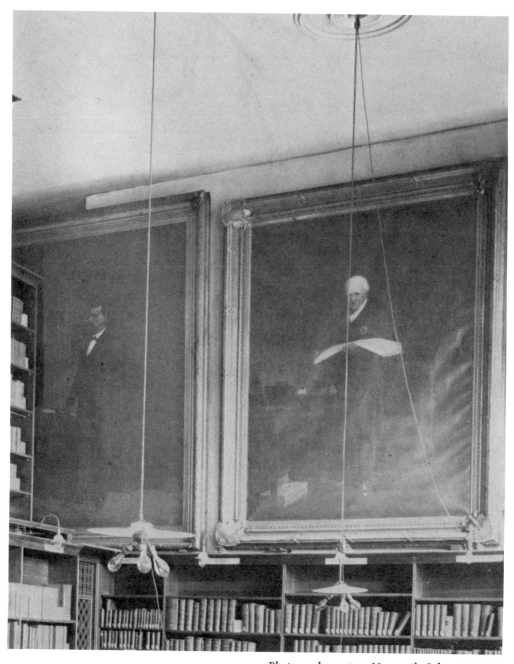

58. The Reference Room of the St. Louis Mercantile Library
about 1888, with the Portraits of Frank P. Blair (left)
and Baron von Humboldt (center)

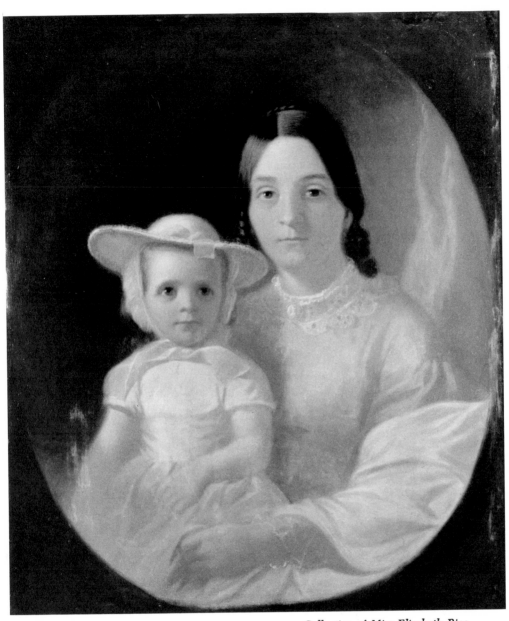

Collection of Miss Elizabeth Rice

59. Susan Howard Hockaday and Her Daughter Susan, 1859?

255

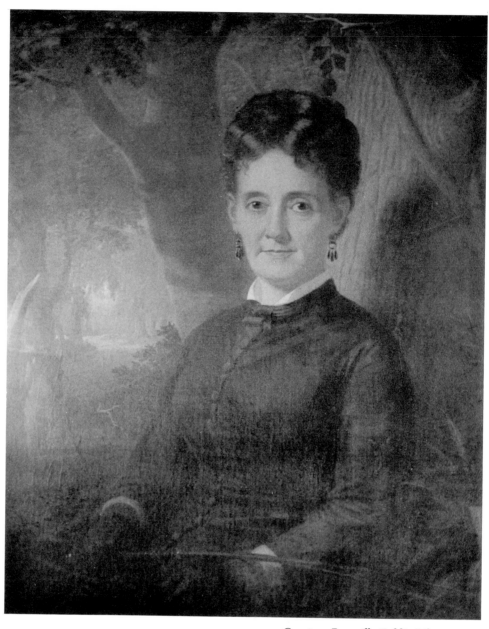

60. Mrs. Thomas W. Nelson, 1862

61. The Thread of Life, 1862?

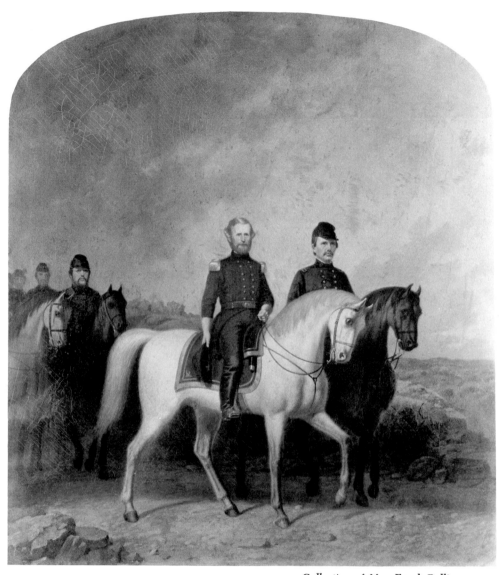

62. General Nathaniel Lyon and General Frank P. Blair
Starting from the Arsenal Gate in St. Louis
to Capture Camp Jackson, 1862?

Collection of William Jewell College

63. Major Dean in Jail, 1866

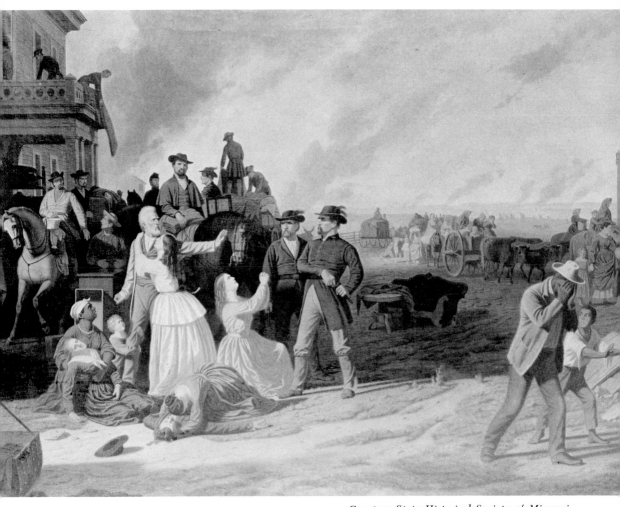

64. Order No. 11, 1868

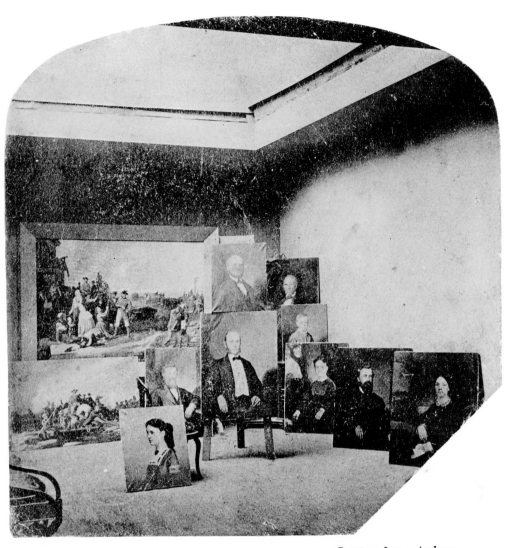

65. Bingham's Kansas City Studio, 1870

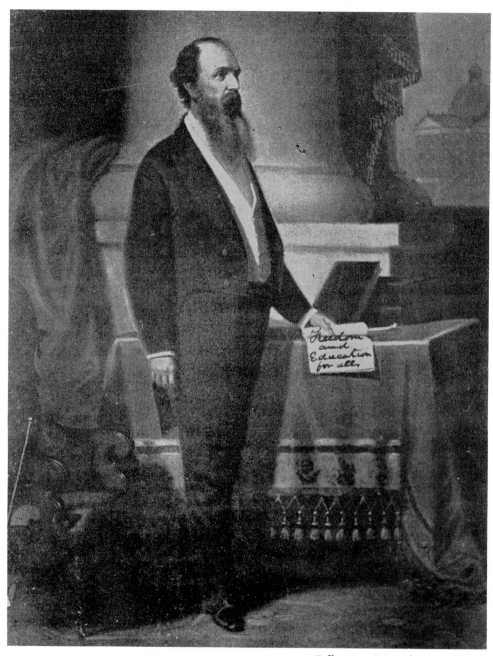

Collection of David Westfall

66. Study for Full-length Portrait of James S. Rollins, 1871

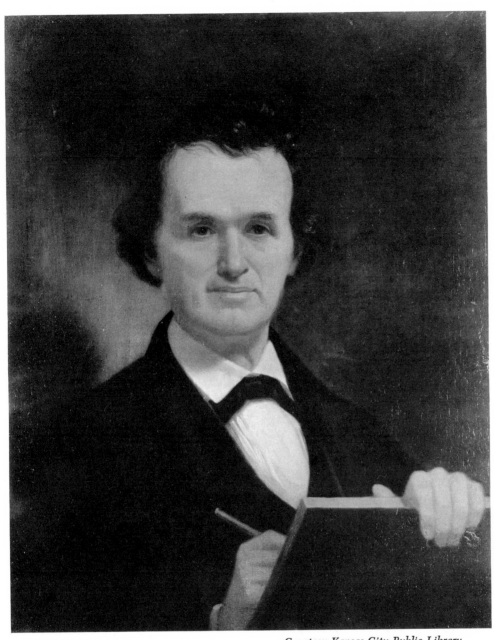

67. Self-Portrait, 1877?

263

Courtesy William Rockhill Nelson Gallery of Art

68. Hugh C. Ward, 1870

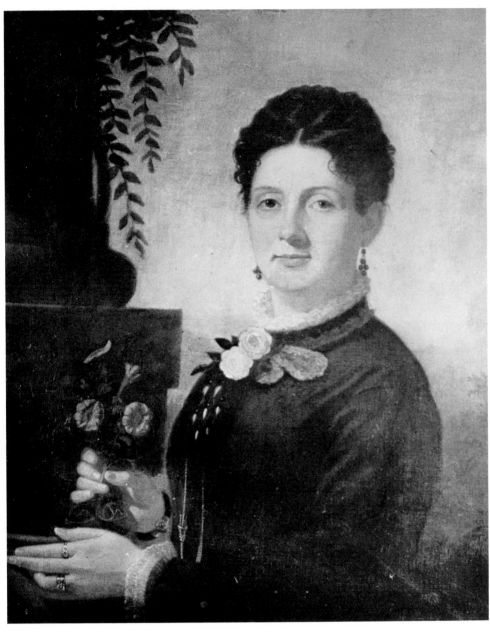

Collection of Mrs. Fulton Stephens, Esparto, California

69. Mrs. James T. Birch, 1877

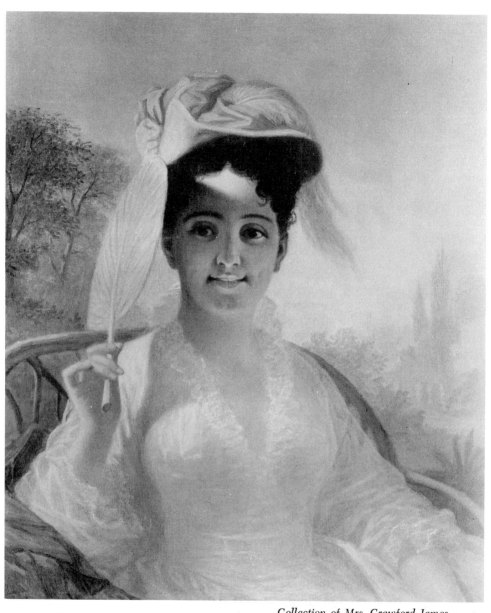

70. The Palm Leaf Shade, 1878

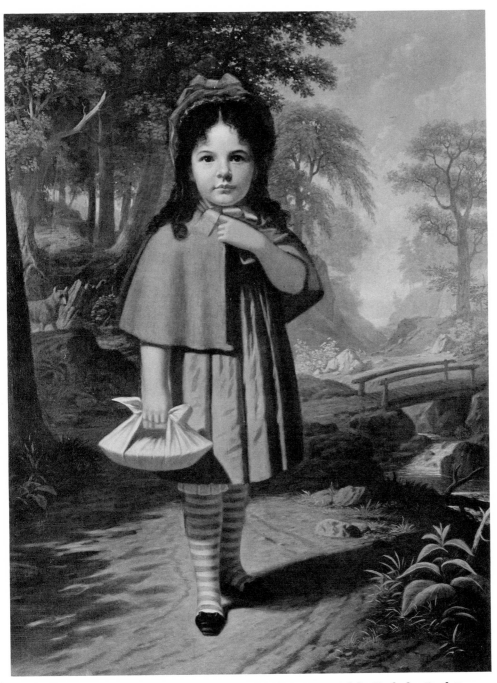

Collection of Miss Eulalie Hockaday Bartlett

71. Little Red Riding Hood, 1878

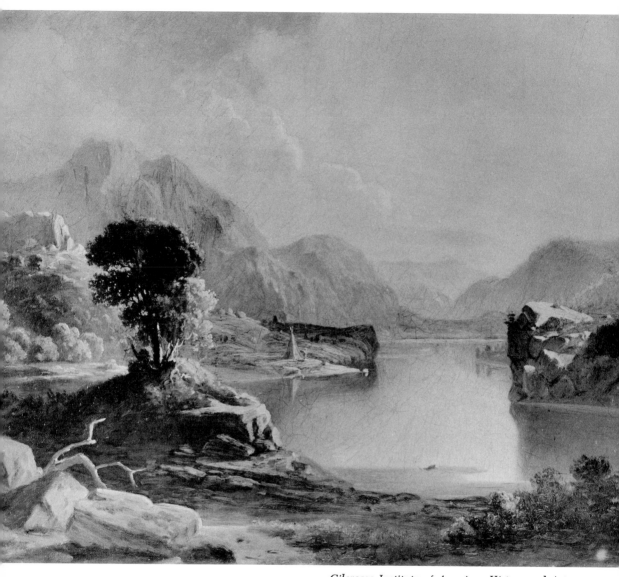

72. Indian Encampment, 1872? 1878?

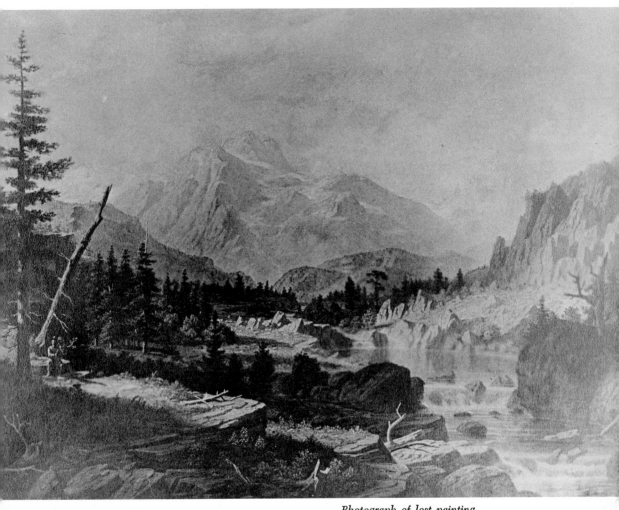

Photograph of lost painting
Courtesy F. C. Barnhill

73. View of Pike's Peak, 1872

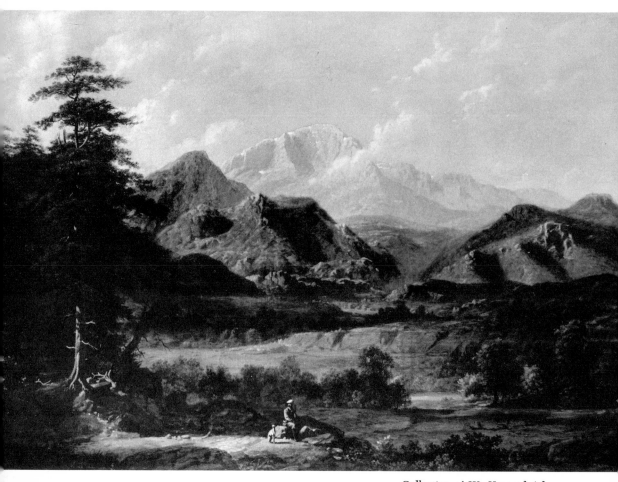

74. View of Pike's Peak, 1872

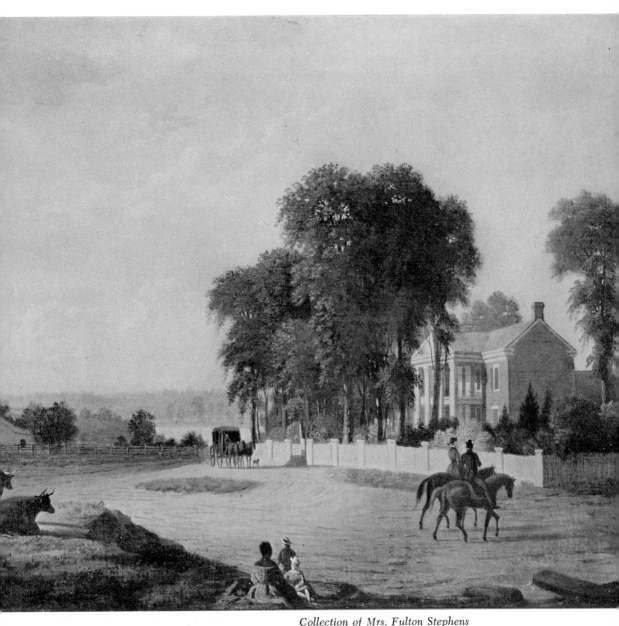

Collection of Mrs. Fulton Stephens
Esparto, California

75. "Forest Hill"—the Nelson Homestead near Boonville, 1877

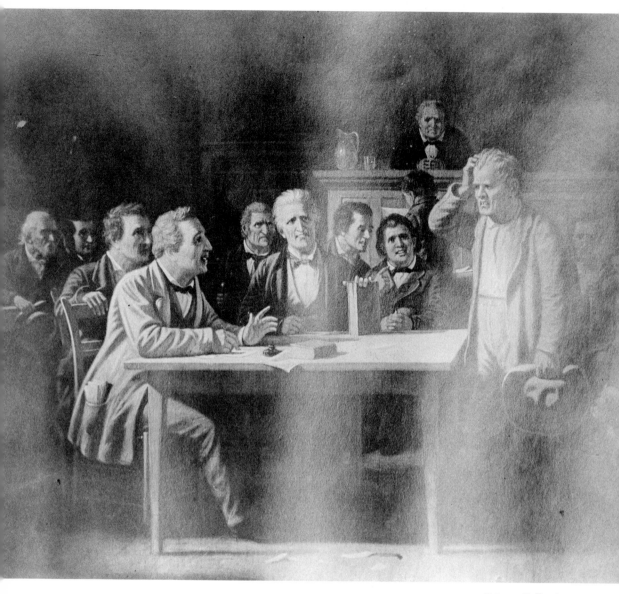

76. The Puzzled Witness, 1879

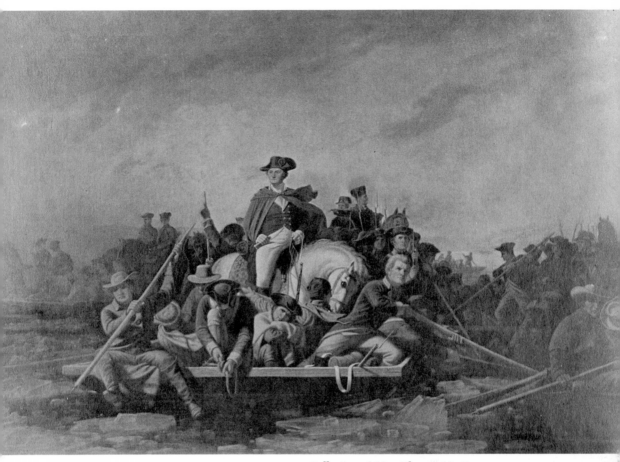

79. Washington Crossing the Delaware, 1872

❧ v ❧

Drawings

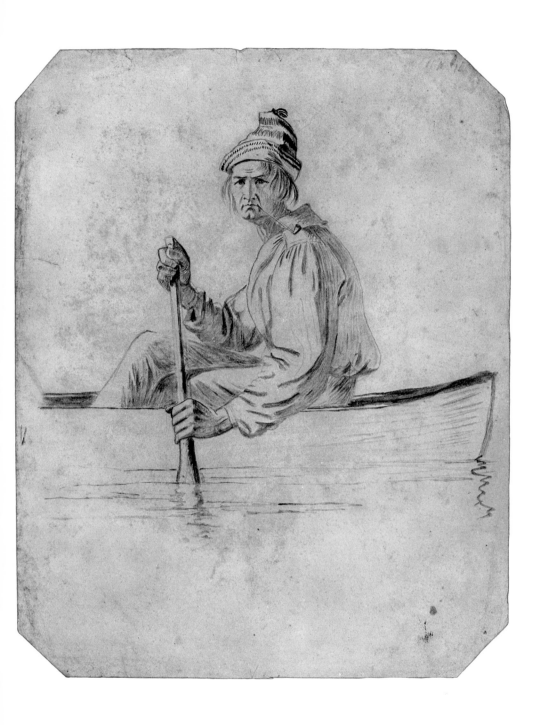

Sketch No. 1

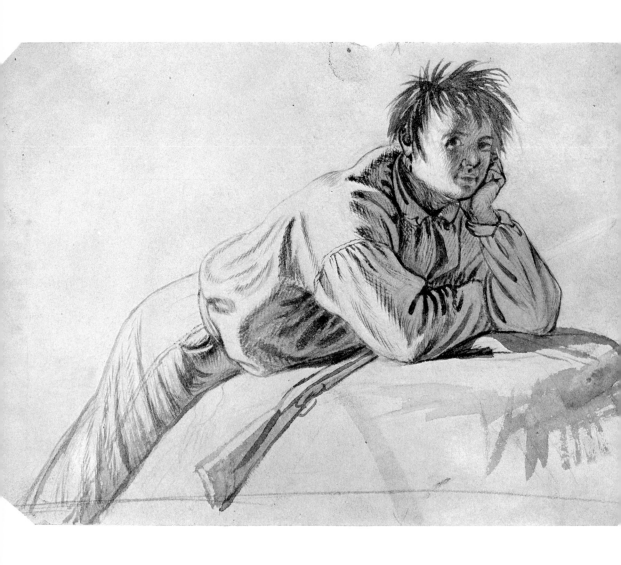

Sketch No. 2

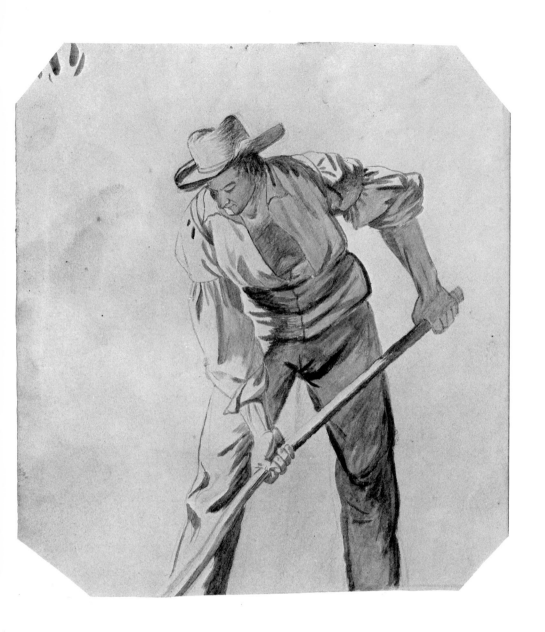

Sketch No. 3

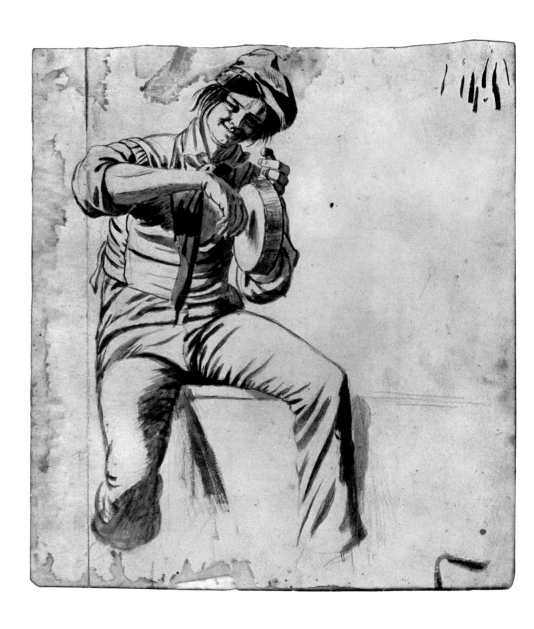

Sketch No. 4

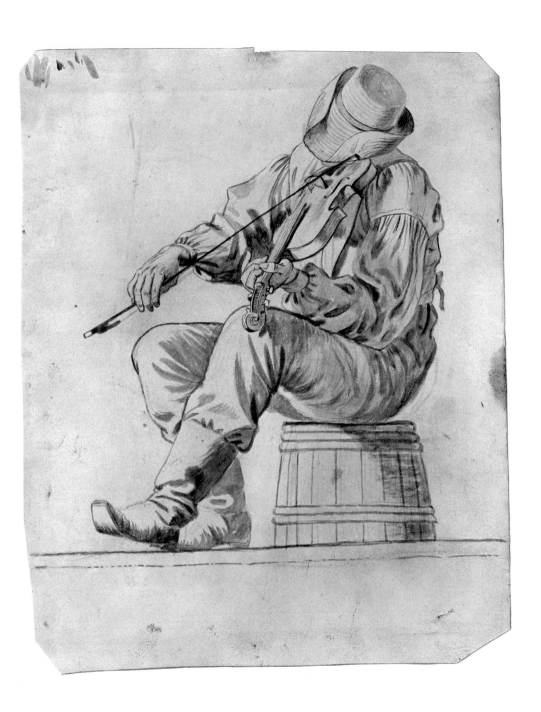

Sketch No. 5

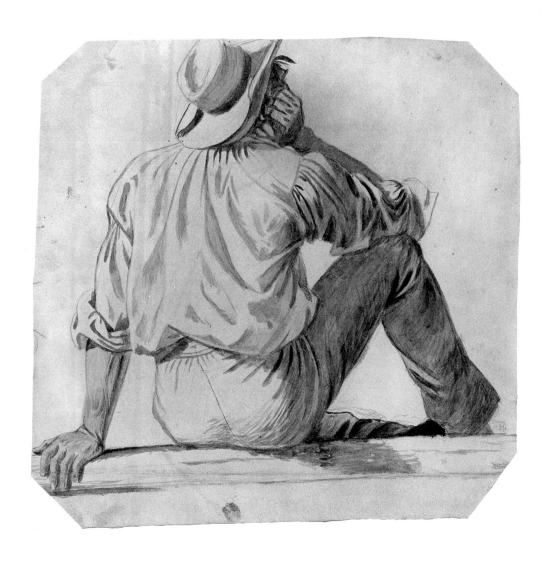

Sketch No. 6

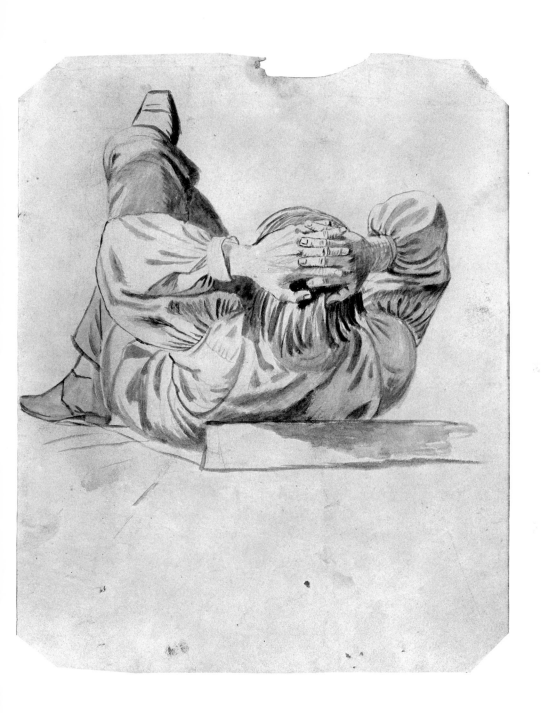

Sketch No. 7

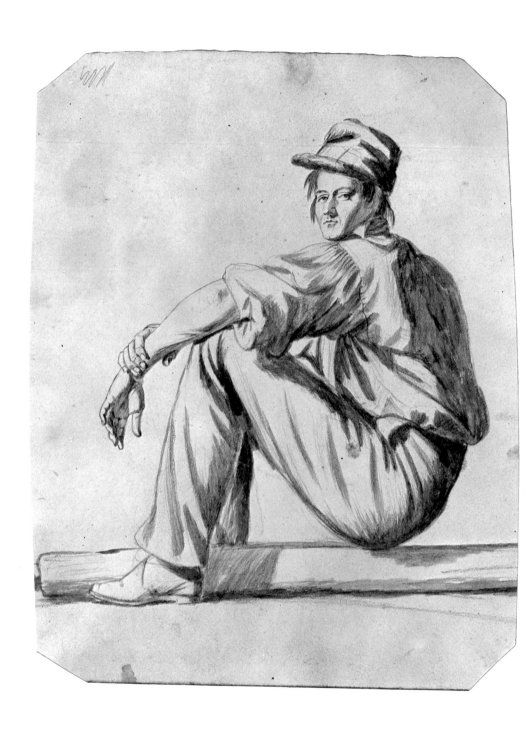

Sketch No. 8

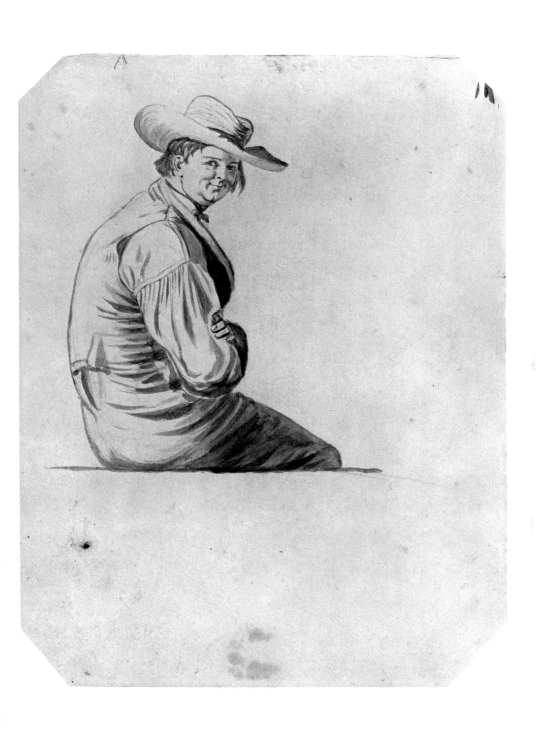

Sketch No. 9

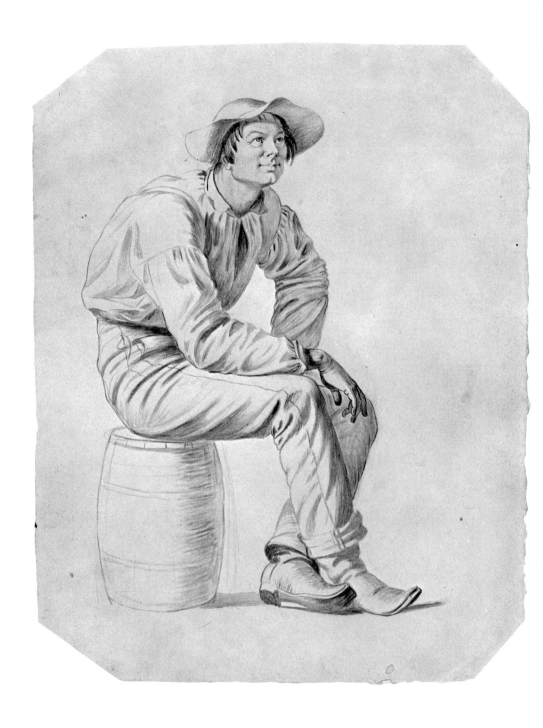

Sketch No. 10

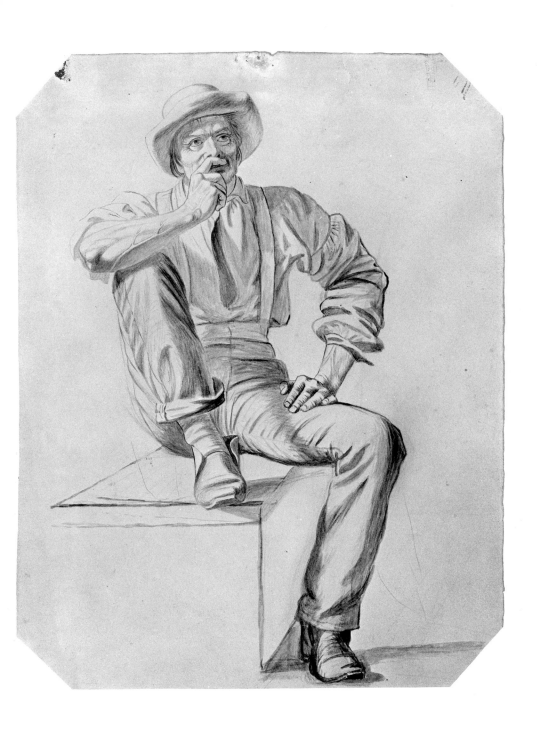

Sketch No. 11

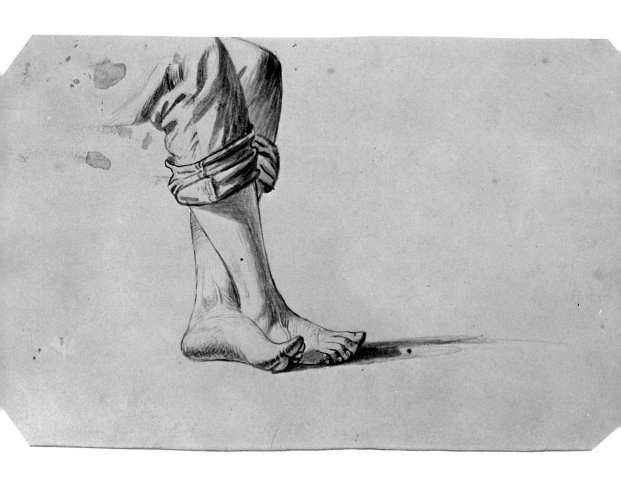

Sketch No. 12

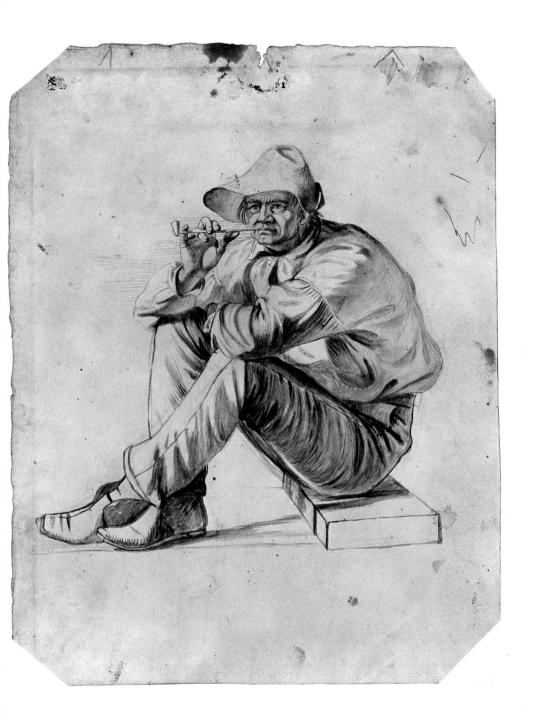

Sketch No. 13

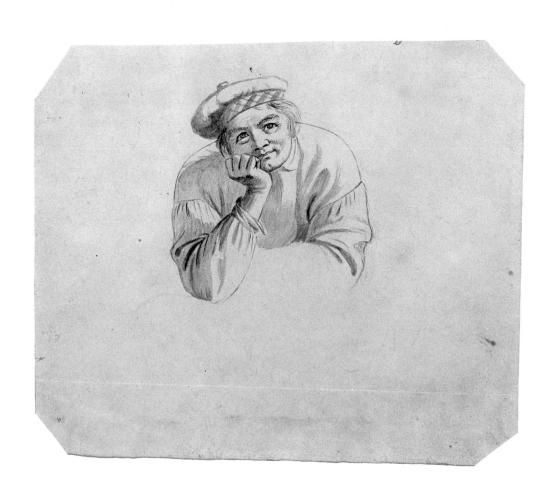

Sketch No. 14

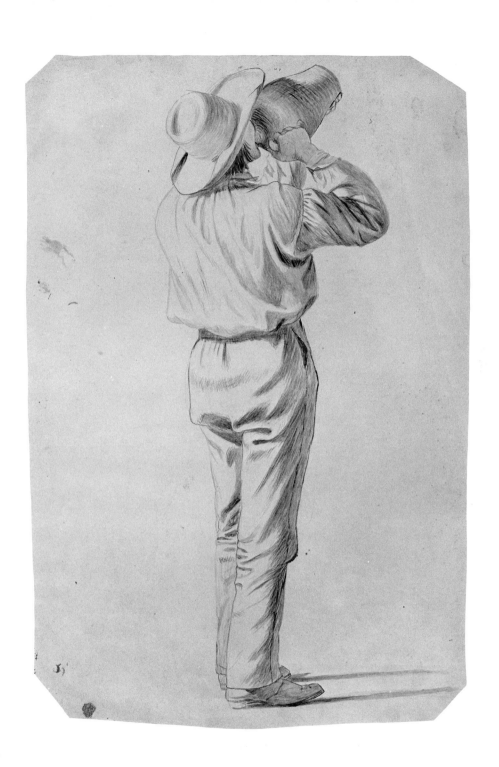

Sketch No. 15

293

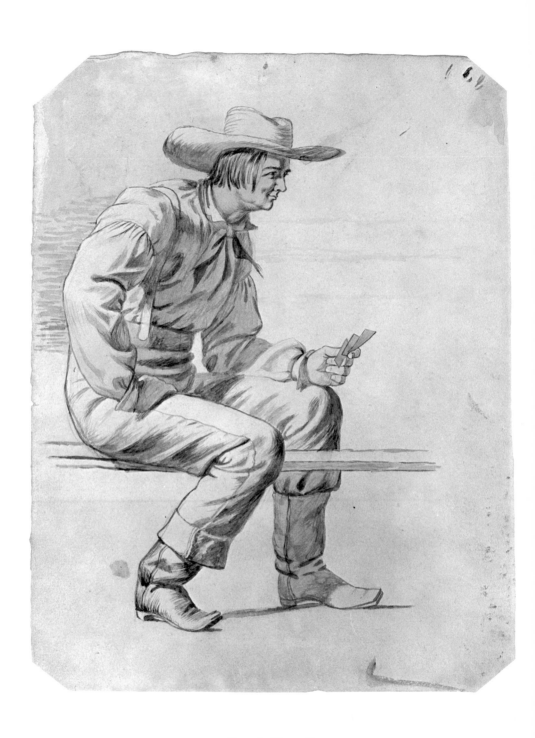

Sketch No. 16

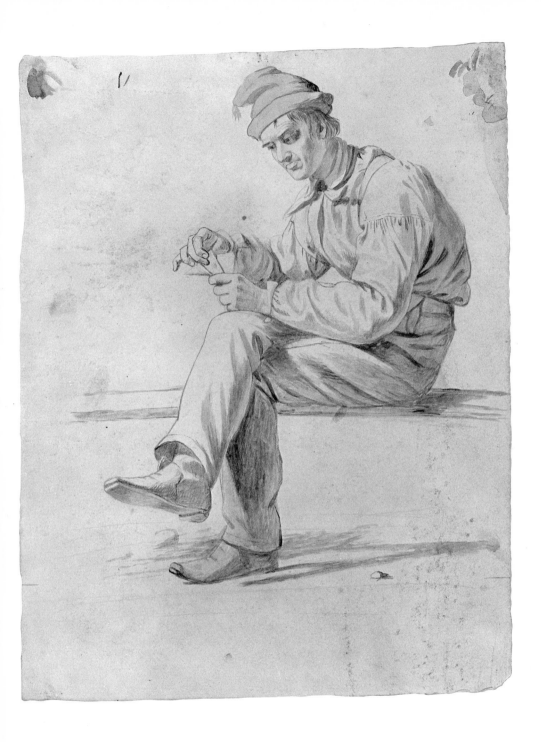

Sketch No. 17

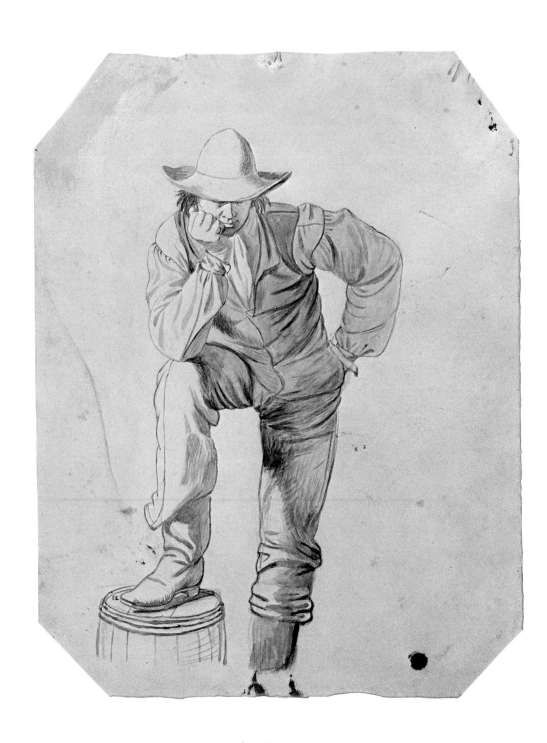

Sketch No. 18

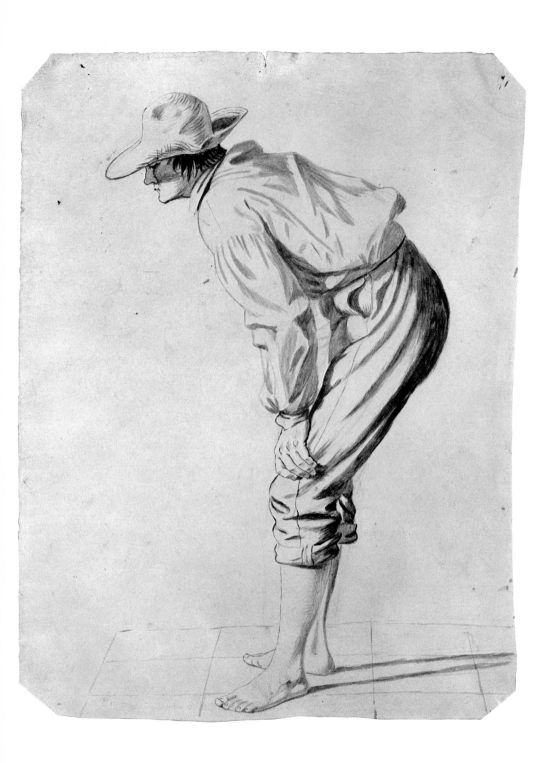

Sketch No. 19

297

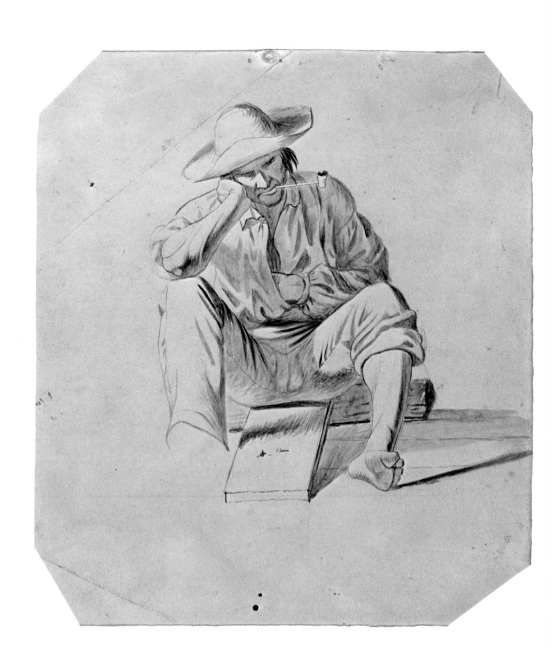

Sketch No. 20

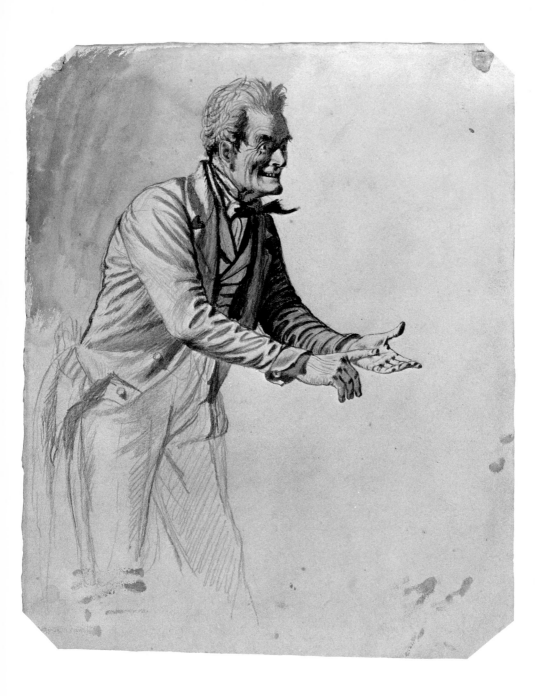

Sketch No. 21

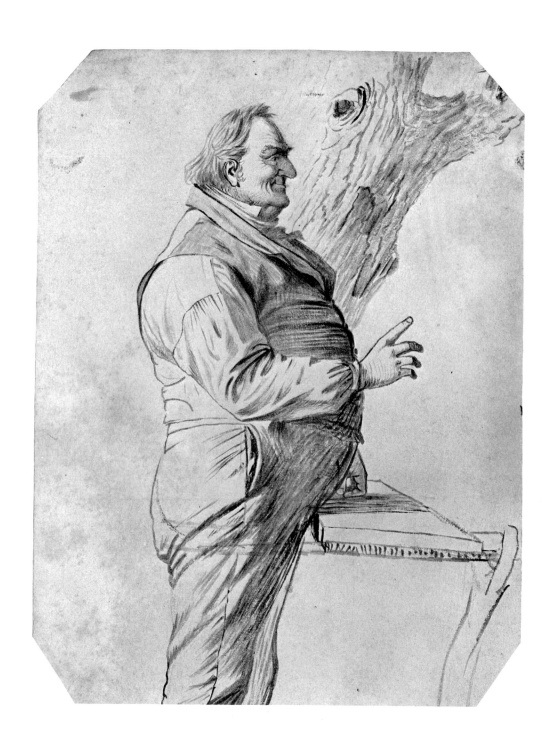

Sketch No. 22

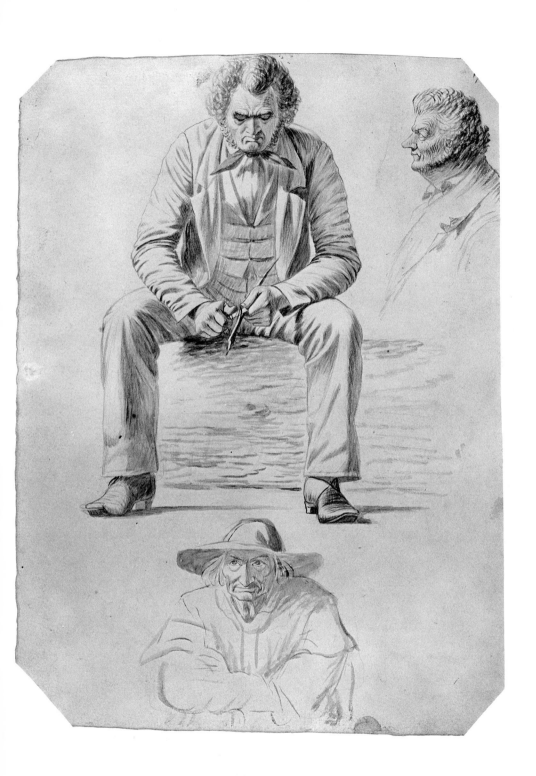

Sketch No. 23

301

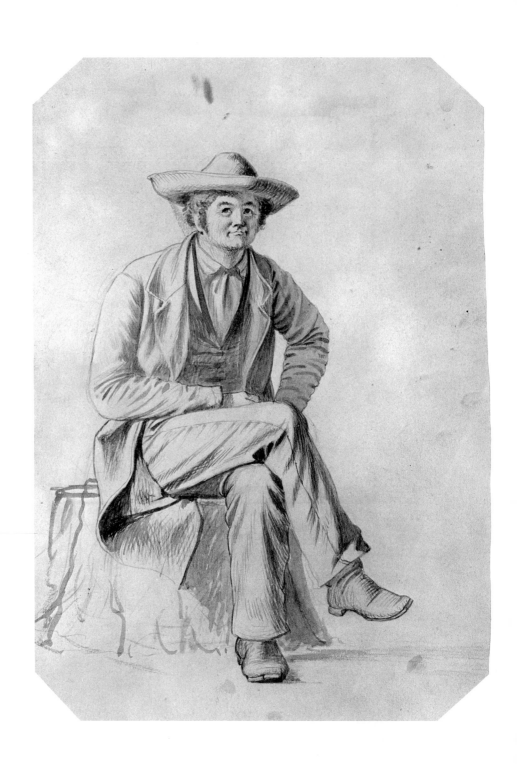

Sketch No. 24

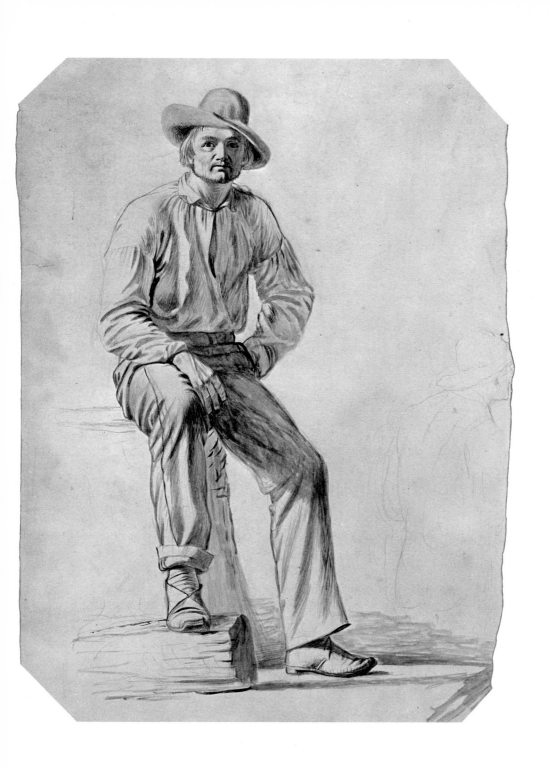

Sketch No. 25

303

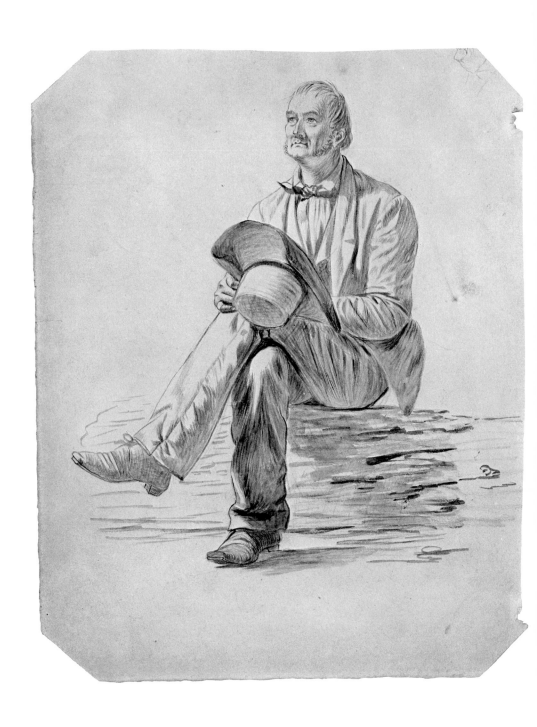

Sketch No. 26

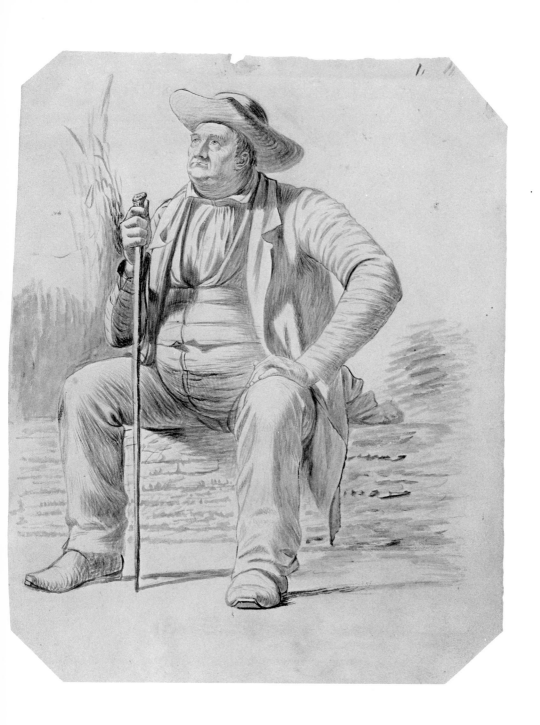

Sketch No. 27

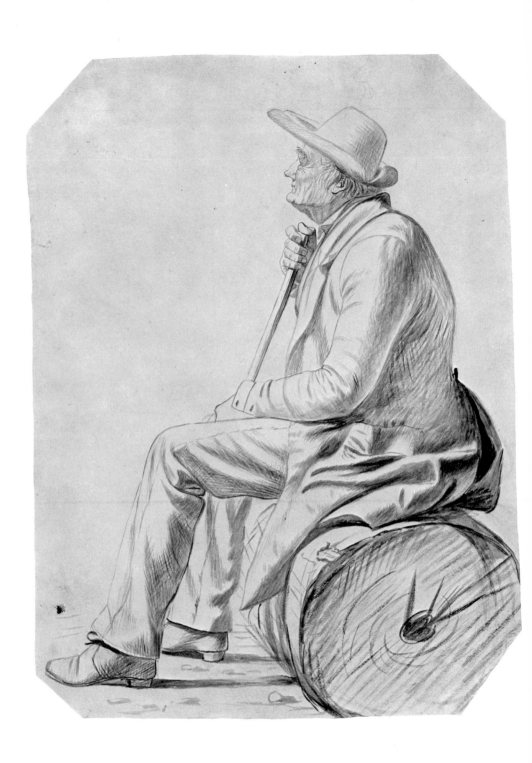

Sketch No. 28

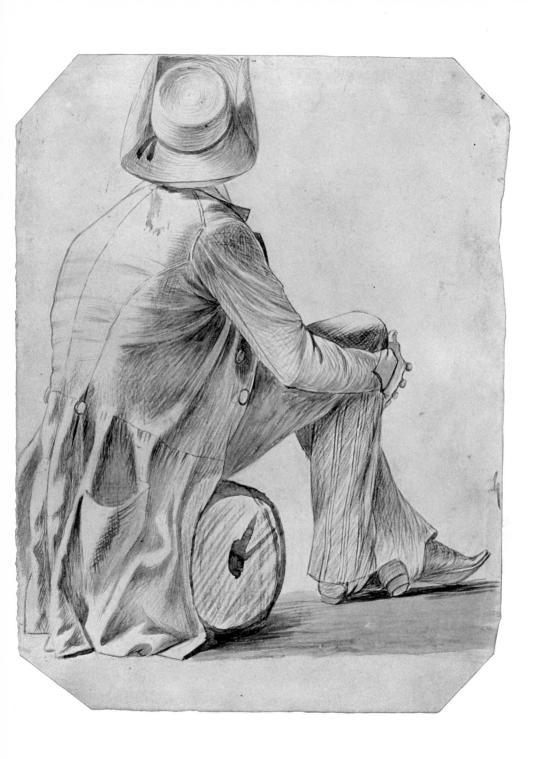

Sketch No. 29

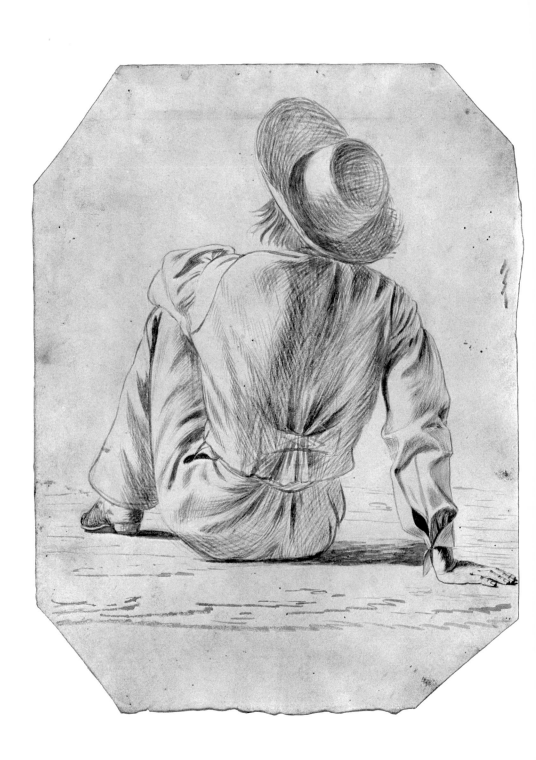

Sketch No. 30

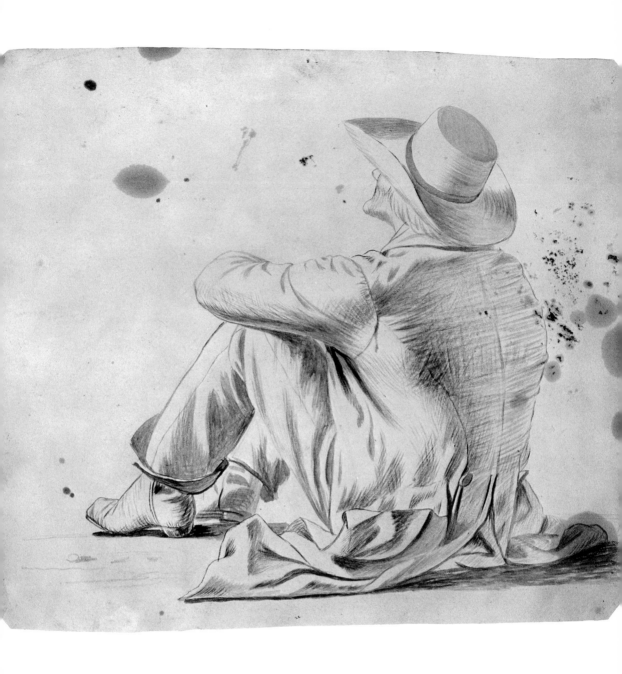

Sketch No. 31

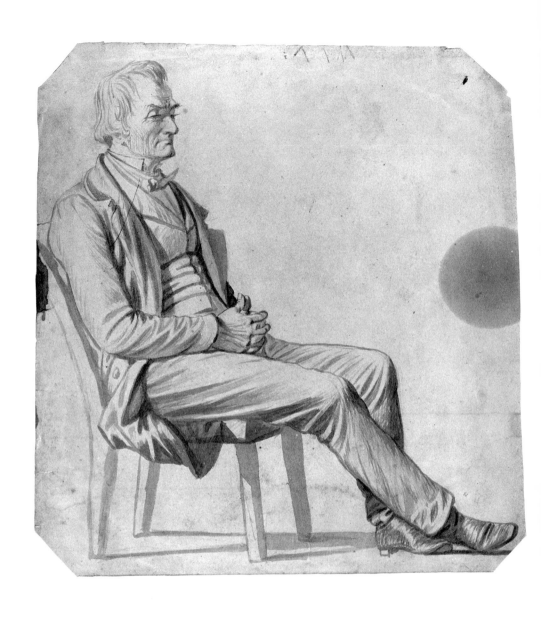

Sketch No. 32

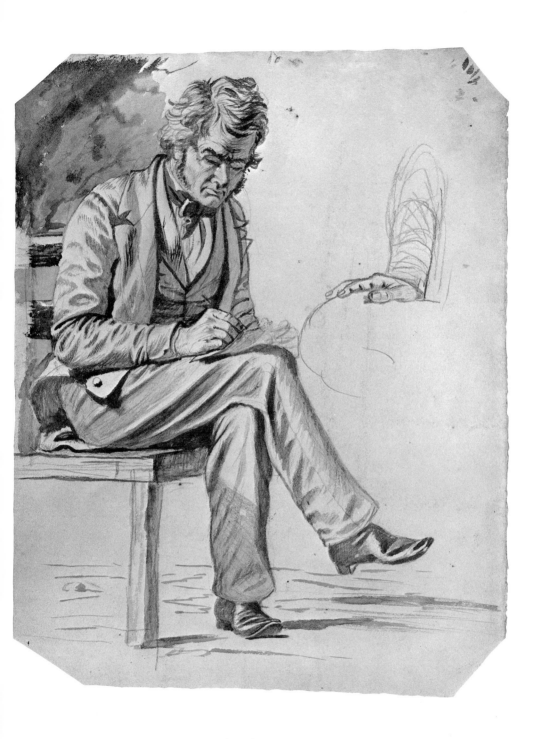

Sketch No. 33

311

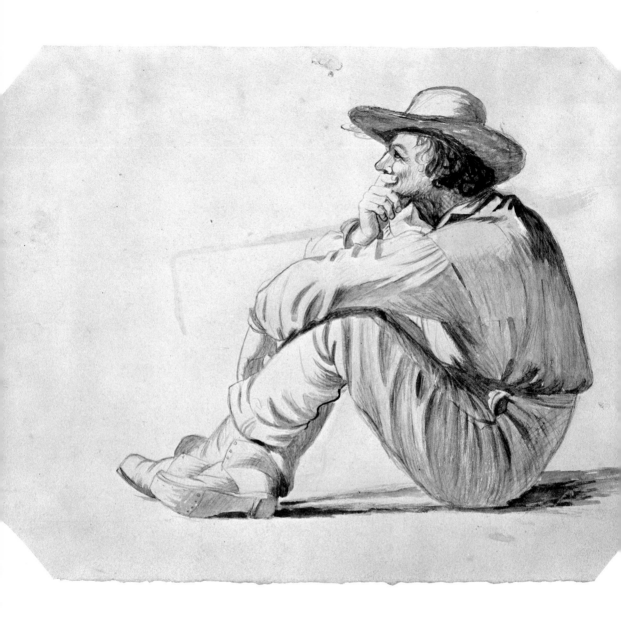

Sketch No. 34

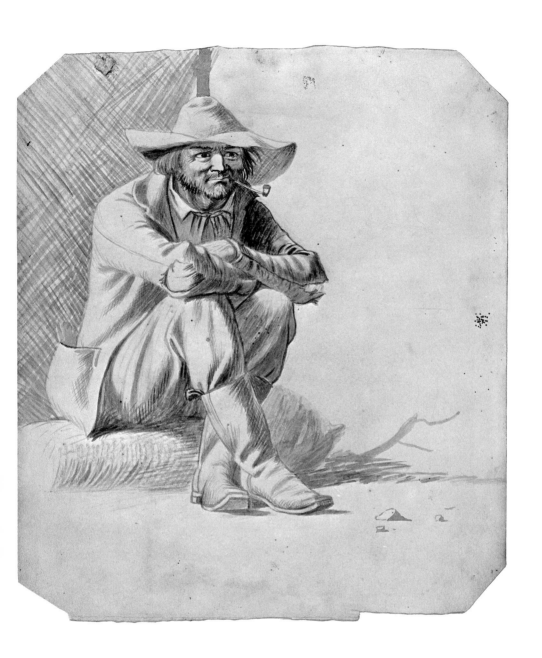

Sketch No. 35

313

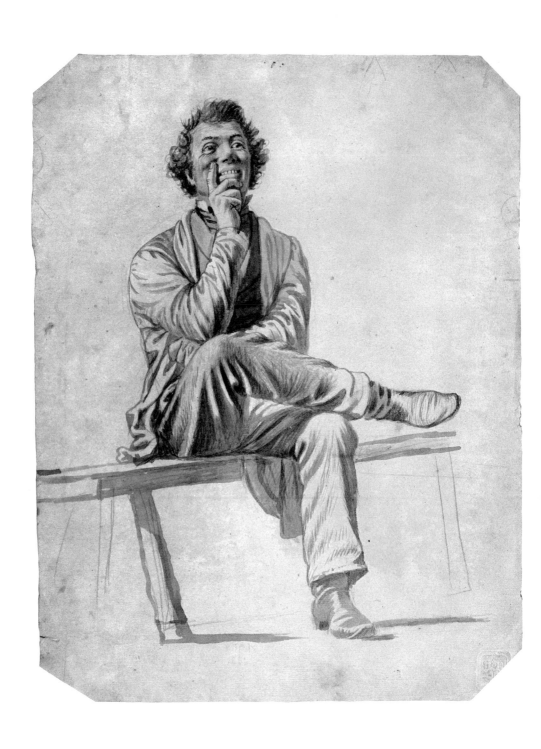

Sketch No. 36

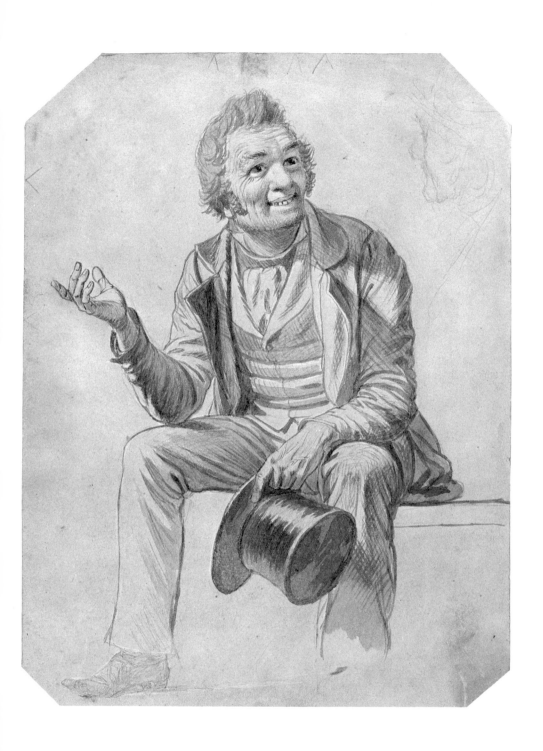

Sketch No. 37

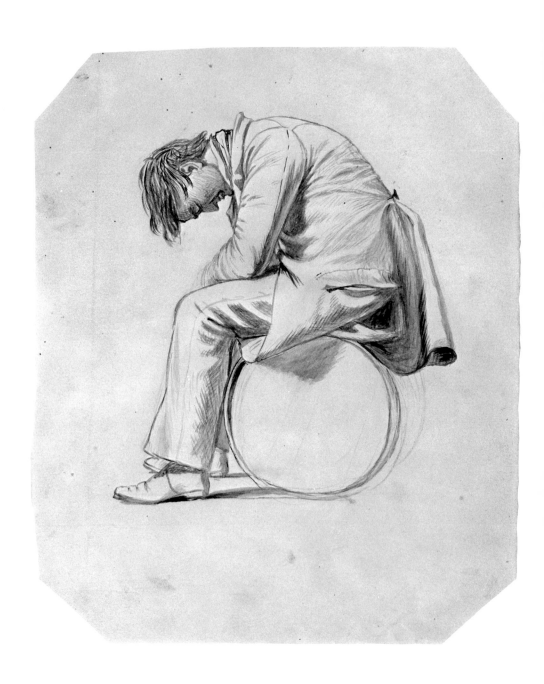

Sketch No. 38

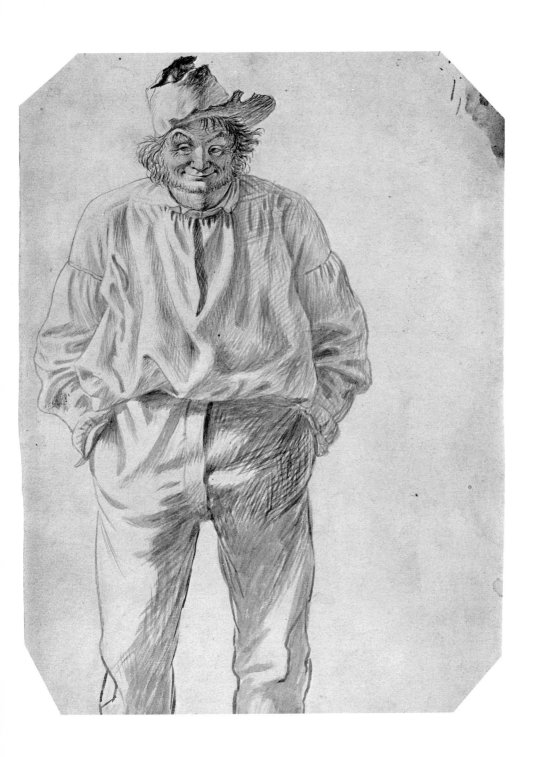

Sketch No. 39

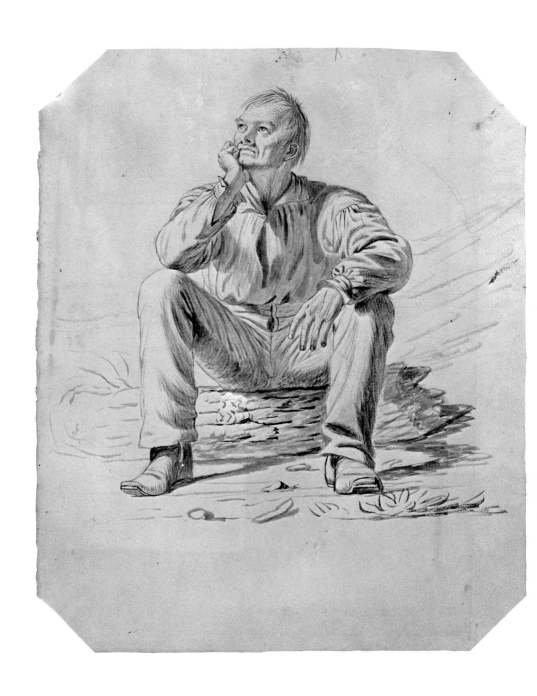

Sketch No. 40

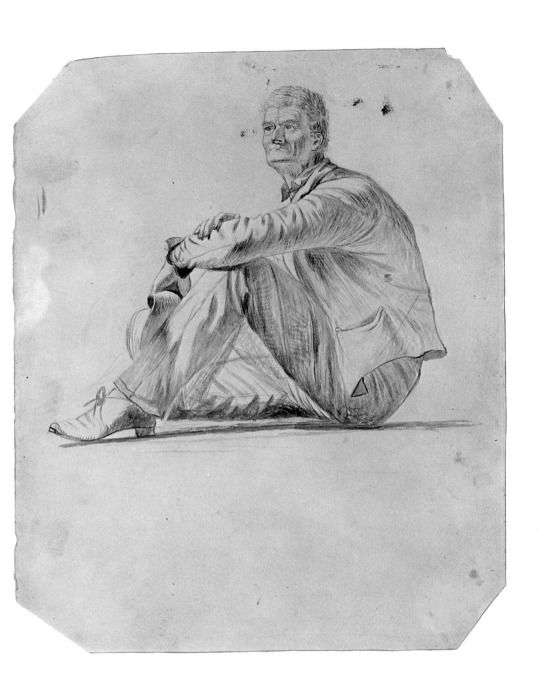

Sketch No. 41

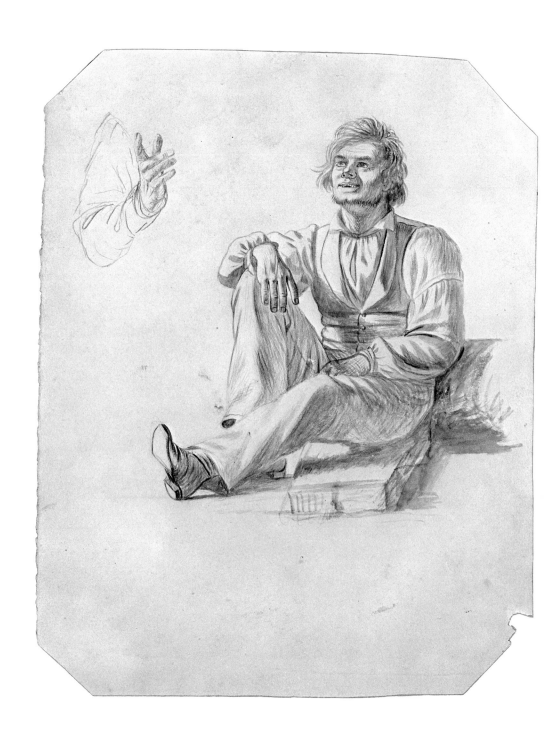

Sketch No. 42

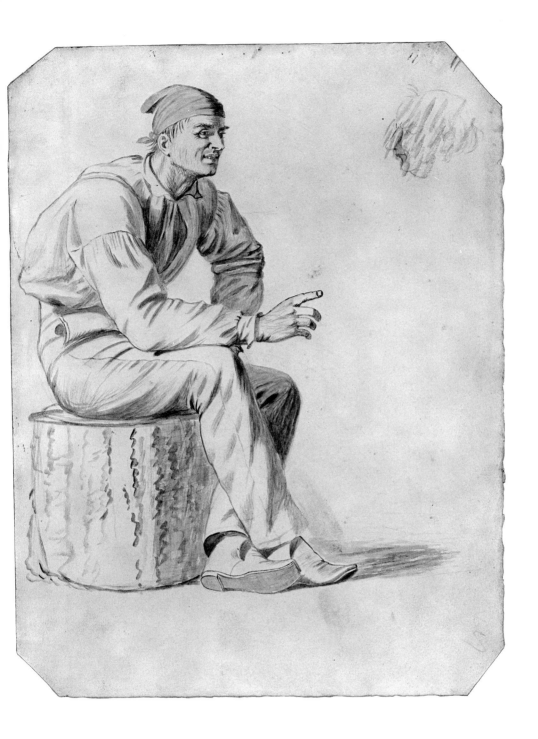

Sketch No. 43

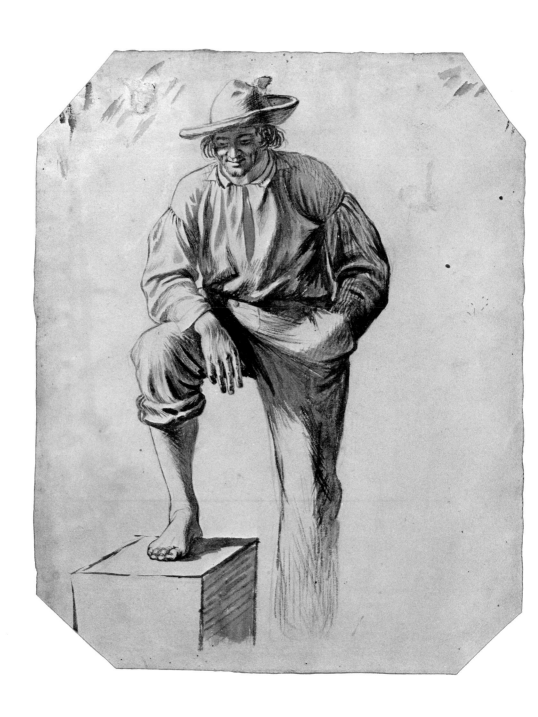

Sketch No. 44

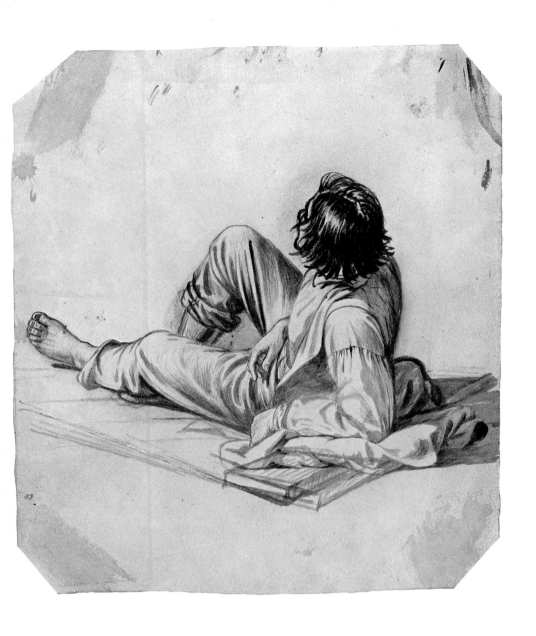

Sketch No. 45

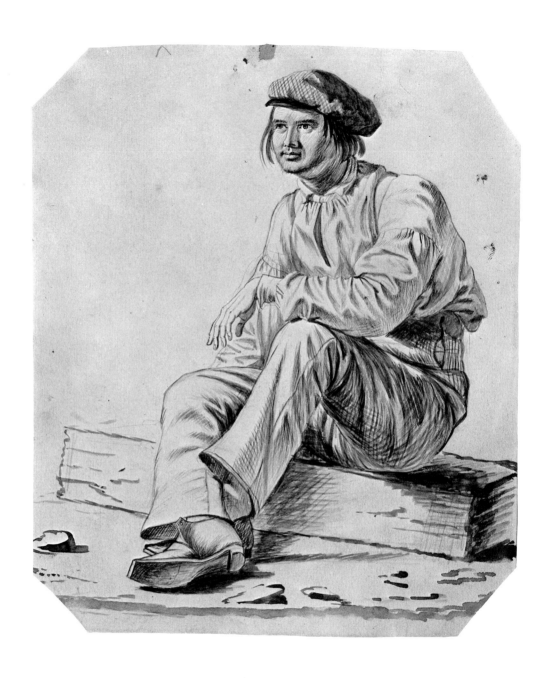

Sketch No. 46

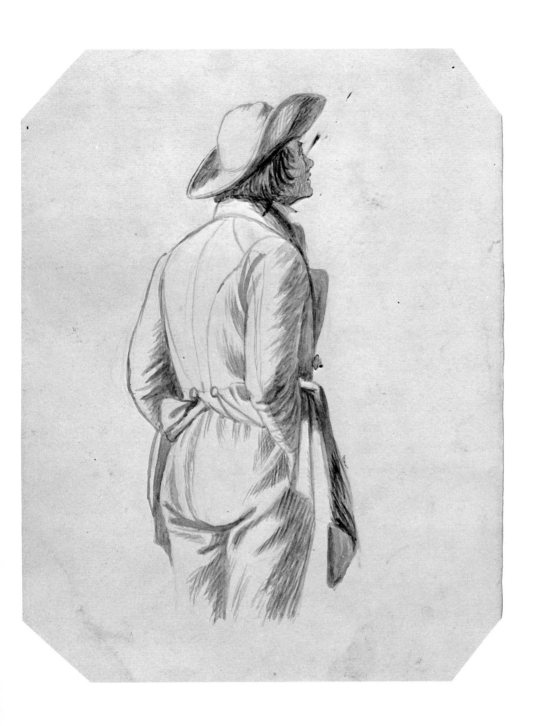

Sketch No. 47

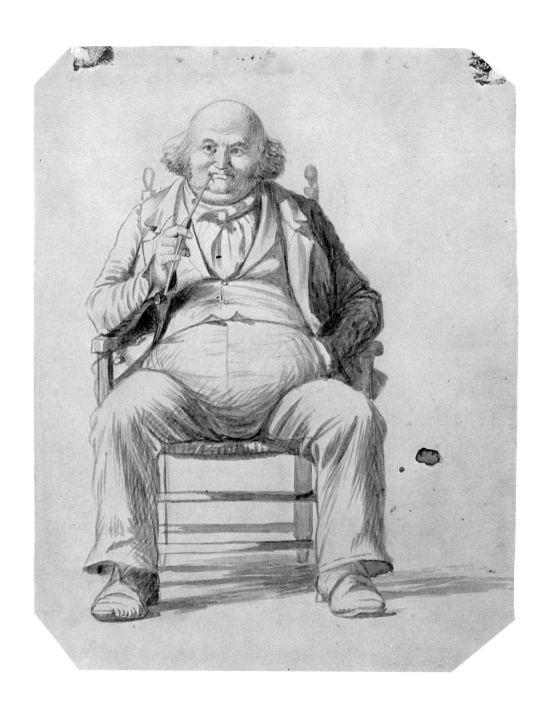

Sketch No. 48

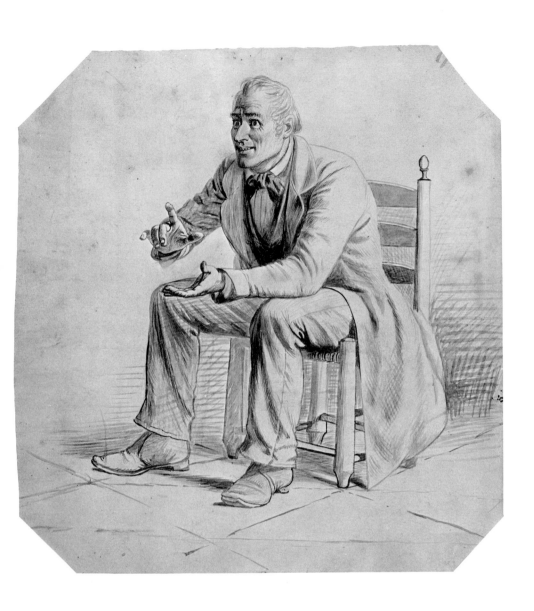

Sketch No. 49

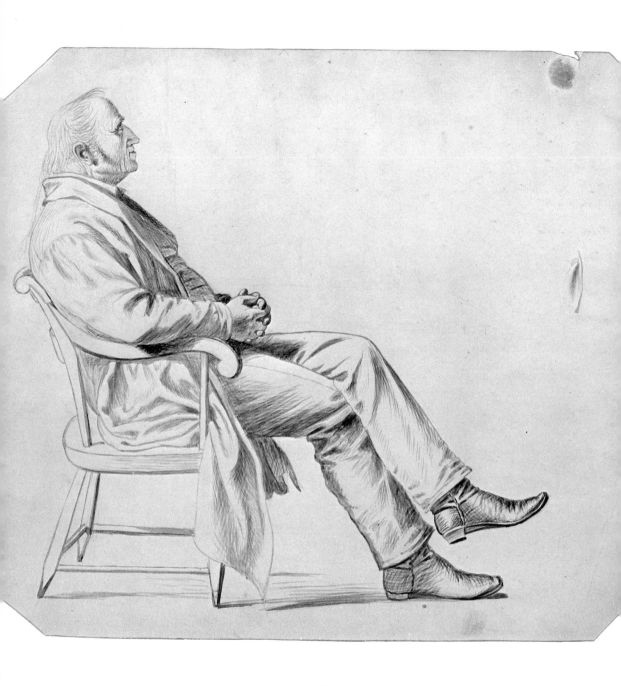

Sketch No. 50

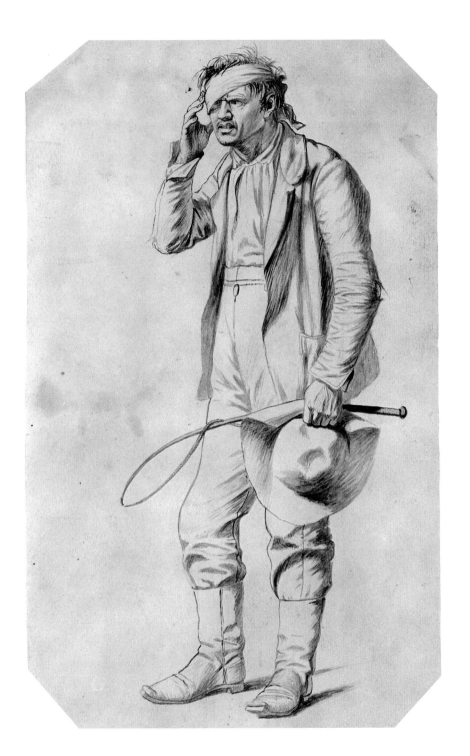

Sketch No. 51

329

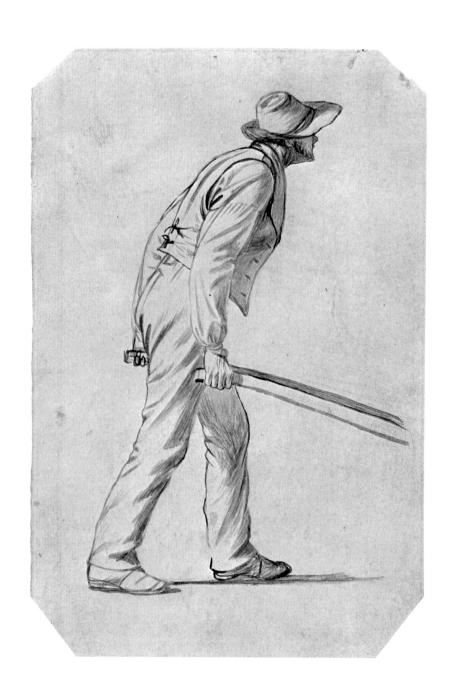

Sketch No. 52

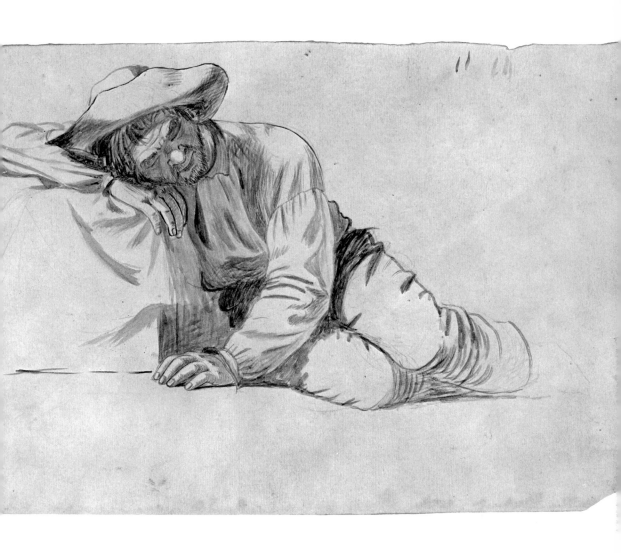

Sketch No. 53

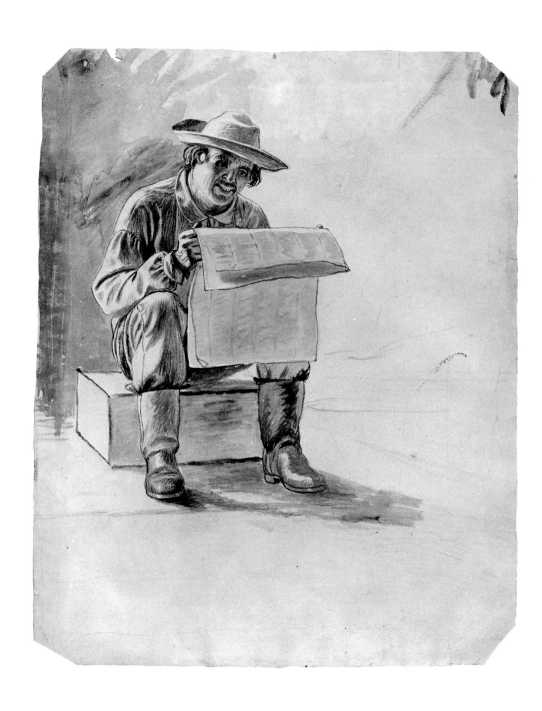

Sketch No. 54

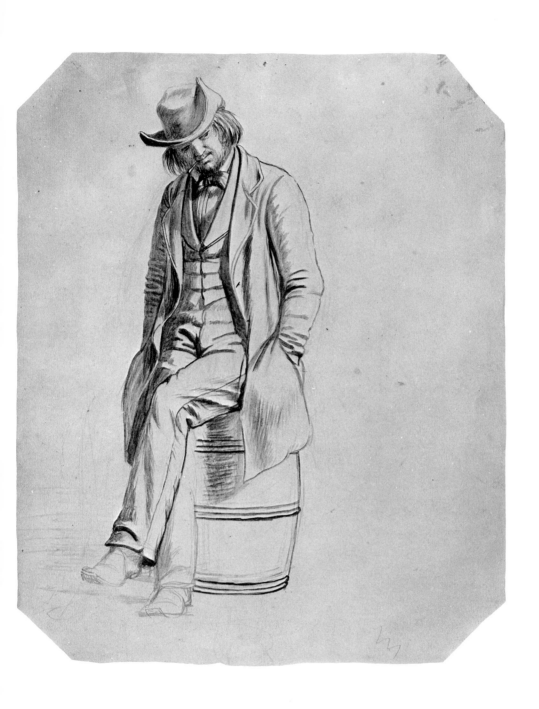

Sketch No. 55

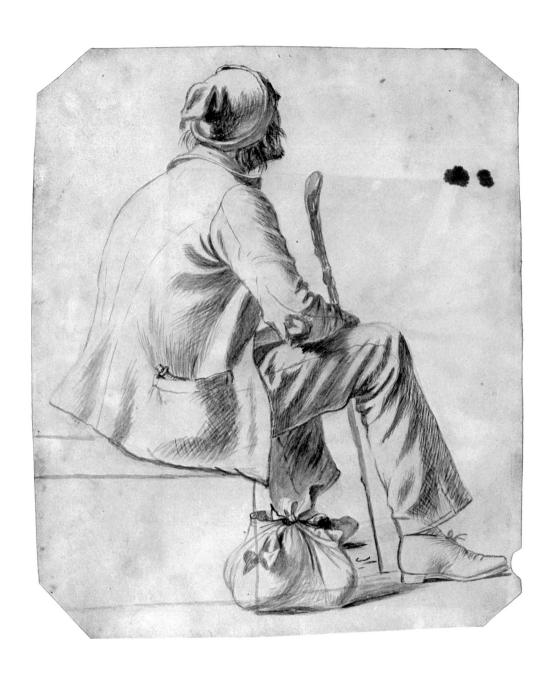

Sketch No. 56

334

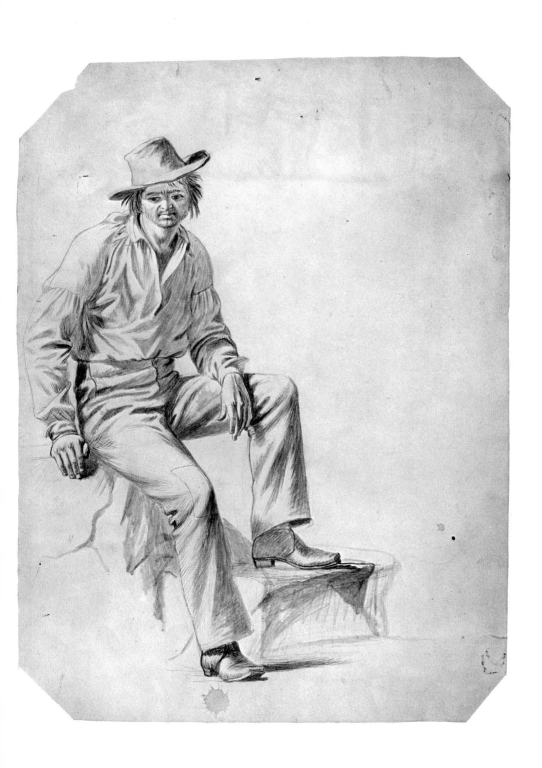

Sketch No. 57

335

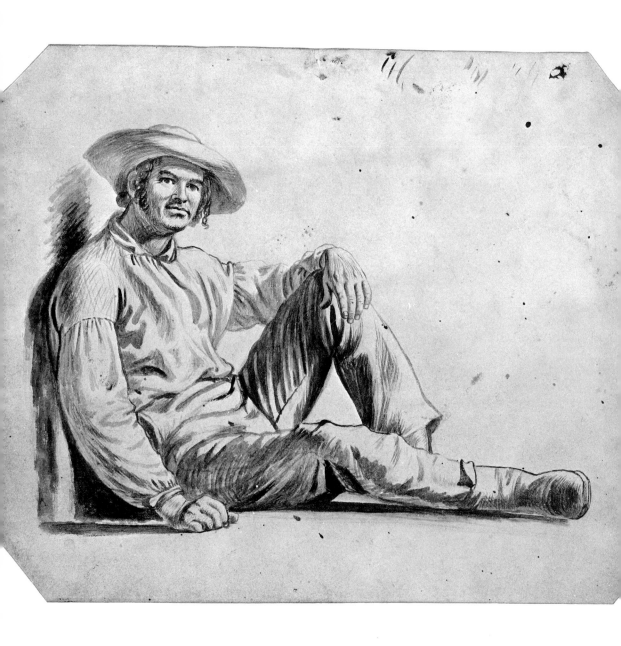

Sketch No. 58

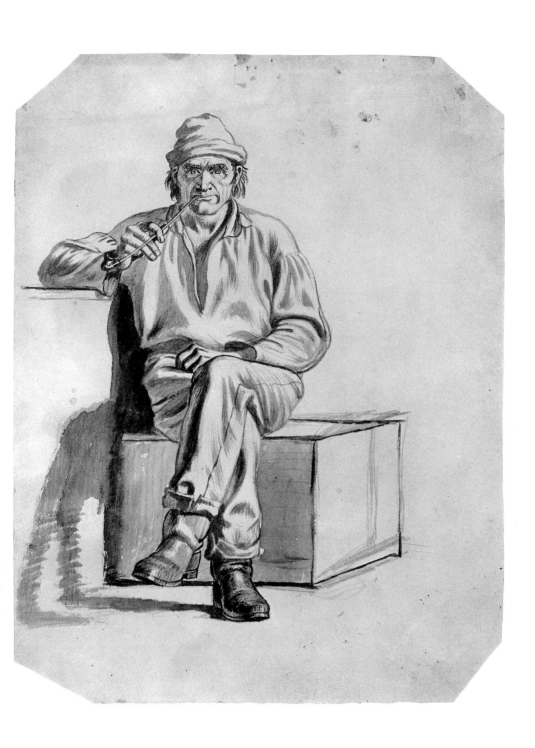

Sketch No. 59

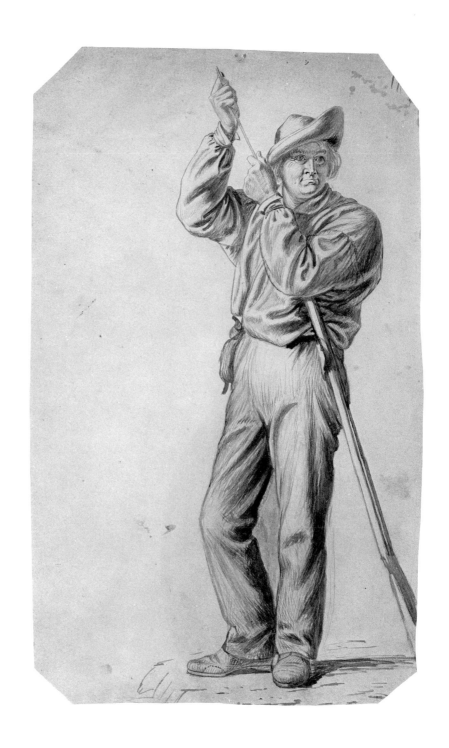

Sketch No. 60

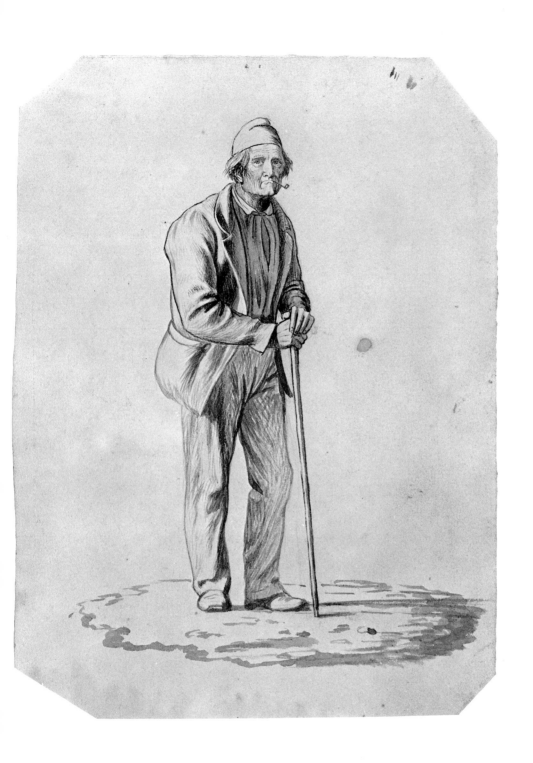

Sketch No. 61

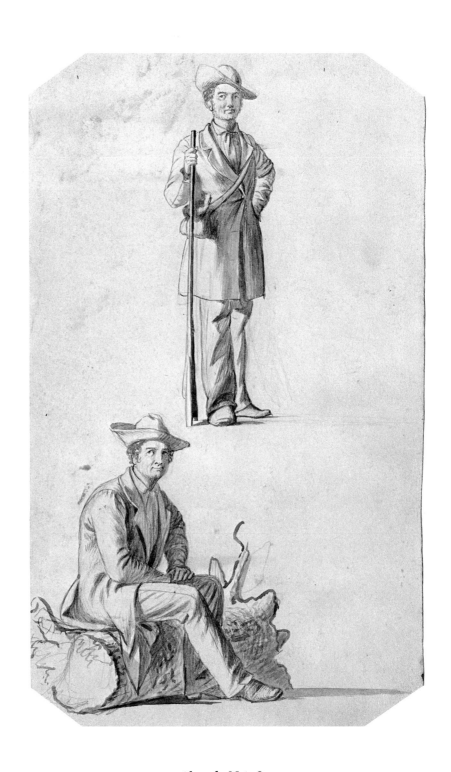

Sketch No. 62

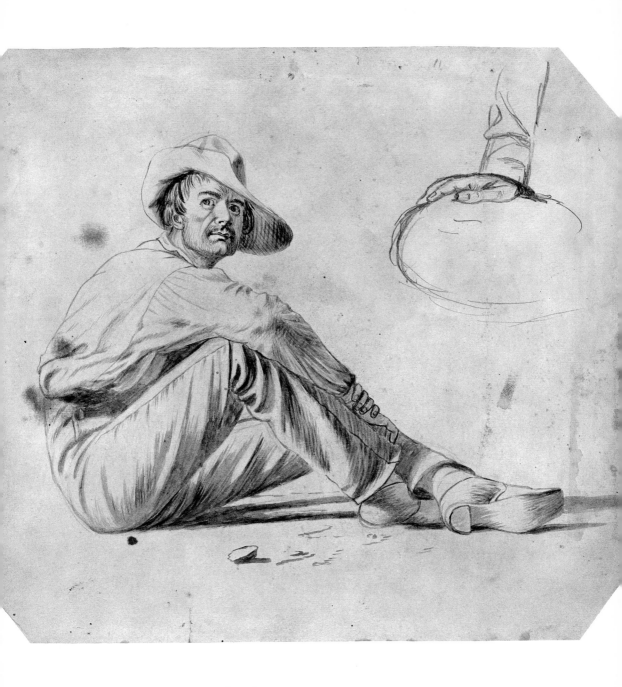

Sketch No. 63

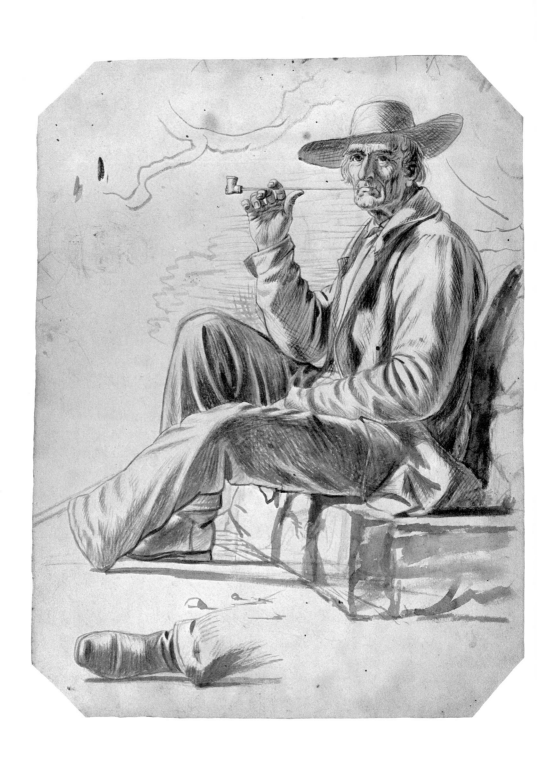

Sketch No. 64

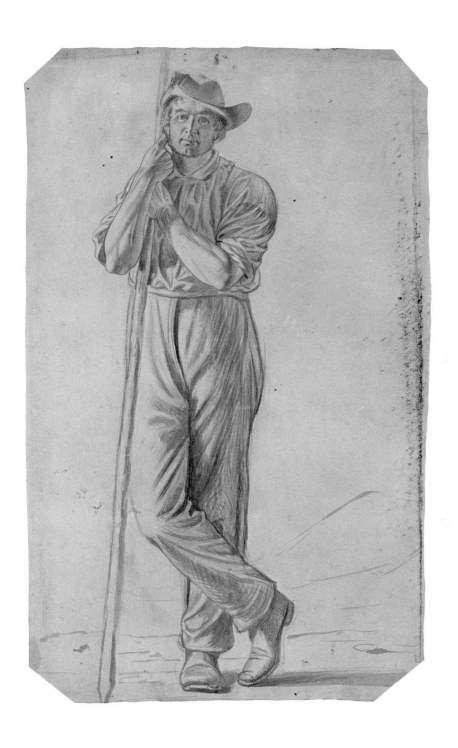

Sketch No. 65

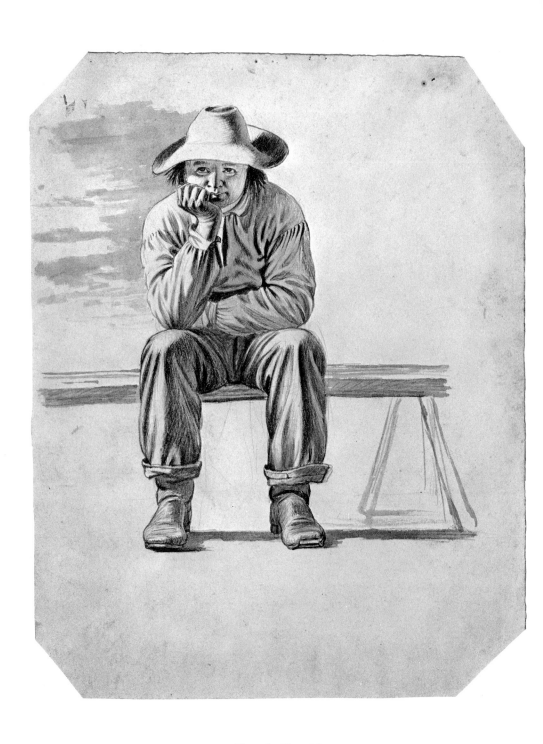

Sketch No. 66

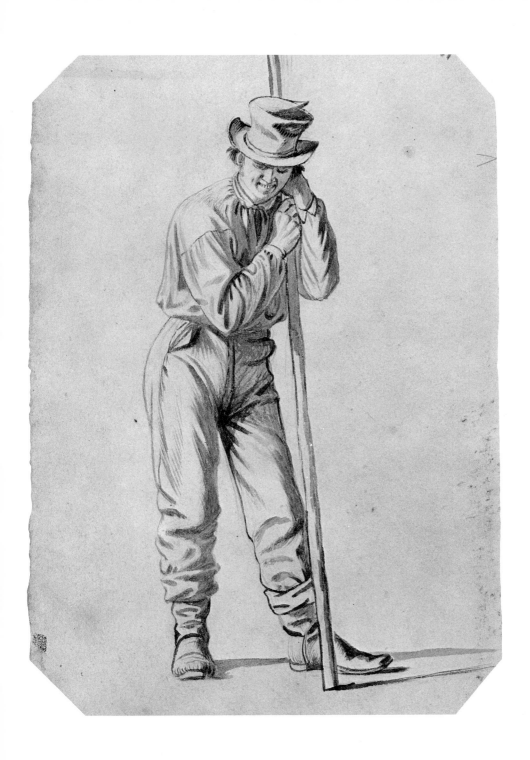

Sketch No. 67

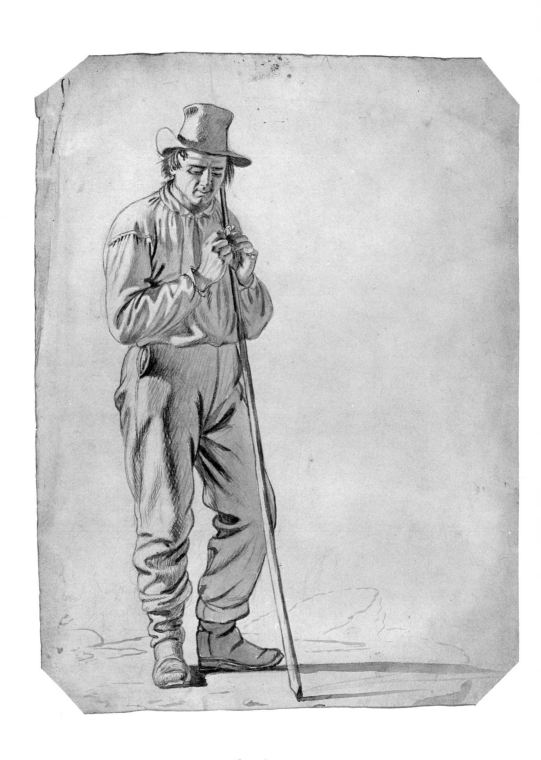

Sketch No. 68

346

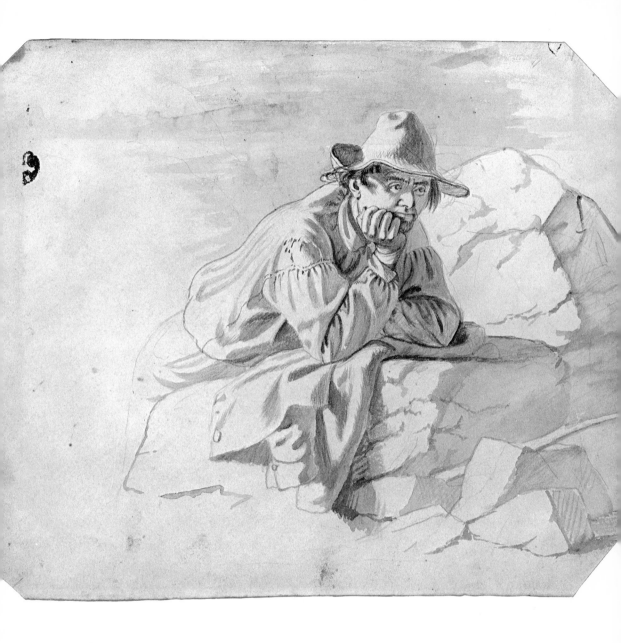

Sketch No. 69

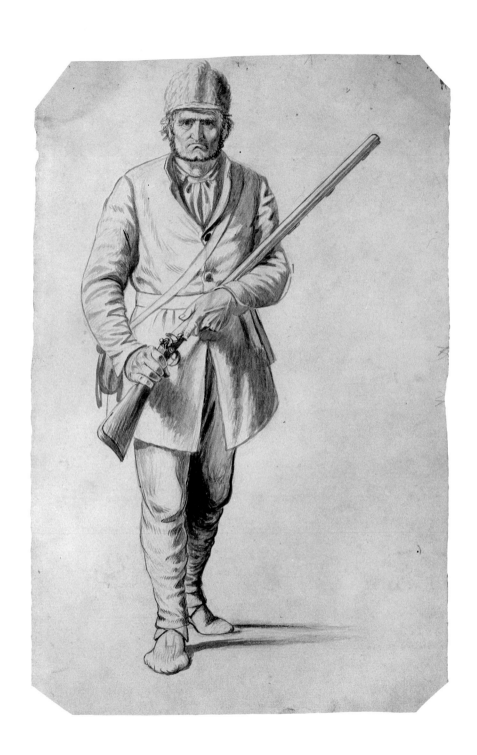

Sketch No. 70

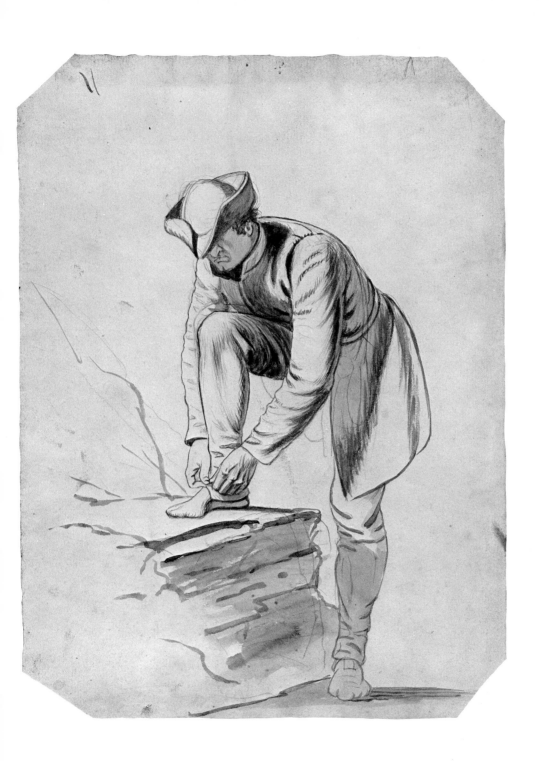

Sketch No. 71

349

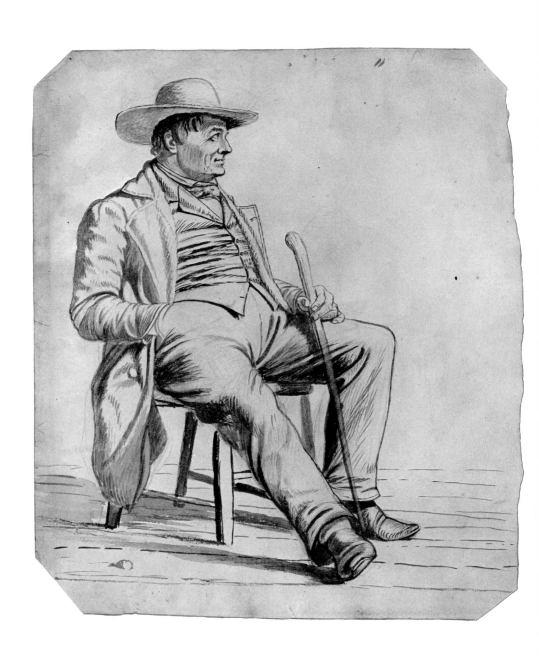

Sketch No. 72

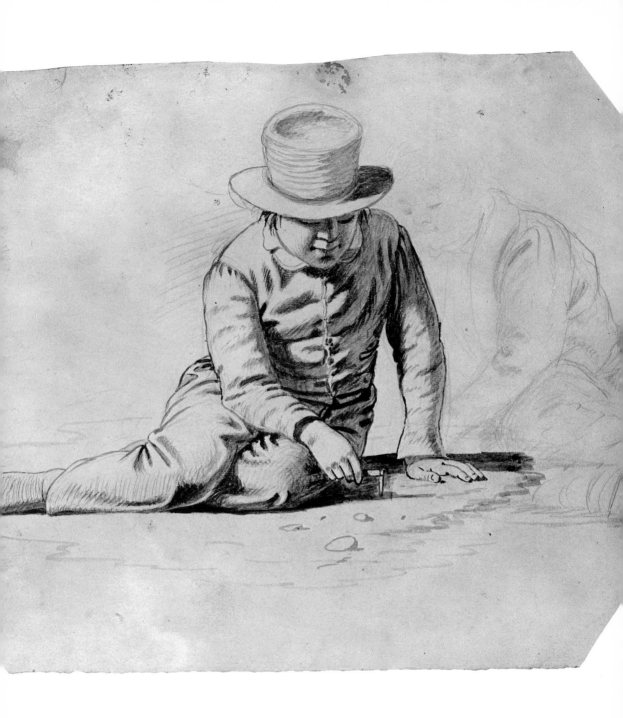

Sketch No. 73

351

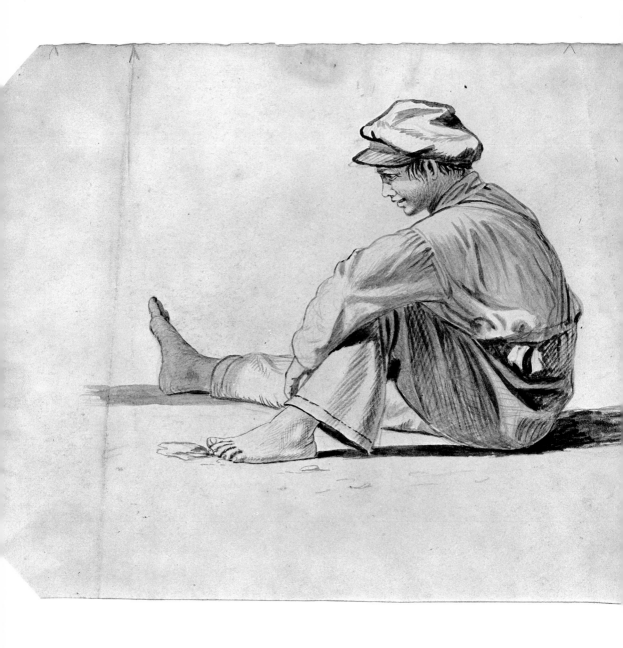

Sketch No. 74

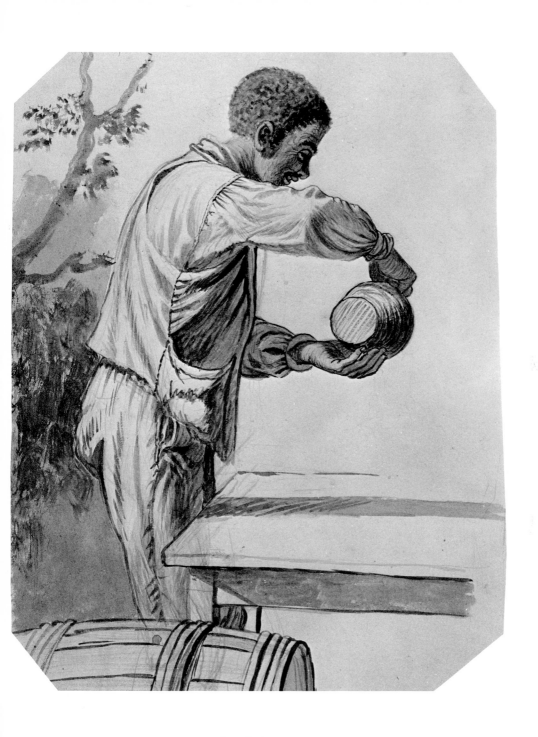

Sketch No. 75

353

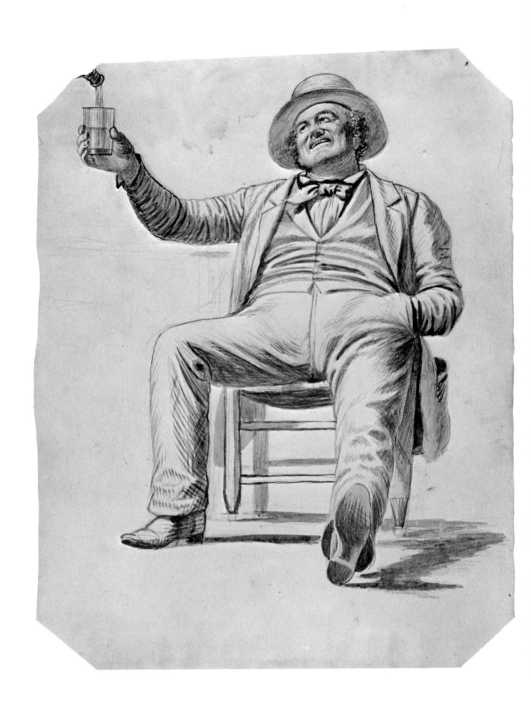

Sketch No. 76

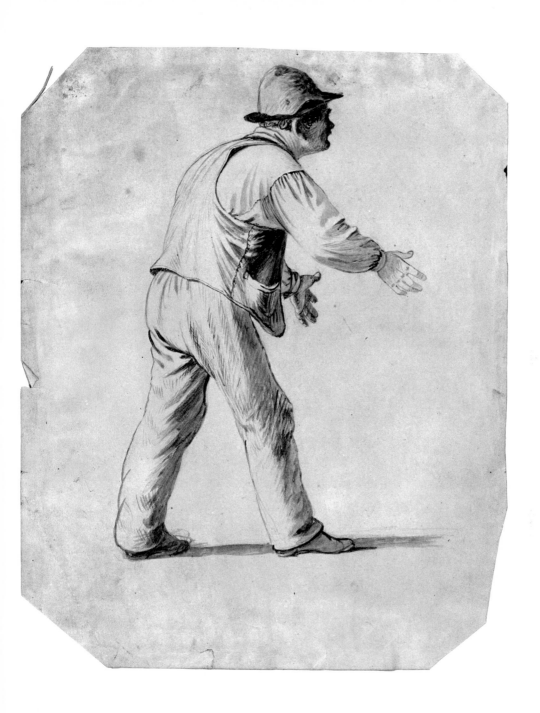

Sketch No. 77

Sketch No. 78

Sketch No. 79

Sketch No. 80

Sketch No. 81

Sketch No. 82

Sketch No. 83

Sketch No. 84

Sketch No. 85

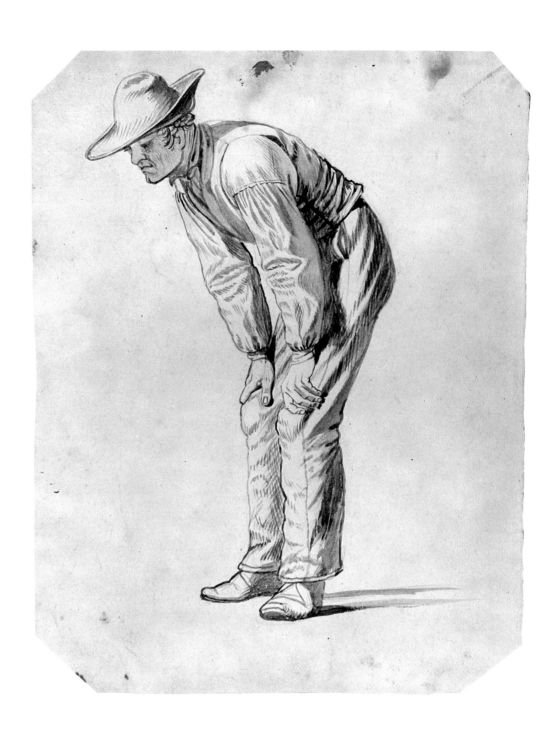

Sketch No. 86

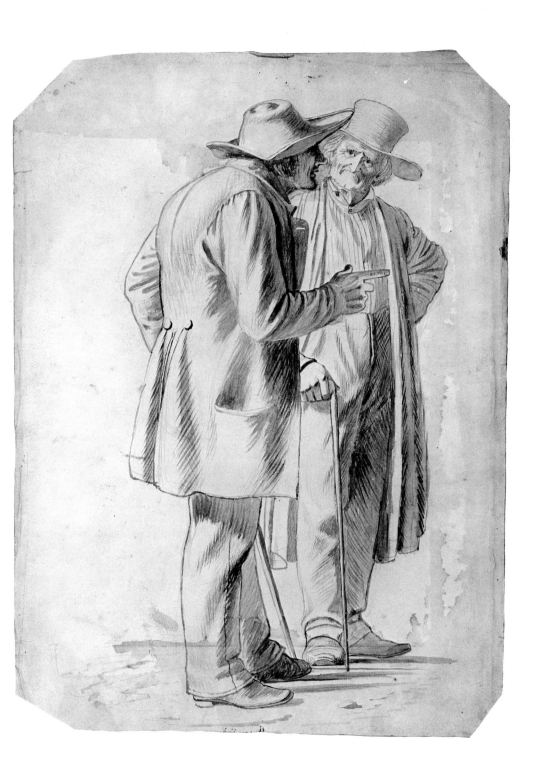

Sketch No. 87

365

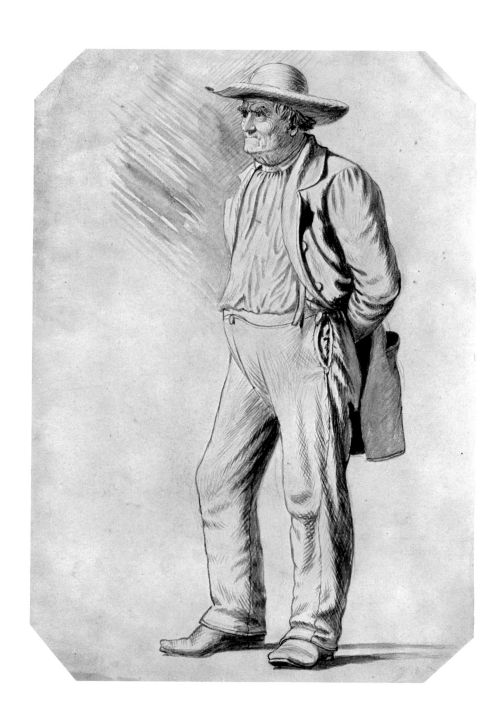

Sketch No. 88

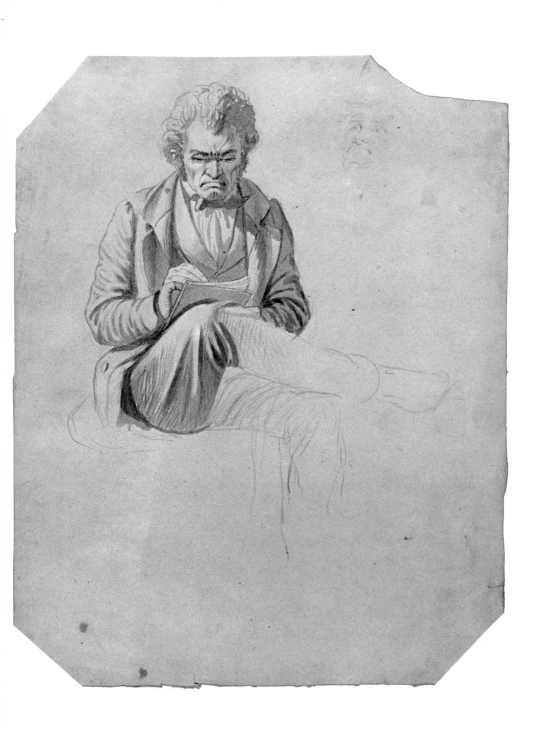

Sketch No. 89

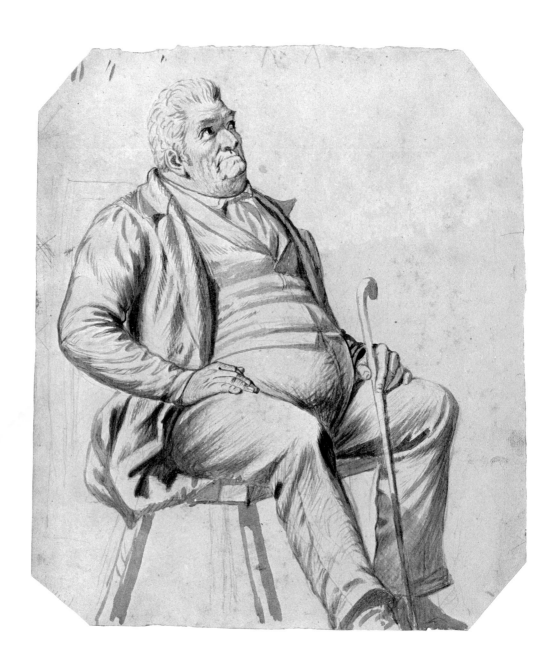

Sketch No. 90

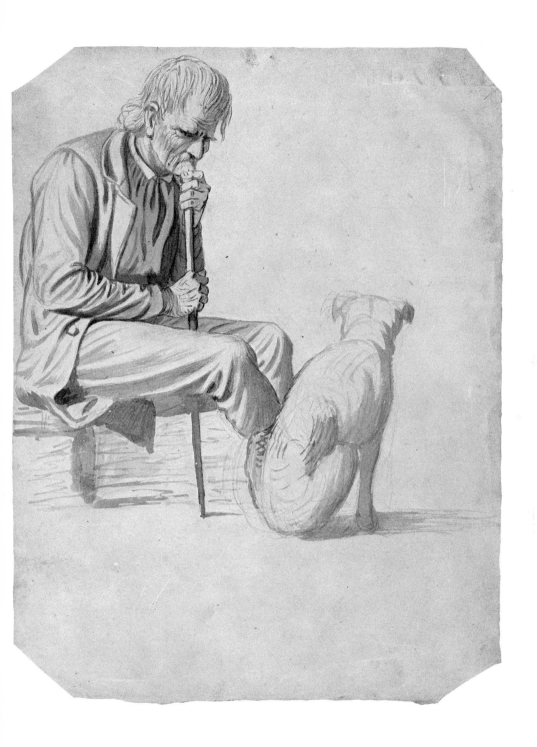

Sketch No. 91

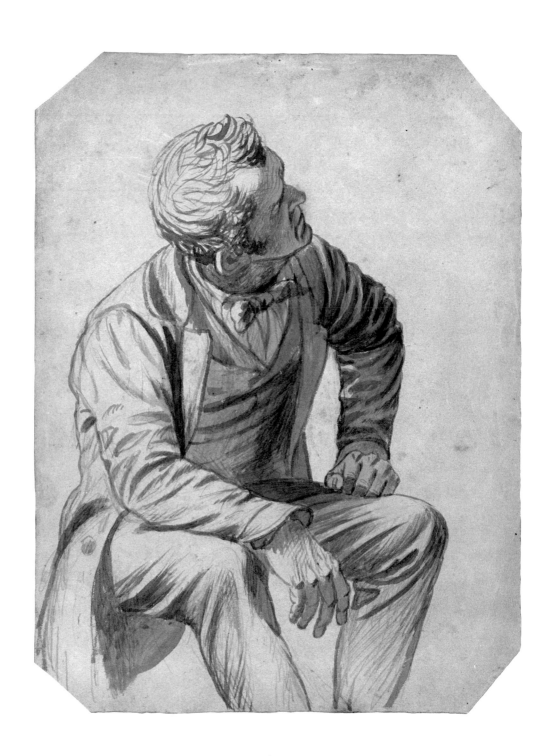

Sketch No. 92

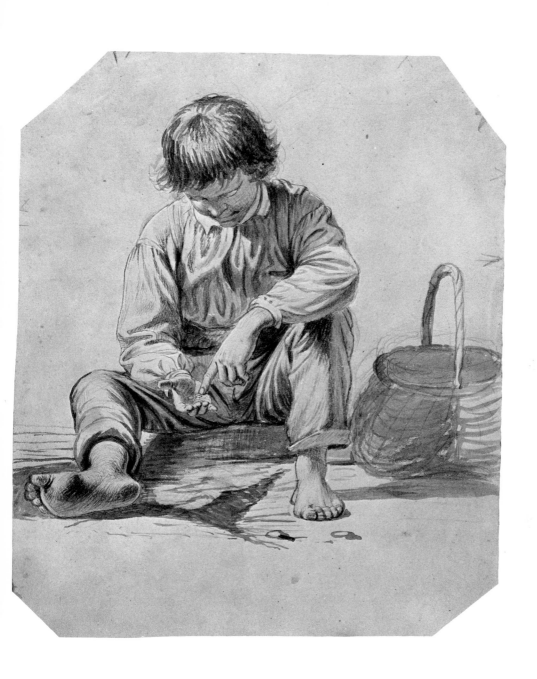

Sketch No. 93

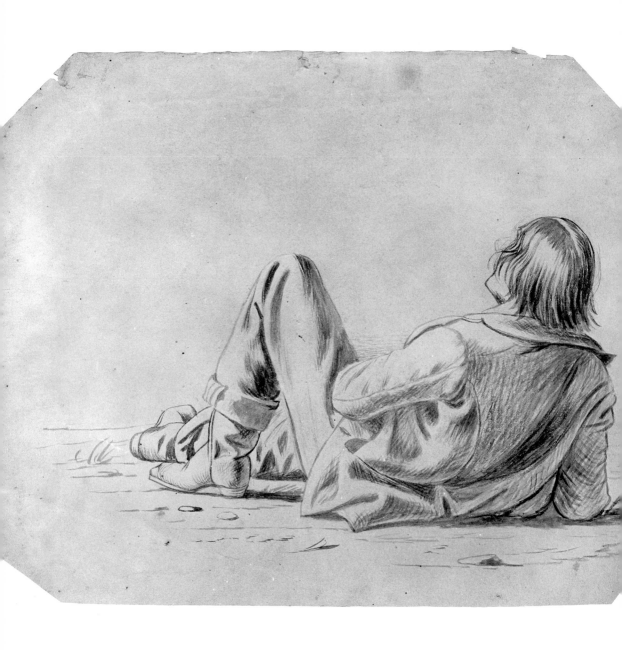

Sketch No. 94

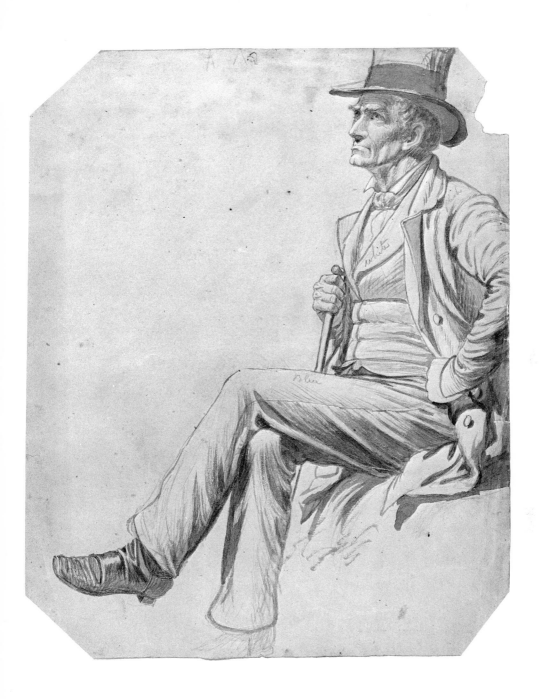

Sketch No. 95

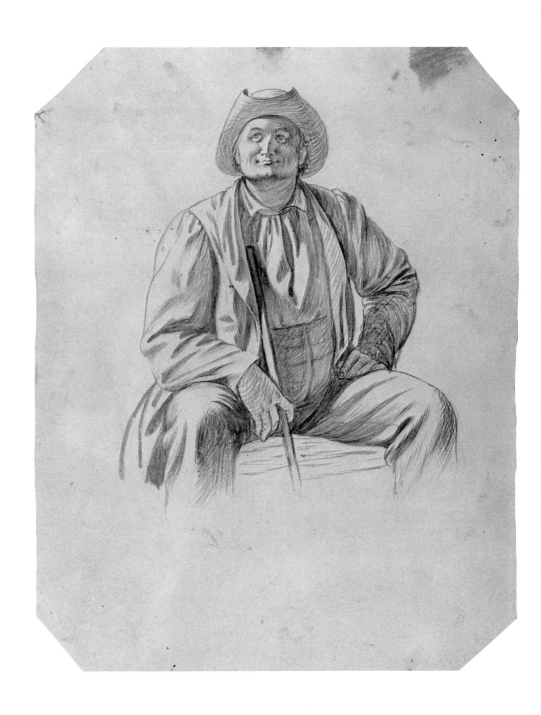

Sketch No. 96

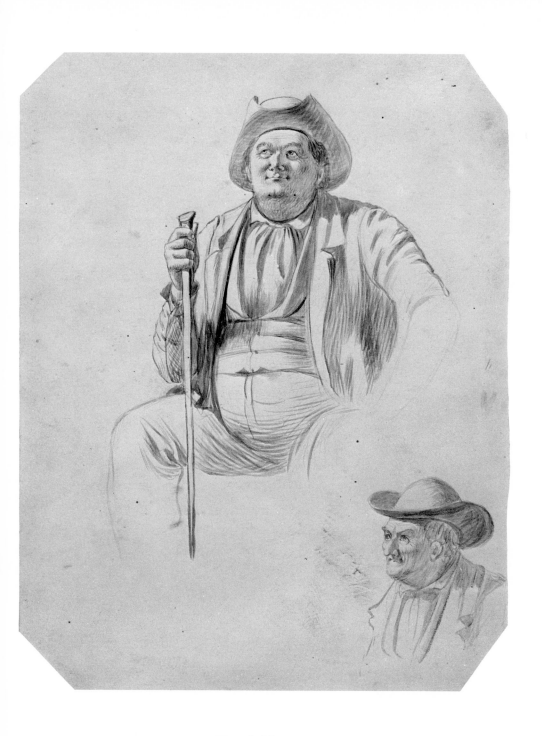

Sketch No. 97

Sketch No. 98

Sketch No. 99

Sketch No. 100

378

Sketch No. 101

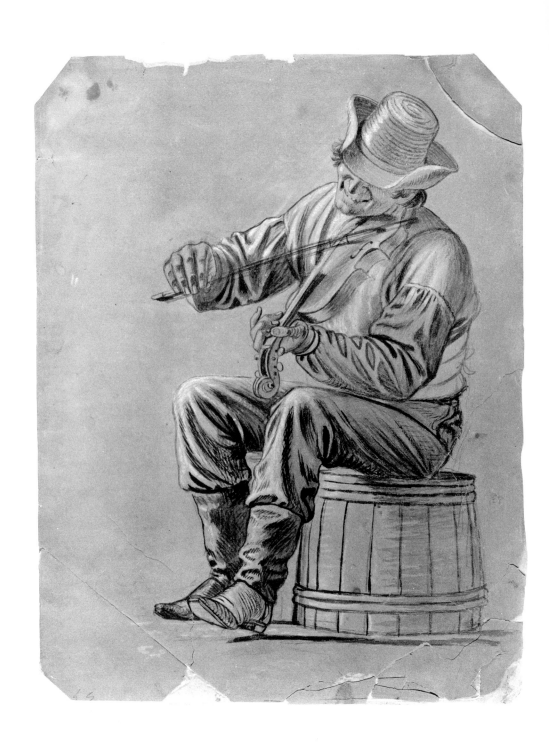

Sketch No. 102

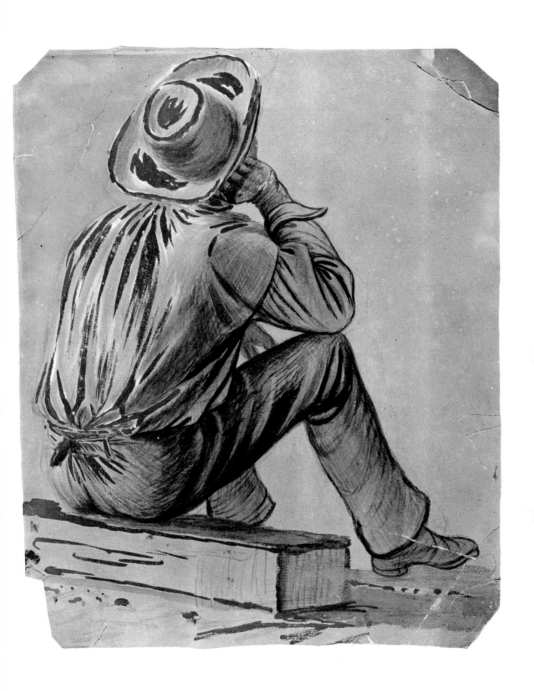

Sketch No. 103

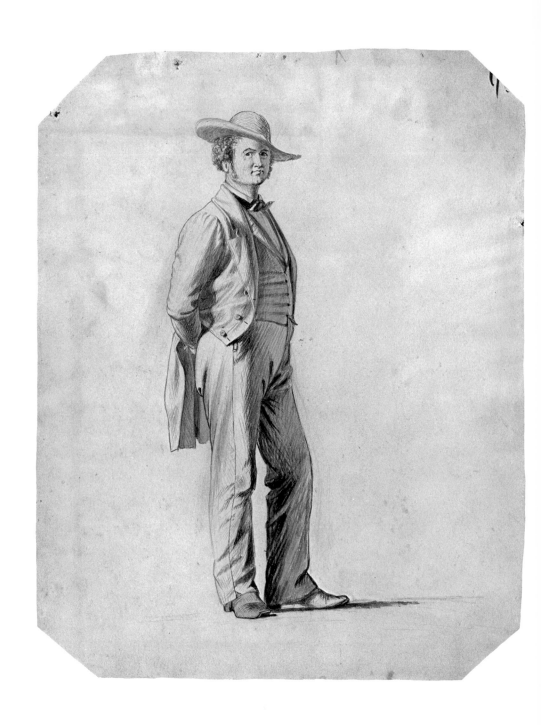

Sketch No. 104

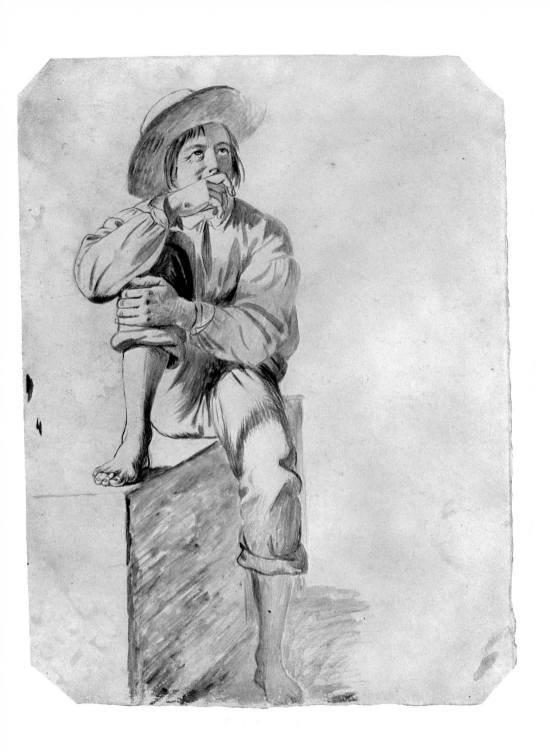

Sketch No. 105

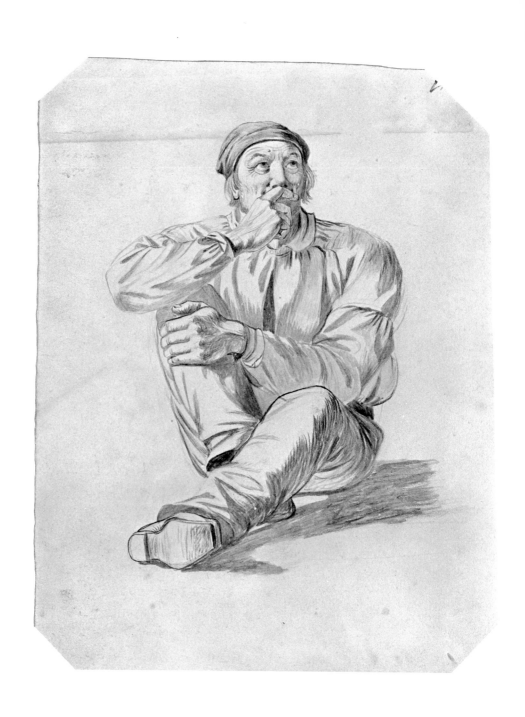

Sketch No. 106

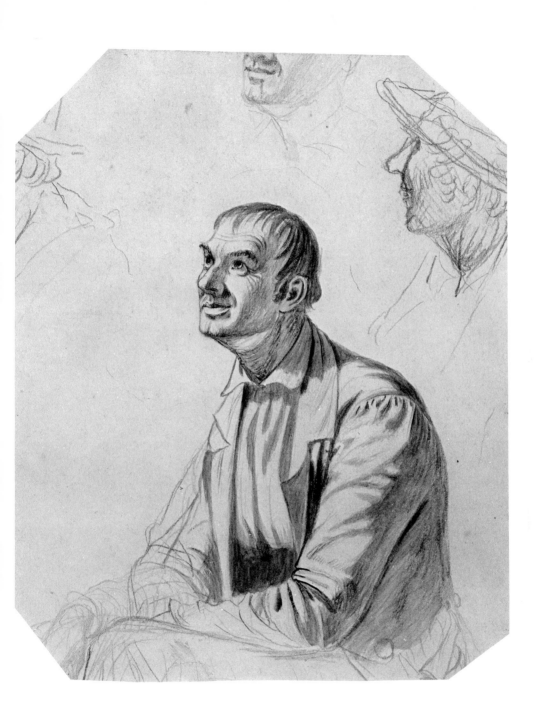

Sketch No. 107

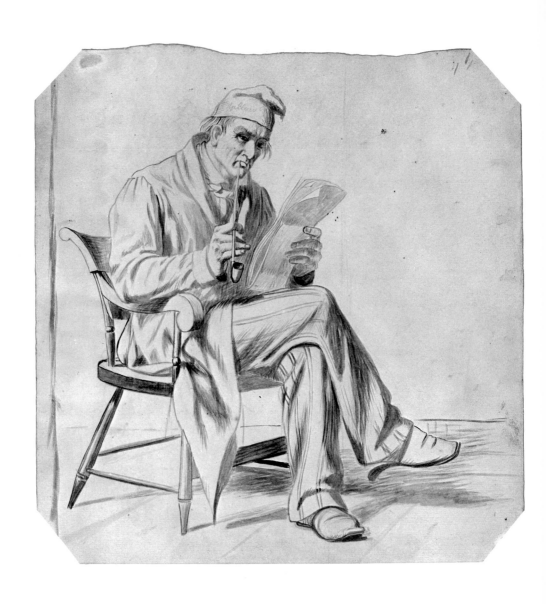

Sketch No. 108

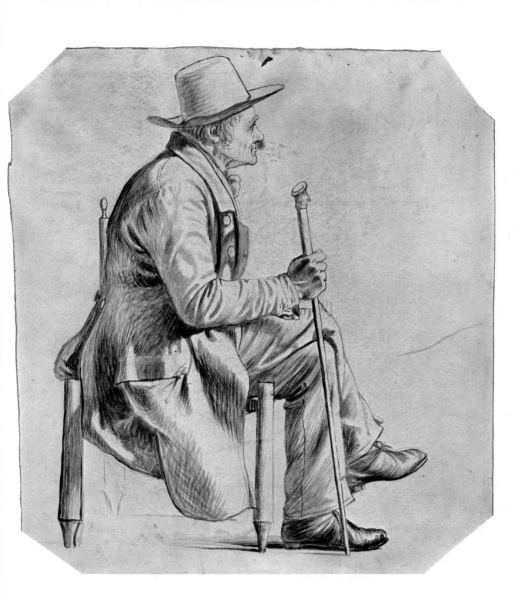

Sketch No. 109

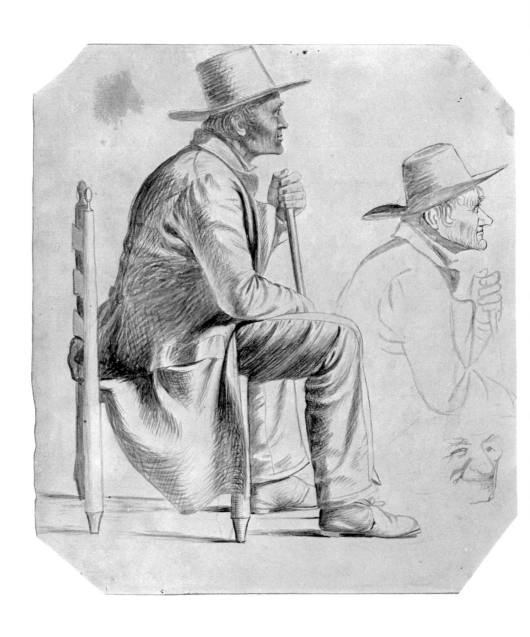

Sketch No. 110

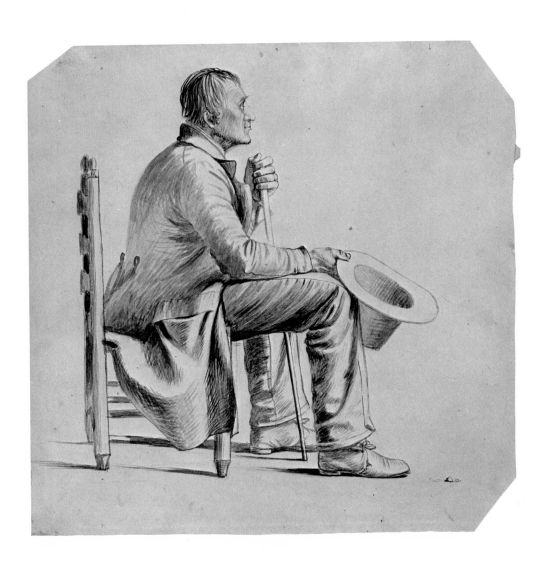

Sketch No. 111

389

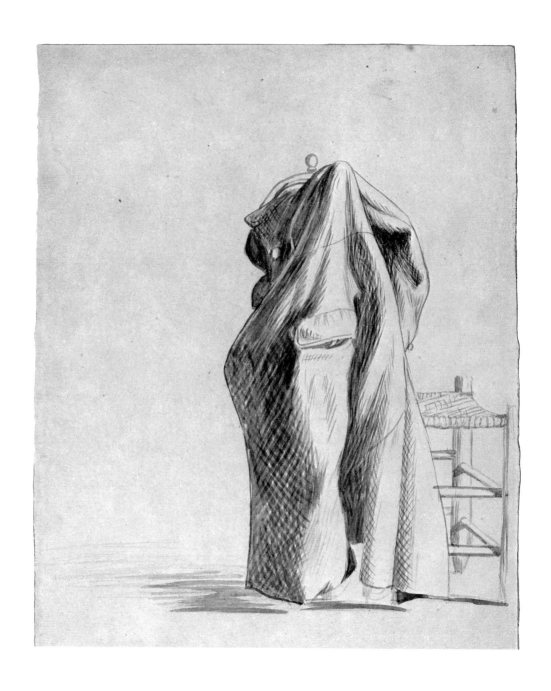

Sketch No. 112

Fragment of an Autobiography

BY GEORGE CALEB BINGHAM

I HAVE no knowledge of my ancestry beyond my maternal and paternal grandfathers. The former was born of German parentage near the city of Little York in the state of Pennsylvania. His name was Matthias Amend. He was by trade a millwright and a most excellent workman in his line. Before the close of the last century he migrated to the valley of Virginia and settled at the place on which is the celebrated cavern known as Wier's Cave. Through his grounds flowed the beautiful little South River which forms one of the three branches of the Shenandoah that intersect each other near the village of Port Republic. Upon this never-failing stream he erected a sawmill and gristmill which furnished lumber and breadstuff to the community for miles around. Its revolving wheels were the earliest wonder upon which my eyes opened, and as an evidence of the skill with which they were constructed, they are yet in motion after a lapse of more than three score years. But two children were born to my Grandfather Amend, a son and a daughter. The former died in early childhood. The death of the mother soon followed, and the daughter, Mary, was the only remaining solace to the bereaved millwright. Upon her were quite naturally centered all his hopes and affections. Having been the child of poverty himself and, consequently, favored with none of the advantages of education, his experience of the evils of such a deprivation impelled him to obtain for his daughter such means of instruction as the country then afforded. The nearest school was six miles from his residence. This Mary attended from the house of a kinsman near-by, to which she went every Monday morning, never failing to return to her father on the succeeding Saturday, in the evening of which and the Sunday following she would impart to him the lessons she had received during the week.

Thus father and child were educated together, the child obtaining a good English education, and the father learning to read and write and to cast up accounts.

My grandfather, George Bingham, was born and raised in some of the New England states, from which at about the close of the Revolution he migrated to Virginia and settled on the east side of the Blue Ridge,

391

about eighteen miles west of Charlottesville, the home of Jefferson and the seat of the Virginia University.

He was what is termed a local Methodist preacher and as such ministered to a congregation in a meeting-house erected for their accommodation upon his plantation. He cultivated tobacco and grain by the aid of a number of slaves, to whom he was exceedingly kind and indulgent, never using the lash or allowing it to be used upon his place.

I remember him well as a tall and white-headed old gentleman, overflowing with the milk of human kindness. He had three sons and four daughters who reached the age of maturity. My father, Henry V. Bingham, was the oldest son and the oldest child. He was blessed with a good constitution, and leading from early boyhood an active life, he presented in his person at the time of my remembrance a fine specimen of vigorous manhood, measuring six feet in height and weighing over a hundred and eighty pounds. His education was only such as could be acquired in the common field schools of the time, but he was a constant reader, and his mind became stored with a good amount of historical and political information.

After reaching his twenty-first year he had the charge of his father's plantation and conducted its affairs with energy and industry, laboring in the fields with the slaves and taking the annual crop of tobacco to market in Richmond.

The present era of railroads and rapid transportation furnishes a striking contrast to the roads and locomotive powers which then furnished the Virginian with the only means of reaching a market with the staple upon which he predicated his hope of future wealth. Not even the common wagon was used. Each hogshead of tobacco was strongly hooped from end to end, the heads were made of thick and substantial material, and in the center of each was inserted a strong hickory pin to which a pair of shafts were attached, and by which a single horse could roll a hogshead of tobacco from the shed in which it was prepared from fifty to a hundred miles, as the distance might be, to the market which furnished a purchaser.

This was generally done at a season of the year when the roads were dry, and when the labor both of horses and men could be best spared from the fields. At such times the roads to Richmond would be filled for miles at a stretch with "tobacco rollers" who enlivened the hours with singing songs and cracking their jokes. Some of the latter were occasionally of a practical nature and calculated to test the temper of their unfortunate subjects.

Taking his provisions and blankets with him, each roller would encamp, and frequently alone, wherever he might be at the approach of night, and in the event of a cloudy morning it not infrequently happened

that a roller, after attaching his horse and traveling several miles, would be astonished by meeting a roller traveling exactly the opposite of the course which appeared to him to be the way to Richmond. Questions and answers would be immediately exchanged which would make it clear to his mind that the shafts of his hogshead, which were toward Richmond when he laid down, had been reversed by some wicked rival while he was asleep, and that deceived thereby he was wending his way homeward instead of lessening his distance to Richmond. Should he meet in Richmond the wag who thus tricked him, a fight might ensue, or a jolly laugh and a drink all around, as the humor of the parties might happen to be.

In consequence of the entire failure of the mill streams on the east side of the Blue Ridge during a period of drouth, it became necessary for my father to take a load of grain "over the mountain" to my Grandfather Amend's mill on the South River. While there he became acquainted, as a matter of course, with my mother, Mary Amend, fell in love with her, and in due time offered himself in marriage and was accepted.

As my mother, Mary, was the only treasure which my Grandfather Amend valued, in giving her away, he also surrendered to my father his entire earthly possessions, stipulating only that he should have a home with his daughter during the period of his natural life.

As soon, therefore, as the wedding was consummated, my father became the proprietor of the lands including the mill and Wier's Cave, so called in honor of its discoverer, a little Dutchman named Barnett Wier, who was in the habit of roaming among the hills and forests with his dog and gun.[1]

[1] Reprinted from Rusk, *Bingham,* 7–11.

❧ II ❧

Art, the Ideal of Art, and the Utility of Art

BY GEORGE C. BINGHAM, PROFESSOR OF DRAWING IN THE UNIVERSITY
OF THE STATE OF MISSOURI.

Ladies, Gentlemen and Students of the University:

I HAVE BEEN REQUESTED by our worthy president to embody in a brief lecture, and present to you some of the views on Art which I have been led to entertain from many years of practice and experience and familiarity with the works of many of its most eminent professors. We are all naturally disposed to prefer that mode of expression by which we can communicate to others, most forcibly and clearly, the thought to which we are prompted to give utterance. Hence artists have generally been averse to giving a mere verbal expression to ideas which they are able to present in a far more satisfactory manner, with the pencil or chisel. It is doubtless owing to this reluctance on their part that the literature of their profession is chiefly the product of theorists who can err in safety under the silence of those who alone have the ability to correct them. These theorists are often laboriously ambiguous even in their definition of Art.

Micheal [*sic*] Angelo, whose sublime and unrivaled productions, both in painting and sculpture, certainly entitle him to be regarded as good authority in all that related to Art, clearly and unhesitatingly designates it as "The imitation of nature."

The Oxford student, however, who ranks as the ablest and most popular writer upon the subject, undertakes to convince his readers that the imitation of nature so far from being Art, is not even the language of Art. He boldly goes still further and asserts that the more perfect the imitation the less it partakes of the character of genuine Art. He takes the position that Art to be genuine must be true, and that an imitation of nature so perfect as to produce an illusion, and thereby make us believe that a thing is what it really is not, gives expression to a falsehood, and cannot therefore be justly regarded as genuine Art, an essential quality of which is truth.

394

Such logic may be convincing to the minds of those admirers who regard him as an oracle upon any subject which he chooses to touch with his pen. But in all candor it seems to me to be merely on a par with that of a far less distinguished character, who, travelling with a companion along the banks of a river, undertook, for a wager, to convince him that the side of the river on which they were journeying was really the other side. He did it by stating as his postulate that the river had two sides, and as the side opposite to them was one of these sides, the side on which they were traveling was necessarily the other side. Truth and such logic are not always in harmony.

The well known story of Zenxas and Appeles, two of the most famous painters of ancient Greece, has been handed down to us through the intervening ages. Being rivals and alike ambitious of distinction, a challenge passed between them for a trial of their skill. One painted a picture of grapes so perfect in its imitation of that luscious fruit, that the birds of the air flocked to partake of them as a servant was carrying the picture to the place of exhibition. The other merely painted upon his canvass a curtain, but so perfect was its resemblance to a real curtain, that his rival stretched forth his hand to remove it in order to get a view of the supposed picture beneath. Such an adherence to nature, and I may add to the truth of nature, constitutes what should properly be called the truth of Art; that Art only which belies nature is false Art.

These imitations are recorded in the literature of that classic period, as evidence of the excellence in Art by which it was characterized. We are loth to suppose in an age made illustrious by the highest civilization which the world had then attained, and surrounded by works of Art which coming ages will never surpass, great statesmen, scholars, artists, and literary men could have been so far mistaken in regard to the true nature of Art, as to recognize as an excellence therein, that which was really a defect.

About the close of the war of 1812 one of the great naval conflicts between the British and American fleets was dramatized upon the stage in the city of Baltimore. The scenery was arranged with all the skill which the most consummate Art could bestow upon it. Even the movements of the vessels and the motion of the waves were closely imitated. An unsophisticated sailor who had participated in such conflicts, happened to be seated in the pit as one of the audience. Becoming absorbed in what was transpiring before him, to an extent which banished all idea of mere stage effect from his mind, he thought he saw one of our vessels beclouded with smoke, and threatened with destruction by the enemies' fleet. His patriotism rose above all considerations of personal safety. He could not rest without an effort to transmit to the imperilled vessel a knowledge of the danger by which it was threatened. This could only be done by

taking to the water, he being an excellent swimmer. He sprang up with great excitement, and approaching the stage and shedding his linen as he went, he plunged head foremost into which he took to be water, but it being only a well devised imitation of that element he went through it to the basement about twenty feet below, leaving our vessel to its fate. What man of ordinary intelligence will venture to affirm that scenic Art thus so nearly resembling the reality of nature is less Art on that account?

More than once in my own experience portraits painted by myself, and placed in windows facing the sun to expedite their drying, have been mistaken for the originals by persons outside, and spoken to as such. Such occurrences doubtless mark the experience of nearly every portrait painter; but none of them ever dreamed that the temporary deception thus produced lessened the artistic merit of such works. The great ability of Ruskin as a writer is generally and justly conceded. He has performed a great work for artists of his own age in destroying the reverence for the works of the old masters which has attributed to them an excellence entirely beyond the reach of modern genius. But no artist can safely accept his teachings as an infallible guide. Artists who expect to rise to anything like eminence in their profession, must study nature in all her varied phases, and accept her both as his model and teacher. He may consider every theory which may be advanced upon the subject nearest to his heart, but he must trust his own eyes and never surrender the deliberate and matured conclusions of his own judgment to any authority however high.

What I mean by the imitation of nature is the portraiture of her charms as she appears to the eye of the artist. A pictorial statement which gives us distant trees, the leaves of which are all seperately and distinctly marked, is no imitation of nature. She never thus presents herself to our organs of vision. Space and atmosphere, light and shadow, stamp their impress on all that we see in the extended fields which she opens to our view, and an omission to present upon our canvass a graphic resemblance of the appearances thus produced, makes it fall short of that truth which should characterize every work of Art. But while I insist that the imitation of nature is an essential quality of Art, I by no means wish to be understood as meaning that any and every imitation of nature is a work of Art.

Art is the outward expression of the esthetic sentiment produced in the mind by the contemplation of the grand and beautiful in nature, and it is the imitation in Art of that which creates this sentiment that constitutes its expression. The imitation is the word which utters the sentiment. No Artist need apprehend that any imitation of nature within the possibilities of his power will long be taken for what it is not. There are attributes of nature which the highest Art can never possess. In the younger days of Micheal Angelo, soon after his rapidly developing genius had

been noised abroad, he visited the studio of an aged sculptor in Florence while he was engaged in giving the finishing touches to the last and noblest of his works. The old man wishing to have an expression of his judgment upon it, exposed it fully to his view allowing the most favorable light to fall upon it. The young Angelo contemplated it for many minutes with wrapped attention, no word passing from his lips. At length turning upon his heel he said *it lacks one thing,* and immediately disappeared. His words fell as a death blow upon the ears of the old man. He had bestowed upon the work the results of his life-long study in the confident expectation that it would transmit his name to posterity, and associate him in history with the greatest Artists of his day. He became gloomy and despondent, soon sickened and was laid on his death-bed. Learning that Micheal Angelo was again in his vicinity he sent him a message inviting him to visit him. When the young sculptor appeared in his presence he reminded him of the remark which he had made at the close of their previous interview, and earnestly entreated him to name the one thing lacking in what he had fondly regarded as the crowning work of his life. I meant, said the younger artist, that it lacked *the gift of speech* and that only! We can well imagine the new life which, at these words instantly sprang up in the soul of the gifted old man, smoothing his passage to that upper and better life to be associated forever with all who love the true and the beautiful.

As the powers of man are limited so is Art necessarily limited in its domain. It can only embody those appearances of nature which are addressed to the eye and exhibited in form and color. Like the work of the grand old Florentine sculptor it can faithfully present the human form in all its symmetry and beauty, but it can not breathe into that form a living soul or endow it with speech and motion. It can give us the hue and forms of hills, mountains, lakes and rivers, or old ocean, whether in calm, sunshine or storm, but all that we see in these results of limited power is alike motionless and voiceless. There is no murmuring in their brooks as they seem to encounter the rocks in their passage. Their clouds are stationary in their skies, their suns and moons never rise or set. There is no sound of lowing coming from their flocks and herds. All is silent and still, and being so can never be mistaken for actual nature. Nevertheless that Art which, within the limited sphere of Art, most nearly resembles actual nature, most clearly expresses the sentiment which actual nature produces in the minds of those who have the taste to relish her beauties. Ruskin, with all his verbal powers of description, failed as an artist, and I have no hesitation in affirming that any man who does not regard the imitation of nature as the great essential quality of Art will never make an artist.

The Ideal in Art

There are various and conflicting opinions as to what constitutes the ideal in Art. In the minds of those liberally endowed artists whose productions exhibit a wide range of thought, it seems to my judgment to be that general and much embracing idea necessarily derived from the love and study of nature in her varied and multitudinous aspects, as presented in form and color. It must, however, be necessarily limited by the taste of the artist, which may confine him to what is special rather than to what is general in nature. I say it may be limited and contracted by the taste of the artist. Artists permit themselves to be absorbed only by what they love. And as nature presents herself to them in a thousand phases, they may worship her in few or many. Such of her phases as take possession of their affections also take possession of their minds, and form thereon their ideal, it matters not whether it be animate or inanimate nature, or a portion of either. A Landseer is captivated by the faithfulness, habits and hairy texture of dogs, and makes them his specialty in Art, being kennelled in his mind, as it were, they exclude other subjects of Art and become the ideal which governs his pencil. When Sidney Smith was requested by a friend to sit to Landseer for his portrait he replied, *"is thy servant a dog that he should do this thing?"* His reply was significant of the apprehension justly entertained that the artist could not avoid giving to his portrait something of the expression which more properly belonged to his favorites of the canine species. Rosa Bonhier [*sic*], early in life, fell in love with the kine which furnishes us all, with the milk, butter and cheese which form so large a portion of the aliment which sustains our physical frames. In living with them and caressing them, their forms and habits took possession of her mind as they had done of her heart, and formed that ideal which makes her pictures of cattle far transcend in excellence those of Paul Potter or any of her predecessors.

I cannot believe that the ideal in Art, as is supposed by many, is a specific mental form existing in the mind of the artist more perfect than any prototype in nature, and that to be a great artist he must look within him for a model and close his eyes upon external nature. Such a mental form would be a fixed and determined idea, admitting of no variations, such as we find in diversified nature and in the works of artists most distinguished in their profession. An artist guided by such a form would necessarily repeat in every work exactly the same lines and the same expression.

To the beautiful belongs an endless variety. It is seen not only in symmetry and elegance of form, in youth and health, but is often quite as fully apparent in decrepit old age. It is found in the cottage of the peasant as well as in the palace of kings. It is seen in all the relations,

domestic and municipal, of a virtuous people, and in all that harmonizes man with his Creator. The ideal of the great artist, therefore, embraces all of the beautiful which presents itself in form and color, whether characterized by elegance and symmetry or by any quality within the wide and diversified domain of the beautiful. Mere symmetry of form finds no place in the works of Rembrant, Teniers, Ostade, and others of a kindred school. Their men and women fall immeasurably below that order of beauty which characterizes the scluptures of classic Greece. But they address themselves none the less to our love of the beautiful, and none the less tend to nourish the development and growth of those tastes which prepare us for the enjoyment of that higher life which is to begin when our mortal existence shall end.

All the thought which in the course of my studies, I have been able to give to the subject, has led me to conclude that the ideal in Art is but the impressions made upon the mind of the artist by the beautiful or Art subjects in external nature, and that our Art power is the ability to receive and retain these impressions so clearly and distinctly as to be able to duplicate them upon our canvas. So far from these impressions thus engraved upon our memory being superior to nature, they are but the creatures of nature, and depend upon her for existence as fully as the image in a mirror depends upon that which is before it. It is true that a work of Art eminating from these impressions may be, and generally is, tinged by some peculiarity belonging to the mind of the artist, just as some mirrors by a slight convex in their surface give reflections which do not exactly accord with the objects before them. Yet any obvious and radical departure from its prototypes in nature will justly condemn it as a work of Art.

I have frequently been told, in conversation with persons who have obtained their ideas of Art from books, that an artist should give to his productions something more than nature presents to the eye. That in painting a portrait for instance, he should not be satisfied with giving a true delineation of the form and features of his subject, with all the lines of his face which mark his individuality, but in addition to these should impart to his work the *soul* of his sitter. I cannot but think that this is exacting from an artist that which rather transcends the limits of his powers, great as they may be. As for myself, I must confess, that if my life and even my eternal salvation depended upon such an achievement, I would look forward to nothing better than death and everlasting misery, in that place prepared for the unsaved. According to all of our existing ideas of a soul, there is nothing material in its composition. The manufacture, therefore, of such a thing out of the earthen pigments which lie upon my palate would be a miracle entitling me to rank as the equal of the Almighty himself. Even if I could perform such a miracle, I would be robbing my sitter of the most valuable part of his nature and giving it

399

to the work of my own hands. There are lines which are to be seen on every man's face which indicate to a certain extent the nature of the spirit within him. But these lines are not the spirit which they indicate any more than the sign above the entrance to a store is the merchandize within. These lines upon the face embody what artists term its expression, because they reveal the thoughts, emotions, and to some extent the mental and moral character of the man. The clear perception and practiced eye of the artist will not fail to detect these; and by tracing similar lines upon the portrait, he gives to it the expression which belongs to the face of his sitter, in doing this, so far from transferring to his canvass the soul of his subject, he merely gives such indications of a soul as appear in certain lines of the human face; if he gives them correctly, he has done all that Art can do.

The Utility of Art

If man were a mere animal whose enjoyments did not extend beyond the gratification of the appetites of such a being, Art might justly be regarded as a thing of very little importance.

In the elevated sense in which we are discussing it, it addresses itself solely to that portion of man which is the breath of the Eternal—which lives forever,—which is capable of endless growth and progress, and the requirements of which are peculiar to itself. The beautiful, and all that is embraced in what is termed esthetics, together with all that contributes to mental development is the natural food of the soul, and is as essential to its growth, expansion and happiness, as is the daily bread we consume, to the health and life of our animal nature. The appetite for this spiritual food, like that for the nourishment essential to our material growth, is a part of our nature. As the latter turns the lips of the new born infant to the breast of its mother, the former exhibits itself in its love of the beautiful. Before it is capable of thought or reason, its eyes will sparkle with intense delight at the presentation of a beautiful bouquet, while it would look upon a nugget of gold richer than the mines of California ever produced, with utter indifference. As the growth, strength and development of the body depend upon the food demanded by its natural appetites, so must the growth and development of the soul, and its capacity for enjoyment, depend upon the spiritual food demanded by those tastes peculiar to and a part of its nature.

The soul is as necessarily dwarfed by withholding from it its proper nourishment, as is the body from a like cause. The natural wants of both should be constantly supplied, that the child as it grows in stature may also wax strong in spirit. If we regard that as useless which meets the demands of the esthetic tastes of our nature, then we must regard God as exhibiting no wisdom in decorating nature in so lavish a manner with

the grand, the sublime, and beautiful. In giving us the fruit, he might have omitted the beautiful bloom which heralds its coming. In giving us the rain which moistens our fields and makes our rivers, he might have withheld the accompanying arch which spans the heavens and exhibits to our delighted gaze its perfect symmetry in form and unequaled glory in color. He might have spread over land and sea and sky a dull and monotonous hue, instead of enriching them with that infinitude of the beautiful, which they ceaselessly unveil to the eye of man. All this display of the grand and the beautiful seems to be a divine recognition of the wants of our spiritual nature and a benevolent purpose to supply them.

The absence of Art in any nation will ever be a mark of its ignorance and degradation. While the highest Art will be the chaplet which crowns the highest civilization, its uses extend far beyond the gratification of our inherent love of the beautiful. As a language, its expressions are clearer than any which can be embodied in alphabetical forms, or that proceeds from articulate sounds. It also has the advantage of being everywhere understood by all nations, whether savage or civilized.

Much that is of great importance in the history of the world would be lost if it were not for Art. Great empires which have arisen, flourished and disappeared, are now chiefly known by their imperishable records of Art. It is indeed the chief agent in securing national immortality. In the remote and prehistoric periods of the past, there have doubtless been nations who gave no encouragement to Art, but like the baseless fabrics of vision they have disappeared and left not a wreck behind. And this glorious Republic of ours, stretching its liberal sway over a vast continent, will perhaps be best known in the distant ages of the future by the imperishable monuments of Art which we may have the taste and the genius to erect.

⤳ III ⤶

Chronology

1808	September 8	Henry Vest Bingham and Mary Amend married.
1811	March 20	George Caleb, second child, born in Virginia.
1819	Autumn	H. V. Bingham took his family to Franklin, Missouri.
1820	Spring	H. V. Bingham opened an inn on the public square in Franklin.
1823	December 26	H. V. Bingham died.
1824		Mrs. Bingham moved her family to a farm in Saline County, Missouri, several miles from where the town of Arrow Rock was later established.
1826		The town of Arrow Rock laid out on land half of which was donated by John Bingham, brother of Henry.
1827		George was apprenticed to a cabinetmaker in Boonville, Missouri.
1831		George fell in love with Miss S——, but was rejected by her family.
1833		Began painting portraits in central Missouri.
1834		Continued taking likenesses in Boonville, Columbia, and "the upper towns" on the Missouri. Fell in love with Sarah Elizabeth Hutchison of Boonville.
1835	January–February	Painted in Columbia.
	March	Made his first professional appearance in St. Louis.
	May	Went to Liberty, Missouri, caught varioloid on

the steamboat, but was ready to work again by the close of the month.

	November	Returned to St. Louis to paint.
1836	mid-March	After more than four months in St. Louis, returned to Boonville and married Miss Hutchison.
	September	Painted in St. Louis until mid-December, where he left for Natchez, Mississippi.
1837	January	Remained in Natchez for five months.
	March	Newton Bingham born.
	May 27	Returned to Missouri and painted portraits at Columbia during the summer.
	July 27	Bought house lot in Arrow Rock.
1838	February (?)	Left for Philadelphia, where he studied at the Philadelphia Academy of Fine Arts. Was still in Philadelphia on June 3. At the close of this visit (later reported by him to have been three months) he kept "an engagement" in Baltimore and visited New York, where he left a genre painting with the Apollo Gallery.
	July	Returned home and spent the remainder of the year painting portraits in central Missouri.
1839	January	Continued painting in the Boon's Lick country through the early spring.
	mid-May	Again in St. Louis.
	June 16	Had on display in St. Louis a "design" from "Tam O'Shanter." Remained in St. Louis throughout the year except for a few weeks in late August and early September and again in December.
	December	Painted in Boonville, but returned to St. Louis late that month.
1840	January	In St. Louis.
	mid-February	Painted in Fayette, Missouri. During this winter he completed and sent to the National Academy of Design show (opening in April) six pictures: portrait studies, story pictures, genre, and landscape.
	May	Worked in Arrow Rock on a political banner for

		the Saline County delegation to the state Whig convention.
	mid-June	Attended Whig convention at Rocheport, Missouri.
	Autumn	Went to Washington, D. C., where he opened a studio in a basement room in the Capitol with the intention of painting portraits of political notables.
1841	mid-February	His *Ariadne* displayed in his studio.
	March 13	Newton Bingham died and Horace Bingham was born.
	April (?)	Went to Petersburg, Virginia, where he painted portraits for six months.
	September	Visited the old Amend-Bingham farm and mill near Port Republic, Virginia.
	October (?)	Returned to Washington.
1842	April	His *Going to Market* exhibited at the National Academy of Design.
	November	Mrs. Bingham took Horace to visit in Boonville; G. C. B. remained at work in Washington.
1843	March	Late in March, Mrs. Bingham returned to Washington.
	June	Bingham went to Philadelphia to see the exhibition at the Pennsylvania Academy of Fine Arts and stayed to paint three portraits.
1844	May 14–28	Painted small portrait of John Quincy Adams.
	September	Had returned to Boonville by September and was engaged in painting political banners for the Whig convention, which he attended at Boonville in October.
	November	During this month and the next, he painted portraits in Jefferson City.
1845	January	Continued painting in central Missouri.
	April	Daughter Clara born at Boonville, April 15. During this winter or spring, he completed the first of his extant genre pictures: *Fur Traders Descending the Missouri.*

	June 4	Had on display in his studio in St. Louis "some paintings which demonstrate the possession of a high order of talent in another line [than portraiture]." Four paintings bought later this year by the American Art-Union. Through the early part of the summer and perhaps longer, he remained in St. Louis painting portraits.
1846		The winter of 1845–46 he probably spent in central Missouri painting portraits and working on new genre subjects.
	March 23	Before this date, he was again in St. Louis showing a number of pictures that were on their way to the American Art-Union, among them *The Jolly Flatboatmen.*
	June	Nominated as Whig candidate for the State Legislature from Saline County.
	August 14	Elected by a majority of three votes.
	November 20	Election contested by opponent.
	December 18	Opponent seated.
1847		Early in this year, engaged in painting two more river pictures.
	March	Lived at Arrow Rock.
	April 20	Showed in St. Louis *Raftmen Playing Cards* and *Lighter Relieving a Steamboat Aground.* During the summer, painted *The Stump Orator.*
	November 29	*The Stump Orator* on display in St. Louis.
1848	April 14	Attended state Whig convention at Boonville.
	June	Accepted nomination as Saline County Whig candidate for legislature.
	August 11	Elected with majority of twenty-six votes.
	November 24	Elizabeth Bingham died at Arrow Rock, Bingham present.
	December	In Jefferson City at legislative duties.
1849		Early months spent at Jefferson City.
	April 17	Had three more genre pictures on display in St. Louis.
	May 1	In Cincinnati on way to New York with pictures

		intended for the American Art-Union. Sold pictures also to Western Art Union of Cincinnati.
	June	Arrived in New York, where he remained throughout the summer, painting pictures for the American Art-Union.
	September 28	Worked in Columbia on portrait of Dr. William Jewell. Painted other portraits during fall months.
	December 3	Married Eliza Thomas at Columbia.
1850	June	*Shooting for the Beef* nearly completed in his studio at Columbia.
	October 10	*Shooting for the Beef* and other pictures shown in St. Louis on their way to New York.
	November	Bingham settled in New York for the winter.
1851		In New York, Bingham painted *The Emigration of Daniel Boone* and other pictures.
	May (?)	His mother, Mary Amend Bingham, died.
	May 12	Arrived in St. Louis from New York on his way to Boonville.
	June	Painted portraits in Columbia. During the summer, worked on *County Election,* which, with other pictures, was on display at his Columbia studio in October.
	November 12	By this date, he had arrived in St. Louis to spend the winter painting portraits and finishing *County Election.*
1852	April 19	Attended Whig convention at St. Louis.
	May	In Boonville and Columbia.
	June 3	Left Columbia for Baltimore as delegate from the eighth Missouri district to the national Whig convention.
	June 27	Arrived in Philadelphia before this date to make arrangements for the engraving of *County Election.*
	October 28	Returned to Columbia with *County Election No. 2* before this date to take subscriptions for the engraving.
	December	At Glasgow.

	December 25	At St. Louis.
1853	January	At St. Louis painting portraits.
	March 10	Left St. Louis for New Orleans with *County Election No. 2*.
	May–July	In Kentucky, sought subscriptions for *County Election* print.
	September 15	Arrived in Philadelphia from Cincinnati to superintend work on engraving.
	September 30	Visited briefly the Crystal Palace exhibition in New York.
	October	In Philadelphia for the winter, painted *Stump Speaking* and other pictures.
1854	mid-April	Sold copyright of *Stump Speaking* to Goupil.
	mid-May	Brief visit to New York. Sold copyright of *County Election* to Goupil.
	September 15	Was in St. Louis after a year in Philadelphia. On way to Columbia and Boonville.
1855	January 1	Returned to Philadelphia. Finished *Verdict of the People* in the spring.
	mid-June	In Independence, Missouri, painted portraits until middle or close of August.
	September 14	Had recently opened studio in Columbia painting portraits.
	November 14	Painted portraits in Jefferson City.
	November 30	Spoke at Whig meeting at Jeffferson City.
1856	January	At Columbia.
	March 14	At Columbia, painted *Washington Crossing the Delaware*.
	May 6	Arrived at St. Louis on his way East, intending to go to Europe.
	June 2	In Louisville. Thence directly to Philadelphia, where he copied Stuart head of Jefferson and painted some private portraits.
	mid-July	Went to Boston to copy Stuart heads of George and Martha Washington. There painted some private portraits.

	August 1	Returned to Philadelphia.
	August 14	Sailed from New York for France.
	September 1	Arrived at Paris.
	November 1	About this date settled in Düsseldorf to work on the Missouri-commissioned portraits of Washington and Jefferson.
1857	June 3	At work on *The Jolly Flatboatmen in Port*.
	October 12	This picture "about finished."
1858	July	*Washington* and *Jefferson* finished.
1859	January 28	Had reached Jefferson City with the portraits.
	February 20	Received commission to paint *Jackson* and *Clay* for the state.
	March	Painted portraits in Jefferson City.
	April	Painted portraits in Kansas City and Brunswick, Missouri.
	May 6	Commissioned to paint Baron von Humboldt for the St. Louis Mercantile Library.
	May 8	Leaves St. Louis to return to Europe.
	June	In Düsseldorf with his family.
	June 12	Death of Mrs. Bingham's father.
	September	Bingham and his family return to Missouri.
1860	January	In Washington to copy head of Sully's *Jackson*.
	March	In Columbia at work on portrait of Humboldt.
	April	*Humboldt* finished.
	Summer	Working on *Jackson* at Kansas City.
	September 15	Painted portraits at Independence.
	October–November	Painted portraits in Kansas City.
1861	January 8	*Jackson* and *Clay* hung in state capitol.
	February 22	*Jackson* and *Clay* on exhibition in St. Louis.
	March 6	Bingham left St. Louis for Texas to see to settlement of estate of elder brother Matthias, recently deceased.
	June 27	Chosen captain of a company of home guards in Kansas City.

	September 21	James Rollins Bingham born.
1862	January 4	Appointed state treasurer. Resigned captaincy and moved to Jefferson City.
1863	August 1	Commissioned to paint equestrian portrait of General Lyon.
1864	June 10	Clara Bingham married Thomas B. King, son of former governor of Missouri.
1865		Finished term as treasurer.
	November 24	In Independence, worked on *Order No. 11*.
1866	July 6	In Independence, worked on *Major Dean in Jail*.
1867	March 8	Equestrian portrait of General Lyon hung in Senate chamber.
1868	May 28	Nominated a Democratic elector for Missouri.
	November	*Order No. 11* finished before Thanksgiving Day.
1870	May	Sold his home in Independence and moved to Kansas City.
1871	January 25	Visited in Jefferson City.
	June	Painted portraits in Kansas City.
	December 22	Arrived in Philadelphia to watch progress on the engraving of *Order No. 11*.
1872	February (?)	Returned to Kansas City.
	July	Attended national Democratic convention at Baltimore. Consulted physician in New York.
	August–October	Painted landscapes in Colorado.
	November	Painted portraits in Kansas City.
1873	April	Visited Texas.
	May–June	Sick in Kansas City.
	September	Took pictures to Louisville Exposition.
	October	In Kansas City "making drawings to be elaborated into pictures" during the winter.
	November–December	Painted portraits in Kansas City.
1874	May	President of the Board of Police Commissioners. Kansas City. Through the winter painted portraits there.

	June 7	Still "engaged daily in the Studio painting portraits . . . 'to make the pot boil.' "
1875	January	Appointed adjutant general of Missouri; moved temporarily to Jefferson City.
1876	February	In Washington on Missouri war-claims business.
	May	Returned home. Wife had been very ill.
	November 3	Death of Mrs. Eliza Thomas Bingham at Fulton.
1877	January 19	Elected professor of art at the University of Missouri (installed in October).
	April	Painted portraits at Jefferson City.
	July–September	Painted portraits at Boonville.
	November	Stayed in Kansas City with his "old and dear friend" Mrs. Lykins.
1878	January	Engaged to Mrs. Lykins.
	February–March	In Washington.
	May	Visited Clara in Texas.
	June 18	Married Mrs. Lykins at Kansas City; went to Denver. In Kansas City again sometime in August.
	November 8	Appointed commissioner for Missouri to assist in selection of a design for a monument to Robert E. Lee. Was at Richmond November 27, and back in Columbia December 6.
1879	February	Had severe attack of pneumonia.
	July 5	Left Columbia after a visit of nearly two months at Rollins' house.
	July 7	Died at Kansas City of cholera morbus.
1892		Fire at the University of Missouri destroyed many portraits by Bingham.
1893	March 25	Sale of Bingham paintings and engravings at Findlay Art Rooms, Kansas City, for benefit of the Confederate Home at Higginsville, Missouri, in accordance with the will of the late Mrs. Bingham.
1910	April 9–24	Special Exhibition of the Paintings of George Caleb Bingham, 'The Missouri Artist,' held by the Art Lovers Guild of Columbia, Missouri: ten

genre, landscape and historical paintings, twenty-eight portraits, eight prints after Bingham, and the Mercantile Library sketch book.

1911 February 5 State capitol burned; the Washington, Jefferson, Jackson, Clay, and Lyons portraits destroyed.

1917 *George Caleb Bingham, the Missouri Artist* by Fern Helen Rusk published.

1933 *Fun Traders Descending the Missouri* purchased by the Metropolitan Museum of New York.

1934 March 15–
April 15 Meyric R. Rogers arranged an exhibition of twenty paintings and eight engravings at the City Art Museum of St. Louis.

1935 January 30–
March 7 City Art Museum exhibition, with a few changes, shown at the Museum of Modern Art in New York.

1937–1939 C. B. Rollins published in the *Missouri Historical Review* 126 letters from Bingham to James S. Rollins.

1940 *George Caleb Bingham of Missouri* by Albert Christ-Janer published.

⋐ IV ⋑

Checklist of Works

A. GENRE, LANDSCAPE, HISTORICAL, AND FIGURE PAINTINGS

ALL MEASUREMENTS are in inches, height by breadth. Where possible, measurements are those recorded in the collections in which the picture is now found. Otherwise, they are set down as approximate (*ca.* 40 x 30). For lost pictures measurements are either those of the original exhibiting institution or they are from contemporary publications. With few exceptions, Bingham's paintings are oil on canvas or linen. Some are referred to as on wood; this means a wooden panel covered with linen or canvas. Titles are, when possible, those of the painter. Dates and locations of paintings are given in parentheses.

1. *Daniel Boone.* Sign painted for Dade's Tavern, Boonville, Missouri. Probably after J. O. Lewis's engraving after Harding's portrait. (*Ca.* 1830, location unknown.)

2, 3. Two landscapes "representing the bufaloe hunts of our western praries." Copies made in St. Louis for "a gentleman . . . taking them to Louisville." (1835, location unknown.)

4. *Western Boatman Ashore.* No. 237, Apollo Association Exhibition, New York, October, 1838. Title possibly should read *Boatmen.* (1838, location unknown.)

5. *Tam O'Shanter Approaching the Kirk.* On display in St. Louis, June, 1839. No. 96 ("Tam O'Shanter, from Burns"), National Academy of Design Exhibition, New York, April, 1840. There listed for sale. (1839, location unknown.)

6. *Group, Two Young Girls.* No. 88, National Academy of Design Exhibition, New York, April, 1840. (1840, location unknown.)

7. *Landscape.* No. 249, National Academy of Design Exhibition, New York, April, 1840. (1840, location unknown.)

8. *Tam O'Shanter.* No. 257, National Academy of Design Exhibition, New York, April, 1840. (1840, location unknown.)

9. *Pennsylvania Farmer.* No. 293, National Academy of Design Exhibition, New York, April, 1840. (1840, location unknown.)

10. *Sleeping Child.* No. 303, National Academy of Design Exhibition, New York, April, 1840. (1840, location unknown.)

11. *The Dull Story* (50 x 38). Ex coll.: Mrs. Wyan Nelson, Kansas City. (1840? Collection of Charles van Ravenswaay, St. Louis.)

12–15. Whig Political Banner. Four-sided, each section 72 x 72: (1) Portrait of General Harrison, (2) The Battle of the Thames, (3) A Log Cabin Boy at his Plough, and (4) A Western River Scene. Carried at the Missouri Whig convention, June, 1840. (1840, location unknown.)

16. *Ariadne* (28 x 36). After Durand's engraving after Vanderlyn's oil. (1841, location unknown.)

17. *Going to Market.* No. 166, National Academy of Design Exhibition, New York, April, 1842. There listed for sale. (1842, location unknown.)

18, 19. Whig Political Banner. Two-sided (84 x 96): (1) full-length portrait of Henry Clay making his "American System" speech, and (2) A Herd of Buffalo Rushing across a Prairie. Painted for Howard County delegation to Missouri Whig convention at Boonville, October, 1844. (1844, destroyed by fire.)

20, 21. Whig Political Banner. Two-sided (84 x 96): (1) The Plain Farmer of Ashland, and (2) An Eagle on an Immovable Rock. Painted for the Ashland Club of Boonville (Cooper County), Missouri Whig convention, Boonville, October, 1844. (1844, destroyed by fire.)

22, 23. Whig Political Banner. Two-sided, on linen: (1) A Mill Boy. Now known as *The Mill Boy* (37¼ x 46½), and (2) A scene showing a little fellow carving the name of Clay. Painted for the Boonville Juvenile Club, Missouri Whig convention, Boonville, October, 1844. (1844. *The Mill Boy* is in the collection of Mrs. Leslie Cowan, Columbia, Missouri; the location of the scene is unknown.)

24. *Fur Traders Descending the Missouri* (29¼ x 36¼). No. 93, American Art-Union, New York, December, 1845. Drawn by Robert S. Bunker, Mobile, Alabama. Acquired by Metropolitan Museum in 1933 from descendant of original owner. (1845, Metropolitan Museum of New York.)

25. *The Concealed Enemy* (29 x 36). No. 95, American Art-Union, New York, December, 1845. Drawn by James A. Hutchinson, Pittsburgh, Pennsylvania. Bequeathed (1945) by D. I. Bushnell, Jr., to Peabody Museum, Harvard University. (1845, Peabody Museum, Harvard University.)

26. *Cottage Scenery.* No. 98, American Art-Union, New York, December, 1845. Drawn by James D. Carhart, Macon, Georgia. (1845, location unknown.)

27. *Landscape.* No. 102, American Art-Union, New York, December,

1845. Drawn by James Thompson, 22 Dey Street, New York. (1845, location unknown.)

28. *Boatmen on the Missouri.* No. 14, American Art-Union, New York, December, 1846. Drawn by J. R. Macmurdo, New Orleans, Louisiana. (1846, location unknown. The illustration used in this volume is a copy of the original painting.)

29. *Interior.* Submitted to but not accepted by the American Art-Union, May, 1846. (1846, location unknown.)

30. *Landscape with Cattle.* No. 131, American Art-Union, New York, December, 1846. Drawn by Charles Wilkes, Washington, D. C. (1846, location unknown.)

31. *The Jolly Flatboatmen* (38 x 48½). Bought by American Art-Union, October 9, 1846, but held out of distribution because it was to be engraved. No. 1, American Art-Union, New York, December, 1847. Drawn by B. Van Schaick, New York. Acquired by William Pell, great-grandfather of present owner, about 1851. (1846, collection of Claiborne Pell, Washington, D. C.)

32. *Landscape with Cattle* (38 x 48). Raffled in St. Louis, September, 1846. Given to the City Art Museum, St. Louis, by Mrs. Chester Harding Krum, 1923. (1846, City Art Museum, St. Louis.)

33. *Lighter Relieving a Steamboat Aground* (29½ x 35⅕). Bought by James C. Yeatman of St. Louis, April, 1847. (1847, private collection.)

34. *Raftmen Playing Cards* (28 x 36). No. 91, American Art-Union, New York, December, 1847. Drawn by Edwin Croswell, Albany, New York. Acquired by present owner from Pittsfield Museum, 1934. (1847, City Art Museum, St. Louis.)

35. *The Stump Orator.* Completed in November, 1847. No. 226, National Academy of Design Exhibition, New York, April, 1848, for sale. No. 212, American Art-Union, New York, December, 1848. Drawn by William Duncan, Savannah, Georgia. (1847, location unknown.)

36. *Captured by Indians* (25 x 30). Signed and dated, lower right corner, "Geo. Bingham 1848." Exhibited as *The Captive* by Charles Derby of St. Louis, Fourth Annual Fair St. Louis Agricultural and Mechanical Association, 1859. Later known as *White Woman Stolen by Indians.* (1848, collection of Arthur C. Hoskins, St. Louis.)

37. *Woodyard on the Missouri* (25 x 30). No. 34, Western Art Union, Cincinnati, December, 1849. Drawn by Miss E. E. Reynolds, Lafayette, Indiana. (1849, location unknown.)

38. *Landscape Composition.* No. 153, Western Art Union, Cincinnati. Exhibited in June, 1849, as the property of Joseph Longworth. (1849, location unknown.)

39. *Feeding Time* (29 x 36). No. 14, Western Art Union, Cincinnati,

December, 1849. Drawn by Joseph M. Dana, Athens, Ohio. (1849, location unknown.)

40. *Cock and Hen* (14 x 16). No. 18, Western Art Union, Cincinnati, December, 1849. Drawn by H. M. Walker, Detroit. (1849, location unknown.)

41. *Landscape with Cattle* (29 x 36). No. 17, Western Art Union, Cincinnati, December, 1849. Drawn by William Chambers, New Orleans. (1849, location unknown.)

42. *Raftmen on the Ohio* (36 x 39). No. 196, American Art-Union, New York, December, 1849. Drawn by James Key, Florence, Alabama. (1849, location unknown.)

43. *Country Politician* (20 x 24). No. 151, Western Art Union, Cincinnati, June, 1849. No. 232, American Art-Union, New York, December, 1849. Drawn by John Boyd, Winsted, Connecticut. (1849, location unknown.)

44. *St. Louis Wharf* (25 x 30). No. 152, Western Art Union, Cincinnati, June, 1849. There entitled *St. Louis Landing*. No. 218, American Art-Union, New York, December, 1849. Drawn by S. Pell, New York. (1849, location unknown.)

45. *A Boatman* (16 x 20). No. 241, American Art-Union, New York, December, 1849. Drawn by "J.," Albany, New York. (1849, location unknown.)

46. *Watching the Cargo* (26 x 36). Signed on barrelhead: "G. C. Bingham 1849." No. 227, American Art-Union, New York, December, 1849. Drawn by Stephen E. Paine, New York. (1849, State Historical Society of Missouri.)

47. *Shooting for the Beef* (33½ x 49½). Signed, lower left, "G. C. Bingham 1850." No. 173, American Art-Union, New York, December, 1851. No. 221, American Art-Union auction, 1852. Bought by Isaac Townsend for $190.00. Ex coll.: Francis P. Garvan. (1850, Brooklyn Museum of Art.)

48. *The Squatters* (23 x 28). Signed, lower left, "G. C. Bingham 1850." No. 130, American Art-Union, New York, December, 1851. No. 162, American Art-Union auction, 1852. Bought by N. C. Hood for $85.00. (1850, private collection.)

49. *The Wood Boat* (25 x 30). No. 152, American Art-Union, New York, December, 1851. No. 352, American Art-Union auction, 1852. Bought by Mr. Herrick for $95.00. (1850, City Art Museum of St. Louis.)

50. *Landscape*. Described as "from nature" and bought by a St. Louis artist (perhaps Emanuel de França). Exhibited (donated for sale) by De França, No. 87, Mississippi Valley Sanitary Fair, St. Louis, 1864. (1850, location unknown.)

51. *Cattle and Landscape*. Described in *Missouri Republican* (October

11, 1850) as a "small gem, an agricultural scene, taken from nature." Offered to American Art-Union (November 19) for $50.00, but apparently declined and returned in February, 1851. (1850, location unknown.)

52. *The Checker Players* (25 x 30). No. 34, Fourth Annual Fair St. Louis Agricultural and Mechanical Association Exhibition, 1859; there titled *The Game of Draughts*. No. 192, Mississippi Valley Sanitary Fair Exhibition, 1864. Title: *Chequer Players;* owner: N. J. Eaton. (1850, Detroit Institute of Arts.)

53. *Cattle Piece* (26¼ x 36). No. 52, American Art-Union, New York, December, 1851. No. 41, American Art-Union auction, 1852. Bought by N. C. Hood for $60.00. (1850, location unknown.)

54. *Cattle Piece.* No. 12, Western Art Union, Cincinnati, January, 1851. Drawn by Dr. A. T. McClure, Cincinnati. (1850, location unknown.)

55. *Landscape.* No. 82, Western Art Union, Cincinnati, January, 1851. Drawn by Harvey Fowler, Indianapolis. (1850, location unknown.)

56. *Cattle at Daybreak—Stable Scene.* Also entitled: *Daybreak in the Stable.* No. 46, Philadelphia Art Union, on exhibition, January, 1851. Drawn by Joseph Weir, Philadelphia. (1850, location unknown.)

57. *Landscape and Cattle.* Not in Philadelphia Art Union exhibition lists, but entered in the *Philadelphia Art Union Reporter,* December, 1851, as selected by A. Coates, Philadelphia. (1850, location unknown.)

58. *Mississippi Boatman* (18 x 24). No. 51, Philadelphia Art Union, on exhibition January, 1851. Eventually presented by the artist to the Philadelphia Art Union and listed in its *Catalogue of Prizes to be Distributed on December 31, 1852.* Disposal unknown. (1850, location unknown.)

59. *In a Quandary* (17 x 21). Also titled: *Raftman Playing Cards, No. 2.* Signed and dated, lower left: "G. C. Bingham 1851." Ex coll.: Francis P. Garvan. (1851, collection of Paul Moore, Jr., Convent, N. J. On loan: Yale University Art Gallery.)

60. *Fishing on the Mississippi* (29 x 36). Sometimes called *Fishing on the Missouri.* Signed and dated, lower left: "G. C. Bingham 1851." No. 120, American Art-Union, New York, December, 1851. No. 53, American Art-Union auction, 1852. Bought by J. C. McGuire for $155.00. (1851, William Rockhill Nelson Gallery of Art.)

61. *The Emigration of Daniel Boone* (36½ x 50). Also known as *Daniel Boone Coming through Cumberland Gap.* Repainted (present state) late in 1852. Given to present owner by Nathaniel Phillips of Boston (formerly of St. Louis), 1890. (1851, Washington University. On loan: City Art Museum of St. Louis.)

62. *The Trappers' Return* (26¼ x 36¼). Signed on the canoe: "G. C. Bingham 1851." No. 660, American Art-Union, New York, December,

1851. No. 194, American Art-Union auction, 1852. Bought by H. Reed for $155.00. (1851, Detroit Institute of Arts.)

63. *Scene on the Ohio near Cincinnati.* Completed by close of October, 1851. Known only by wood-cut—See "List of Engravings," No. 4, below. (1851, location unknown.)

64. *Scene on the Ohio* (18 x 20). Signed and dated: "G. C. Bingham, 1851." Ex coll.: Mrs. Joseph McCoy, Kansas City; Miss Marie Collins, New York. (1851, State Historical Society of Missouri.)

65. *Canvassing for a Vote* (25⅛ x 30³⁄₁₆). Signed and dated, lower left: "G. C. Bingham 1852." Signature under original varnish. (1852, William Rockhill Nelson Gallery of Art.)

66. *Belated Wayfarers* (25 x 30). Signed and dated, lower right: "Geo. Bingham 1852." Exhibited as *In Camp* by Charles Derby of St. Louis, Fourth Annual Fair St. Louis Agricultural and Mechanical Association, 1859. Later known as *Emigrants Resting at Night.* (1852, collection of Arthur C. Hoskins, St. Louis.)

67. *County Election* (49 x 63). Exhibited over various titles: *The Election,* No. 7, Fourth Annual Exhibition, Washington Art Association, 1860; *The Election,* No. 273, Thirty-Seventh Annual Exhibition, Pennsylvania Academy of Fine Arts, 1860; *County Election,* No. 24, First Annual Exhibition Western Academy of Art, St. Louis, 1860; *Voting,* No. 40, Mercantile Library collections, 1862; *The Election,* No. 117, Mercantile Library, 1871; *The Country Election,* No. 340, Nineteenth St. Louis Fair and Exposition, 1879; *The Election,* No. 218, World's Columbian Exposition, 1893. Ex coll.: the Artist; St. Louis Mercantile Library. (1852, City Art Museum of St. Louis.)

68. *County Election—No. 2* (49 x 63). Completed by October 20, 1852 and sold to Robert J. Ward at New Orleans, 1853. Ex coll.: Robert J. Ward, —— Irvine, Mrs. Irvine, Charles J. Hemphill, James Hemphill (all of Kentucky), and C. R. Rollins, Columbia, Missouri. (1852, The Boatmen's National Bank of St. Louis.)

69. *View near Lake George* (29 x 36). No. 51, Works to be distributed January, 1857, Cosmopolitan Art Association. Drawn by Worcester Eaton, Lowell, Massachusetts. (1853–56? Location unknown.)

70. *Washington's Head-Quarters* (12 x 18). No. 129, Works to be distributed January, 1858, Cosmopolitan Art Association. Drawn by J. G. Burt, Jackson, Michigan, (1853–56? Location unknown.)

71. *Landscape: Morning.* No. 80, Wyman's Museum, St. Louis, 1857. (1853–56? Location unknown.)

72. *Landscape: Noon.* No. 69, Wyman's Museum, St. Louis, 1857. (1853–56? Location unknown.)

73. *Mountain Lake.* No. 88, Mississippi Valley Sanitary Fair Exhibition,

St. Louis, 1864. Owned by the artist and donated for sale. (1853–56? Location unknown.)

74. *Landscape.* No. 77, Mississippi Valley Sanitary Fair Exhibition, St. Louis, 1864. Owned by Mr. Oglesby and donated for sale (1853–56? Location unknown.)

75. *The Storm* (25 x 30). Ex coll.: Meyric R. Rogers; Henry E. Schnakenberg. (1853–56? Wadsworth Athenaeum.)

76. *View of a Lake in the Mountains* (21 x 30). Signed on rock, lower left: "G. C. Bingham." (1853–56? Harry Shaw Newman Gallery, New York.)

77. *Mountain Gorge* (24½ x 29½). Ex coll.: Hugh Campbell, St. Louis. (1853–56? Collection of William A. Hughes, Newark.)

78. *Mountain Scene with Fisherman* (31 x 36). Ex coll.: Charles H. Peck; Mrs. Rebecca Peck Dusenberry. (1853–56? Missouri Historical Society.)

79. *Mountain Scene with Deer* (31 x 36). Ex coll.: Charles H. Peck; Mrs. Rebecca Peck Dusenberry. (1853–56? Missouri Historical Society.)

80. *Stump Speaking* (42½ x 58). Exhibited over various titles: *Stump Speaking,* No. 6, Fourth Annual Exhibition, Washington Art Association, 1860; *Before the Election,* No. 246, Thirty-Seventh Annual Exhibition, Pennsylvania Academy of Fine Arts, 1860; *Stump Speaking,* No. 348, First Annual Exhibition Western Academy of Art, St. Louis, 1860; *Stump Speaking,* No. 39, Mercantile Library collections, 1862; *Stump Speaking,* No. 116, Mercantile Library collections, 1871; *The Stump Speech,* No. 339, Nineteenth St. Louis Fair and Exposition, 1879; *The Stump Speech,* No. 209, World's Columbian Exposition, 1893. Ex coll.: the Artist; St. Louis Mercantile Library. (1854, The Boatmen's National Bank of St. Louis.)

81. *Raftmen by Night* (24 x 30). Signed and dated, lower left: "G. C. Bingham 1854." Ex coll.: Warnolts family, Brooklyn, New York. (1854, James Graham and Sons Gallery, New York.)

82. *Flatboatmen by Night* (29 x 36). Signed and dated, lower left: "G. C. Bingham 1854." Ex coll.: Col. J. L. D. Morrison, St. Louis; Charles Holmes after 1866; Alfred Clifford after 1885; Safron Gallery, New York, 1944. (1854, M. and M. Karolik Collection, Museum of Fine Arts, Boston.)

83. *The Verdict of the People* (46 x 65). Exhibited over various titles: *Result of the Election,* No. 8, Fourth Annual Exhibition, Washington Art Association, 1860; *After the Election,* No. 330, Thirty-Seventh Annual Exhibition, Pennsylvania Academy of Fine Arts, 1860; *Election Returns,* No. 253, First Annual Exhibition, Western Academy of Art, St. Louis, 1860; *Annunciation of the Vote,* No. 41, Mercantile Library collections, 1862; *Annunciation of the Vote,* No. 118, Mer-

cantile Library collections, 1871. *Announcement of the Vote,* No. 341, Nineteenth St. Louis Fair and Exposition, 1879; *Election Returns,* No. 220, World's Columbian Exposition, 1893. Ex coll.: the Artist; St. Louis Mercantile Library. (1855, The Boatmen's National Bank of St. Louis.)

84. *The First Lesson in Music.* No. 167, Thirty-Fourth Annual Exhibition, Pennsylvania Academy of Fine Arts, 1857, E. P. Mitchell, owner. (1856? Location unknown.)

85. *Old Field Horse* (13 x 15). In 1867, owned by J. C. McGuire, Washington, Ex coll.: Max Safron. (Before 1857? City Art Museum of St. Louis.)

86. *The Jolly Flatboatmen in Port* (46¼ x 69). Exhibited over various titles: *The Jolly Flat-boatmen,* No. 9, Fourth Annual Exhibition, Washington Art Association, 1860; *The Jolly Flat-Boat-Men in Port,* No. 141, Thirty-Seventh Annual Exhibition, Pennsylvania Academy of Fine Arts, 1860; *Flatboatmen in Port,* No. 12, First Annual Exhibition, Western Academy of Art, St. Louis, 1860; *Jolly Flat-boatmen,* No. 42, Mercantile Library collections, 1862; *Jolly Flat-boatmen,* No. 119, Mercantile Library collections, 1871; *Jolly Flatboatmen,* No. 329, Nineteenth St. Louis Fair and Exposition, 1879; *Jolly Flatboatmen in Port,* No. 206, World's Columbian Exposition, 1893. (1857, City Art Museum of St. Louis.)

87. *Moonlight Scene* (14 x 20). Ex coll.: Mrs. J. M. Piper, Kansas City; R. S. Thomas, Blue Springs, Missouri. (1857–58? Collection of W. Howard Adams.)

88. *The Thread of Life* (26 x 22). (1862? Collection of A. J. Stephens, Kansas City.)

89. *General Nathaniel Lyon and General Frank Blair Starting from the Arsenal Gate in St. Louis to Capture Camp Jackson* (*ca.* 28 x 26). Ex coll.: G. B. Rollins, Columbia. (1862? Collection of Mrs. Frank Rollins, Columbia, Missouri.)

90. *General Nathaniel Lyon at the Battle of Wilson's Creek* (oil study for). (1865, location unknown.)

91. *Major Dean in Jail* (14 x 14). Ex coll.: W. E. Thomas, Kansas City. (1866, William Jewell College Library, Liberty, Missouri.)

92. *General Nathaniel Lyon at the Battle of Wilson's Creek.* (1867, destroyed by fire, Missouri state capitol, 1911.)

93. *Order No. 11* (54⅞ x 78). Successively entitled: *Civil War, Martial Law,* and *Order No. 11.* Ex coll.: James S. Rollins, Columbia, Missouri. (1868, State Historical Society of Missouri.)

94. *Order No. 11—No. 2* (55 x 77½). Appraised in Bingham's estate, 1879, at $250.00. Bought in 1893 sale by J. W. S. Peters of Kansas City for $675.00. (1870, Cincinnati Art Museum.)

95. *Order No. 11—No. 3* (18 x 24). In 1917, owned by R. W. Thomas, Kansas City, Missouri. (1870? Location unknown.)

96. *The Flatboatman.* Known only from its entry as No. 36 in the St. Louis Mercantile Library Exhibition of Paintings, October, 1871, James E. Yeatman, owner. (Before 1871? Location unknown.)

97. *Washington Crossing the Delaware* (*ca.* 38 x 59). (1872, collection of Thomas S. Mastin, Kansas City.)

98. *View of Pike's Peak* (*ca.* 42 x 60). Bought in 1893 sale by R. Saunders. In 1917, owned by Findlay Gallery, Kansas City. (1872, location unknown.)

99. *View of Pike's Peak* (30 x 48). Ex coll.: R. S. Thomas, Kansas City. (1872, collection of W. Howard Adams, Kansas City.) On view: William Rockhill Nelson Gallery of Art.

100. *Moonlight Scene on the Gasconade.* Bought by R. Saunders, 1893; owned in 1917 by R. W. Thomas, Kansas City. (1872? Location unknown.)

101. *Landscape with Cliffs* (22 x 26). (1872? 1878? McCaughen-Burr Gallery, St. Louis.)

102. *Indian Encampment.* Ex coll.: Mrs. J. M. Piper, Kansas City; Mrs. John Keiser, Bunceton, Missouri; Charles van Ravenswaay, Boonville, Missouri; Safron Gallery, St. Louis. (1872? 1878? Gilcrease Institute of American History and Art, Tulsa, Oklahoma?)

103. *Scene in Colorado.* (1872? 1878? Collection of Mrs. George Duggins, Colorado Springs, Colorado.)

104. *"Forest Hill"—The Nelson Homestead near Boonville* (*ca.* 24 x 30). Sometimes mistakenly titled *The Birch Homestead.* (1877, collection of Mrs. Fulton Stephens, Esparto, California.)

105. *The Palm Leaf Shade* (*ca.* 29 x 25). Ex coll.: J. W. S. Peters, Kansas City; L. M. Miller, Kansas City. (1878, collection of Mrs. Crawford James and Mrs. Wallace Trumbull, Kansas City.)

106. *The Jolly Flatboatmen—No. 2* (*ca.* 28 x 38). (1878, collection of Thomas S. Mastin, Kansas City.)

107. *The Verdict of the People—No. 2* (22⅞ x 30⁵⁄₁₆). Also known as *The Result of the Election.* Ex coll.: J. W. S. Peters, Kansas City. (1878, collection of Richard W. Norton, Jr., Shreveport, Louisiana. On view National Gallery of Art, Washington, D. C.)

108. *Mountain Landscape.* (1878, location unknown.)

109. *Little Red Riding Hood* (*ca.* 52 x 40). (1878–79, collection of Miss Eulalie Hockaday Bartlett, Kansas City.)

110. *The Puzzled Witness* (*ca.* 23 x 28). (1879, private collection.)

111. *A Winter Scene.* Also known as *Winter Scenery.* (1879, location unknown.)

112. *The Pleague of Darkness.* Not finished. Valued in estate at $5.00 (1879.) (1879, location unknown.)
113. *Musidora about to Take a Bath.* Appraised at $100.00 in Bingham estate (1879): bought by J. N. Goodwin, Kansas City, for $45.00 (1893). Date of painting not known. (1841? 1879? location unknown.)
114. *Feeding the Cows.* Bought by Fred C. Hey, Kansas City (1893) for $30.00. (? Location unknown.)
115. *Landscape.* Bought by Fred C. Hey, Kansas City (1893) for $33.50. (? Location unknown.)
116. *Flock of Turkeys.* Offered at 1893 sale, but no report of sale. (? Location unknown.)
117. *Bunch of Letters.* Offered at 1893 sale, but no report of sale. (? Location unknown.)

The following pictures are said to have been painted by Bingham but supporting contemporary documentation for them has not been found.

118. *Girl at Prayer.* Mentioned by Rollins Bingham (Rusk, 126).
119. *The Horse Race.* Rusk (27, n. 3) cited N. T. Gentry for existence of a drawing "the present location of which is not known, representing a horse race with all its attendant scenes very cleverly portrayed. . . . We do not know whether the subject of the horse race was ever worked out in a painting by Bingham." This was obviously a subject well within the interest of Bingham.
120. *The Horse Thief.* Rusk (126) cited Matt Hastings, St. Louis artist and friend of Bingham, as source for a picture of this title. May Simonds ("A Pioneer Painter," 76) wrote: "The 'Horse-thief' excited much attention in Boston." The subject sounds out of character for Bingham.
121. *Lumbermen Dining.* Rusk (47–48) reported that a picture of this title was referred to in the *St. Louis Republican* of November 27 and 28, 1847. These references I have not been able to find.
122. *The Wilmot Proviso.* Probably the same picture as *Country Politician* though May Simonds' description (quoted in Chapter II, Section 8, note 13 above) does not coincide with those of the *Missouri Republican* and the American Art-Union catalogue.

B. PORTRAITS

This list of portraits is intended to be useful, not definitive. Bingham must have painted, at the very least, one thousand portraits. He spent six months at Natchez and six months at Petersburg, Virginia, busily employed, but no likenesses from either place have been reported. The three

years in Washington, D. C., must have resulted in far more heads than are here listed. So, too, for the several lengthy periods of work in St. Louis.

When I have known the pose of the figure, I have stated it. The early portraits can be assumed busts commonly 30 x 25 inches, although as early as 1837 we find the painter varying both pose and size of canvas. Since measurements have come from many sources, they are often approximate. With rare exceptions the portraits are oil on canvas; occasionally one is reported on wood. Very few are signed.

To make this working list as inclusive as possible, I have corresponded with many persons reported to own Binghams and have also checked holdings in public museums. With my findings I have combined subjects listed by Dr. Rusk in 1917. By the use of superior numbers I distinguish between portraits I have seen;[1] portraits reported to me by owners, but not seen by me;[2] portraits seen by Dr. Rusk, but not by me;[3] portraits reported to Dr. Rusk, but not seen by her;[4] portraits mentioned in contemporary documents or publications.[5] Locations are the latest known; the year 1917 in brackets refers to the Rusk monograph. Dates and locations of paintings are given in parentheses.

1. *David Todd.*[5] Listed by Rusk, 18–19, 118, as 1830–33. Given by George W. Samuel of St. Joseph, Missouri, to the University of Missouri, December 22, 1879 (*Missouri Statesman*, January 16, 1880). (1833? Destroyed, University of Missouri fire, 1892).

2. *Mrs. William Johnston.*[3] On wood. Listed by Rusk, 19, as 1830–33. (1833? Dr. J. T. M. Johnston, Kansas City [1917].)

3. *Washington Adams.*[5] In subject's possession, 1882 ("Letters of George Caleb Bingham, XXXIII, 207n.) (1833? Location unknown.)

4. *Henry Miller.*[5] Listed by Rusk, 118, as about 1830. (1833? Location unknown.)

5. *Dr. John Sappington.*[1] (27 x 21¾). The date 1834 and the subject's age (59) appear on face of canvas. (1834, Daughters of the American Revolution Museum, Arrow Rock Tavern, Arrow Rock, Missouri.)

6. *Mrs. John Sappington*[1] (27 x 21¾). Nee Jane Breathitt. The date 1834 and the subject's age (51) appear on face of canvas. (1834, Daughters of the American Revolution Museum, Arrow Rock Tavern, Arrow Rock, Missouri.)

7. *Caleb S. Stone.*[4] Rusk, 19, 118. (1834, Mrs. E. H. Fudge, Chicago [1917].)

8. *James S. Rollins*[1] (28 x 23). Rusk, 19, 118. Ex coll.: James S. Rollins, C. B. Rollins. (1834, C. B. Rollins Estate, Columbia, Missouri.)

9. *Warren Woodson.*[1] Rusk, 19, 118. Ex coll.: Dr. Woodson Moss, Columbia, Missouri. Now framed oval. (1834, Mrs. Mary Stephens Gray, St. Louis.)

10. *Josiah W. Wilson.*[3] Rusk, 19, 118. (1834, Mrs. J. W. Stone, Columbia, Missouri [1917].)

11. *Meredith M. Marmaduke.*[1] Dated on face of canvas. (1834, Missouri Historical Society, St. Louis.)

12. *Matthias McGirk.*[5] Exhibited in St. Louis, March, 1835. (1834–35, location unknown.)

13. *Joshua Belden*[1] (*ca.* 30 x 25). (1834–35, Mrs. Belden Taylor Graves, Clayton, Missouri.)

14. *Mrs. Joshua Belden*[2] (*ca.* 30 x 25). Nee Agnes Elizabeth Lewis. (1834–35, Mrs. Belden Taylor Graves, Clayton, Missouri.)

15. *Self-Portrait*[1] (28 x 22½). Ex coll.: James S. Rollins, G. B. Rollins. (1835, City Art Museum of St. Louis.)

16. *John Thornton.*[1] At age 48. Signed and dated on back of stretcher. (1835, Mrs. Charles P. Hough, Jr., Kansas City. On exhibition: William Rockhill Nelson Gallery.)

17. *Shubael Allen.*[2] Painted at Liberty, Missouri. (1835, Mrs. Charles F. Kornbrodt, Kansas City [1946].)

18. *Mrs. Shubael Allen.*[2] Nee Dinah Ayres Trigg. Painted at Liberty, Missouri. (1835, Mrs. Charles F. Kornbrodt, Kansas City [1946].)

19. *Oliver Perry Moss.*[1] Age 21. Painted at Liberty, Missouri. (1835, Mrs. Mary Stephens Gray, St. Louis.)

20. *Fanny Kemble.*[5] Painted from the engraving after Sully in *The Gift for 1835*. In the estate of William P. Clark, St. Louis, 1840, valued at $5.00. (1835, location unknown.)

21. *Jacob Wyan*[2] (30 x 26). Framed oval. According to Charles van Ravenswaay, Bingham painted four or five pairs of the Wyan portraits at about the same time. One pair is owned by Charles W. Leonard of Ravenswood, Cooper County, Missouri. (1835–38, Mrs. W. L. Harlan, Boonville, Missouri.)

22. *Mrs. Jacob Wyan*[2] (30 x 26). Framed oval. (1835–38, Mrs. W. L. Harlan, Boonville, Missouri.)

23. *General W. H. Crowther.*[4] Rusk, 118. (Before 1837, Mrs. Sue Ewing, Stockton, Kansas [1917].)

24. *Mrs. W. H. Crowther.*[4] (Before 1837, Mrs. Sue Ewing, Stockton, Kansas [1917].)

25. *Sergeant S. Prentiss.*[5] Recorded by Rollins, "Recollections," 468. (1837, Mississippi Hall of Fame, Jackson, Mississippi.)

26. *James S. Rollins*[1] (28 x 22). In wedding clothes. (1837, Mrs. Curtis F. Burnam, Baltimore, Maryland.)

27. *Mrs. James S. Rollins*[2] (28 x 22). In wedding clothes. (1837, Mrs. Curtis F. Burnam, Baltimore, Maryland.)

28. *Dr. Anthony W. Rollins*[2] (28 x 22). (1837, Mrs. James Lackey, Richmond, Kentucky.

29. *Mrs. Anthony W. Rollins*[1] (29 x 24). (1837, C. B. Rollins Estate, Columbia, Missouri.)

30. *Mrs. Anthony W. Rollins*[2] (30 x 24). (1837, Mrs. E. A. MacLeod, Columbia, Missouri.)

31. *Sarah Helen Rollins*[2] (45 x 28). Daughter of Dr. and Mrs. A. W. Rollins. Painted at age 12. (1837, Rollins Burnam, Radford, Virginia.)

32. *Henry Lewis*[1] (29 x 22). Painted at Glasgow, Missouri. (1837, Mrs. Richard Hawes, St. Louis.)

33. *Mrs. Henry Lewis*[1] (29 x 22). Painted at Glasgow, Missouri. Nee Elizabeth Morton Woodson. (1837, Mrs. Richard Hawes, St. Louis.)

34. *Richard Gentry*[1] (*ca.* 30 x 25). Painted at Columbia, prior to his departure for the Seminole War. (1837, Estate of William R. Gentry, St. Louis.)

35. *Roger North Todd*[1] (*ca.* 29 x 26). Painted at Columbia, Missouri. Ex coll.: North Todd Gentry. (1837, William R. Gentry, Jr., St. Louis.)

36. *William McClanahan Irvine.*[2] Painted at age 14. (1837, "Irvington," Richmond, Kentucky.)

37. *Thomas Miller*[1] (2¾ x 2). Bingham's only miniature, Rusk, 24. (1837, Mrs. W. D. A. Westfall, Columbia, Missouri.)

38. *Josiah Lamme.*[3] Rusk, 23, 119. (1837, C. B. Rollins Estate, Columbia, Missouri.)

39. *Mrs. David Steele Lamme (nee Sophia Woodson) and her son Wirt Lamme.*[1] Incorrectly identified as Mrs. Josiah Lamme in Rusk, owner reports. (1837, C. B. Rollins Estate, Columbia, Missouri.)

40. *Samuel Bullitt Churchill*[2] (34½ x 26½). Painted in St. Louis. (1837, Mrs. Roland Whitney, Louisville.)

41. *Mrs. Robert Aull*[2] (26½ x 22½). Nee Matilda Donohue; d. 1838. Painted at Glasgow, Missouri. (1837? Walter Henderson, Jr., Glasgow, Missouri.)

42. *Thomas E. Birch.*[2] Painted at Fayette, Missouri. (1838–39, George H. Whitney, Upland, California.)

43. *Lewis Bumgardner.*[5] Painted at Fayette, Missouri. (1839–39, location unknown.)

44. *Mrs. Lewis Bumgardner.*[5] Nee Betty Haldstead. Painted at Fayette, Missouri. (1838–39, location unknown.)

45. *Samuel C. Grove.*[5] Painted at Fayette, Missouri. (1838–39, David Kunkle, Craigsville, Virginia [1899].)

46. *David Kunkle.*[5] Painted at Fayette, Missouri. (1838–39, David Kunkle, Craigsville, Virginia [1899].)

47. *Mrs. David Kunkle.*[5] Nee Sarah Ann Cooper. Painted at Fayette, Missouri. (1838–39, David Kunkle, Craigsville, Virginia [1899].)

48. *Mrs. Thomas Shackelford*[2] (35½ x 29½). Nee Eliza Pulliam. Dated on

card in hand of sitter January 1, 1839. (1838–39, Mrs. George S. Shackelford, Kansas City.)

49. *Elijah R. Pulliam*[2] (*ca.* 30 x 25). (1838–39, R. B. Snow, Ferguson, Missouri—believed destroyed.)

50. *Martha J. Shackelford.*[4] Dated by Rusk, 119, about 1839. (1838–39, Mrs. C. C. Hemenway, Glasgow, Missouri [1917].)

51. *Mrs. John Harrison.*[4] Dated by Rusk, 119, about 1839. (1838–39, Mrs. C. C. Hemenway, Glasgow, Missouri [1917].)

52. *Captain John F. Nicolds.*[4] Rusk, 119. (1838–39, Mrs. A. A. Brown, Gazelle, California [1917].)

53. *Mrs. John F. (Elizabeth M.) Nicolds.*[4] Rusk, 119. (1838–39, Mrs. A. A. Brown, Gazelle, California [1917].)

54. *Thomas Lawson Price.*[2] First mayor of Jefferson City. (1839, Thomas Price Gibson, San Francisco. On exhibition: Cole County Historical Society.)

55. *Sallie Buckner.*[5] (1839, location unknown.)

56. *John H. Turner.*[4] Rusk, 119. (1839–40, John H. Turner, Glasgow, Missouri [1917].)

57. *Dr. Tamnel T. Crews.*[4] Rusk, 119. (1839–40, Mrs. Margaret W. Ferguson, Fayette, Missouri [1917].)

58. *Mrs. T. T. Crews.*[4] Nee Elizabeth Ward. Rusk, 119. (1839–40, Mrs. Margaret W. Ferguson, Fayette, Missouri [1917].)

59. *Mrs. William Ward.*[4] Rusk, 119, 1839–40, Mrs. Margaret W. Ferguson, Fayette, Missouri [1917].)

60. *Pleasant Cayce.*[2] Died 1840. (1839–40, Milton Pleasant Cayce, Jr., Farmington, Missouri.)

61. *Marbel Camden*[1] (38 x 30). Seated half-length. Painted at St. Louis. (1840, Miss Eleanor McKinley Case, Ferguson, Missouri.)

62. *Sallie Ann Camden*[1] (38 x 32). Painted at age of 6. Full-length, seated, outdoors, St. Louis. (1840, Miss Eleanor McKinley Case, Ferguson, Missouri.)

63. *Peter G. Camden*[1] (38 x 32). Half-length, seated, posed with copy of *Daily Pennant* in lap, St. Louis. (1840, Mrs. Calvin Case, St. Louis.)

64. *Richard Henry Robinson.*[2] (1840? Mrs. W. R. Patterson, Lexington, Kentucky.)

65. *Thomas W. Nelson*[2] (29 x 24). (1840, George Bingham Birch, Teaneck, New Jersey. On loan to Department of Art, State University of Iowa.)

66. *Mrs. Thomas W. Nelson*[2] (29 x 24). Nee Mary Gay Wyan. (1840, George Bingham Birch, Teaneck, New Jersey. On loan to Department of Art, State University of Iowa.)

67. *William B. Sappington.*[4] Listed by Rusk as about 1842 but unless

painted in Washington this date impossible; probable date 1840 or 1845. (1840? Mrs. J. C. Sappington, Boonville, Missouri [1917].)

68. *Mrs. William B. Sappington.*[4] Listed by Rusk as about 1842 but unless painted in Washington this date impossible; probable date 1840 or 1845. (1840? Mrs. J. C. Sappington, Boonville, Missouri [1917].)

69. *Elizabeth Hutchison Bingham and her son Newton.*[2] (1840–41, Mrs. W. P. Bowdry, Fort Worth, Texas.)

70. *John Howard Payne*[3] (9 x 7). Bingham's only known water color (Rusk 30, 120). (1841–42, Mrs. J. V. C. Karnes, Kansas City [1917].)

71. *Elizabeth Hutchison Bingham.*[2] Full-length, standing portrait, of which only the head remains. (1842, Mrs. W. P. Bowdry, Fort Worth, Texas.)

72. *George Tompkins.*[5] Judge of Missouri Supreme Court. (1842, location unknown.)

73. *Mrs. John Shaw and Miss Elizabeth Robertson (or Robison).*[5] Painted on one canvas. Mrs. Shaw was born Jane Hood of Boonville. (1842, location unknown.)

74. *Daniel Webster*[1] (32 x 28). (1842–44, Thomas Gilcrease Institute of American History and Art, Tulsa.)

75. *Charles Anderson Wickliffe.*[5] Postmaster-general under Tyler. Mezzotinted by Sartain. (1843, location unknown.)

76–78. Three portraits of the Wright family, painted in Philadelphia (Mrs. Wright, an aunt of Jane Shaw, No. 73).[5] (1843, location unknown.)

79. Portraits painted for Mrs. Brawner, boardinghouse proprietor of Washington, to the "full amount" of board for three months.[5] (1843, location unknown.)

80. *Robert Tyler.*[5] (1844, location unknown.)

81. *Henry A. Wise.*[5] (1844, location unknown.)

82. *Horace Bingham*[2] (*ca.* 30 x 25). Asleep in chair. (1844, Mrs. Bingham King, Stephenville, Texas.)

83. *John Quincy Adams*[1] (10 x 7½). On walnut panel. Ex coll.: James S. Rollins, C. B. Rollins. (1844, James Sidney Rollins, Columbia, Missouri.)

84. *John Cummings Edwards*[1] (40 x 34½). Ex coll.: Mrs. Warren V. Patton, great-niece. (1844, Missouri Historical Society, St. Louis.)

85. *Bela M. Hughes.*[5] (1844, location unknown.)

86. *David Rice Atchison.*[5] (1845, location unknown.)

87. *John Quincy Adams*[1] (29⅜ x 24½). (1845, Mrs. W. D. A. Westfall, Columbia, Missouri.)

88. *Charles Harper Smith*[2] (*ca.* 36 x 36). Painted at Boonville, Missouri. (1845, Ed. S. Carroll, Independence, Missouri.)

89. *Mrs. Charles Harper Smith*[2] (*ca.* 36 x 36). Painted at Boonville, Missouri. (1845, Ed. S. Carroll, Independence, Missouri.)

90. *William Franklin Switzler.*[1] Painted at Columbia, Missouri. Ex coll.: Mrs. Charles Collins, St. Louis. (1845? Missouri Historical Society, St. Louis.)

91. *Mrs. William Franklin Switzler.*[1] Nee Mary Jane Royall. Painted at Columbia, Missouri. (1845? Mrs. Charles Collins, St. Louis, Missouri.)

92. *Erasmus D. Sappington.*[2] (1845? L. M. Nelson, Pueblo, Colorado.)

93. *Mrs. Erasmus D. Sappington.*[2] Nee Penelope C. Breathett. (1845? L. M. Nelson, Pueblo, Colorado.)

94. *Oscar F. Potter*[1] (30 x 25). (1848, City Art Museum, St. Louis.)

95. *Dr. William Jewell.*[5] Study for a full-length portrait. Willed to his grandson, 1852. (1849, location unknown.)

96. *Dr. William Jewell.*[2,5] Full-length, life-size portrait bequeathed, 1852, to William Jewell College. Much damaged in a fire many years ago and restored. How much of Bingham's work remains is uncertain. (1849, William Jewell College, Liberty, Missouri.)

97. *Captain Sinclair Kirtley.* Rusk, 127. Kirtley left Missouri for California in 1850. (1849? Location unknown.)

98. *John H. Lathrop.*[2] President of the University of Missouri. Portrait given by "the ladies of Columbia" in December, 1850. (1850, destroyed in University of Missouri fire, 1892.)

99. *Captain William Johnston.*[3] Rusk, 122. (1850, Dr. J. T. M. Johnston, Kansas City [1917].)

100. *John Quincy Adams*[1] (10 x 7⅞). (1850, Detroit Institute of Arts.)

101. *Mrs. Isaac Lionberger*[2] (*ca.* 30 x 25). (*Ca.* 1850, Charles van Ravenswaay, Boonville, Missouri.)

102. *Mrs. John R. Richardson*[2] (*ca.* 30 x 25). (*Ca.* 1850, Charles van Ravenswaay, Boonville, Missouri.)

103. *Moss Prewitt*[2] (*ca.* 30 x 25). (*Ca.* 1850, Charles van Ravenswaay, Boonville, Missouri.)

104. *Mrs. Moss Prewitt*[2] (*ca.* 30 x 25). (*Ca.* 1850, Charles van Ravenswaay, Boonville, Missouri.)

105. *Thomas Hart Benton.*[1] Exhibited in loan exhibition held at Mary Institute, 1879, then the property of Mrs. Frank P. Blair (Junior?). (*Ca.* 1850, Missouri Historical Society, St. Louis.)

106. *David McClanahan Hickman*[2] (30 x 25). (*Ca.* 1850, Mrs. James H. Guitar, Columbia, Missouri.)

107. *Mrs. David McClanahan Hickman.*[2] Nee Cornelia Ann Bryan. (*Ca.* 1850, Mrs. James H. Guitar, Columbia, Missouri.)

108. *Sarah Ann Hickman*[2] (41 x 30). Married Archibald Young, 1856. (*Ca.* 1850, Mrs. James H. Guitar, Columbia, Missouri.)

109. *Dr. J. B. Thomas.*[3] Rusk, 122. (Mrs. E. Hutchison, Independence, Missouri [1917].)

110. *Sallie Cochran McGraw*[1] (29½ x 23¾). (1852? Mrs. Frederic James, Kansas City. On loan: William Rockhill Nelson Gallery.)

111. *Mrs. John Darby*[1] (38 x 32). (*Ca.* 1852, Missouri Historical Society, St. Louis.)

112. *Mrs. Charles D. Drake*[1] (30 x 24). Nee Margaret Cross. Married Drake, 1843. (*Ca.* 1852, Missouri Historical Society, St. Louis.)

113. *Sallie Thomas.*[2] At the age of 18. Sister of Eliza Thomas Bingham. Ex coll.: Mrs. H. Smith, Prairie Home, Missouri (Rusk, 122). (*Ca.* 1853, Mrs. Thomas B. Hall, Kansas City. On loan: William Rockhill Nelson Gallery.)

114. *Reverend Robert S. Thomas.*[2] Presented to William Jewell College, 1945, by Miss Mayme Thomas. Father of Eliza Thomas Bingham. (*Ca.* 1853–55, William Jewell College, Liberty, Missouri.)

115. *Mrs. Robert S. Thomas.*[2] Mother of Eliza Thomas Bingham. (*Ca.* 1853–55, William Jewell College, Liberty, Missouri.)

116. *Locke Hardeman.*[4] Rusk, 122. (*Ca.* 1856, G. H. Hardeman, Gray's Summit, Missouri [1917].)

117. *George Washington*[1] (*Ca.* 32 x 27). Head. After Gilbert Stuart's portrait in Boston Athenaeum. (1856, St. Louis Mercantile Library.)

118. *Martha Washington*[1] (*Ca.* 32 x 27). Head. After Gilbert Stuart's portrait in Boston Athenaeum. (1856, St. Louis Mercantile Library.)

119–24. Six copies of the copies of George and Martha Washington.[5] (1856, location unknown.)

125. *Thomas Jefferson*[1] (25 x 19). Head. After Gilbert Stuart's portrait. (1856, State Historical Society of Missouri, Columbia, Missouri.)

126. *George Washington.*[5] Small study for a full-length portrait. (1856, location unknown.)

127. *George Washington.*[5] Over-life-size, full-length. (1858, destroyed in state capitol fire, 1911.)

128. *Thomas Jefferson.*[5] Over-life-size, full-length. (1858, destroyed in state capitol fire, 1911.)

129. *Mrs. Katherine Stith Jones.*[2] Mother of Mrs. William D. Swinney. Died 1858. (Before 1859, Mrs. W. E. Rossiter, Kansas City.)

130. *William Daniel Swinney.*[2] Painted in Glasgow, Missouri. (Before 1859, Mrs. W. E. Rossiter, Kansas City).

131. *Mrs. William Daniel Swinney.*[2] Painted in Glasgow, Missouri. Nee Lucy A. Jones. (Before 1859, Mrs. W. E. Rossiter, Kansas City.)

132. *Anne and William Daniel Swinney, Jr.* Grandchildren of Mr. and Mrs. William Daniel Swinney. Painted in Glasgow. Double portrait, framed oval. (Before 1859, Mrs. W. E. Rossiter, Kansas City.)

133. *Benoist Troost*[1] (40½ x 29⅝). (1859, William Rockhill Nelson Gallery of Art.)

134. *Mrs. Benoist Troost*[1] (40⅜ x 29⅝). (1859, William Rockhill Nelson Gallery of Art.)

135. *Andrew Jackson.*[5] Head. After portrait by Thomas Sully. (1859, location unknown.)

136. *Elijah S. Stephens*[2] (*ca.* 32 x 26). Painted at Columbia, Missouri. Ex coll.: Mrs. Anna Hockaday Smith; E. W. Stephens (Rusk, 71, 123). (1859, E. Sydney Stephens, Columbia, Missouri).

137. *Mrs. Elijah S. Stephens*[2] (*ca.* 32 x 26). Painted at Columbia, Missouri. Ex coll.: Mrs. Anna Hockaday Smith, E. W. Stephens (Rusk, 71, 123). (1859, E. Sydney Stephens, Columbia, Missouri.)

138. *Isaac Hockaday.*[1] (1859? Miss Elizabeth H. Rice, Washington, D. C.)

139. *Mrs. Isaac Hockaday* (*nee Susan Howard*) *and her Daughter Susan.*[1] (1859? Miss Elizabeth H. Rice, Washington, D. C.)

140. *James B. Howard.*[1] (1859? Miss Elizabeth H. Rice, Washington, D. C.)

141. *Mrs. James B. Howard.*[1] (1859? Miss Elizabeth H. Rice, Washington, D.C.)

142. *James S. Gordon.*[3] (*Ca.* 1859, Frederick Gordon, Columbia, Missouri. [1917].)

143. *Annie Allen.*[4] Portrait of a child (Rusk, 123). (*Ca.* 1859, Miss Helen M. Long, Kansas City [1917].)

144. *Mrs. Robert L. Todd and Daughter.*[3] Rusk 73, 123. (1860, Mrs. J. C. Whitten, Columbia, Missouri [1917].)

145. *Eliza Thomas Bingham*[1] (38 x 30). Ex coll.: Mrs. E. Hutchison, Independence, Missouri. (1860, Mrs. Arthur Palmer, Independence, Missouri.)

146. *Baron von Humboldt*[5] (*ca.* 96 x 72). Ex coll.: St. Louis Mercantile Library. Head (13 x 12) given by Mrs. W. D. A. Westfall, 1952, to State Historical Society of Missouri. (1860, State Historical Society of Missouri, Columbia, Missouri [head only].)

147. *Andrew Jackson.*[5] Equestrian portrait, life-size. (1860, destroyed in state capitol fire, 1911.)

148. *Henry Clay.*[5] Full-length, life-size. (1860, destroyed in state capitol fire, 1911.)

149. *Samuel L. Sawyer.*[4] Rusk, 123. (*Ca.* 1860, Mrs. S. W. Sawyer, Independence, Missouri [1917].)

150. *Odon Guitar.*[2] Rusk, 123. (*Ca.* 1860, R. A. Brown, St. Joseph, Missouri.)

151. *James L. Minor.*[4] Rusk, 123. (*Ca.* 1860, Mrs. S. Minor Gamble, Kansas City [1917].)

152. *Dr. Archibald Young*[2] (30½ x 27). (*Ca.* 1860, Mrs. James H. Guitar, Columbia, Missouri.)

153. *John Bristow Wornall*[2] (29½ x 24½). (*Ca.* 1860, John B. Wornall, Kansas City.)

154. *Mrs. John B. Wornall*[2] (29 x 24). Nee Eliza Shalcross Johnson. (*Ca.* 1860, *Kearney Wornall*, Kansas City.)

155. *Jacob Hall*[2] (29 x 25). (1861, Mrs. Mary Morris Luther, Siloam Springs, Arkansas.)

156. *Mrs. Jacob Hall*[2] (29 x 25). Nee Mary Louisa Colcord. (1861, Mrs. Mary Morris Luther, Siloam Springs, Arkansas.)

157. *Mary Francis Hall*[2] (28 x 21). (1861, Mrs. Mary Morris Luther, Siloam Springs, Arkansas.)

158. *James M. Piper*[1] (*ca.* 44 x 36). (1862, Mrs. Arthur Palmer, Independence, Missouri.)

159. *Mrs. James M. Piper*[1] (*ca.* 43 x 35). Sister of Eliza Thomas Bingham. 1862, Mrs. Arthur Palmer, Independence, Missouri.)

160. *Dr. Edwin Price.*[1] (1862, R. B. Price, Columbia, Missouri.)

161. *R. B. Price.*[1] (1862, R. B. Price, Columbia, Missouri.)

162. *Mrs. R. B. Price.*[1] Nee Emma Prewitt, age 22. (1862, R. B. Price, Columbia, Missouri.)

163. *Mrs. Thomas W. Nelson.*[2] (1862? Public Library, Boonville, Missouri.)

164. *Anne Swinney*[1] (35 x 25). Age 21. Painted at Glasgow, Missouri. (*Ca.* 1863, Mrs. Frank Williams, Lynchburg, Virginia.)

165. *William Daniel Swinney, Jr.*[1] (31 x 21). Painted at Glasgow, Missouri. Cut down from 35 x 25. (*Ca.* 1863, Mrs. Frank Williams, Lynchburg, Virginia.)

166. *Mrs. Younger Pitts II*[2] (30 x 25). Nee Elizabeth Rogers. Painted near Glasgow, Missouri. Seated, half-length. Framed oval. (*Ca.* 1863, Mrs. Charles H. Coppinger, Liberty, Missouri.)

167. *Younger Pitts III*[2] (*ca.* 40 x 35). Painted near Glasgow, Missouri. Half-length, seated, oval frame. (*Ca.* 1863, William Carl Pitts, Clay County, Missouri.)

168. *Mrs. Younger Pitts III*[2] (*ca.* 40 x 35). Nee Eleanor Hawkins. Painted near Glasgow, Missouri. Half-length, seated, oval frame. (*Ca.* 1863, William Carl Pitts, Clay County, Missouri.)

169. *Edward Bates.*[5] (*Ca.* 1866–69, destroyed in University of Missouri fire, 1892.)

170. *Rollins Bingham*[1] (28 x 24). (1867, Mrs. John B. Hutchison, Independence, Missouri.)

171. *Thomas Hoyle Mastin*[2] (35 x 27). (1869, Hoyle M. Lovejoy, River Forest, Illinois.)

172. *John J. Mastin.*[3] At eighteen months (Rusk, 90, 124). (Mrs. Thomas H. Mastin, Kansas City [1917].)

173. *Mrs. John B. Wornall*[2] (26 x 21). Nee Roma Johnson. (1870, John B. Wornall, Kansas City.)

174. *Hugh C. Ward*[1] (23½ x 19½). Age 7. (1870, Hugh C. Ward, Boston.)

175–77. Portraits of Mr. and Mrs. Kinney of New Franklin and of their

son and daughter (Rusk, 125). (*Ca.* 1870, Miss Alice Kinney, New Franklin, Missouri [1917].)

178. *Dr. David Lionberger.* (*Ca.* 1870, Missouri Historical Society, St. Louis.)

179. *Frank P. Blair, Jr.*[4,5] Small study for full-length portrait. (1871, Mrs. Edward Henrotin, Cherry Plain, Rensaeller Co., New York.)

180. *Frank P. Blair, Jr.*[3,5] (*ca.* 96 x 72). Life-size, full-length. Ex coll.: St. Louis Mercantile Library. Passed to Missouri Historical Society, 1926; in restoration cut down considerably. Since disappeared. (1871, location unknown.)

181. *Frank P. Blair, Jr.* Bust? In 1893, Thomas Mastin bought a portrait of General Blair. (1871? Thomas H. Mastin, Kansas City?)

182. *James S. Rollins*[1] (30 x 24). Small study for full-length portrait. (1871, David Westfall, Columbia, Missouri.)

183. *Dr. Anthony Rollins.*[2] Painted after the 1837 portrait. (1871, destroyed in University of Missouri fire, 1892.)

184. *Mrs. James S. Rollins.*[2] (1871–72, C. B. Rollins Estate, Columbia, Missouri.)

185. *Sarah Rodes Rollins.*[1] Painted from photograph after her death. (1872, C. B. Rollins Estate, Columbia, Missouri.)

186. *James S. Rollins.*[5] Full-length, life-size, standing portrait. (1873, destroyed in University of Missouri fire, 1892.)

187. *James S. Rollins.*[1] Bust. (1873, property of J. Sidney Rollins, Columbia, Missouri. On loan to State Historical Society of Missouri, Columbia, Missouri.)

188. *Maud Walker*[1] (*ca.* 30 x 26). Born 1869, daughter of L. D. Walker, Farmington, Missouri, probably painted in Jefferson City. Three-quarter length, standing figure, with landscape background. (*Ca.* 1875, collection of Mrs. Max McClure, Webster Groves, Missouri.)

189. *Susan Walker*[1] (*ca.* 30 x 26). Baby daughter of L. D. Walker, Farmington, Missouri, probably painted at Jefferson City. Seated full figure with landscape background. (*Ca.* 1875, collection of Mrs. Max McClure, Webster Groves, Missouri.)

190. *Miss Coleman.* Granddaughter of Senator Crittenden (Rusk, 100, 125). (1876, location unknown.)

191. *Vinnie Ream*[1] (40 x 30). (1876, State Historical Society of Missouri, Columbia, Missouri.)

192. *Vinnie Ream.* According to C. B. Rollins a second portrait of Vinnie Ream was in the family of her husband, General Hoxie ("Letters of George Caleb Bingham," XXXIII, 73–74n.). (1876, location unknown.)

193. *Dr. Alexander P. Davidson*[2] (29 x 24). (1877, J. Porter Henry, St. Louis.)

194. *James T. Birch*[1] (29 x 24). Signed, lower left, "G. C. Bingham." (1877, Mrs. Benjamin E. Read, St. Louis.)

195. *Mrs. James T. Birch*[1] (29 x 24). Nee Margaret Nelson. Signed, lower left, "G. C. Bingham." (1877, Mrs. Benjamin E. Read, St. Louis.)

196. *Mrs. James T. Birch*[2] (*ca.* 9½ x 29½). Half-length. Signed, lower left, "G. C. Bingham." (1877, Mrs. Fulton Stephens, Esparto, California.)

197. *Col. Joseph L. Stephens.*[5] Life-size, full-length. Painted at Boonville. (1877, location unknown.)

198. *Mrs. Joseph L. Stephens.*[5] In 1901, owned by her daughter, Mrs. Abiel Leonard (Boonville *Weekly Advertiser,* June 14, 1901). (1877? Location unknown.)

199. *Self-Portrait.*[1] (1877? Kansas City Board of Education. On loan: William Rockhill Nelson Gallery of Art.)

200. *Thomas W. Nelson.*[2,3] (1877? Mrs. Wyan Nelson, Kansas City [1917].)

201. *Mrs. Thomas W. Nelson.*[2,3] (1877? Mrs. Wyan Nelson, Kansas City [1917].)

202. *Samuel Spahr Laws.*[5] President of University of Missouri, 1876–89. (1878, destroyed in University of Missouri fire, 1892.)

203. *Mrs. Samuel S. Laws.*[5] (1878, location unknown.)

204. *William Broadwell.*[5] Father of Mrs. S. S. Laws. Copied from another portrait. (1878, location unknown.)

205. *Mrs. William Broadwell.*[5] Mother of Mrs. S. S. Laws. Copied from another portrait. (1878, location unknown.)

206. *Mattie Lykins Bingham.*[5] Identified in papers of Bingham estate as a portrait of Mrs. General Bingham. (1878, location unknown.)

207. *Mary Rollins Overall.*[5] Grandchild of James S. Rollins. (1878, Mrs. Sidney R. Overall, St. Louis.)

208. *James H. Rollins.*[5] (1878, location unknown.)

209. *Mrs. James H. Rollins.*[5] (1878, location unknown.)

210. *Washington Adams.*[5] In subject's possession, 1882. (1878? Location unknown.)

211. *Judge F. M. Black.*[3] Rusk, 126. (1878? Historical Society, Kansas City [1917].)

212. *A child of Judge David Waldo.* Full-length. (1879, location unknown.)

For lack of information about their composition the following portraits are listed alphabetically:

213. *Henry V. Bingham.*[4] Brother of the artist (Rusk, 127). (Mrs. L. J. B. Neff, Marshall, Missouri [1917].)

214. *Johnson Bowen Clardy.*[1] (Mrs. Charles Hudson, St. Louis.)

215. *Mrs. B. W. Clark and Brother.*[1] Attributed to Bingham. (William Rockhill Nelson Gallery of Art.)

216. *Dr. Thomas Cockerill.*[4] Rusk, 127. (Mrs. Florence Follin, Glasgow, Missouri.)

217. *Mrs. Thomas Cockerill.*[4] (Mrs. Florence Follin, Glasgow, Missouri.)

218. *Mrs. Agnes Nelson Day.*[1] Youngest sister of Margaret Nelson Birch. (Mrs. Benjamin E. Read, St. Louis.)

219. *William F. Dunnica.*[4] Rusk, 127. (Thomas Shepperd, Pittsburgh.)

220. *Mrs. William F. Dunnica.*[4] Rusk, 127. (Thomas Shepperd, Pittsburgh.)

221. *Henry S. Geyer.*[2] Died 1859. (University of Missouri School of Law.)

222. *Mrs. Henry S. Geyer.*[2] (University of Missouri School of Law.)

223. *John Woods Harris*[1] (28 x 24). (State Historical Society of Missouri, Columbia, Missouri.)

224. *John W. Henry*[2] (*ca.* 30 x 25). Judge, Supreme Court of Missouri. (Donald D. Henry, St. Louis.)

225. *Mrs. John W. Henry*[2] (*ca.* 30 x 25). (Donald D. Henry, St. Louis.)

226. *Mrs. Sophia Hickman.*[5] (C. B. Rollins, Columbia, Missouri [1910].)

227. *William H. Hudson.*[5] President of the University of Missouri, 1856–59. (Destroyed in University of Missouri fire, 1892.)

228. *Johnston Lykins.*[1] Died 1876. (Native Sons of Kansas City.)

229. *Ebenezer McBride*[2] (26 x 21). (James M. Kemper, Jr., Kansas City.)

230. *Mrs. Ebenezer McBride*[2] (26 x 21). (Mrs. Charles E. McArthur, Jr., New York.)

231. *J. P. McBride.*[2] Judge, Supreme Court of Missouri. (Mrs. James Thompson, Fayette, Missouri.)

232. *Mrs. J. P. McBride.*[2] (Mrs. James Thompson, Fayette, Missouri.)

233. *Mr. McCoy.*[5] Among paintings in 1893 sale. (Location unknown.)

234. *Mrs. McCoy.*[5] Among paintings in 1893 sale. (Location unknown.)

235. ——— *McIlvain.*[2] (Mrs. Lucinda McMillan, Webster Groves, Missouri.)

236. *Dr. William Price.*[2] (Mrs. Christian De Waal, Lexington, Kentucky.)

237. *Mrs. William Price.*[2] Nee Mary Ellen Sappington. (Mrs. Christian De Waal, Lexington, Kentucky.)

238. *Daniel Read.*[5] President of the University of Missouri, 1866–76. (Destroyed in University of Missouri fire, 1892.)

239. *Judge Richardson.*[5] (Burned at Chicago World's Fair.)

240. *James S. Rollins.*[5] Bust. In 1893, went to J. H. Woodman, Kansas City, for $25.00. (Location unknown.)

241. *James Shannon*[5] (30 x 25). President of the University of Missouri, 1850–56. (State Historical Society of Missouri, Columbia, Missouri.)

242. *Robert B. Todd.*[5] (Destroyed in University of Missouri fire, 1892.)

243. *Robert L. Todd.*[5] (Destroyed in University of Missouri fire, 1892.)

C. DRAWINGS

1. *St. Louis Mercantile Library Sketchbook*

A collection of 117 figures and details on 112 sheets of varying sizes now mounted on 110 leaves in a scrapbook—pencil, ink, and wash drawings probably made between 1844 and 1849—given to the library by John How of St. Louis, 1868. From a study of the genre paintings it seems probable that this lot represents no more than half of the artist's portfolio of figure sketches.

In the present volume the sketches have been arranged in the sequence in which the figures appear in the successive extant paintings. For convenience of reference the Mercantile Library numbers are also given below.

Sketch No.	Mer. Lib. No.		
1	35	30	12
2	26	31	9
3	95	32	52
4	10	33	58
5	11	34	68
6	47	35	32
7	14	36	16
8	23	37	75
9	55	38	92
10	46	39	88
11	61	40	80
12	97*	41	42
13	33	42	81
14	103†	43	31
15	56	44	93
16	5	45	105
17	4	46	69
18	63	47	73
19	6	48	102A
20	87	49	65
21	28	50	62
22	74	51	24
23	20	52	106
24	38	53	37
25	71	54	29
26	70	55	85
27	83	56	34
28	67	57	15
29	43	58	57

59	48	86	18
60	100	87	17
61	96	88	8
62	107	89	78
63	44	90	64
64	51	91	99
65	101	92	60
66	94	93	91
67	104	94	36
68	22	95	79
69	50	96	45
70	3	97	59
71	102B	98	108
72	21	99	76
73	25	100	54
74	27	101	41
75	86	102	2
76	53	103	1
77	39	104	84
78	13	105	7
79	72	106	77
80	82	107	103*
81	40	108	19
82	49	109	66
83	98	110	89
84	97†	111	90
85	30	112	109

* Lower sketch.
† Upper sketch

2. *M. and M. Karolik Collection of Drawings, Museum of Fine Arts, Boston*
One drawing—a variation of No. 34 here published (Mercantile Library No. 68).
Signed and dated: "G [middle initial erased] Bingham 1836" but date and signature almost certainly forged. Correct date is 1844 or after.

3. *Bingham Collection, State Historical Society of Missouri*
More than 30 figures and heads drawn on 11 sheets of varying size and on the reverse of 5 of the sheets and pasted on 6 pages in the Rollins Scrapbook. Included are 4 nudes, 3 religious figures, 1 cow, I head of a cow, a standing figure of a woman holding a child, a seated old woman reading a Bible, a half-length of a young woman, a seated man, a man on horseback, the upper portion of the body of a reclining,

clothed, sleeping female, an aged, seated man with a cane, the upper portion of the body of a seated, aged man, 9 heads of men, 2 busts of men, an elderly man reading, and several dogs.

Probably sketched in 1838 at the Pennsylvania Academy of Fine Arts or soon after his return to Missouri.

4. Collection of John Davis Hatch, Jr.

One drawing picturing a man holding and supporting another who appears to have been wounded in a duel. Ex coll.: Col. Niles.

Subject does not fit any extant painting. "Bingham" without initials written in lower right corner.

5. Lost figure drawings

In September, 1873, Bingham informed Rollins that he was then making "drawings to be elaborated into pictures" in the winter and declared that he intended to "try to make arrangements with the Harpers and others to supply them with illustrations of Western life and manners, as exemplified upon our rivers plains and mountains" ("Letters," XXXIII, 349).

Nothing is known of the specific nature or the disposal of this material.

6. Lost sketches from nature

According to his son Rollins, portfolios containing "a great many" sketches from nature in oil and pencil in existence shortly before Bingham's death were since lost or destroyed (Rusk, 96).

D. ENGRAVINGS AND LITHOGRAPHS AFTER BINGHAM

1. Charles Anderson Wickliffe. Mezzotint by J. Sartain after a lost portrait. Published June, 1843. No copy located. (1843)

2. The Jolly Flatboatmen. Etching on steel by Thomas Doney. Picture size 4⅜ x 5¾. Frontispiece for *Transactions of the American Art-Union for 1846.* Published March, 1847. Edition about 8,000. (1847)

3. The Jolly Flatboatmen. Mezzotint by Thomas Doney. Picture size 18⅝ x 24. Print issued by the American Art-Union to members for 1847. Entered by the American Art-Union, 1847, *but note:* first prints pulled for honorary secretaries, March, 1848; distribution to members begun, May, 1848. Edition about 10,000. (1848)

4. Scene on the Ohio River near Cincinnati. Woodcut by G. A. Bauer after a lost landscape. Picture size 2¾ x 3¾. Published in the (St. Louis) *Western Journal and Civilian,* January, 1852 (VII, 289). (1852)

5. In a Quandary. On stone by Regnier after the painting by the same title. Picture size 14⅝ x 18¾. Published by Goupil & Co. before June 27, 1852. Dedicated to "Major James S. Rollins of Missouri." (1852)

6. The Emigration of Daniel Boone with his Family. On stone by Regnier after the painting in its first state. Picture size 18 x 24. Published by

Goupil & Co. Dedicated to "The Mothers and Daughters of the West." (1852)

7. *Canvassing for a Vote.* On stone by Regnier. Picture size 14⁷⁄₁₆ x 18⁵⁄₈. Published by Goupil & Co. Entered by Knoedler, 1853. (1853)

8. *The County Election.* Engraving on steel by John Sartain. Picture size 22⅜ x 30⅜. Printed by James Irwin, Philadelphia. Published by Goupil & Co. Artist's proofs, proofs before letters, color, and black and white. Plate now owned by Boatmen's Bank, St. Louis, together with twelve proof impressions taken during progress of plate. (1854)

9. *Stump Speaking.* Engraving on steel by Gautier. Picture size 22⅜ x 30⅜. Published by Goupil & Co. Entered 1856. Dedicated to "The Friends of American Art." Plate now owned by Boatmen's Bank, St. Louis. (1856)

10. *The Verdict of the People.* On stone by unknown lithographer. Picture size 21⅞ x 30⅜. To be published by Goupil & Co., but stone was destroyed during siege of Paris. Two proofs only survived—one given by Bingham to James S. Rollins is now in the possession of the State Historical Society of Missouri. (1870)

11. *Martial Law.* Engraving on steel by John Sartain after the painting later entitled *Order No. 11.* Picture size 21⁵⁄₁₆ x 31. Published by Geo. C. Bingham and Company. Dedicated to "The Friends of Civil Liberty." Subtitle reads: "As Exemplified in the Desolation of Border Counties of Missouri, During the enforcement of Military Orders, Issued by Brigadier General Ewing, of the Federal Army, from his Headquarters, Kansas City, Aug. 25th 1863." The complete text of General Order No. 11 was also carried on the engraving. According to C. B. Rollins (Kansas City *Star,* November 13, 1932), 5,000 proofs were pulled. (1872)

12. *Little Red Riding Hood.* An engraving after Bingham's portrait of this title was exhibited at the special exhibition of Bingham's works in Columbia, Missouri, 1910. No copy has been located.

Sources Consulted

MANUSCRIPTS

Adams, John Quincy. Diary, 1840–1844. The Adams Trust and the Massachusetts History Society.

American Art-Union Records. The New-York Historical Society. Includes letters sent, letters received, minutes of the committee on management, register of works received, scrapbooks, etc.

Bates, Edward. Diary, 1846–1852. Missouri Historical Society, St. Louis.

Beauregard, Nettie H. Curator's Diary, August, 1926–February, 1927. Missouri Historical Society, St. Louis.

Bingham Papers, State Historical Society of Missouri, Columbia. Includes letters of George Caleb Bingham to his family and to James S. Rollins, and drawings by Bingham in the Rollins Scrapbook.

Broadhead Papers, Missouri Historical Society, St. Louis.

Goupil Papers, Knoedler Galleries.

Lewis, Henry. Letters to his brother George. Private Collection.

Miller, Clarence E. Forty Years of Long Ago: Early Annals of the Mercantile Library Association and its Public Hall, 1846–1886, St. Louis, Mo.

Minutes of The St. Louis Mercantile Library Association.

Minutes of the Board of Trustees, Missouri Historical Society, St. Louis.

Probate Court Records. The City of St. Louis and Cooper, Howard, Saline, and Jackson Counties, Missouri.

Harriet Sartain Collection, Historical Society of Pennsylvania.

Tucker-Coleman Papers, Colonial Williamsburg.

NEWSPAPERS

Baltimore *American,* 1852.
Boonville, Missouri, *Commercial Advertiser,* 1846.
Boonville, Missouri, *Weekly Advertiser,* 1844–48, 1879, 1901.
Boonville, Missouri, *Weekly Eagle,* 1877.
Boonville, Missouri, *Weekly Observer,* 1844, 1846, 1847, 1854.
Boonville, Missouri, *Weekly Topic,* 1877.
Columbia, *Missouri Intelligencer,* 1835.

Sources Consulted

Columbia, *Missouri Statesman*, 1843, 1844, 1846, 1847, 1851–57, 1859, 1860, 1862, 1865, 1869, 1871–74, 1877–80.
Columbia, *Weekly Missouri Sentinel*, 1852, 1853.
Columbia, *University Missourian*, 1917, 1922.
Fayette, Missouri, *Advertiser*, 1845–47.
Fayette, Missouri, *Boon's Lick Times*, 1840.
Fayette, *Missouri Democrat*, 1846–49.
Fayette, *Missouri Intelligencer*, 1826–29.
Franklin, *Missouri Intelligencer*, 1819–26.
Glasgow, Missouri, *Weekly Tribune*, 1852.
Jefferson City, Missouri, *Weekly Inquirer*, 1844, 1845, 1850–52, 1859, 1861.
Jefferson City, Missouri, *Metropolitan*, 1846–50.
Jefferson City, Missouri, *Republican*, 1836.
Jefferson City, Missouri, *Daily Tribune*, 1877, 1893.
Kansas City *Journal*, 1893.
Kansas City *Journal Post*, 1878.
Kansas City *Evening Mail*, 1878.
Kansas City *Star*, 1893.
Lexington, *Kentucky Statesman*, 1853.
Liberty, Missouri, *Weekly Tribune*, 1846, 1848, 1849, 1852, 1853, 1857, 1859–62, 1864–69.
Louisville *Commercial*, 1873.
Louisville *Daily Courier*, 1853.
Louisville *Courier-Journal*, 1873.
Louisville *Daily Journal*, 1853.
Louisville *Daily Times*, 1853.
Natchez *Mississippi Free Trader and Natchez Gazette*, January–May, 1837.
New Orleans *Picayune*, 1853.
New York *American*, 1842.
New York *Express*, 1842.
New York *Tribune*, 1842.
Petersburg, Virginia, *Statesman*, 1841.
Philadelphia *Dollar American*, 1852, 1854.
Philadelphia *Sunday Dispatch*, 1854, 1855.
Philadelphia *Evening News*, 1854.
Philadelphia *Daily News*, 1855.
Philadelphia *North American*, 1852, 1854.
Philadelphia *Morning Pennsylvanian*, 1854, 1855.
Philadelphia *Public Ledger*, 1854, 1855.
Philadelphia *Sun*, 1854.
St. Louis *Argus*, 1837–41.
St. Louis *Beacon*, 1829.
St. Louis *Commercial Bulletin*, 1835–38, 1840.

St. Louis *Daily Countersign,* 1864.
St. Louis *Daily Democrat,* 1869, 1874.
St. Louis *Evening Gazette,* 1839, 1840.
St. Louis *Globe-Democrat,* 1898, 1904.
St. Louis *Evening Intelligencer,* 1851, 1853.
St. Louis *Log Cabin Hero,* 1840.
St. Louis *Mill Boy,* 1844.
St. Louis *Missouri Democrat,* 1862.
St. Louis *Missouri Republican,* 1835–52, 1856, 1862, 1869, 1872, 1874, 1876, 1877, 1879.
St. Louis Tri-Weekly Missouri Republican, 1856.
St. Louis *Missouri Saturday News,* 1840.
St. Louis *Morning Signal,* 1852.
St. Louis *New Era,* 1840–50.
St. Louis *Daily Evening News,* 1853, 1854.
St. Louis *Peoples Organ,* 1844.
St. Louis *Times,* 1850.
St. Louis *Daily Union,* 1846, 1849, 1850.
St. Louis *Weekly Reveille,* 1845–47.
St. Louis *Western Atlas,* 1840.
St. Louis *Western Watchman,* 1857.
Washington *Chronicle,* 1876.
Washington *Daily Globe,* 1840–44.
Washington *Daily Madisonian,* 1841–44.
Washington *National Era,* 1860.
Washington *National Intelligencer,* 1840–44, 1860.
Washington *National Republican,* 1876.
Washington *Post,* 1878.
Washington *Evening Star,* 1860.
Washington Sentinel, 1878.
Washington *True Whig,* 1841, 1842.

CATALOGUES

Catalogue of Paintings Exhibited at the Nineteenth St. Louis Fair and Exposition. St. Louis, 1879.
Catalogue of Paintings Exhibited at the St. Louis Mercantile Library. St. Louis, 1871.
Catalogue of Prizes to be Distributed by the Art Union of Philadelphia on December 31, 1852. Philadelphia, 1851.
Catalogue of the Art Gallery of the Mississippi Valley Sanitary Fair. St. Louis, 1864.
Catalogue of the Fifteenth Annual Exhibition of the Pennsylvania Academy of the Fine Arts. Philadelphia, 1838.

Catalogue of the First Annual Exhibition of the Western Academy of Art. St. Louis, 1860.

Catalogue of the First Exhibition of Philadelphia Artists and the School of Painting and Design. Philadelphia, 1838.

Catalogue of the First Exhibition of Statuary, Paintings, &c. opened May 9th . . . 1859. Chicago, 1859.

Catalogue of the First Fall Exhibition of the Works of Modern Artists at the Apollo Gallery. New York, 1838.

Catalogue of the Thirteenth Annual Exhibition of the National Academy of Design. New York, 1838.

Catalogue of Traditional Americana . . . belonging to the Estate of the late Hugh Campbell. St. Louis, Ben J. Selkirk & Sons, 1941.

Complete Guide to the Saint Louis [Wyman's] *Museum.* St. Louis, 1857.

Fourth Annual Exhibition of the Washington Art Association. Washingington, 1860.

Guide to the Sculpture, Paintings, Coins and other Objects of Art in the Halls of the St. Louis Mercantile Library Association. St. Louis, 1862.

Guide to the Works of Art in the St. Louis Mercantile Library. St. Louis, 1871.

Life in America—Loan Exhibition of Paintings Held during the New York World's Fair, 1939. New York, The Metropolitan Museum, 1939.

Loan Exhibition in aid of the St. Louis School of Design, held at Mary Institute. St. Louis, 1879.

Report of the Fourth Annual Fair of the St. Louis Agricultural and Mechanical Association, 1859. St. Louis, 1860.

Revised Catalogue of the Department of Fine Arts, World's Columbian Exposition. Chicago, 1893.

Special Exhibition of the Paintings of George Caleb Bingham, "The Missouri Artist." Columbia, Missouri, The Art Lovers Guild, 1910.

Survey of American Painting. Pittsburgh, Carnegie Institute Department of Fine Arts, 1940.

BOOKS AND PERIODICALS

American Art-Union. *Bulletin*, 1849, 1850, 1851.

American Art-Union. *Transactions for the Years* 1845, 1846, 1847, 1848, 1849, 1850.

"Anecdotes of Major Daniel Ashby," *Glimpses of the Past* (Missouri Historical Society), Vol. VIII (October–December, 1941), 103–47.

Baker, Charles E. "The American Art-Union." In vol. I of Cowdrey, *The American Academy and the American Art-Union, q.v.*

Barker, Virgil. *American Painting: History and Development.* New York, The Macmillan Company, 1950.

Bates, Edward. *Diary of Edward Bates, 1859–1866.* Ed. by Howard K. Beale. *Annual Report of the American Historical Association for 1930,* vol. IV, Washington, 1933.

Baur, John I. H. *American Painting in the Nineteenth Century—Main Trends and Movements.* New York, Frederick A. Praeger, 1953.

Bell, John R. *The Journal of Captain John R. Bell, Official Journalist for the Stephen H. Long Expedition to the Rocky Mountains, 1820.* Ed. by Harlin M. Fuller and LeRoy R. Hafen. Glendale, California, Arthur H. Clark Company, 1957.

Bender, J. H. "Catalogue of Engravings and Lithographs after George C. Bingham," *Print Collector's Quarterly,* Vol. XXVII (February, 1940), 106–108.

Bingham, George Caleb. *An Address to the Public Vindicating a Work of Art Illustrative of the Federal Military Policy in Missouri during the late Civil War.* Kansas City, 1871.

———. "Art, the Ideal of Art and the Utility of Art." Pp. 311–24 in *University of Missouri Public Lectures, 1878–1879, q. v.*

Bingham, Henry Vest. "The Road West in 1818, the Diary of Henry Vest Bingham." Ed. by Marie George Windell. *Missouri Historical Review,* Vol. XL (October, 1945–January, 1946), 21–54, 174–204.

"Bingham Re-Understood," *Art News,* Vol. LII (April, 1953), 36.

Bloch, E. Maurice. "The American Art-Union's Downfall," *New-York Historical Society Quarterly,* Vol. XXXVII (October, 1953), 331–59.

———. "Art in Politics," *Art in America,* Vol. XXXIII (April, 1945), 93–100.

Caffin, Charles H. *The Story of American Painting.* New York, Frederick A. Stokes Company, 1907.

Chambers, William Nisbet. *Old Bullion Benton—Senator from the New West.* Boston, Little, Brown and Company, 1956.

Childs, Marquis W. "George Caleb Bingham," *American Magazine of Art,* Vol. XXVII (November, 1934), 594–99.

Christ-Janer, Albert. *George Caleb Bingham of Missouri; the Story of an Artist.* New York, Dodd, Mead and Company, 1940.

Clement, Clara Erskine and Lawrence Hutton. *Artists of the Nineteenth Century and their Works.* 2 vols. Boston, Houghton, Osgood and Company, 1879.

Cosmopolitan Art Journal, 1856, 1857.

Cowdrey, Mary Bartlett. *American Academy of Fine Arts—American Art-Union Exhibition Records, 1816–1852.* 2 vols. New York, New-York Historical Society, 1953.

———. *National Academy of Design Exhibition Record, 1826–1860.* 2 vols. New York, New-York Historical Society, 1947.

The Crayon, 1858.

Davis, Walter B. and Daniel S. Durrie. *History of Missouri.* St. Louis, 1876.

The Family Magazine, 1839.

Flint, Timothy. *A Condensed Geography and History of the Western states or the Mississippi Valley.* 2 vols. Cincinnati, 1828.

"George Caleb Bingham, an old Missouri Artist, now Comes Back into Favor," *Life Magazine* (September 11, 1939), 40–43.

George Caleb Bingham, the Missouri Artist, 1811–1879. New York, Museum of Modern Art, 1935.

"George Caleb Bingham, Painter of Missouri," *Art World,* Vol. III (1917), 94–98.

The Gift for 1836. Philadelphia, 1835.

Hall, Virginius C. "George Caleb Bingham, the Missouri Artist," *Print Collector's Quarterly,* Vol. XXVII (February, 1940), 8–25.

Harding, Chester. *My Egotistigraphy.* Cambridge, 1866.

Isham, Samuel. *The History of American Painting.* New edition with supplemental chapters by Royal Cortissoz. New York, The Macmillan Company, 1936.

James, Edwin. *Account of an Expedition from Pittsburgh to the Rocky Mountains performed in the years 1819, 1820 under the command of Major S. H. Long.* Vols. XIV–XVII in R. G. Thwaites (ed.), *Early Western Travels (q.v.)*

Larkin, Lew. *Bingham: Fighting Artist; the Story of Missouri's Immortal Painter, Patriot, Soldier, and Statesman.* Kansas City, Burton Publishing Company, 1954.

Larkin, Oliver W. *Art and Life in America.* New York, Rinehart and Company, 1949.

Levens, Henry C., and Nathaniel M. Drake. *A History of Cooper County, Missouri.* St. Louis, 1876.

Local Laws and Private Acts of the State of Missouri. 18th General Assembly, Adjourned Session, 1855.

McDermott, John Francis. "Another Bingham Found: 'The Squatters,'" *The Art Quarterly,* Vol. XIX (Spring, 1956), 68–71.

———. "Bingham's Portrait of John Quincy Adams Dated," *The Art Quarterly,* Vol. XIX (Winter, 1956), 412–14.

———. "George Caleb Bingham and the American Art-Union," *New-York Historical Society Quarterly,* Vol. XLII (January, 1958), 60–69.

———. "George Caleb Bingham's 'Stump Orator,'" *The Art Quarterly,* Vol. XX, (Winter, 1957), 388–99.

———. "How Goes the Harding Fever?" *Missouri Historical Society Bulletin,* Vol. VIII (October, 1951), 52–59.

———. "Jolly Flatboatmen: Bingham and his Imitators," *Antiques,* Vol. LXXIII (March, 1958), 266–69.

———. *The Lost Panoramas of the Mississippi.* Chicago, The University of Chicago Press, 1958.

————. "The Quandary about Bingham's 'In a Quandary' and 'Raftmen Playing Cards,'" *Bulletin of the City Art Museum of St. Louis*, Vol. XLII (1957), 6–9.

Minutes of the Annual Conferences of the Methodist Episcopal Church, South, 1859.

Monaghan, Jay. *Civil War on the Western Border, 1854–1865.* Boston, Little, Brown and Company, 1955.

Mountjoy, Shannon. "Missouri's Great Painter of Political Campaign Scenes," *Sunday Globe-Democrat*, St. Louis, November 6, 1904, Magazine Section, p. 5.

Musick, James B. "Bingham's Historical Background in Missouri." Pp. 13–14 in *George Caleb Bingham, the Missouri Artist, 1811–1879.*

————. "Praise the Lord and Pass the Ammunition," *Antiques*, Vol. XLIII (February, 1943), 60–63.

Napton, William Barclay. *Past and Present of Saline County, Missouri.* Indianapolis, Bowen Company, 1910.

New York Literary World, Vols. II and III (1847, 1848).

[Parsons, Mrs. Helen R.] "Missouri's Greatest Painter—George P [*sic*]. Bingham (1811–1879)," Kansas City *Public Library Quarterly*, Vol. I, (July, 1901), 65–68.

Paul Wilhelm, Duke of Württemberg. *First Journey to North America in the Years 1822 to 1824.* Translated from the German by William G. Bek. *South Dakota Historical Collections*, Vol. XIX (1938).

Philadelphia Art Union Reporter, 1851, 1852.

Pope, Arthur. "Bingham's Technique and Composition." In *George Caleb Bingham, the Missouri Artist, 1811–1879, q.v.*

Powell, Mary. "George Caleb Bingham," *Bulletin of the City Art Museum of St. Louis*, Vol. IX (October, 1924), 57–62.

Rathbone, Perry T. *Mississippi Panorama.* St. Louis. The City Art Museum, 1949.

————. *Westward the Way.* St. Louis, The City Art Museum, 1954.

Richardson, Edgar P. "'The Checker Players' by George Caleb Bingham," *The Art Quarterly*, Vol. XV (Autumn, 1952), 251–56.

————. *Painting in America: the Story of 450 Years.* New York, Thomas Y. Crowell, 1956.

————. "The Trappers' Return by George Caleb Bingham," *Bulletin of the Detroit Institute of Arts*, Vol. XXX (1950–51), 81–84.

Rogers, Meyric R. "An Exhibition of the Work of George Caleb Bingham, 1811–79, 'The Missouri Artist,'" *Bulletin of the City Art Museum of St. Louis*, Vol. XIX (April, 1934), 13–27.

————. "George Caleb Bingham, 1811–1879." Pp. 7–12 in *George Caleb Bingham, the Missouri Artist, 1811–1879. q.v.*

Rollins, C. B. (ed.). "Letters of George Caleb Bingham to James S. Rol-

lins," *Missouri Historical Review,* Vol. XXXII, 3–34, 164–202, 340–77, 484–522; Vol. XXXIII, 45–78, 203–29, 349–84, 499–526 (October, 1937–July, 1939).

———. "Some Recollections of George Caleb Bingham," *Missouri Historical Review,* Vol. XX (July, 1926), 463–84.

Rusk, Fern Helen [*see also* Fern Rusk Shapley]. *George Caleb Bingham, the Missouri Artist.* Jefferson City, Missouri, The Hugh Stevens Company, 1917.

Rutledge, Anna Wells. *Cumulative Record of Exhibition Catalogues: The Pennsylvania Academy of the Fine Arts Exhibition Record, 1807–1870; The Society of Artists, 1800–1814; The Artists' Fund Society, 1835–1845.* Philadelphia, The American Philosophical Society, 1955.

St. Louis Mercantile Library Association Annual Reports for 1859, 1860, 1861, 1862, 1865, 1867, 1868, 1879, 1941, 1944.

Shackelford, Thomas. "Early Recollections of Missouri," *Missouri Historical Society Collections,* Vol. II (April, 1903), 1–20.

Shapley, Fern Rusk [*see also* Fern Rusk]. "Bingham's 'Jolly Flatboatmen,'" *The Art Quarterly,* Vol. XVII (Winter, 1954), 352–56.

Shoemaker, Floyd C. *Missouri, Day by Day.* 2 vols. Columbia, State Historical Society of Missouri, 1942, 1943.

———. "Remarks on Senator Allen McReynolds and the Bingham Portrait of Thomas Jefferson," *Missouri Historical Review,* Vol. XLVIII (October, 1953), 42–45.

Simonds, May, "Missouri History as Illustrated by George C. Bingham," *Missouri Historical Review,* Vol. I (April, 1907), 181–90.

———. "A Pioneer Painter," *American Illustrated Methodist Magazine,* Vol. VIII (October, 1902), 71–78.

Smith, William B. *James Sidney Rollins.* New York, 1891.

Spencer, Thomas Edwin. *A Missourian Worth Remembering, George Caleb Bingham.* St. Louis, 1930.

Taggart, Ross E. "'Canvassing for a Vote' and Some Unpublished Portraits by Bingham," *The Art Quarterly,* Vol. XVIII (Autumn, 1955), 228–40.

Taylor, James L., Jr. "Shubael Allen, Native of Orange County, N. Y., and Pioneer in Western Missouri," *New York Genealogical and Biographical Record,* Vol. LXXXV (July, 1954), 133–39.

Thwaites, Reuben Gold (ed.). *Early Western Travels, 1748–1846.* 32 vols. Cleveland, Arthur H. Clark Co., 1904–1907.

Tuckerman, Henry T. *Book of the Artists. American Artist Life.* New York, G. P. Putnam & Son, 1867.

University of Missouri Public Lectures, 1878–1879. Columbia, 1878.

Van Ravenswaay, Charles. "Architecture in the Boon's Lick Country," *Missouri Historical Society Bulletin,* Vol. VI (July, 1950), 491–502.

———. "A Rare Midwestern Print," *Antiques,* Vol. XLIII (February, 1943), 77, 93.

———. "Arrow Rock, Missouri," *Missouri Historical Society Bulletin,* Vol. XV (April, 1959), 203–23.

Viles, Jonas. "Old Franklin: A Frontier Town of the Twenties," *Mississippi Valley Historical Review,* Vol. IX (March, 1923), 269–82.

The Washington Directory for 1843. Washington, 1843.

Webb, W. L. *Battles and Biographies of Missourians; or the Civil War Period of our own State.* Kansas City, Missouri, Hudson-Kimberly, 1900.

Wehle, Harry B. "An American Frontier Scene by George Caleb Bingham," *Bulletin of the Metropolitan Museum of Art,* Vol. XXVIII (July, 1933), 120–22.

Western Art Union. *Record, 1849.*

Western Art Union. *Transactions for the years, 1849, 1850.*

Western Journal and Civilian, 1851, 1852.

Wetmore, Alphonso. *Gazetteer of the State of Missouri.* St. Louis, 1837.

Whitley, Edna Talbott. *Kentucky Ante-Bellum Portraiture.* Lexington, National Society of Colonial Dames in Kentucky, 1956.

Index

447

449

Index

451